THEORY RULES

THEORY RULES
ART AS THEORY / THEORY AND ART

EDITED BY JODY BERLAND, WILL STRAW AND DAVID TOMAS

YYZ BOOKS
AND
UNIVERSITY OF TORONTO PRESS
TORONTO BUFFALO LONDON

THEORY RULES

© YYZ Books 1996
Toronto

A co-publication with
University of Toronto Press Incorporated
Toronto Buffalo London

Canadian Cataloguing in Publication Data
 Main entry under title:
 Theory Rules: art as theory/theory and art
 Papers printed at a conference Art as Theory/theory and art
 held at the University of Ottawa,
 Nov. 29–30, Dec. 1, 1991.
 ISBN 0-8020-0707-4 (hardcover)
 ISBN 0-8020-7657-2 (paperback)
 1. Arts – Philosophy – Congresses
 2. Art criticism – Congresses.
 I. Berland, Jody.
 II. Straw, Will.
 III. Tomas, David G. (David Georges), 1950–

 BH39.T54 1995 700'.1 C95 931750-3

YYZ Books acknowledges the generous assistance of
the Canada Council, Special Projects, Visual Arts to this publication.
YYZ Books also receives operational funding from the Canada Council,
Ontario Arts Council, the City of Toronto through the Toronto Arts Council,
and the Municipality of Metropolitan Toronto, Cultural Affairs Division.

University of Toronto Press acknowledges the financial assistance
to its publishing program of the Canada Council and the Ontario Arts Council.

CONTENTS

THEORY RULES

INTRODUCTION
The Art as Theory / Theory and Art Conference

MOST OF THE PAPERS collected in this volume were first presented in their original form at the conference "Art as Theory/Theory and Art" held at the University of Ottawa near the end of 1991. The conference was hosted by the university's Department of Visual Arts, and received funding from the Social Sciences and Humanities Research Council of Canada and the Canada Council.

The impulse to hold the conference sprang from informal discussions between the three co-organizers in 1990 and 1991. It grew from a shared recognition that Theory (with a capital T) has emerged as a privileged site of mediation between processes of market valorization and discourses of intellectual or political legitimation in the production and circulation of art. The conference was planned to address the conditions under which Theory has assumed this new role, and the resulting implications for artistic and theoretical work.

Within cultural life, a tension between theoretical work and artistic practice has long been observed. Indeed, the desire to resolve these tensions has been a principal impulse shaping the history of artistic work and criticism over the last century. Nevertheless, the last decade has seen the emergence of a broad, interdisciplinary body of theoretical work whose relationship to artistic practice is quite novel and distinct. The origins of this work range from poststructuralist

literary theory to that amorphous entity called "cultural studies." There is increasingly common reference, within artworks, to principles and vocabularies developed within this body of theory. The convergences of purpose between art, art criticism, and theoretical writing suggest that a significant shift in the relationship between artistic production and critical/theoretical activity has occurred.

More and more, works of art, criticism, and scholarship have come to define their project as one of cultural analysis. Across these activities, one increasingly finds the deployment of a shared set of analytical tools, or the reference to a common body of authors and texts. In the space of mutual sustenance created here, the relationships between these various activities, and between the institutional contexts in which they normally occur, are being transformed. These transformations, and their implications for artistic and scholarly work, provided one focus for the conference. They were addressed in the "Statement of Concerns" which was sent to individual presenters. This statement is included as an appendix to this preface.

Many of these concerns have a practical dimension. If theoretical work and practical activity within the visual arts have become intertwined in distinctly new ways, we can expect the material conditions of each to be transformed. Already, in the evolving relationship of the academy to the art school, we recognize shifts in the traditional patterns by which artists are trained and artistic careers unfold. These shifts have produced new tensions and have raised a host of new questions. When developments in cultural theory nourish artistic practice, for example, what is the effect of this upon the normal processes by which artists are trained or otherwise acquire the competencies necessary to an artistic career? Is such a career possible in the absence of an academic education which emphasizes the cultivation of theoretical knowledges? And if, as is generally the case, artists will often supplement income from their work with teaching activity, will theoretical training be needed in order that they acquire the qualifications deemed necessary for this activity?

What, then, will be the relationship between these artists and those of their academic colleagues who are designated as theorists? As "movements" or new directions in artistic practice respond more and more to developments in cultural theory itself, what will be the status of those artistic works or tendencies which do not participate in these movements?

Discussions of the relationship between artistic practice and academic, theoretical work typically begin with the assumption that there is a division between the two which dialogue or further analysis will overcome. The conference on which this volume is based was meant to address quite a different situation—one in which theories of culture have, for some time now, played a significant role in the production, dissemination, and interpretation of works of art. The shifting or withering of boundaries between artistic practice and the academy may be glimpsed in any trip to the magazine store or gallery book shop.

The circulation of theoretical work within such venues as the art gallery (evident in artists' statements and the growing importance of exhibition catalogues) and the art magazine has created new forms of support and sites of intervention for the professional academic. With the emergence of a broad interdisciplinary and international audience for cultural theory, the rates of change and commodity value of theoretical innovations have increased. In this respect, just as the domain of artistic production has grown noticeably more "academic," the field of cultural theory and analysis within the academy has come more and more to resemble the market for art, with similar cycles of fashionability and a comparable emphasis on currency and innovation. In grant applications, exhibition statements, and catalogues, one increasingly finds artists using theoretical tropes as the most effective means for positioning their past and projected work. Conversely, the waning of disciplinary boundaries as the principal context within which theoretical work is undertaken has heightened the value of a writer's signature and reputation. Instances of theoretical intervention thus come to be seen as signalling shifts or

embellishments of authorial personality rather than contributions to the slow, collective revision of institutional or disciplinary traditions.

Those invited to the conference included professional academics, practising artists, critics, and curators. We did not assume that the ascendant influence of cultural theory upon the visual arts was evidence of the final bridging of an age-old gulf; nor did we seek simply to institute a dialogue between theory and practical activity. The conference sought, above all, to address a range of new questions concerning the institutional, political, and intellectual conditions within which intellectual and artistic work is undertaken.

The conference was organized as an international event, and brought together presenters from Canada, the United States, and Europe. (Tony Bennett, from Australia, was unable to attend the conference, but kindly submitted a paper for inclusion in this volume.) Nevertheless, the special relevance of this conference's themes to the Canadian context seemed clear. The relative underdevelopment of a commercial art market in this country, in proportion to the large and productive artistic sector (galleries, museums, government agencies, royal commissions, schools, etc.), has had numerous effects which relate directly to the conditions addressed by the conference. That so many artists fund their work through government grants, in combination with the long-standing practice of awarding such grants on the basis of judgments by juries of one's peers, encourages artists to write statements about their work that signal their awareness of current trends and discourses, and that locate and legitimate their art in terms of contemporary critical issues and vocabularies. The lack of a significant market for art also makes artists more dependent upon institutions of higher learning for their income and a context in which to work. A remarkable number of accomplished Canadian critics and curators have returned to university in recent years for postgraduate studies, mindful of the short-term and potentially secure income sources for academic work.

Artists in Canada have also created a well-developed parallel gallery system, which, in conjunction with avenues of public support for critical and curatorial work, has nourished artistic production and criticism that engage with advanced theoretical analysis. Indeed, it might be argued that the weakness of the commercial market for certain categories of art-making within Canada has heightened the influence of theoretical and critical discourse upon it. It is often critical writing that provides the basis upon which the value of this work is established and claimed.

The conference took place during a period in which the role and purpose of artistic institutions had become the object of renewed attention within the academic, political, and public spheres in Canada. The new importance of the museum and art gallery as objects of interdisciplinary study within universities has accompanied (and contributed to) a crisis of sorts in the relationship of these institutions to the cultural heritage they are meant to preserve and the public they are intended to serve. One symptom of this crisis is the ongoing debate over the extent to which museum and gallery exhibitions should depart from traditional principles of organization (such as those based around individual artists or historical periods) in favour of other principles whose coherence is more obviously grounded in the concerns of contemporary cultural theory. (The recent collection edited by Ivan Karp and Steven D. Lavine, *Exhibiting Cultures: The Politics and Poetics of Museum Display*, offers a useful overview of these debates.) At the same time, the current preoccupation of that theory with cultural identity, and with the problem of defining national cultures, has gone hand-in-hand with the growing internationalization of cultural theory, such that the same points of reference will be found in writings from a number of different countries.

Thankfully, the organizers of a conference are rarely able to exercise total control over what transpires within it. Many of the memorable moments in the event recorded here came when speakers departed from the list of published concerns to address others which we had overlooked or to

recount experiences which brought to the fore new, unforeseen concerns. With regret, and because of space limitations, we have not published transcriptions of the discussions which followed most panels. Nevertheless, the liveliness of these discussions, and the ability of those involved to make provocative connections between individual presentations, made the conference a gratifying and stimulating event.

Themes

In his contribution to this volume, Tony Bennett speaks of the need to "trace the formation of those spaces and institutions in which works of art are so assembled, arranged, named, and classified as to be rendered visible as, precisely, 'art'." The claim that a given notion of the artistic is produced within institutional and historical circumstances is, of course, a commonplace within contemporary critical theory. In fact, the demonstration that "art" is founded upon critical matrices, institutional workings, or broader regimes of visibility and judgment invites a second move. In this, we may trace those ways in which the accumulated symbolic capital of artworks functions in return to legitimize the spaces and intellectual positions in which judgment, classification, and arrangement are practised.

The legitimizing function of art is typically discussed in terms of the monumental and enduring prestige it may bring to the most transitory holders of economic or political power. As artistic movements — whose oppositions to each other once took the form of struggles to the death — sit comfortably beside each other in the space of the gallery or within the narrativized forms of art-historical writing, the works produced within them resonate with the values of a secure, legitimizing permanence. Recognition of this process, however, may simply lead to exhortations to keep art dangerous, as if its legitimacy came only from the reassuring solidity it almost inevitably acquires.

As the articles by Will Straw and Thierry de Duve suggest, however, art may legitimate through its continued promise to rescue knowledges from the bureaucratic constraints of

institutional location. For the theory-trained academic, the spaces of art feed fantasies of intervention in a space which, however sociologically circumscribed, beckons with the promise of an urban "real." In doing so, these spaces recast the theorist/critic as transgressor of boundaries, partner in a natural alliance which struggles against the compartmentalization and professionalization of intellectual labour. Beneath these fantasies, one arguably finds a tendency to mistake the material concreteness of the academic institution for a social isolation which urban art/theory scenes, with their less conspicuous subcultural boundaries, are seen to have resolved.

For the art teacher, in important historical moments, the art school has been legitimized as the necessarily free space in which innate creative faculties are to be fostered and directed. As de Duve argues, the conception of this space as free did not work to diminish the perceived value of the professionally trained art teacher. On the contrary, by reformulating the technical problems of artistic work as the pedagogical challenges raised by new psychologies of creativity, art schools found legitimation as cultural laboratories fulfilling functions which could not be fulfilled elsewhere. In a broader sense, we may note the contradictory ways in which shifting notions of artistic practice alter the institutional status of the academic institution. The overturning of aesthetic norms may diminish the prestige of those institutions in which such norms have congealed, casting them, for a moment, as outmoded guardians of musty tradition. In time, however, these successive overturnings will revalorize the broad historical perspective such institutions claim as their mark of difference, enshrining it as the only effective basis of critical understanding.

In a comprehensive study excerpted here, Timothy Clark has traced the insinuation of Foucauldian ideas into Canadian art criticism and theory over a quarter century. The invocation of Foucault's work in the writing of Canadian critics has its roots in the biographical and intellectual trajectories of each of these individuals, but it also marks a

broader reordering of intellectual and institutional relations. With the increased reference to continental, poststructuralist theory, the frameworks of critical understanding have shifted from heroic narratives of twentieth-century artistic modernism to more totalizing accounts of Western rationality and its regimes of knowledge and visibility. Arguably, the effects of this shift extend beyond the intrusion into art historical or critical writing of a range of new and compelling "themes" (such as the link between monocular vision and the constitution of gender identities). They are manifest, as well, in a certain epic flair within much contemporary criticism, such that the older themes of twentieth-century writing (the relations between popular and high culture, or the linking of artistic practice to social movements) are diminished within a much broader historical scope.

The scope of this criticism, for which works are symptoms of broader historical regimes of authority, is mirrored in that of the Platonic claim that art brings "lasting benefit to human life and human society." Citing Plato, Kevin Dowler points to ways in which the discourses of art have been disarmed in the face of political or administrative critique through their own dismantling of the modernist insistence that the freedom embodied in individual works ensured the long-term social benefit of artistic practice. In any case, what has emerged in recent controversies over artworks in Canadian institutions is the insistence on specificity, the demand that justification be offered for the precise price paid for this painting, or that the specific function of rotting meat in Jana Sterbak's *Vanitas* be explicated. In such instances, traditional formalist analyses frequently reveal themselves as the most strategically useful tools of defence, even when their deployment involves a level of bad faith.

We are living, as Virginia Dominguez suggests in her contribution to this volume, amid the widespread "culturalization" of political and social life. This has caused artistic works to be folded back into the broad socio-political fabric, just as it has often made terms derived from art criticism

("representation," "image," etc.) part of the common language of political discourse in general. Dominguez is speaking broadly, here, of the organization of political impulses around the categories of ethnic, national, and racial identity. We might note, as well, the tendency for political mobilization to gravitate around phenomena which are cultural in a more limited, traditional sense. Art magazines, parallel gallery shows, and controversies over musical theatre or literary appropriation have assumed a significant role within recent Canadian life, as those practices or events around which oppositional politics coalesce.

If there are notable differences of perspective between many of the articles in this volume, they rest, as Jamelie Hassan explicitly argues, on the appropriate role to be accorded "culture" as a phenomena. Does the contemporary privileging of culture reproduce, as Dominguez suggests, a Eurocentric conviction that "viable and distinctive cultures" are the necessary price of admission to a world of political rights and recognition? In the widespread insistence that we understand the coherent cultural dynamics of particular populations, do we not find concealed the claim that groups unable to offer this coherence for understanding are less deserving of the rights they demand? Or is it the case, as Hassan argues, that rootedness in a "viable and distinctive culture" is the necessary basis of any artistic and political practice set against the forces of colonialist power?

Visions and Knowledges

Art has traditionally been conceived as a privileged site for the training (the education) of the eye or, in the latter part of the last century and for most of this century, for the deployment of its excesses in the dissonant shapes of various avant-garde aesthetic practices and products. If a resistance is to be detected in connection with the encroachment of new forms of theory or theoretical work within the domain of traditional and non-traditional artistic practices, it is because artistic vision is still conceived by many to be a

special site, an almost autonomous medium for the expression of an individual's subjectivity. Or, alternatively, it is conceived as a privileged field for the display of transnational and, indeed, transcendental visual effects of the kind that were circulated most successfully under the authority of a Modernist "art for art's sake" aesthetic practice.

The art of the 1980s was dominated for the most part by an almost mystic return to the individuality of an artist's touch, to the uniqueness of her or his vision. And this was in a decade that also witnessed major theoretical inroads into art's traditional domain and area of expertise—the disarticulation of vision—under the auspices of feminist, gay, lesbian, and race politics. The conflicting agendas and lessons of this return and these inroads have yet to be completely digested by artists or independent and academically-based theorists and historians. But the clash of "high" and "low" cultures that it entailed, combined with the machinations of many of its elite art world and academic protagonists, as well as their prestige-based power politics and strategies of high finance, prove in the meantime that practices of the eye can never be divorced from the broader social economy in which they find legitimation.

All these phenomena prove, as Olivier Asselin demonstrates in his contribution to this volume, that vision is itself a site of theory as well as being a site for the canonization of various forms of social knowledge. The question of language and art, of vision and writing is, as Asselin shows in his elaboration of the historical relationship between concepts of the sublime and artistic practices, often subtle, complex, and historically determined. Not only are "the arts of vision...permeated with language" but, as he suggests, "[f]rom the point of view of its production, the work is often already motivated by language": oral guidance in art schools and university-based art departments, treatises, books, periodicals, etc. Theory functions accordingly as an evaluative language as well as a language of legitimation. Tracing a history of the sublime which is itself grounded in contemporary theory, Asselin demonstrates not only the

importance of language and theory, but, as well, the role that they play and that the sublime might play in a recent "inflation of commentary," one he detects in the discourses of modernity. As if rooted in an aesthetic of the sublime, these discourses reflect on the invisible, on that which exceeds the eye, on that which is unpresentable, imperceptible, unimaginable.

The critical importance of an aesthetics of vision, of the invisible and its de facto links to an inflation of commentary in contemporary art and museum practices, are sustained in one form or another in four closely-related papers in this volume (those by Francine Dagenais, Barbara Harlow, Janine Marchessault, and David Tomas). As the contributions by Dagenais and Marchessault demonstrate, the cultural logics of new imaging systems such as virtual reality are rooted in the history of social formations, as well as in economic and political imperatives. If the stereoscope (Dagenais) or cinema and television (Marchessault) can serve to bring into focus a new imaging system's cultural, social, and political logics, if writing can trace the outlines of new forms of sedentary spectatorial consciousness, and if words can be used to trace out the implications of virtual reality's potential impact on the artist's traditional identity and relationship to theory and practice (Tomas), then this is perhaps because this new imaging system seems to embody, as its condition of existence, an exemplary relationship to the unpresentable, the imperceptible, the unimaginable — and perhaps even to the history of the sublime itself.

On the other hand, questions of theory and practice, or those which address ultramodern technologies of representation and the imaging powers of theory itself, are expressed by practitioners (Marchessault and Tomas) in texts rather than artworks, just as the theorists here (Dagenais and Asselin) move through the field of vision in vehicles made of language and theory. As these papers and their authors' backgrounds suggest, vision and language, theory and practice, are criss-crossed by innumerable paths and many different kinds of travellers. Indeed, some of these paths move

beyond the clearly demarcated institutional and discipli-
nary boundaries of the art world and the academy to emerge,
as Harlow demonstrates in her unusual contribution, in
the gloomy interior of the prison cell. Such paths bring
into focus a different kind of writing surface which is in the
service of another set of political, social, and (one might
add) aesthetic imperatives. If art, writing, and politics can
actually meet outside the mirror-like hallways of the art
school or academy, Harlow's contribution suggests that this
meeting takes place, more often than not, outside related
aesthetic boundaries as well. The invisible takes many
forms, just as the inflation of commentary may serve many
interests.

Feminist Strategies
It seems logical, even necessary, that each of the contribu-
tors offering feminist perspectives on art and theory in this
volume dedicate some of their attention to looking back at
the intellectual trends and critical legacies of the 1980s.
During this period, a number of new critical and artistic
spaces opened up, particularly for women, and this develop-
ment helped to shape the institutional circulation of theo-
retical work to which we have referred. This change also
influenced the ways in which the social, institutional, and
intellectual processes we have been describing found expres-
sion within artwork itself. This was also the decade in which
poststructuralist theory claimed its greatest influence on
art practices. Together, these influences gave rise to a range
of critical and artistic strategies initiated by feminist artists
seeking to critique and to sabotage Western and modernist
traditions of representation. Deconstructive impulses were
manifest in the overt recycling and collaging of images and
modes of representation, in the proliferation of attention to
frames, narratives, and conventions, often from a stance of
self-conscious distantiation and elusive irony, and in the
blurring of previously assumed boundaries between art,
theory, and criticism, and between subjects (selves) and
locations (genres, identities, etc.).

It was a time of rapidly increasing activity by, and co-operation among, women who often played multiple roles (artists, critics, curators, teachers, editors). Inevitably this cooperation and multiplicity also found expression in the work that was exhibited and published, particularly in ways that such work implicitly or explicitly transgressed the conventional boundaries between artwork and commentary, image and text. As Janet Wolff and Beth Seaton argue, this created a rich ground for theoretically informed artistic and critical work by women; the field was not without conflict, however, and some of these conflicts are spelled out in their articles. For instance, Wolff describes critiques levelled against esoteric theorizing and theoretical artwork, and Seaton considers the theory-based prohibitions that accompanied the quandary about what it meant to engage art as a woman artist in a time when "authorship" was deemed obsolete.

For "gone were the days," as Wolff cites from a *Guardian* report, "when feminist artists listened to their spleens...." In the longer contours of historical change, this is not difficult to understand. Women had for too long been identified in biological and emotional terms, and the period witnessed a strong reaction against any work that uncritically echoed that history. In their artistic and critical work, feminist artists set out to dismantle the cultural construction of gender and rejected any representation of the feminine that could be construed as biological essentialism. Work was nothing (from this theoretical perspective, at least) if not conceptually rigorous, theoretically dense, aesthetically cool: this was the work of the mind, even where (as Jody Berland points out) its "content" was the feminine body. Seaton writes, "[W]omen have not been socially endowed with the fictional identity of a determinate and sovereign artistic subject deemed to be the requisite criteria for authorship." In other words, the only subject permitted to be shown in art according to the poststructuralist optic was a theoretically mediated, fictionally constructed one: this was, after all, the epoch of the Death of the Author, and women were as good at that as anyone.

Seaton and Berland share a certain macabre pleasure in pointing out that the widely heralded "death of the author" that dominated poststructuralist perspectives on aesthetics and cultural production was accompanied by a fantastic increase in the number of women successfully exhibiting and writing about their work. "Authorship" was being defined as intensely problematic, while at the same time the tendentious signification of the (fragmented, gendered, multiple, or even impossible) subject — the subject of the subject, in other words — was inescapable in both visual and critical production. The author might be dead, but, to put it in the most cynical terms, art publishing was flourishing as never before.

This was the paradoxical space, the epistemological (but also, of course, institutional) battlefield into which feminist theory and feminist art plunged head first. To some extent, the intellectually dense combination of psychoanalytic and feminist theory signalled a kind of a dual attack and rescue system for the floundering claims of postmodernist art. Feminist theory and a number of feminist artists achieved unprecedented status and influence in the interlocking domains of the art schools, universities, critical journals, artist-run galleries, and museums to which this book owes its existence. Such artists were, for the most part, characterized by their ability to engage with (or to be used as evidence for) contemporary theoretical discourses, and were a major part of the process through which discourses such as the "death of the author" and, of course, the demise of modernism, were producing a new kind of cross-disciplinary intellectual celebrity.

As Wolff, Seaton, and Berland all observe in different ways in their respective articles, this rich period of activity also led to the constituting of a new orthodoxy in contemporary art and critical practice. At the most fundamental level, this orthodoxy held that the task of feminist art was to interrogate traditional strategies of representation and, in particular, ideological constructions of gender that formed dominant traditions of representation in Western art, visual

culture, and the mass media. Because of the consequent emphasis on deconstruction, feminism and postmodernism seemed to some observers to be indissoluble parts of the same (anti)modernist trajectory, whether conceived in negative or positive terms. As Wolff and Seaton point out, other critics have challenged this iconoclastic orthodoxy from various perspectives: for instance, the apparent impossibility of positing or celebrating a feminine subject of any sort; the esoteric nature of so much of the work informed by these discourses; the evacuation of non-white or non-Western experience; the reluctance to explore qualities or domains of experience outside of traditional (dominant, dominating) modes of representation of the feminine. Looking at the feminist canon in light of these issues, and from a certain degree of hindsight, we can see more clearly the necessary but unhappy paradox of the project and the time: it brought together a fundamental and far-reaching theoretical unravelling of patriarchy in conjunction with a stubborn ambition to join and to master (if only to pry apart) its discourses and its institutions.

These themes are taken up in different ways by the authors in Section Two, leaving us to ponder how much the intellectual strategies of leading women artists and theorists of the 1980s alluded to by these authors was one of the prices of admission that women (voluntarily) paid for their inclusion — and, to some extent, their leadership — in the advance-guard of contemporary art during a period of profound critical change. Certainly women had a major voice in shaping the theoretically sanctioned critical practices and discourses circulating through these "certain institutions," and feminist strategies played an important role in opening their doors to other voices and different kinds of interventions.

The establishment of a critical discourse on and among women, which now circulates in (and between) art, criticism, and feminist theory, is one of the most important and impressive effects of the growing interdisciplinarity and institutionalization of art that we have described. The

institutional contexts which enabled this critical community
to emerge have also created specific constraints and contra-
dictions which are now being addressed in artistic and crit-
ical practice, as well as in the essays in this volume. Today
these institutional contexts are gravely reduced and threat-
ened because of substantial cutbacks in public spending.
How this instability will affect the opportunities for women
artists and critics, and influence the nature of feminist art
practices, we cannot yet know. A critical revisiting of the
recent past — the groundwork of the present — remains an
important task, and the papers contained in this thematic
section mark an important beginning.

Acknowledgments
Many people contributed to the organization and running of
the conference, and the organizers would like to express
their gratitude. Francine Périnet was centrally involved in
all aspects of the conference planning and was in large mea-
sure responsible for its success. The Department of Visual
Arts at the University of Ottawa generously agreed to host
the event, and to make space available. Clive Robertson,
Susan Ditta, Francine Périnet, Keith Kelly, and Christine
Conley all participated in an insightful and lively panel
discussion on artistic practice in Ottawa. Tim Clark and
Tony Bennett, who were unable to speak at the conference
itself, kindly allowed us to publish the papers each would
have given. Rosemary Donegan, Keya Ganguly, and Tom
Hill delivered important presentations at the conference,
but were unable to be part of this volume.

In preparing this volume, the work of the copy-editors,
Nancy Shaw and Dennis Denisoff, was invaluable. Marc de
Guerre, Janine Marchessault, Christine Davis, and Jane
Kidd of YYZ Artists' Outlet in Toronto initiated and encour-
aged the discussions which have led to the publication of
these proceedings. Jeremy Stolow provided important edito-
rial assistance in the preparation of this volume. Michèle
Fenniak, Janet Csontos, Christine Ling, Gordon H. Baker,
Colm Hogan and Milinda Sato of YYZ Artists' Outlet worked

diligently inputting the many revisions to authors' texts. Joan Bulger of the University of Toronto Press facilitated co-publication of this work with YYZ Artists' Outlet. Finally, we would like to thank the following for working so hard to make the conference come off smoothly and enjoyably: Chris Robinson, Heather Rollo, Caryn Roll, Shannon Fitzpatrick, Bart Beatty, Carole Girouard, Yves Leduc, Michael Chapman, Madeleine Murphy, Chantal Durivage, Jay Heins, and Joy Naffoug.

Jody Berland, Will Straw, David Tomas

BEWITCHED, BOTHERED, AND BEWILDERED

Will Straw

MY TITLE WAS DEVISED in a hurry over a year ago when the publisher asked for one and I plucked a song title from my preconscious. It would, I hoped, enumerate the contradictory feelings I was anxious to describe. These feelings are the fuzzy substance of an ongoing ambivalence which, for myself and many others, has been a common response to newly emergent relationships between Art and Theory. In my own case, as one who taught Film Studies for a decade, this ambivalence first emerged in response to the preponderance of theory-films produced over a decade ago — films which my students invariably found less interesting than the writings on which they drew. These feelings have congealed over a half-decade or so of observing the signs of an expanding Art/Theory Scene: the artworks whose reference to theoretical writings is increasingly explicit, the gallery catalogues and magazines, and the increasingly congested two-way traffic between universities and the spaces of art practice and criticism.

Many of the questions raised for me by the emergence of this scene have found their way into the preface jointly authored by the co-organizers of the conference; I see no need to repeat those here. What follows, briefly and somewhat randomly, are more personal responses, mixed with gestures towards a broader analysis of the art/theory interchange. These may appear to bear the marks of a curmudgeonly

cynicism. One of the peculiarities of art/theory worlds is that their two defining sensibilities are profoundly contradictory: a deeply rooted critical suspicion, on the one hand, and a well-meaning, even platitudinous faith in activist good intentions, on the other. The weight one gives to either of these relative to the other always risks being inappropriate for a given moment or context. My own commitment to the politicized spaces of the art/theory interchange may not be obvious in what follows, but I would hope it may be assumed.

I will turn in a moment to the most striking feature of the art/theory interchange: the regular insinuation of theoretical references into contemporary artistic works. Privileging this movement, however, leads easily to the claim that the significant migrations at stake here are unidirectional, that we are dealing merely with a theorization of art. For reversals to be observed, we must cease thinking about Art and Theory in terms of the possible relations between them and consider the institutions, forms of productivity, and criteria of value which have taken shape around each. We might, in particular, delineate those ways in which academic work (in many corners and some centres of the university) has been produced and has come to circulate in ways or spaces more typical of art worlds.

Organizational sociologists will sometimes distinguish between those careers which unfold along the rigid pathways of institutional rank or status and others devoted to accumulating prestige elsewhere, within more informal, geographically dispersed hierarchies of influence and reputation. These are rarely separable, of course; the politics of universities or art worlds are driven by attempts to enact conversion between these different forms of capital. Indeed, it is through such conversions (failed or successful) that intergenerational battles for succession or disciplinary squabbles over turf are often resolved. Newly appointed deans may remake departmental boundaries in ways which are meant to reveal long-nourished visions of intellectual community, but which work, in fact, to freeze innovative moves towards broad interdisciplinary contact. Similarly, young academics

nurtured in the entrepreneurial celebrity culture of modern cultural politics may find the skills acquired there being deployed more and more in the service of institutional processes. Increasingly, they arrive at university posts with ranges of contacts and skills in grant-seeking, conference organization, and publishing, which in another era would have come only with seniority of rank.

In the academic humanities, the relative weakening of disciplinary boundaries, as the contexts from which intellectual work derives legitimation, has nourished new modes of entrepreneurship more typical of non-academic spheres of cultural activity. The coincidence of a shrinking academic job market and an explosion of art/theory activity outside the university has produced a partial unmooring of individual reputation from institutional or disciplinary status. It has increased the importance and lure of those extra-institutional spaces within which a "reputation" may take shape, circulate, and realize an exchange value: the parallel gallery and exhibition sectors, the conference circuit, and the more amorphous, overlapping spaces of graduate-student cultures, artist-run centres, and small-scale publishers. It is within and across these spaces that something like an art/theory scene has taken shape.

Like many university teachers, I have been bewitched by this scene, often succumbing to the sense that it offers a more glamorous and immediately gratifying context for intellectual work than the university. (Returning to university life in Ottawa after a talk for Public Access·in Toronto in 1992, I felt like Cinderella after midnight.) I retain, nevertheless, an unshakable suspicion of the motives (or of my own, at least) which lead us to gravitate towards this scene. What is so often framed (to oneself, or to others) as a move "into the community" is very often capitulation to the lure of a scene less socially diverse and stratified than one's own undergraduate classes. Within this scene, it should be acknowledged, there are generally fewer restrictions on the scope of rhetorical gestures or the political claims one may get away with; its appeal is entirely understandable.

The entrepreneurship which has come to organize a good deal of academic practice manifests itself in time spent cooking up events, planning journals or anthologies, and testing new forms of collaboration across a variety of boundaries. This is only partially the result of institutional pressures to produce. (In any event, the activities described here have an ambiguous status within institutional evaluations of productivity.) It has much to do with those developments which Jody Berland's contribution to this volume insightfully describes — developments which have enhanced the exchange value of the authorial "signature" and made the unfolding career and autobiography to which it is attached a principal context within which works assume significance.

This foregrounding of signature is a rarely considered effect of moves towards interdisciplinarity within the university, moves normally described in a language of democratic collaboration and exchange. As I have suggested elsewhere, the installing of a transdisciplinary space of dialogue has also instituted a vantage point from which the relative status of individuals and their work may be judged.[1] From this vantage point, gestures of authorial bravura are more readily seized upon as indices of value than is one's place within the slow, circumscribed unfolding of a discipline's history. There is much to be welcomed here: the steady accumulation of cultural sites in which one's work is known may feel like progress on the road to becoming a "public" intellectual, an ambition with platitudinous status in contemporary academic life. Arguably, however, what looks like a dissolution of barriers between the academy and a network of sites outside it (magazines, galleries, the spaces of public speaking) is to a considerable extent a movement outwards of these boundaries so as to encircle both.

The dilemmas implicit in this encirclement reveal themselves when academics undertake to write about new art practices. Confronted with artworks which are quickly reducible to the theoretical citations which underlie them, we often feel a rising scepticism, but we are already in a

world where works which lack these underpinnings will seem naive and outmoded (and critical writing upon them will recuperate those qualities as having theoretical interest). If, amid galleries full of works which literalize the insights of film theory, we cease to feel inspired, we are nevertheless unable to imagine what might acceptably take their place. Attempting to write about such works, we struggle to avoid either of two slippery slopes: one ends in a renewed intentionalism, the critic reconstructing or, at best, reshuffling the theoretical references concealed in the work; the other, in a new and often desperate aestheticism, leading the critic to grope for those elements she or he may claim are in excess of a work's theoretical propositions. The disarming choice here is between a subservient compliance with the work's theoretical agenda and the pre-preemptive move to claim that what is significant about the work lies outside that agenda. If this discomfort were the symptom of a genuine incompatibility between artistic and theoretical discourse, we might embrace it as a productive tension. More typically, it is marked by an irritating sense of excessive familiarity.

Despite this discomfort, the reconciliation of Art and Theory continues to be posited as a goal towards which we should all struggle, rather than as a defining reality of contemporary art worlds. In a dialectic lazily conceived, the bridging of the gulf between art and theoretical criticism is still imagined as the condition of some imminent future, when long-standing dilemmas concerning the artwork's knowledge-effect will be resolved. The relationship between art and theory is persistently framed in language which invites earnest effort towards a moment of projected reconciliation:

> *In terms of the thematic focus of this panel, we would like to examine how the disciplinary segregation of the functions of art production and art criticism has been traditionally utilized to preserve patterns of cultural specialization which may now require serious re-evaluation. We are interested in addressing*

whether such conceptual and practical distinctions are still legitimate, or whether they merely serve to reinforce the institutional frame of high culture for the sake of particular marketplace interests. Specifically, we want to reconsider how certain types of art production construct and enable modes of critical engagement—for example, the critique of art history, the deconstruction of aesthetic ideologies, the analysis of socio-political conditions, the de-coding of ethnic and gender identities, etc.— in other words, to re-evaluate those strategies which may go far beyond the current disciplinary boundaries of art criticism.[2]

The assumption that this reconciliation has yet to transpire has set two traps. The first is a refurbished vanguardism. Typically, works which, it is claimed, have breached this divide—which have given artistic form to theoretical propositions—are held up as markers of a road to be followed, rather than as characteristic present-day practices which raise their own, persistent questions. Such works are perpetually invoked as signs of hope and progress, even when the long-standing, admittedly dull questions of accessibility and social locatedness linger on. The persistence of such questions need not paralyse a theoretically informed art practice (though it might dampen their self-congratulatory veneer). Nevertheless, one should not imagine such questions obsolete because new works triumphantly offer bridges to recognizable bodies of ideas or theoretical work.

More significantly, exhortations towards future reconciliation conceal the extent to which the institutional/discursive economies of art and theory are already intimately intertwined, at least within those cultural spaces self-defined as oppositional (and especially within countries like Canada, with their strong traditions of artist-run centres and critical publication). The teleology of imminent reconciliation requires that we keep alive the sense that art and theory are divided in the present, partly so that the concrete consequences of their convergence need not be scrutinized.

Arguably, the insinuation of theoretical work into artistic practice is less the result of historical reconciliation than it

is the product of institutional and sociological realignments. What is needed are analyses which specify the dispositional, institutional, and social economies within which theory has come to occupy new relationships to artistic practice. In a variety of ways, and bracketing the question of its specific and variable substances, theory has assumed a diversity of new functions: as a competence which has displaced art-historical knowledges; as guarantor of a work's link to an activist politics; as that through which the work is inserted in a larger history.

The last of these functions is perhaps the most symptomatic. In a period when artistic styles and forms are multiple and fragmented, the space of shared theoretical references has taken over from the artistic school or medium as the terrain on which historical time is marked. This is of particular importance when the dispersion of identity politics seems likely to install an artistic pluralism. It is the common space of the critique of representation, with its shifting hierarchies of authors and paradigms, which locates the theoretically informed work in a temporal continuum. When, for entirely legitimate reasons, no one feels comfortable discussing political causes in terms of curves of fashionability, the rhythms of replacement and obsolescence may be more acceptably noted in lists of influential authors or works.

It is for this reason that reminders of how art has always been implicitly "theoretical" miss specific features of the current situation. The crucial questions have less to do with whether a practice is somehow "theorized" than with its links to an unfolding history and geography of theoretical developments. These links will position a given practice as indigenous or cosmopolitan in its theoretical underpinnings, and more-or-less naive or out-of-date, efficient, clumsy, coy, or obvious in its staging or specifying of theoretical propositions. Whereas in an earlier period the function of theoretical reference within criticism was to remove a work from the continuum of art-historical time, rubbing it up against broader socio-political phenomena, that function has now been reversed. It is the critical elaboration of a work's

theoretical project which now restores it to a larger collective endeavour, that of a generalized cultural critique in which diverse activist communities are presumed to collaborate. The sense that different activist practices have anything in common—that a magazine can legitimately cover them all as instances of a singular phenomenon—is more and more dependent on the threads of theoretical reference which lead them all back to a common intellectual space.

The sociological shifts which have produced recent convergences between Art and Theory are, I would argue, rather easily grasped. As intellectual politics in Canada and elsewhere have come to revolve around questions of social identity, they have, at the same time, become increasingly cultural. The observable politicization of art worlds is in many ways a residual effect of broader shifts through which activist political currents have come to privilege the cultural as their terrain of intervention. One of many significant effects is a waning of the real or perceived social distance between activist cultural communities and their political referents—a distance which forever haunted a now declining class-based, political militancy. In a very real sense, the urban subcultures of activist identity politics have become (or take themselves for) the communities they seek to serve; the question of a broader accessibility for ideas, which haunted earlier traditions of cultural militancy, has (rightly or wrongly) lost much of its resonance. The problem of the insinuation of theory into artistic practice—of how works might embed particular knowledges within themselves—has displaced attention from the older problem of how either might come to circulate within broader discursive fields and social spaces.

It is the perennial illusion of an art-world politics that its crucial moments are those in which individual works resolve, embody, or communicate questions of political significance. I would claim, instead, that artworks and writings assume their primary importance inasmuch as the moments of their production or circulation become those in which solidarities or fractures between particular communities are

produced. It is clear, for example, that the interweaving of art and theory and of both with an activist identity politics has heightened the identification of all of these activities with youth, as they have become intimately bound up with the institutional and wage economies of graduate study, freelance writing, and such sites of social interaction as the dance club. The significant phenomenon here is not the role assumed by artistic works in the communication of theory, but the social continuities produced between a theoretical education, political militancy, and particular definitions of hipness.

At the same time, arguably, what is significant about a magazine like *Fuse* is not the specific knowledges it appears to offer, but the image it conveys of certain knowledges (and the activities or communities in which they are cultivated) properly belonging together in ways presumed to have political effects. As constituents of the material culture of particular overlapping communities, what works of art and theory signify are the terms and forms of involvement characteristic of such communities: the competencies they presume, the collaborations and inter-institutional relationships they require or enable, and the instances of empowerment they manifest. New convergences of art and theory have produced new ways of partaking in particular communities and social spaces, but only minimally as a result of changes in the cognitive role of artworks themselves.

This is to suggest, in a sense, that processes occurring within the worlds of art/theory-making are little different from those common in such subcultures as that around computer hacking (to invoke the most contrastingly unappealing example). Around certain practices, people occupy places within—and work to alter—particular relations of power, institutional interchange, and social differentiation. One should take the self-defined vanguardism of neither of these subcultures at face value. The broader effects of what goes on within them have little to do with the ways in which they imagine their relationship to a larger world as allegorical. What may unite art and theory in politically meaningful

ways is not (or not merely) that they stand as forms of knowledge whose disempowering separation has now been overcome — neither art nor theory, in this interchange, has truly resolved the problem of its place within social hierarchies of intelligibility. More importantly, the production and circulation of these forms, as processes which transpire within (and link themselves to) specific social histories and geographies, are loci around which the broader contours of social and intellectual relations take shape and are remade.

Notes

1. See "Shifting Boundaries, Lines of Descent: Cultural Studies and Institutional Realignments in Canada," *Relocating Cultural Studies: New Directions in Theory and Research*, ed. Valda Blundell, John Shepherd, and Ian Taylor (London: Routledge, 1993), 86–102.

2. Joshua Decter, in a presentation made during the roundtable "Sites of Criticism/Practices: The Problem of Divisions of Cultural Labour," *ACME Journal*, 1, no. 2 (1992): 39.

BACK TO THE FUTURE:
The Sequel

Thierry de Duve

THE PAGES YOU ARE ABOUT to read were written in 1987. They had another title then, but "Back to the Future" would have been just as fitting. At the time, I was a professor at the University of Ottawa, in the same Department of Visual Arts that hosted the conference whose proceedings you are holding in your hands. My colleagues and I were discussing what improvements we might introduce into our teaching methods, when I sensed intuitively that the very system — the modernist system — upon which art teaching was based (art teaching in general, not just our own) needed to be rethought. These pages are the result of my first attempt at doing just that. They have since then been followed by more thoughtful reflections, which is why they were never published. For some years, I left them at rest and only recently read them again. Were they ever written in haste! But I like the energy, the roughness, the anger with which I wrote them. Suddenly, they had to be shared. It then occurred to me that this book would be the proper vehicle for them, even though what I actually said at the conference, addressing similar issues, was a bit different. Here they are.

* * *

It used to be that art teaching was academic and art teachers were proud of it. Rooted in the observation of nature

and the imitation of previous art, the long apprenticeship of a would-be painter or sculptor was primarily an acquisition of skills put under specific cultural constraints. Life-drawing and its underlying discourse, anatomy, provided the basic skill ennobled with humanistic knowledge. Never, though, was art equated with skill. What deserved admiration in the accomplished artist was talent, not craft. Yet there were rules, conventions, and codes outside of which raw talent could neither develop nor express itself. Tradition set the standards against which the production of art students was measured. Academic teaching had great ambitions regarding the maintenance of tradition; it had little vanity regarding its ability to "turn out" individual artists. All it could do was nurture and discipline its students' gifts (if nature had provided them with some) and then only within the limits of nature's generosity. In the process, even ungifted students were given a technical know-how which secured them a recognized, if humble, place in society and a plausible, if modest, source of income. Between the work of the artisan and that of the genius, there was qualitative difference; there was also cultural continuity.

All of this was disrupted by the social changes which brought about the advent of modern art. As industrialization — and the social upheaval, scientific progress, and ideological transformations that went with it — decomposed the hitherto stable social fabric and, on the whole, more or less destroyed all craftsmanship, the examples of the past lost their credibility in art and elsewhere, and the chain of tradition was eventually broken. To the sensitive artist, academic art and training became just that — academic — and the new art began to look toward the future with both fear and hope. The avant-garde was launched. Painters and sculptors, progressively turning away from the observation and imitation of outside models, turned inwards and started to observe and imitate their very means of expression. Instead of exerting their talent within relatively fixed conventions, the modernist artists put those conventions themselves to the aesthetic test and, one by one, discarded those whose

constraints they no longer felt. Excellence in art came to be measured against the resistance of the medium, as if the medium could set the rules itself, take command over skill, and provide a vessel for talent.

Soon, art schooling was affected by the avant-garde. As the examples and standards of the past could no longer be trusted, as imitation and observation could no longer provide the basics for the apprenticeship of art, art teaching had to look elsewhere for roots in both nature and culture. It achieved this in two ways. The figure of Man—the universal measure of all things in nature—was relinquished as the outer model for observation, but was recouped as the inner subjective principle. Psychology, not anatomy, became the foundational discourse for a new artistic humanism. The new doctrine was that all people are endowed with innate faculties which it is the function of education to allow to grow. Thus specialization in visual arts meant the specific training and growth of the faculties of visual perception and imagination. How to train them became a pedagogical issue. It would have remained a technical impossibility steeped in solipsism, had not psychology—not the introspective kind but perception psychology, gestalt theory, etc.—provided the idea that the ability to perceive is, by nature, already cultural, and that perception is, so to speak, a basic reading skill. It followed from there that imagination was a basic writing skill of sorts. "Creativity" is the name, the modern name, given to the combined innate faculties of perception and imagination. Everybody is endowed with it, and the closer it remains to sheer, blank endowment, the greater its potential. A child or a primitive has more creativity than a cultivated adult. The ideal art student, the artist of the future, came to be seen as an infant whose natural ability to read and write the visual world need only be properly tutored. If only the practice of painting and sculpture could be broken into semantic "atoms," if only some elementary visual alphabet and syntax could be set up, then art could be taught and taught anew without resorting to a now obsolete tradition: art

itself, not merely skill, but also talent. Talent lies in a raw state in everyone's creativity, and skill lies "ready-made" in the properties of the medium: in the linearity of drawing, in the two-dimensionality of the picture plane, in the volumetric properties of sculpture. In principle, if not in fact, art learning becomes simple: students should learn how to tap their unspoiled creativity, guided by immediate feeling and emotions, and to read their medium, obeying its immanent syntax. As students' aesthetic sensibility and artistic literacy would progress, their ability to feel and to read would translate into the ability to express and to articulate. Nurtured perception and imagination would produce artworks of a new kind.

Perhaps I have made this short tableau of modernist art teaching into a caricature. But the historical evidence is overwhelming. All progressive pedagogues of this century from Froebel to Montessori to DeCroly, all school reformers and philosophers of education, from Rudolf Steiner to John Dewey, have based their projects and programs on creativity or, rather, on the belief in creativity, on the conviction that creativity, not tradition, not rules and conventions, is the best starting point for education. Moreover, all great modern theorists of art, from Herbert Read to E.H. Gombrich to Rudolph Arnheim, have entertained similar convictions and devoted considerable energy to breaking up the "visual language" into its basic components and demonstrating the universality of its perceptual and psychological "laws." And finally, needless to say, there is not one pioneer of modernist art, from Malevich to Kandinsky and Klee, or from Itten and Moholy-Nagy to Albers, who has not been actively involved in the creation of art schools and teaching programs based on the reduction of practice to the fundamental elements of a syntax innate to the medium. Kandinsky wrote *Von Punkt zur Linie zur Flache* in 1924, and since then every art school in the world has a 2-D and a 3-D studio. If they had been strictly faithful to Kandinsky, if they had also taken their clue from Cubism, they would have a 1-D and a 4-D studio as well.

My point is not intended to be ironic, and I am certainly not inclined to dismiss this philosophy without further trial, but merely to stress that it is a philosophy, and a biased and dated one at that. Let us call it the Bauhaus philosophy. It was never carried out with the radical purity of my description, not even at the Bauhaus itself, which died from the pressure of its own contradictions as much as it did at the hands of the Nazis. But the Bauhaus model, more or less amended, more or less debased, has set up a series of assumptions about art teaching upon which dozens of art and architecture schools around the world have been built and which, today, still underlay, often subliminally, almost unconsciously, most art curricula, including our own here at the University of Ottawa. I took the nomenclature of some of our courses for a symptom of this, which may be unfair since I don't teach them. You may argue that what matters is not the course's name but what we do with it, and you would be right. You may say that although courses entitled "2-D" and "3-D," or "Photo 1" and "Photo 2," or "Introduction to Visual Analysis," may betray a belief in creativity and elementary visual language, there are others, such as "Experimental Media Workshop" or "Instrumentality and Reality," which do not. I'm not sure they don't, but maybe that is beside the point. Whether creativity exists or whether it is merely a useful illusion is, for all practical purposes, irrelevant as long as it is useful. Whether there is such a thing as "visual language" or whether it is merely a pedagogical ideology is equally irrelevant as long as it works.

The question is: Does the amended Bauhaus model work? Is it still useful? We all have some mitigated answers to this. Yes it works, yes it is useful, but very often in spite of itself. Many of us have grown to value the perverse effects of a teaching method organized, if only nominally, in terms of the purity and separateness of the media. Many of us have come to praise the subversive students who do not behave as if they tapped into unspoiled creativity with which they are supposedly endowed but who, instead, tap

the "Pop Kulch" with which they come equipped. Those of us who teach the "basic" courses know all too well that they can only communicate rules and conventions, and that significant art is art that overthrows, displaces, abandons, or subverts rules and conventions. Who has not dreamed, if only secretly, of having students—the best students—forcing the teacher to give them an A+ because they have transgressed the rules of the assignment so intelligently that they display a perfect awareness of what art making is about? It sometimes happens; the dream comes true and, when it does, it becomes a nightmare. Those of us who teach "mixed media," "inter-media," "multi-media," or "experimental media"—whatever we name the no man's land which most art schools have ended up institutionalizing as if it were a medium of its own—know all too well that unless they assign subject matter or set technical constraints, formal limits, severe deadlines, or whatever rules or conventions, they will not achieve much more than organized escapism. The fruits which the Bauhaus tree yielded and still yields are strange hybrids. We all know that. We have come to expect it, even foster it. The last art school with a strict Bauhaus ideology (though already considerably amended) was Black Mountain College, and its best "fruit" was Rauschenberg. Meanwhile, the Bauhaus itself, with all those great artists teaching there, did not produce a single student of a stature equal to that of their masters.

Seen from this angle, the failure of the Bauhaus pedagogy may be a comforting thing. Perhaps it should be maintained in order to be subverted by teachers and students alike. After all, if it produced a Rauschenberg once, it may be worthwhile to try the method again. It certainly has the advantage of flattering the artist in each teacher at the expense of the academic. There is a special pleasure in encouraging subversion of the rule which one sets. But beware. Here is an anecdote. When I was teaching in Belgium, we had a first-year student who had assimilated Hans Haacke and Daniel Buren and understood the "logic" of Duchamp so well (or so he thought; and so I thought, at the

time), that his proposal for the final exam put us in a nice hole. The rule was that both first-year and fourth-year students had to show their work to an outside jury. In first-year, the jury's mark counted for half the total mark; in fourth-year, it counted for the total mark. This particular student was doing performance at the time. Here was his project: he would pose as a fourth-year student and do a performance in front of the unsuspecting fourth-year jury. He would accept whatever mark the jury would give him. We would have to accept that if he passed the test, he would have obtained his degree after only one year. He was very serious. We were not, and laughed wholeheartedly at his proposal. He became very angry and accused us of not abiding by what we taught. He was brilliant and gifted. As far as I know, he does not make art any more but is well-off selling real estate.

I got more than one lesson out of this story, but what it all boils down to is that the perverse effects of a subverted Bauhaus model now backfire. It is fun to see the institution caught at its own game once in awhile; it is no fun to see a whole generation of art students purportedly playing the most advanced art "strategies" with their own schooling institutions only to be lost once they are out in the real world. Should we revert to a "straight" Bauhaus model and set rules so strict, medium per medium and step by step, that no escapism is possible? Chances are that no creation would be possible either. And as long as art teaching is predicated on creativity, creation is its expected outcome. But today, it is neither credible nor desirable to revert to a "straight" Bauhaus model. There are many reasons why this is so. I shall highlight three of them. The first one is more in the nature of a symptom, the second one may be the beginning of an explanation, and the third one investigates some consequences.

The demise of the Bauhaus model has everything to do with "postmodernism." It is, of course, no surprise that art schools should be affected by what is happening outside. (Is it not also the other way around? More about that

THEORY

later.) I don't know what the word "postmodernism" means, beyond the fact that it is a blatant symptom of a crisis in modernism. When people want to change their name, it is an obvious sign that they are not satisfied with the one they have. Twenty-five years ago, everybody wanted to be modern. To be called modern, to call something modern, was a compliment: Shakespeare was modern, Piero della Francesca was modern.... Now it seems that no one wants to be modern any longer, and so the name "postmodernism" appears, whose only secure meaning is "anti-modernism." But the propensity to invent new names and new isms, the alternation of the "pro" and the "anti" or the "post," is a very modern, even modernist, habit. So what postmodernism is (not what it means) is that it is the latest avatar of modernism.

What it refers to is still another matter. Basically it is used (by critics — artists usually don't bother) to designate two quite opposed groups of works. The first group comprises a series of returns: to painting, to figuration, to craftsmanship, to history, to tradition. It recycles the premodern past and is definitely anti-modernist, in that it seeks to present itself as if modernism had not happened. This is why it is avant-gardist in spite of itself; it believes in the tabula rasa. The second group comprises a series of advances out of the purist media of modernism and into high technology, pop culture, and mass media. It acknowledges the "historical avant-gardes" and recycles them as if nothing had happened before modernism. It is therefore equally avant-gardist, but since the avant-gardes are now "historical," it is academic in spite of itself. There are good and bad works in both groups.

Let us now assume that both groups (or the critics representing them) are being given a chance to set up an art school. Both would reject the Bauhaus model and substitute a postmodernist model. The first group would set up an academic system of teaching and be proud of it. They would pose as connoisseurs and be openly conservative. They would make the past — past techniques, past styles — available to

their students. They would insist on the narrowness and meaninglessness of modern reductivism. They would revive grand ambitions and refurbish heroic models, but they would be tolerant: they would allow students to be modernist or pre-Raphaelite on the same plane. They would encourage eclecticism and entice their students to let their creativity take them on a trip through the fantastic "databank" of history. They would call their school an academy, and it would be just that—academic. The second group would set up an avant-garde school and be proud of it. They would be deliberately ideological (preferably leftist). Their teaching would be based on suspicion, but they would call it critique. They would also make techniques and styles of the past available to their students, not because they are worth being studied, but because they are no more than techniques and styles, and thus need to be criticized, that is, suspected. They too would be tolerant in their dogmatic way. They would tolerate painting and sculpture as long as they were framed in heavy quotation marks, like, for example, "bad painting." They would not shy away from exploring the past but would allow the students to visit only those places where the teachers have been before. They would not believe in creativity but in commitment.

This brings me to the second point. The two postmodern schools imagined above are both debased, perverted versions of the Bauhaus model. Modernism and the avant-garde are indeed in a crisis in their art as well as in their teaching. Subversion is not a way out; it is part of the crisis. At the root of the crisis is a gross misinterpretation regarding what the avant-garde was and meant. It is too often confused with what it thought it was, hoped it was, dreamed it was. The thing is confused with its alleged justification, the works with their (simplified) ideology. The avant-garde is equated with avant-gardism and modernity with modernism. Let me use examples. There is no doubt that for Malevich, in 1915, the *White Square* was a clean slate, carrying prospects of a culture yet to come and ready, so to speak, to receive the imprint of future meaning. It is clear that for us,

in 1987, it is no longer a clean slate and that it has received a number of meanings, including the one previously stated: it was a clean slate. Today's meaning or content of the *White Square* lies in that past tense. Yesterday, its content lay in its avant-gardistic justification (I'm betraying Malevich here, but not his reception). This justification held that it was a radical break with tradition and that it deserved to be called art, and avant-garde art at that, because it broke with tradition. Did it? I'll take a short cut: it did, in that in order to erase the past, you need to have one. And so it didn't. (The *White Square* makes no sense unless an aesthetic acquaintance with Picasso, Cézanne, Manet... and Titian links it, in retrospect, to a significant series of abandonments.) Certainly this invalidates the avant-gardistic explanation: the *White Square* is not art because it broke with tradition. Is it art because it launched a new tradition, as Malevich hoped? Yes and No. Yes, if you take this new tradition as simply all the modern art that is companion to the *White Square* at the Museum of Modern Art. But then the modern tradition is tradition *tout court*, not a new one. No, if you take it to mean the new visual "language" made of elementary forms and colours which Malevich and the other pioneers of abstract art had invested with their hope. On that level, it failed.

It is here that the failure of the Bauhaus model sets in. As I said, you can erase the past if you have one. But once it is erased, what can you teach the next generation? Nothing, unless you believe that a basic visual language can be inscribed on a blank slate, "from point to line to surface." Nothing, unless you are convinced that creativity can replace memory, that pure perception and imagination can substitute for an aesthetic acquaintance with tradition. And so we are back to the Bauhaus model. Its failure to produce students of the calibre of their masters is no surprise, and there is no surprise either about its subsequent demise and perversion. What hinders a new way of thinking about art teaching should now be clear: the myth of creativity and the myth of a visual language. I am not suggesting that

these words be eradicated from our vocabulary, but I would be pleased to see them historicized, for example, in the way we would use the word "ether," in a scientific context, not in order to refer to the substance once believed to fill the void and conduct light, since the belief in such a substance has vanished, but in order to allude both to the substance and to the belief, and thus give them a dated flavour. Nor am I suggesting that the myths of creativity and visual language be demystified. They already have been, and that much has been shown by the second brand of postmodernism. Even a cursory inventory of the fashionable words in current art criticism demonstrates this: "appropriation," "recycling," "simulacrum" are words that belong to the sphere of consumption, not of production, let alone creation. "Rhetoric" is in fashion, "language" is out; and to speak of the "artist's vision" is definitely corny, whereas to speak of the "spectator's gaze" is very much in pace with the times.

Keeping pace with the times is the quickest path to obsolescence. One has to be either faster or slower, and it would be wise to recognize that art schools can only be slower. And this brings me to my third and last point. Until now I have spoken of academies and art schools and traced the transformations — some real, some imaginary — of the Bauhaus model, which I take to be quasi-universal, albeit in as many watered-down versions as there are art schools. But there is another phenomenon. Our art school is a department within a university. Some of you might think that our incorporation into academia makes it *ipso facto* difficult to seek a reform which would make the department less academic. I'm not so sure. It may be that, in its own way, the university's administration expects us to be avant-garde. Universities are in no way homogeneous institutions, and it is well known that they are in fact torn between two rather incompatible functions. On the one hand, they are professional schools geared to the needs of the labour market, where highly specialized skills are transmitted; on the other hand, they are protected areas where accumulated knowledge and scientific progress can be pursued for their own sake

without being tied up with immediate economic results. In the case of the natural sciences this contradiction is no longer sensed as acute. Everybody is now convinced of the beneficial spin-offs of fundamental research for technology and the economy in general. But in the case of art—and possibly of the humanities as a whole—this contradiction is exacerbated. There is, strictly speaking, no labour market for independent artists. Their ability to support themselves through their work depends not, or very little, on the demands of society; in the long run, it depends on the one thing that their schooling cannot produce—their talent. In that sense, an art department like ours does not accomplish its mission as a professional school. However, the criteria of objective scientific verification do not apply to the output of the teachers in an art department. This is obvious, as far as artists are concerned, but the situation is similar with regard to critics and art historians. Since their discourse is interpretative and not demonstrative, their credibility rests on erudition and connoisseurship, which are qualities recognized by the university, but also considered a little gratuitous and eccentric by more scientifically attuned minds. Moreover—and this is crucial because here the critics are on equal footing with the artists—their activity implies the exercise of personal aesthetic judgment and is therefore highly vulnerable, like that of their fellow artists, to dismissals based on either diverging tastes or on arguments saying that "these things are just a matter of taste." In that respect, an art department like ours does not fulfil the scientific function which is expected of, say, a natural science or even a philosophy department.

This has kept art teaching out of universities for a very long time. It is no longer the case, and it should be stressed that the penetration of art into academia has rested on a particularly powerful, but also ambiguous, ideological amalgam. This penetration is actually heavily dependent upon the notion of the avant-garde, in an interpretation even different from the ones we have encountered so far. Only when modern art began to enjoy social and economic success did

academia entertain the idea of hosting professional art schools. But this alone would not have sufficed. "Scientific" credentials were needed too. (Remember that lucrative businesses such as acupuncture and homeopathy are still banned from most medical schools.) Traditional academic teaching offered no such credentials. It was merely technical, on the one hand, and normative, on the other, whereas scientific training should be neither. It is thus only when it became obvious to society at large that the success of modern art did not stem from technical know-how and obedience to tradition, but, rather, from innovation and free exploration, that academia began to consider the idea that it could turn out professional artists, if it could only train students in invention and free exploration. We recognize something similar to the shift from the academy to the Bauhaus model, but the keyword here is not "creativity." The keyword is "experimentation" and the ideological rationale is that artistic experimentation is akin to scientific research. The similarities have allowed the differences to be hidden. Artistic innovation was seen in the same relation to scientific discovery as technical invention, and free exploration was assimilated to academic freedom in general and to research in particular. The results of experimentation are equally unpredictable in art and in science; thus, they are to be fostered for their own sake and allowed a protected institutional space, in the hope that they will have an effect on the economic world in the long run. If the university is proud to play host to the avant-garde of disinterested scientific research, then it should take equal pride in hosting the avant-garde of disinterested artistic experimentation. With this rationale, art teaching entered academia after World War II.

A number of things should be pointed out here. "Experimentation," as a concept, is no more to be trusted than creativity. Should I quote my master, Clement Greenberg? "The true and most important function of the avant-garde was not to 'experiment', but to find a path along which it would be possible to keep culture moving in the midst of

ideological confusion and violence." Not only is artistic experimentation a poor substitute for what should be called freedom but, when amalgamated with scientific experimentation, it has the disastrous effect of hiding the one specificity of art and art teaching that sets our department apart from every other in the university: it rests on aesthetic judgment, it revolves around aesthetic judgment, it has no other function but to develop aesthetic judgment. Now that both the rules and conventions of academic art and the historical drive of avant-garde art have seen their day, what, if not judgment, is going to distinguish between good and bad art? Now that neither skill nor the properties of the medium can put constraints on the postmodern artist (to whom all skills, manners, styles, and media are available) what, if not judgment, is going to dictate his or her choice? Now that art history has relinquished both the stylistic, cyclical, or "civilizational" models and the progressive, linear, avant-garde models, what, if not judgment, is going to guide the students to a decision about which past is relevant for them today, and which is not? Now that art theories abound, wrapped in abstruse, pseudo-scientific jargon or clad in deliberately ideological smoke-screens, what, if not judgment, is going to confront the theories with the works they are supposed to uphold? Despite experimentation, this judgment is not of the kind that sanctions scientific research. It sanctions aesthetic quality, not truth or falsity. There should be a place in the university for this kind of judgment and it should be recognized. Then the alibi of experimentation or research would no longer be necessary. "Je ne cherche pas, je trouve," Picasso once said.

The postmodernist syndrome, with its eclecticism and historicism, its pluralism and permissiveness, is the result of, among other things, a lack of judgment. Universities have a great deal of responsibility for this. Particularly deserving of blame is the process of teaching art history, a discipline which has unfortunately gained its academic credentials on the false pretence that it is scientific. I am not saying that it is totally unscientific, or that it should not

strive for some kind of objectivity. Facts are facts, and you can't juggle with them. It is a fact that Cézanne was born in 1837 and that he painted the *Montagne Ste Victoire*. It is not a fact that Cézanne is a great artist. That is a judgment. That Cézanne has been judged a great artist by many people, however, is another fact. And so is the fact that you remain free to judge otherwise. Art history is jurisprudence, nothing else. Had it been thought of and taught like that, students would never have had to believe that history itself was speaking through the teacher's mouth as if it were just a dull string of objective facts, and thus they would never have felt free to pick and choose from the past at random (postmodernism of the first kind), or felt compelled to parody tradition (postmodernism of the second kind).

Most postmodern artists of both kinds (for example, Julian Schnabel and Sherry Levine) are perfect products of art teaching in universities. They have been bred on art history, that is, on dull, "factual" slide-shows. They should not be blamed for recycling images; their teachers should be. The preposterous thing is that this kind of art history teaching disguises even its judgments as facts, accompanying each slide with dithyrambs about how great and how original and creative and untraditional the artist was. The more it does so, the more the intelligent students are going to sense the formidable equalization of values that goes on in this Hollywood rerun of tradition. When the time comes for their own production, they will find nothing better to do than plunder and reframe art history in the shape, and on the level, of soap opera. Never have they been told that these things of which they have seen slides — most of the time reproductions of reproductions — are examples selected so as to be standards against which to check their own work. One preposterous thing leading to another reminds me that I started this analysis by saying that, whereas academic teaching had great ambitions regarding the maintenance of tradition, it had little vanity regarding its ability to turn out individual artists. The contrary, alas, is true for both university art departments and

for art schools based on the Bauhaus model. This we should change.

A few principles may be drawn from this analysis, leading to new teaching strategies, to a change of viewpoint on strategies which have proved efficient but could still be improved. A square seen in profile remains a square; it may also reveal itself as a cube, or just a line, or a monster with a square base. One will never know what it is unless one shifts one's viewpoint. Everything revolves around one hypothesis: what if we dropped the notions of creativity and visual language? The two go together, but they can be looked at from different angles and they give way to the following themes.

Jammed Box vs Clean Slate
The myth of creativity holds that the less a child has been constricted by cultural rules and conventions, the more creative it is. Hence, there is a tendency to idealize incoming students (we call them freshmen!) as if they had a blank, but infinitely receptive, mind. Whether we want it or not, "basic" studios flatter this tendency. The equivalent to the students' blank mind is the blank page in front of them. Art teaching is supposed to start from scratch. But when they arrive, students are no longer infants. They have long been consumers of cultural artefacts, their eyes are cluttered with ready-made images (from TV to record sleeves to Salvador Dali), and their brains are full of romantic notions about the artist. It is a jammed box rather than a clean slate. (I took this metaphor from a very successful exercise designed by Peter Gnass for his sculpture students.) We know that. Still, we think that our first task is to undo those recruitment fantasies and "clean up" their expectations. It is somehow cruel. The result is that we unwittingly teach them scorn for their own culture, while the acquisition of a replacement culture has to wait. (I do this all the time and often feel guilty about it.) Should we not start from a more generous assumption? Their culture is a complex one which offers room for quality judgment from

within, and comparison from without. This should be our starting point. At the end of first year, students should not even dream of being artists, creators, or producers, but they should be sophisticated consumers, able to choose critically.

Talent vs Creativity
The myth of creativity holds that it is a faculty natural to all human beings. We suspect that it is unevenly distributed but we, true democrats that we are, think that everyone has a right to an equal share of it. "Everyone an artist" is the modernist motto. Though it is belied by reality, we think that to assume otherwise is elitist. This is why creativity had to be an empty form, a clean slate, for only then could a proper pedagogy (such as the Bauhaus model) develop it evenly in all students. What academic teaching called talent, which is not a potential but a gift, avant-garde teaching redubbed creativity, which is a potential and not a gift. A first corollary to this is the myth that teaching can provide talent (meaning develop creativity) or else that talent is not necessary. A second corollary (highly visible in schools where the Bauhaus model is still pure enough) is a pedagogy based on problem-solving exercises with built-in results. And a third corollary is the illusion that art schools can "turn out" artists. In fact, there is nothing wrong with problem-solving exercises at an early stage of the students' development, when they need to be encouraged and surprised by their results, as long as they are not led to believe that it is their creativity that expresses itself there, and as long as the teacher's critique highlights the differences in talent made visible precisely by a method where all other things are kept equal. The sooner the students know where they stand regarding their talent, the sooner they will learn to curtail or redirect their ambitions. What is at stake is, in a new way, recovering the old cultural continuity between the artisan and the genius in a realistic context. The culture industry actually has jobs for students whom we know will never become artists but should nonetheless be given an honourable perspective. This is well understood

anti-elitism. If we made it an official policy of the department that we cannot and do not wish to "turn out" artists, we would see fewer students living in a dream world and dodging responsibility, or dragging along their anxieties and self-doubts for four years in a row.

History vs Basics

The myth of the visual language upholds a literal view of artistic literacy. Basic forms and colours compose the alphabet. Spatial relationships provide the grammar. Etcetera. Start from scratch. Proceed from simple to complex. Add dimensions one at a time: first the line, then the plane, then the volume. Introduce procedures one by one: placing, repeating, sequencing, composing. Complexify rules and conventions in due order: from drawing into painting into sculpture. End with multi-media. Of course, I'm not saying this is what we do. It is "basic design" itself reduced to the basics. But notice that the history of modernism actually ran this curriculum in reverse. Take painting, for example. First, there were very complex rules and conventions prescribing that a painting should depict a battle horse or a nude in perspective and with anatomical proportions and shades and values. But soon, out went chiaroscuro, and then perspective, and then proportion, and then Euclidian space. Then the nude and the battle horse vanished, figure-ground relationships were deemed unessential, and when colour was dispensed with the monochrome went blank. In the meantime, we have thirty-nine television channels to choose from. Is it not under the pressure of that competition with industrial media, from the invention of photography on, that painting was forced to entrench its specificity in the flatness of its medium? So-called multi-media appeared when this reduction process could not be carried any further, and soon they were given a specificity of their own, even in art schools. But to think in terms of specific media betrays historical reality on at least two counts: from the outset, the history of modern art was interspecific. I do not mean that we should rewrite it as the history of mixed

media, but that each medium sees its specificity defined in terms of at least one other medium which is its specific adversary. Reciprocally, the (inter)specificity of each medium is historical. There is no definition of painting at large, there is only what we judge to be painting at a certain moment in time. In that sense, flatness (2-D) is not a basic element or definition of painting; it is a dated judgment about painting. It's fine to have a 2-D studio in the department, but not as a preparation to painting in general, rather as a sort of role-playing pedagogy: "Now let's pretend we were at the Bauhaus."

Simulacrum vs Simulacrum

Role-playing pedagogy is the vaccine to role-playing careers. Michael Schreier once told me that he was still waiting for Cindy Sherman to put on her artist's costume. That would indeed be the test. I'm afraid it would look very much like the emperor's new clothes. Let us go over the evidence. The Bauhaus model failed and got subverted. Art teaching in academia succeeded and got subverted. Students need to revolt against their education in order to innovate. Since the Bauhaus had taught them to be creative purists, they became impure appropriators. Since academia had taught them to be experimental innovators, they became existential simulators. The result is called postmodernism. The last two great postmodernists (i.e., paradoxical modernists), Joseph Beuys and Andy Warhol, died just a year apart from each other. Their shadows loom large over the two groups of younger postmodernists. Role models they are, not aesthetic standards. If you want to play the hero, choose Beuys; if you want to play the star, choose Warhol. The former's motto — "Creativity is the true capital" — proved ironically true; it's a gold mine if you can exploit it. And the latter's prediction — "In the future, everyone will be world famous for fifteen minutes" — has proved no less true. Grab your choice. But, poor kid, that's over; they're dead, and before they died they had already parodied themselves. You want to parody the parody? What else is left? OK. We'll teach you simulation.

I'm dead serious. And I am not perversely calculating that, since students ought to revolt against their schooling, we should teach them simulation so that they can reject it. I am perfectly aware that this too can backfire: only the best would revolt and we would be left with a bunch of Warhol clones. But please consider that all the threads are coming together in this teaching strategy. Postmodernism is a symptom, but symptoms have their truth. It is true that hard-core modernism is no longer tenable after the monochrome and similar far-out reductions. And it is not true that painting is dead. Its revival in neofiguration and elsewhere is healthy. Students should be allowed to explore the past — not just the modernist past, but the whole of tradition, and not just the pre-modern past but also the avant-garde. It is true that the avant-gardes are "historical," but are we in a position to know that their history is finished? The avant-gardist ideology of the avant-garde should be dumped, because it doesn't describe the course of history as it happened and because it doesn't allow for qualitative comparisons with the art of the past. But the works are to be kept and valued; they are our heritage — that is, they are not models (to be imitated, as in academicism), let alone role models (to be simulated, as in postmodernism); rather, they set standards to be emulated (as in true modernism).

It seems that I am advocating faithfulness to modern art, and I am. Why, then, am I also advocating the postmodern simulacrum? The answer lies in the word I just used, I said "postmodern," not "postmodernist." A new name has appeared which expresses the fact that some of our contemporaries don't want to be modern any more. So strong is the power of names that, by the very same token, no one is modern any more. But we don't have to buy the ism. I don't accept simulation as an ideology, a norm, a doctrine. I take it to be an adequate description of the condition in which we find our students, and ourselves. Simulation, recycled images, consumer culture, is their and our reality, and that is from where we ought to start. It is theirs because that is what they come equipped with when they

enter school, and it is ours because that is what we provide them with when we teach, for example, art history. We are employees of a travel agency called Art History — tour operators taking our students on a packaged visit to the past. Is it Disneyland? It is. No amount of grandiloquence will bring the works into the classroom when all we have are slides. So much for art history and art historians. But surely when we teach studio classes, we deal with making, not with sampling and regurgitating ready-made images. Really? Beware of the double bind. Studio teaching as pure making presupposes the blank page and the blank mind again; it presumes that there is nothing in the classroom but tools and raw materials and that the students have left their impressions of last night's movie at home. And we are back to the Bauhaus model and its myths. In this case we are indeed running a travel agency, and with a very limited choice of destinations at that. There is only one place to go — modernism. But if, as is most often the case, among the tools in the classroom there are a few instamatic cameras and maybe a VCR, and if among the raw materials some are "cooked" — snapshots and advertisements torn from magazines and xeroxes and art reproductions — then we've got the whole world in our package. The trouble is, we're not sure who is running the agency. The whole world is a bit much to handle for a single tour operator; it's great turf, though, for tourists on the loose. Out of school, it's called postmodernism; within, it's called escapism.

The obvious lesson to be drawn from this is that we should run the travel agency and not let the students run it. This is the kind of simulation I have in mind. Whether they will have enough humour, up there in the dean's office and in the Senate, to understand that academia should simulate a travel agency is up for bets. It's also up to us to sell them the idea if we like it. Humour, actually, is the one thing that can keep us abreast of a situation otherwise ironically cruel. For the reality is that universities have already been turned into travel agencies. "Serious" academic teaching of course denies this, which is why it is academic, and which is also

why really serious teaching had better acknowledge it. If that is too avant-garde for the administration, let's sell them the idea that it is experimental. So, what would serious art teaching be? If we decide to maintain survey courses in art history, they should be — with a zest of humour — deliberately advertised as package deals in cultural tourism. They should not be taught in first year, though. They would be very efficient in second year, if we succeed in training first-year students to become sophisticated consumers. In first year, traditional art history would disappear, but a program designed to raise historical awareness of aesthetic issues should be integrated into the studio work. As for studio teaching, first-year studios should be deliberately historicized as well. We would take our students on simulated field trips in past and foreign cultures and play the teaching game according to the rules of the places we visit. This is not as weird as it may sound. Actually, we do it all the time. If you teach a basic colour exercise with red, yellow, and blue, it is obvious that you are taking the students to the Bauhaus model, and, as I said, there is nothing wrong with that if it is made clear to the students. By the same token, it would be a wonderful occasion to introduce them to Mondrian and Van Doesburg, and to explain colour theory to them, and say why, on a TV screen, the basic colours are red, green, and blue, while in printing they are magenta, yellow, and cyan. Then you could also tell them what this colour theory owes to Goethe and to Chevreul, and to the existence of ready-ground pigments in tube, and why, in the Renaissance, they did not have such a colour theory, and so on. Now, say you are teaching perspective drawing. Why not do it at the hand of Alberti's *Della Pittura*, or use a window pane as did Leonardo and Dürer, and tell them? Then they could draw for hours and develop their skill and sensitivity, all the while knowing that they are in the Renaissance and that they will have to put on another mental costume if they want to draw like Matisse.

It is role-playing, granted, but it is not mere costuming, since these costumes will have content. It is simulation,

granted, but in the process it is also assimilation. It is not mere posing and it is not mere imitation. It allows endless opportunities for parallels, contrasts, and comparisons with the present, and that is the one thing we do not even have to program, since both we and the students come equipped with our present-day sensibility and knowledge. And finally, it invites aesthetic judgment constantly. Fruitful judgment, not the sterile kind which was so harmful when there seemed no way out of dogmatic modernism. Just an example: how many times have I heard that Manet was a great painter because he rejected Renaissance perspective? Is Masaccio therefore a bad artist? Aesthetic criteria change with time, but they do not cancel out previous criteria. Historical awareness is as essential to aesthetics as judgment is essential to art history. And both should nurture practice. After a year of practice nurtured in such a way, though, none of the students would have the illusion that they were dealing in art. It would be apprenticeship in the good old academic sense. It would be simulation in the postmodern sense, put to good use. It would be creativity regained, in the modern sense, and, last but not least, it would be fun.

THEORIZING CULTURALISM:
From Cultural Policies to Identity Politics and Back

Virginia R. Dominguez

"INSTITUTIONALIZED THEORY in a Post-Colonial World" can mean a number of things.[1] "Theory" and "post-colonial" are key terms here, but "institutionalized" should not be overlooked. What does it mean to situate theory in institutions? What does it add to our invocation of postcoloniality?

While an explicit metatheoretical discussion of theories of postcoloniality certainly has merit, a different level of questions concerns me here. I find myself pursuing a kind of Foucauldian analysis of institutions and their discursive positivities — one that conceptualizes theory not just as named "Theory" but as the presuppositions and creations constituted by the objects of our public discourses, enabled by them, and seemingly naturalized by them but always socially, temporally, and spatially produced. What theory or theories, I keep asking myself, currently residing in public discourse, public institutions, and the academy implicate art and the art world? Or, to open up the conceptual possibilities even further, inform, affect, or are invoked by "the art world?" And just as consequently, how can we, how do we, or how should we position ourselves *because of* that theorizing and the practices it engenders?

I am specifically concerned with the contemporary tendency across several discursive communities to "culturalize" difference and to privilege the culturalization of difference. What it enables us to see and do needs to be

evaluated in conjunction with what it sacrifices. I have articulated some of these concerns in my contribution to *South Atlantic Quarterly*, entitled "Invoking Culture: The Messy Side of Cultural Politics,"[2] and I note with interest the near simultaneous publication of equally cautionary statements on the part of similarly situated scholars, such as Akhil Gupta[3] and Paul Gilroy.[4]

Unease is articulated in different ways, but the conditions that produce it, I believe, are the same. I call it culturalism, and think of it as the tendency to think about many things in terms of culture, the tendency to invest "culture" with a great deal of semantic as well as social and communicative value, the tendency to naturalize the idea of culture in particular political movements in this officially postcolonial era, and the tendency to problematize the alleged attributes, contents, and reputed worth of alleged cultures but rarely to question our current insistence on the "reality" — or at least the referentiality — of what we speak of, and objectify, as "culture" in all invocations of "the cultural" as a type of field or domain.

In important ways, the fear I will articulate here concerns unintentional but dangerous simplifications of systems of differentiation and classification and the categories of identity that constitute and engender them. Paul Gilroy's final words in "Cultural Studies and Ethnic Absolutism" echo that fear. "The invocation of nationality and ethnicity," he writes, "corresponds to real political choices and to the wider field of political struggle." "Yielding to them," he adds, "makes the world a simpler place but if the political tradition of cultural studies scholarship teaches us anything at all, then it is surely that the drive towards simplicity should be distrusted."[5]

Culturalism is inherently political. It also takes a number of different forms, and can be, and is, appropriated by elites and non-elites, in European societies, European settler societies, and elsewhere, by scholars on the right and scholars on the left, by increasing numbers of community activists and by intellectuals and artists. It is this reach that makes

it so powerful (and so potentially dangerous) and that imbues it with power (and makes it so potentially dangerous). It is also this "messiness" of culturalist politics to which I want to draw attention, especially as it implicates those of us engaged in movements for social and political change, national sovereignty and self-determination, and opposition politics.

That we are used to condemning racism, trying to undermine colonialism, and fighting sexism is relevant. In our search for alternatives, we take varying stances on nationalism, religious fundamentalism, and identity politics. In the midst of all this, many of us have found culture appealing as a way of focusing positively, rather than negatively, on tangible, perceivable products of social communities in all their past and present diversity. Culture acquires a ubiquity as a favoured object of discourse in intellectual, political, artistic, and journalistic communities that cross many national boundaries and, in a wide number of countries, in semi-autonomous popular discourses for which "culture" is a key term as well.[6]

As an anthropologist, I am expected to find this a welcome sign. After all, the discipline I represent has been deeply invested in the concept of culture throughout the twentieth century.[7] But the truth is that I have long wondered about the presumed referential transparency of "culture" within anthropology, and about the utility, value, and epistemological consequences of invoking culture in our descriptions or analyses. As public discourse on culture—in talk of cultural politics, multiculturalism, cultural identity, cultural pluralism, cultural policies, and cultural studies—spreads well beyond anthropology and throughout much of the world, my interest is piqued and my ambivalence grows. When a noticeably polysemous term[8] acquires such discursive ubiquity, we are remiss if we don't probe any further. As John Tomlinson echoes in his recent book, *Cultural Imperialism*, "what we need to understand is not what culture is, but how people *use the term* in contemporary discourses."[9]

Over the course of the past four to five years, I have found myself toying with the pros and cons of all this *culturalism* and debating (with myself) what it is that I want my own public stance to be. For an anthropologist not to applaud political, social, and intellectual moves that highlight the need for sensitivity to differences would be to shoot oneself in the foot; for a student of racial/ethnic/nationalist conflict, as I have been for years, not to be encouraged by these moves would seem paradoxical; and for a non-Anglo, foreign-born, Spanish-surnamed woman scholar in the United States not to be an avid supporter of these moves would be to risk being misappropriated by an old-guard conservative political faction that wants to minimize threats to its own position of social privilege.[10]

But the problem is that culturalism is more problematic than the pluralizers of cultural policies and cultural identities appear to think, and not as oppositional or radical as the old guard fears. Hence, my dilemma and my remarks here. I am specifically concerned with certain beliefs fostered by all this widespread talk of cultural politics and cultural identities late in the twentieth century: (1) the belief (illusion?) that culturalism is an improvement over racism—that it transcends racism; and (2) the belief (illusion?) that all groups of people in order to be self-respecting and to obtain the respect of others must have a culture and proclaim and cherish their cultural identity.

Consider a series of seemingly disparate phenomena—the current U.S. public obsession with multiculturalism, the U.N.'s promotion of cultural policies in its member nations, and the explosion in the humanities in the past twenty years of talk of (literary) canons, their maleness, their elitism, and their Eurocentricity, and of the need to challenge their perpetuation in a world proclaimed to be postmodern. These things have in common: (1) the couching of socially significant arguments in terms of culture; (2) an intended politics of resistance to Eurocentricity; (3) an intended politics of resistance to Eurocentricity late in the twentieth century (after formal European colonialism and at a time of

uncertainty about the extent and longevity of U.S. power); (4) an emphasis on inclusions and exclusions; and (5) a disavowal of race as a legitimate category of difference.

Most casual observers and most of the active litigants perceive the resistance to Eurocentricity and the rethinking of standing practices of inclusion and exclusion of people and their creative or social products as central to these contemporary forms of culturalism. This is the case with scholars, artists, writers, and curators fighting for greater institutional attention to "non-Western" people and their tangible products (seen as art, artefacts, history, or heritage) but also with scholars, artists, writers, and curators fighting for greater institutional inclusion of non-elite "Western" people and the tangible products they consume and/or produce, like comic books, graffiti, and rap music. What concerns me is that, in the heat of the arguments, what may be the most significant aspect of all of these movements is barely noticed, or at least barely discussed — that these struggles are taking place now not because of existing or expanding or narrowing "cultural" differences between groups of people but, rather, because at this point in time much of the world has internalized culture as a marker of difference and value (perhaps even the socially and politically pre-eminent marker of difference and value).

David Wu, Geoff White, Betty Buck, and Larry Smith, colleagues at Honolulu's East-West Center, alluded to this in a working paper in 1989. "The major worldwide cultural development in the 1980s," they write, "has been a global resurgence of assertions of cultural identity and distinctiveness." "This has come in many forms," they add, "at the national level as state-defined national ideology; among ethnic groups as assertions of minority rights and values; and among indigenous populations as regional and even separatist nationalist movements." Concentrating on Asia/Pacific out of interest and geographic location, they go on to argue that "these trends will become increasingly prominent during the 1990s due to new economic and political developments and due to intensified cultural interaction through

international communication and trade, including trade in cultural commodities [and that] the contemporary importance of culture in the 1990s lies in its dynamic quality as an object of discussion, debate, manipulation and struggle."[11]

One could put it differently — that we have got so carried away with the content of our discussions and debates that we pay little attention to the fact that there is nothing natural or obvious about conceptualizing difference or value in terms of culture.[12] That this may be a vision of privilege and difference that remains elite and European in origin and Eurocentric in conception is underplayed. Likewise for its corollary — that this may be counterproductive as resistance politics because it gives the appearance of equality in value, multiplicity of form, and decentralization of power in a world still largely dominated by European elites and their descendants.

How does all of this work itself out? My answer is: Through the baggage of the terminology we're invoking and the societal institutions in which, and vis-à-vis which, the framing and reframing is taking place. The question that case after case leads me to ponder is: How much real change is possible when the terms of definition — the very conceptualization or objectification — are not under attack, when there is a great deal of contestation of the facts but not much of the categories of understanding or apprehending the social world?

Let me share my apprehensions about three current examples of oppositional politics drawing on, and perpetuating, culturalist thinking: the multiculturalism campaign in the United States, Fourth World invocations of cultural claims in both the United States and Canada, and the postcolonial spread of official governmental cultural policies throughout most of the world.

On the Multiculturalism Campaign

Two things concern me, though they share a bottom line. First, I have yet to be convinced that what is meant by multiculturalism transcends racism. Second, I worry that, by employing an old elite European concept that was used for

years to justify the existing privileges of the very few, we are still letting that long-privileged elite dictate what are taken to be the legitimate criteria for defining and valorizing ourselves and others.

What is the discourse on multiculturalism in the United States today? Others have circumscribed it in light of their perceptions and/or interests, as those of us who have kept an eye on the U.S. national news media can attest. *The New Republic*, *The Atlantic Magazine*, *Time*, "The MacNeil/ Lehrer NewsHour," "Firing Line," and "This Week with David Brinkley" all did special features on multiculturalism and political correctness in 1990–91 alone. Rarely did a month go by without a major article in *The Chronicle for Higher Education* on the multiculturalism/political correctness "debate." William Bennett, Stanley Fish, and Dineesh D'Souza have been featured (along with some others) as central to the discussion. I for one have found these examples much more revealing as data about "multiculturalism" than as interpretations of varying positions.

Some people clearly interpret all the talk of multiculturalism to be about value as defined by the presumed purveyors of Kultur (an elitist, upper-class European idea heavily relying on the notion of refinement, creative achievement, and the fine arts) and the wares they promote — those things defined as literature, philosophy, and the fine arts. Hence much of the explicit debate is about the comparative value of particular things — canonized and non-canonized books, paintings, and philosophical treatises, as well as non-canonized forms and genres. I find that discussion useful but find the perception that multiculturalism is henceforth a real (desired or feared) attack on the status quo ingenuous. Notice, for example, how this gets echoed in Gupta and Ferguson's critique: "'Multiculturalism' is both a feeble acknowledgment of the fact that cultures have lost their moorings in definite places and an attempt to subsume this plurality of cultures within the framework of a national identity."[13] European culture, usually referred to as Western culture, features prominently in all of this public discourse,

as does the movement that questions the need to continue to privilege it so strongly in school curricula, museum exhibitions, and the writing of U.S. and world history. Those who value what they believe to be European culture feel an erosion of value. Ironically, those who are questioning its privilege question the privileging of European content, not the European idea that culture is something of value.[14] I know we have all internalized that notion, but shouldn't we pause as well and think about it? Why is "culture" something of value? What does it mean to make arguments about equality, respect, dignity, power, resources, or self-definition by arguing that certain things do indeed fit the criteria someone else has long employed to assert their own value at other people's expense? And why should we buy into the notion that all self-respecting individuals or groups must have it?

I find the bulk of the discussion, and of the activism mobilized by such discussion, quite narrow and reactive. Paul Gray's description of the issues in *Time* magazine's featured cover article of 8 July 1991 highlights this for me. "The multicultural crusade," he wrote,

> has become part of a wider ferment on American campuses that includes the efforts to mandate a greater "diversity" within faculty and student bodies as well as the movement, derisively labelled "political correctness," that seeks to suppress thoughts or statements deemed offensive to women, blacks or other groups. Some of this has provoked flare-ups, notably at Stanford University, which in 1988 decided to revamp its first-year course, Western Culture, in response to critical pressure. Some students and faculty members at the elite, ethnically diverse institution had complained that the course syllabus offered only the writings of white males. The prospect of one or more of these — Plato? Shakespeare? — being kicked out to make room for women and minorities caught traditionalists' attention, as did a demonstration at which students chanted "Hey, hey, ho, ho, Western Culture's got to go!" In the end, Stanford excised no one from the reading list; it added optional new assignments.[15]

But I am as concerned with the aspects of this hot discourse of multiculturalism that don't seem to be noticed by its promoters. If we pay attention to the actual instances of invoking multiculturalism (and remember that every case of invoking "the theory" of multiculturalism is itself a socially situated practice), we notice:

(1) that most of the discussions — indeed all that I have seen in print so far — focus on the "multi" in multiculturalism and not on the "culturalism" of it;

(2) that the discussion is really about whether we should have it, not about whether it exists — that is, whether it is good to reconceptualize U.S. society as multicultural, not, as a few decades ago, whether all these immigrants and immigrant groups, reconceptualized as carriers of different cultures, were ever going to be *acculturated*;

(3) that most participants in the debate think they're talking about the cultures of various parts of the world when, in fact, they're typically referring to U.S. citizens or residents;

(4) that when multiculturalism is invoked in the organization of an event, or the policies of an organization, head counts of certain "kinds" of individuals always follow; and

(5) that "communities" whose members are sought in order to bolster the claim of multiculturalism are always the same: "black"/"African-American," "Asian," "Hispanic," and "Indian"/"Native American." And, of course, these are the same "types"/"communities" that are evoked whenever Americans talk about Americans in terms of race.[16]

A great deal of this talk then perpetuates, in practice, much more than it seemingly challenges. Questions of relative worth or merit or access are still posed in terms of the old standby principle of hierarchical distinction — an upper-class European circumscription of something called culture by which value is defined.[17] Another U.S. standby — a notion of race and a perception of certain populations (and not others) as racial others — remains untouched in the discourse on multiculturalism for, while they may be talking in terms of culture, the targeted, marked people are still

those perceived to be *racial* others.[18] Moreover, it is evident that the advocates of multiculturalism are still advocates of the redeployment of power and resources within the United States, and not advocates of internationalism or of a less U.S.-centric curriculum. To put it bluntly, multiculturalism as oppositional politics leaves me frustrated for it claims far more as an oppositional strategy than I have so far found warranted.

On Fourth World Culturalist Activism
Culturalism has been picked up quite noticeably over the past ten years by a number of activist, under-empowered, indigenous movements with far more specific group-oriented goals. Here the struggle is over rights, resources, and privileges, and the strategy is the invocation of culture. Nothing about fighting for dignity, equality, voice, and resources seems surprising or troublesome. But again I wonder about the insistent invocation of culture and the reliance on culturalism. I worry that what at first appears to be an ingenious strategy of oppositional politics ends up becoming more of a trap.

The strategy certainly appears appealing as well as potentially effective, given the manner in which they and their causes have been dismissed, disempowered, and peripheralized over the past couple of centuries. The point is to disarm culture as an ideological/discursive/rhetorical instrument of discrimination and oppression long used against them, and to turn it to their own advantage—to appropriate the idea of culture as something that applies to themselves (and not just to the historically privileged populations) and to employ the idea of culture to buttress a variety of claims they may be making (many of which they have long been making but without much efficacy).

European culturalism is simultaneously emasculated and reproduced. Control is wrested away from historically elite and Eurocentric institutions, and their gate-keeping role is challenged. And yet it is still the 200-year-old European valorization of something called culture and some dimension of

social life they call cultural that sets the terms of definition for this late-twentieth-century form of political struggle for equality, self-determination, and land claims. A nineteenth-century European creation — the affirmation that legitimate peoples have, and can be identified by, visible and distinctive cultures — is revived and deployed in this late-twentieth-century political arena. That culturalism is an appropriation of non-indigenous thoughts and practices is noteworthy. However, it is the paradoxes in which it traps this form of political activism that give me reason to pause. Let me briefly comment on two recent examples — the Hawaiian sovereignty movement and the Canadian Indian/ First Nations activism.

Culture has featured prominently in the activities of the Hawaiian sovereignty movement and its current discourse of self-consciousness.[19] Land, recognition, better living standards, and self-governance are the movement's tangible goals, with an extreme position arguing for independence and Hawaiian control over the Hawaiian islands, and many others — less ambitious — arguing for their right to much of the land and for some form of sovereignty.[20]

Hawaiian activists typically see themselves as people at odds with anthropologists, historians, tourists, and bureaucrats who, for sometimes different and sometimes overlapping reasons, frequently call into question some part of the sovereignty movement's culturalist assertions. The activists' strategy has been to go on the offensive, rather than to be reactive or defensive. When a cultural claim is called into question, the response has increasingly been to question the challengers' assumptions about culture and their historically hierarchical patterns of invoking culture differentially.

A number of the leading activists are scholars, lawyers, and students, and the university has become a visible battleground for this kind of culturalist argumentation. The claims are being made both by the differential use of "historical data" and by an insistent appropriation of culturalism as a valid form of argumentation. To wit, Hanauni-Kay

Trask's vehement response in 1991 to two otherwise sympathetic and well-established anthropologists, Jocelyn Linnekin of the anthropology department at the University of Hawaii in Manoa and Roger Keesing from the Australian National University.[21] (Hanauni-Kay Trask is herself head of the Hawaiian Studies Program at the University of Hawaii at Manoa.) She wrote:

> In the Hawaiian case, the "invention [of tradition]" criticism [following in the footsteps of Terence Ranger and Eric Hobsbawm (1983) and extending it to the Pacific Islands] has been thrown into the public arena precisely at a time when Hawaiian cultural assertion has been both vigorous and strong-willed.... Representatives of the dominant culture—from historians and anthropologists to bureaucrats and politicians—are quick to feel and perceive the danger because, in the colonial context, all Native cultural resistance is political: it challenges hegemony, including that of people like Keesing who claim to encourage a more "radical stance" toward our past by liberating us from it.[22]

The debate was obviously a healthy one at one level, but acerbic and limiting on the other: there was so much commitment to a culturalist form of argumentation on the part of the leading Hawaiian activists that alternatives, and even willing allies, were held at bay.

In Canada, a similar dynamic pits indigenous activists invoking cultural claims against lawyers, government administrators, folklorists, and anthropologists who may call those claims into question. Canadian Indian/First Nations activism seeks to expedite resolution to their land claims and push for greater political control. Evelyn Legaré has insightfully noted that

> in order to legitimate their claims to Indianness, both in their own eyes and those of other people with whom they share national boundaries[,]... aboriginal peoples must "maintain and retain" their aboriginal cultures. If they incorporate aspects of Euro-American/Euro-Canadian culture, they lose their Indianness.

Ironically, then, the "vanishing Indian" that haunted the fears of late nineteenth-century and early twentieth-century anthropologists like Franz Boas is now a major concern of aboriginal peoples [themselves].[23]

Legaré writes that activists often end up placed in "a defensive position, continually forced to 'prove' that they do not possess anything definable as 'Euro-Canadian (i.e., modern) culture' and to 'prove' the purity and authenticity of their culture."[24] Paul Tennant cites the case of a government lawyer who formally argued that the Gitksan had no legal basis for their land claims because they watched television and ate pizza.[25] Indian activists' political argument, he goes on to argue, ends up buried within an abstract non-specific pan-native ideology with little relation to local issues.[26]

Here, as in the Hawaiian case, activists respond audibly by appropriating and redeploying the discourse on culture. Marie Smallface Marule, member of the Blood tribe and chief administrator for the World Council of Indigenous Peoples as well as lecturer in Native studies at the University of Lethbridge, Alberta, is a good example. She has written that: "it is assumed by many that very little remains of traditional Indian ideology and philosophy because the traditional Indian life-style is no longer in evidence; that is, [that] we don't live in teepees anymore."[27] She adds that Indian culture does not "have to remain static to remain Indian."[28] The problem is that culturalism does lead people to want to find and have identifiable, visible, and neat differences, and in the process to dehistoricize, romanticize, freeze, and reify cultures by drawing selectively on certain things in people's lives and devaluing the significance of others. And as both the Hawaiian and Canadian examples reveal, culturalist arguments become easy political targets in the academy, in the press, and in the courts. Given these strains and traps, my question remains whether culturalism is really worth all the attention it's getting in circles committed to oppositional politics.

On Promoting the Articulation of Cultural Policies

I have written at greater length on the epistemological and political paradoxes of cultural policies in my 1992 *South Atlantic Quarterly* contribution. Here I am particularly interested in discussing the business of promoting the development and articulation of cultural policies as a post-colonial institutional strategy. I have for years been partially aware of the existence of ministries of culture in a variety of Latin American, Middle Eastern, and European countries. But it was not until I was asked to serve as discussant at a week-long international conference on cultural policies and national identity that I became aware of the extent of institutional culturalism throughout the world. That meeting brought together scholars from the People's Republic of China, Taiwan, Japan, Thailand, Papua New Guinea, Singapore, the Solomon Islands, New Zealand, and the United States at the initiative of Honolulu's East-West Center. I was struck by the amount of evidence they presented suggesting that "cultural policies" were neither just the concern of European, Euro-American, or European-trained local intellectuals, nor something associated with the colonial era and now targeted for elimination. The opposite, if anything, seems to be the case.

As I have asked before of the U.S. public discourse on multiculturalism and the culturalist moves of certain Fourth World indigenous movements, let me once again ask the seemingly rarely asked question: Why? Shouldn't we wonder, or at least note, the apparently enormous success European countries have had over the past century and a half convincing the rest of the world that culture is a thing, that it is something of value, and that any self-respecting group of people must have it? What we see when we look around is that governments contest the extent to which the content of their "culture" must be European in origin in order for it to be of value, but that they are still overwhelmingly buying into the old elite European idea that there is such a thing as culture and that it is through one's culture that one's value is judged. Some of what we see is an

adaptation of the Kultur notion itself (the most acclaimed, usually elite, manifestations of a society's achievements); some is an adaptation of the nineteenth-century European nationalist invocation of certain non-elite characteristics as the cultural essence of an emerging nation-state. In both forms, however, we see an insistence on the idea that it is through culture that one and/or one's society is distinguished. Mention just a few examples and it's hard not to see my point — China's 1980's "culture fever,"[29] Japan's ongoing Nihonjinron,[30] Papua New Guinea's panic about developing a national culture by doing something about "tradition,"[31] or, closer to home, Québécois cultural nationalism.[32]

Cultural policies are apparently things to be had. UNESCO actively encourages all member states to develop official cultural policies. In 1970 and again in 1982, UNESCO sponsored world conferences on cultural policies. Throughout the 1970s and 1980s, it commissioned and published well over forty country-by-country reports on cultural policies.

If we remember that most member states are themselves not European and that most were even formally recent colonies of European countries, this push for global institutional culturalism takes on greater significance. It doesn't look like it is really Europe that is pushing for global culturalism right now but, rather, those who have historically been discriminated against by European culturalism. As the preface to the UNESCO series on cultural policies reveals, Europe looms large in the background but is never foregrounded. "The purpose of this series," it notes, "is to show how cultural policies are planned and implemented in various Member States. As cultures differ, so does the approach to them; it is for each Member State to determine its cultural policy and methods according to its conception of culture, its socio-economic system, political ideology and technical development." But note that it encourages nations to develop a cultural policy, nonetheless, and, as it goes on to say, to acknowledge that there are common methodological, institutional, administrative, and financial problems

from country to country, and that there is a need "for exchanging experiences and information about them."

At the same time that de-Europeanization and globalization are presumably promoted by providing for a much wider range of possible inclusions from country to country, two things continue to occur: (1) European countries, singularly and collaboratively, take institutional steps to make sure that Europe is still a player in "the cultural sector" and that Europeans continue to care about European culture, and (2) "the cultural" is discursively promoted as an arena of life to which the term refers and that is discursively separable from other arenas for which there might be other types of policies (i.e., economic, energy, foreign).

Both of these practices exert pressure, ideologically and institutionally. Europe may worry about preserving its influence, but it continues to claim the privilege of culture. Quotable examples are not hard to come by. A 1980 document, printed by the Office for Official Publications of the European Communities and announcing itself as "a commentary on the Community action programme in the cultural sector," sells itself on the back cover with the following claims:

– that "European culture antedates the division of Europe into nation states," implying pan-Europeanism, the possibility of recouping losses incurred through national/ist fragmentation, and an emphasis on continuities or essences rather than historical developments or change;

– that "for centuries, culture has spread with superb indifference to frontiers and barriers," a celebratory statement that can easily be heard as an attempt to salvage, if not quite justify, world-wide colonialism; and

– that the heads of state or government since their The Hague Summit of 1969 "have stressed the need for Community action in the cultural sector," and have spoken "of *the need to preserve Europe as an exceptional seat of culture*" calling for "particular attention ... to non-material values and goods" (emphasis added).[33]

Even when it is obvious that a great many of these institutional initiatives focus on pan-European collaboration and the potential for unification, the wording is suspiciously celebratory and not so post-colonial, and the timing—that is, the period since the late sixties—interesting, to say the least.

Couple this with the discursive promotion, and carving out, of "the cultural" and there are important ramifications for the belief that postcolonial official cultural policies can be effective means of countering the legacy of European colonialism and domination. The continued objectification of the cultural (like the nineteenth-century "rise of the cultural" that P. James[34] analyses with reference to Europe) produces a belief in its referentiality, its "real" existence presumably outside discourse. With it, it produces the felt need to have something that fits the concept, no matter how slippery the concept may prove to be. The action is reactive, and the need is felt to be urgent. When so many things require attention, the energy expended to define, articulate, establish, and promote a policy thought to fit the European-promoted notion of the cultural seems troubling, at least to me.

The ramifications are institutional in another way as well. The pressure is to substitute local, non-European content for European content promoted during the colonial era. Museums mount at least some alternate exhibits and arts councils promote at least some activities deemed to have more local, regional, or national content. The "stuff" may vary but the idea that there must be "stuff" to put into these "cultural" institutions is a hard one to shake. So emerging nations end up creating museums, setting up universities, and encouraging or developing folklore troupes, art academies, and national ballet companies.

I am not suggesting that all of these things are bad, just that they are everywhere and that this prevalence needs to be noted, explicitly acknowledged, and not just celebrated or endorsed. Oppositional politics that are culturalist in form and strategy must be more aware of what it sacrifices, what it compromises, and what it retains.[35]

Culture and culturalism are with us not because they are natural, real, or universally applicable but, rather, because we are thinking and acting in terms of them, and we are making strategic and political interventions invoking them — unfortunately, I believe, while often unaware of their ramifications. A culturalist form of legitimation and argumentation has taken over in the late twentieth century — the contemporary world's counterpart of earlier racialist theories, evolutionist theories, civilizational theories, moral theories, class theories, and naturalist theories. What it produces is a *culturalization of difference* that most of us now promote domestically and internationally with the same degree of conviction (and often even the fervour) of our Enlightenment or modernist predecessors from whom we otherwise seek to distance ourselves. This is one thing we can do with difference, but it is certainly not the only thing. As Gupta and Ferguson put it, "if we question a pre-given world of separate and discrete 'peoples and cultures', and see instead a difference-producing set of relations, we [can] turn from a project of juxtaposing preexisting differences to one of exploring the construction of differences in historical process."[36]

Notes

1. "Institutionalized Theory in a Post-Colonial World" was the official title given by the conference organizers to the session in which I was asked to speak.

2. Virginia R. Dominguez, "Invoking Culture: The Messy Side of Cultural Politics," *South Atlantic Quarterly,* 91, no. 1 (1992): 19–42.

3. Akhil Gupta and James Ferguson, "Beyond 'Culture': Space, Identity, and the Politics of Difference," *Cultural Anthropology,* 7, no. 1 (1992): 6–23.

4. Paul Gilroy, "Cultural Studies in Ethnic Absolutism," *Cultural Studies*, ed. Larry Grossberg, Cary Nelson, and Paula Treichler (New York: Routledge, 1992), 187–198.

5. Ibid., 197.

6. Cf., Richard Fox, *Nationalist Ideologies and the Production of National Cultures* (Washington: American Ethnological Society

Monograph Series, 1990); Richard Handler, *Nationalism and the Politics of Culture in Quebec* (Madison: University of Wisconsin Press, 1988); David Harvey, *The Condition of Postmodernity* (Oxford: Basil Blackwell, 1989); Gayatri Spivak, *In Other Worlds: Essays in Cultural Politics* (New York and London: Methuen, 1987); Arthur M. Schlesinger Jr, *The Disuniting of America: Reflections on a Multicultural Society* (New York: W.W. Norton, 1992).

7. Cf., George Stocking Jr, *Race, Culture, and Evolution: Essays in the History of Anthropology* (New York: Free Press, 1968).

8. Cf., Raymond Williams, *Keywords* (London: Fontana, 1983); R. Robinson, "The Sociological Significance of Culture: Some General Considerations," *Theory, Culture and Society,* 5 (1988): 2–23; Clifford Geertz, *The Interpretation of Cultures* (New York: Basic Books, 1973); Alfred Kroeber and Clyde Kluckhohn, "Culture: A Critical Review of Concepts and Definitions," *Papers of the Peabody Museum of American Archaeology and Ethnology, Harvard University,* 47 (1952).

9. John Tomlinson, *Cultural Imperialism: A Critical Introduction* (Baltimore: Johns Hopkins University Press, 1991), 5.

10. Even a casual reading of the platform/charter/statement of the National Association of Scholars illustrates the possibility, even likelihood, of any critique of the "multiculturalist campaign" being co-opted inappropriately. Hence, I believe, a number of generally sympathetic, though specifically uneasy, scholars have been reluctant to express reservations in public.

11. D. Wu, G. White, E. Buck, and L. Smith, "Cultural Construction and National Identity: A Concept Paper for a Proposed ICC Program Area," Working Papers, no. 1 (1989) (Cultural Studies East and West Series, Institute of Culture and Communications, East-West Center, Honolulu).

12. Cf., Pierre Bourdieu, *Distinction: A Social Critique of the Judgement of Taste* (Cambridge: Cambridge University Press, 1984), and Virginia R. Dominguez, *White by Definition: Social Classification in Creole Louisiana* (New Brunswick: Rutgers University Press, 1986).

13. Gupta and Ferguson, "Beyond 'Culture'," 7.

14. Cf., Bill Ashcroft, Gareth Griffiths, and Helen Tiffin, *The Empire Writes Back* (London: Routledge, 1989).

15. Paul Gray, "Whose America?" *Time* (8 July 1991): 13.

16. Phyllis Pease Chock, "The Landscape of Enchantment: Redaction in a Theory of Ethnicity," *Cultural Anthropology*, 4 (1989): 163–181, and "Culturalism: Pluralism, Culture, and Race in the Harvard Encyclopedia of American Ethnic Groups," *Identities*, 1 no. 4 (1995).

17. Cf., Uli Linke, "Folklore, Anthropology, and the Government of Social Life," *Comparative Studies in Society and History*, 32 (1990): 117–148.

18. Virginia R. Dominguez, "The Management of Otherness: 'Ethnicity' in the U.S. and Israel," *Journal of Ethnic Studies — Treatises and Documents; Razprave in Gradivo/Treatises and Documents* (Institut za Narodnostna Vprasnja — Institute for Ethnic Studies), 21 (December 1988): 161–167; and Davydd Greenwood, *Taming Of Evolution* (Ithaca, N.Y.: Cornell University Press, 1988).

19. Cf., Jeff Tobin, "Cultural Construction and Native Nationalism: Report from the Hawaiian Front." (unpublished manuscript, 1991).

20. Melody Kapilialoha MacKenzie, *Native Hawaiian Rights Handbook* (Honolulu: Native Hawaiian Legal Corporation and Office of Hawaiian Affairs, 1991).

21. Cf., Roger M. Keesing, "Creating the Past: Custom and Identity in the Contemporary Pacific," *Contemporary Pacific*, 1 (1989): 19–42; and "Reply to Trask," *Contemporary Pacific*, 2 (1991): 168–171; Jocelyn Linnekin, "Text Bites and the R-Word: The Politics of Representing Scholarship," *Contemporary Pacific*, 2 (1991): 172–177.

22. Haunani-Kay Trask, "Natives and Anthropologists: The Colonial Struggle," *Contemporary Pacific*, 2 (1991): 159–167.

23. Evelyn Legaré, "The Indian as Other in a Multicultural Context." (Paper presented at the Annual Meetings of the American Ethnological Society, Charleston, North Carolina, March 1991): 60. See also Legaré, "Canadian Multiculturalism and Aboriginal People," *Identities*, 1, no. 4 (1995).

24. Ibid.

25. Paul Tennant, *Aboriginal Peoples and Politics: The Indian Land Question in British Columbia*, 1849–1989 (Vancouver: University of British Columbia Press, 1990), 15.

26. Ibid., 33–34; Legaré, "The Indian as Other in a Multicultural Context," 61.

27. Marie Smallface Marule, "Traditional Indian Government: Of the People, by the People, for the People," *Pathways to Self-Determination: Canadian Indians and the Canadian State*, ed. Leroy Little Bear, Menno Boldt, and J. Anthony Long (Toronto: University of Toronto Press, 1984), 37.

28. Ibid.

29. Haiou Yang, "Culture Fever: Cultural Discourse in China's New Age." (Paper presented at the Workshop on Cultural Policies and National Identity, East-West Center, 1990; also available as a Working Paper in the Cultural Studies East and West series, Institute of Culture and Communication, East-West Center, Honolulu.)

30. Harumi Befu, "Cultural Construction and National Identity: The Japanese Case." (Paper presented at the Workshop on Cultural Policies and National Identity, East-West Center, 1990; also available as a Working Paper in the Cultural Studies East and West series, the Institute of Culture and Communication, East-West Center, Honolulu).

31. Lamont Lindstrom, "'Pasin Tumbuna': Cultural Traditions and National Identity in Papua, New Guinea." (Paper presented at the Workshop on Cultural Policies and National Identity, East-West Center, June 1990; also available as Working Paper in the Cultural Studies East and West series, the Institute of Culture and Communication, East-West Center, Honolulu.)

32. Described at length by Handler, *Nationalism and the Politics of Culture in Quebec*.

33. UNESCO, *Cultural Policies in Europe* (Office for Official Publications of the European Communities, 1980) and *Final Report of World Conference on Cultural Policies* (Mexico City and Paris, 1982).

34. Paul James, "National Formation and the 'Rise of the Cultural': A Critique of Orthodoxy," *Philosophy of the Social Sciences*, 19, no. 3 (1989): 273–290.

35. James Clifford, *The Predicament of Culture* (Cambridge, Mass.: Harvard University Press, 1989).

36. Gupta and Ferguson, "Beyond 'Culture'."

IN DEFENCE OF THE REALM:
Public Controversy and the Apologetics of Art

Kevin Dowler

> *Art which is the most complex part of culture, the most sensitive*
> *and at the same time the least protected, suffers most from the*
> *decline and decay of the bourgeois society.... Art can neither*
> *escape the crisis nor partition itself off. Art cannot save itself.*
> (Leon Trotsky)

In *The Rhetoric of Purity*, Mark Cheetham draws our atten-
tion to Plato's remarks at the end of the *Republic* about the
way art might prove its worth to society and justify its
return to the community from which it was to be banished.[1]
As Cheetham notes, there are two ways in which this
restoration might occur. The first would be that art defends
itself immanently, as it were, through its own production. It
is not made clear how this would come about, although
there is the suggestion that this might be accomplished
through the restriction to epideictic rhetoric, to "paeans in
praise of good men," as Plato says.[2] The second method
would give the critics a chance to have their say: "we should
give her defenders, men who aren't poets themselves but
who love poetry, a chance of defending her in prose and
proving that she doesn't only give pleasure but brings last-
ing benefit to human life and human society."[3] Aside from
reiterating the masculine core of Greek society, this state-
ment is, first and foremost, a reminder for us that the ques-
tion of the relation between theory and art is a very old one.

It also reminds us that the relationship between art and society, as one fraught with tension and distrust, is not a modern phenomenon by any means, and that it is here for the first time that the tradition of an apologetics of art appears.

What is also interesting is the way that Plato's description of a group pleading the case for art in front of a tribunal sounds remarkably similar to some recent cases which are familiar to most Canadians: the controversies that surrounded the purchase of the abstract painting of three vertical stripes, *Voice of Fire* by Barnett Newman, and the exhibition of Jana Sterbak's *Vanitas: Flesh Dress for an Albino Anorectic*, a sculpture made of pieces of beef stitched together in the form of a dress. In the same way that lovers of art who were not artists were called before the republican tribunal to make the case for epic and lyric poetry, so too were the officials of the National Gallery of Canada (NGC) called before the House of Commons Standing Committee on Communication and Culture to prove, once again, the value of art as a "lasting benefit to human life and human society" or, at least in this instance, to Canadian society.

Although the NGC normally appears before the House Committee on a regular basis to explain its purchases as a condition for the use of public monies, in April of 1990, in regard to the purchase of the Newman painting, and again in April of 1991, in regard to the exhibition of Sterbak's sculpture (for which the NGC purchased the meat used in its fabrication), officials from the gallery found themselves embroiled in a public controversy in which the ostensible question of fiscal responsibility was overshadowed by the latent hostility and antipathy toward contemporary art. The NGC, perceived to be the custodian of such art on behalf of the Canadian public, was attacked for its practices in the name of that very same public. Felix Holtmann, chair of the Standing Committee, declaimed to the press about *Voice of Fire* that he could do as well as Newman with "two cans of paint and two rollers and ten minutes," providing the ideal sound bite that set the terms in which the debate would be defined. Although the question was how the NGC could

justify spending close to two million dollars on a single painting (especially an American painting) given the small size of its acquisition budget,[4] Holtmann's comment was clearly intended to be more than simply a comment on fiscal responsibility, and in effect constituted a direct attack by a public official on contemporary art. Indeed, the hue and cry raised as a result was enough to foster rumours that the all-powerful Expenditures Review Committee of the cabinet, chaired by the prime minister, was considering a review of the NGC's purchase one month before the gallery was to report to the House of Commons.[5]

Similar questions were raised in regard to the exhibition of Sterbak's *Vanitas* one year later, although the question of fiscal restraint took on a more symbolic dimension. Since the cost of the meat was minimal ($300), concern revolved around the appropriateness of displaying a sculpture made from meat at a time when the poverty levels in the country were rising.[6] Especially repugnant to many was the fact that the meat itself actually decomposed in full view, thus symbolically reinforcing the sense of waste that in some people's opinions the sculpture represented. This provided the opportunity for opponents of the NGC's practices, defeated in their attempts to censure the gallery over the purchase of the Newman painting, to attack the gallery again.[7]

These two moments provided the rare conditions under which the question of the social function of art could be raised. It is not often asked, since "the extraordinary question of the source of the artwork's value [is] normally taken for granted."[8] The problem becomes how to articulate a response against this background of the normally taken for granted, where the question is never posed. Members of the art "world" have not, until recently, been called upon to explain the value of the work of art, or its function. Within the condition of relative autonomy that the sphere of art has enjoyed for some time, the shared assumptions of aesthetic worth that act as the price of admission to the art world prevented the possibility of asking such a question.[9]

However, once this status of autonomy is brought into question in the name of the public, which does not necessarily share those assumptions, a response becomes mandatory.

The collapse of the distinction between, on the one hand, the sphere of aesthetic production and reception and, on the other, the spheres of everyday social and political interaction, even if only brief, can produce some interesting and unanticipated consequences. Until recently, the uselessness of art, its pure negativity, ensured its freedom to function as critique, since it rested beyond (and therefore was incapable of infecting) the horizon of everyday life. However, with the erosion of the autonomy of aesthetic practices and the broadening of the scope of reception (once encouraged by the avant-garde), art can no longer hold the privileged position that was the sign of both its freedom from constraint and its lack of utility.

Ironically, the occasions which do seem to produce some social effects and which would indicate a certain success as regards the claim for the centrality of aesthetic experience have led instead to a shrill rhetoric in defence of artistic (and, concomitantly, institutional) freedom. This appears to run into a contradiction that emerges in relation to both aesthetic practices and discourses: the persistent desire, first expressed by the avant-garde, to reunite aesthetic experience with quotidian experience, and the insistence that art remain immune to the social and political criticism of its contents.

The two examples provide a convenient site in which to reflect on what could be called a communication "crisis" that emerged as a result of the demand by the public to explain the social function of the work of art. This goes to the core of the debate within the art world over the communicative function of the work of art (as it is currently being played out through the various strategies of postmodernist art practices), and has consequences for the social effects of artworks. The net effect of a "failure" of communication is, potentially, increasing irrelevance to a social order already highly disdainful of contemporary art;

thus the stakes are high. Furthermore, it raises the question of the function of expert culture as the mediator between the work of art and the general public, and the extent to which such a culture is equipped to meet the social criticisms directed toward both works of art and the theoretical and critical discourses out of which they emerge. To pose Plato's question again, can the lovers of art defend it rhetorically in a way that could demonstrate its "lasting benefit to human life and human society," especially given the increasing remoteness of aesthetic experience from the everyday as it has evolved over the course of this century?

This questioning, of course, is not a phenomenon restricted to Canadian society. In the United States, as in Canada, the ostensible concern is with the appropriate use of public monies, but it is evident that in both countries this has been a smokescreen for a general indictment of contemporary art.[10] As the Canadian case makes clearer, it is not simply a question of the obscene, of what can and cannot be shown (since in Canada the apparent offence had nothing to do whatsoever with obscenity), but rather the more fundamental issue of the importance of art to the citizenry, and the expression of moral outrage and indignation at what apparently has little to do with the day-to-day existence of the majority of people in both countries.

Given this distance, the contemporary reenactment of the Platonic tribunal comes with a twist. We should recall that Plato was acting out a *fantasy* where art had already been banished from the state; in fact, of course, art was for Plato all too central. The problem for Plato had to do with the centrality of art within the historical and political experience of the Greek *polis*; he was imagining what he thought would be a better world where art no longer had the power to organize experience in the way that it evidently had at that time.[11] In our times, however, if we discount the possible aesthetic experiences arising from mass culture, Plato's projection has in fact been realized. Art has become marginalized to such a degree that it no longer has any social effect.

Art is therefore in the exact place that Plato desired it to be. This was already recognized many decades ago by the avant-gardists, who were the first to question the social and institutional division which had separated aesthetic experience from the everyday. The failure of the attempt to erase that line perhaps marks, as Peter Bürger suggests, the institutional capacity to absorb the most radical moves within the field, circumventing their possible power to organize experience.[12] More recently, it may signify indifference toward artwork which no longer corresponds to quotidian experience. At minimum, it indicates that the link between work and world has been effectively severed.

For some, most notably Theodor Adorno, this lack of social or communicative effect is central to art's sustained capacity for critique. In the negative theology expounded by Adorno, modern art, as he succinctly puts it, measures "the chasm between praxis and happiness." By its refusal to be reconciled to a life-world overburdened by instrumental reason, art "not only expresses the idea that current praxis denies happiness, but also carries the connotation that happiness is something beyond [capitalist] praxis."[13] Art negates meaning, however, in this very process by showing itself to be the image of alienation which it simultaneously measures. As in Albrecht Wellmer's description of Adorno's complicated and paradoxical formulation: "The modern work of art must, in a single pass, both produce and negate aesthetic meaning; it must articulate meaning as the negation of meaning, balancing, so to speak, on the razor's edge between affirmative semblance and an anti-art that is bereft of semblance."[14]

The utopian, or perhaps Sisyphean, dimension of this problem was brought out explicitly by Bronwyn Drainie of the *Globe and Mail*, some weeks after the representatives of the NGC appeared before the Commons committee to explain the purchase of *Voice of Fire*.[15] In addressing the question "Why do we, as a society, hate this red-and-blue-striped painting so much?" Drainie rejects all of the main arguments against the painting that had been put forward

during the controversy: that it cost too much money; that the money should have been spent on Canadian art; or that the NGC had fumbled the public relations exercise. What she says, pointedly, is that "Canadians don't like the *Voice of Fire* because it doesn't like them." She goes on to claim that this painting in particular and, by extension, all modernist works of art, are "drained of anything that might relate them to other human beings."

It appears that Drainie and, one assumes, other Canadians as well, experienced firsthand this painting's depiction of "meaning as the negation of meaning" as Wellmer eloquently puts it. Thus it would seem that Adorno's formula stands proved, at least in part. The hatred engendered by the painting is not, however, directed at the social conditions under which it was made, as Adorno might have hoped, but, rather ironically, it is directed at the painting itself. This, of course, is Drainie's point. It is not the conditions under which the painting is made and which at the same time the painting protests, Adorno's *casus belli*, which are ever in question; instead, it is the effrontery of the work to refuse to communicate its meaning, and therefore what is troubling is its apparent disdain for the public. This is quickly extended to include the officials responsible for its purchase, as well as those guilty of participating in the movement which gave rise to the painting in the first place. In that sense, the painting merely stands in as an example of the configuration of social relations existing between the general public and an art world which stands accused of self-referentiality — as does the painting itself.

It is clear, then, that Drainie has had *some* sort of experience in front of the work, albeit a negative one, and of a type of negativity that corresponds to Adorno's insight into the alienating effects of the modernist work of art.[16] This is so despite the fact that she perhaps misdirects her critique toward the aesthetics, rather than recognizing the necessity of such an aesthetics under prevailing conditions, if art is to represent a genuine alternative to a life-world colonized by instrumentality (if we follow Adorno's

reasoning).[17] However, what Drainie does recognize, and more important, respect, is a genuine experience of the painting in herself and in others, and she insists on the authenticity of such an experience. This is a crucial point, since it marks the first moment of a possibility of communicative interaction between the parties, notably absent in the preceding debate.

The disregard for non-expert aesthetic judgments can be seen in the reaction to Felix Holtmann's public outbursts. He caused considerable outrage when he made his infamous statement that he could reproduce Newman's painting with "two cans of paint and two rollers and about ten minutes." This remark, as others have noted, prompted some to do just that.[18] Much of the furore raised by this comment clearly derived from Holtmann's previous career as a hog farmer, and thus his presumed ignorance of the field of art. John Bentley Mays, for instance, in a column which attempted to defend the gallery's purchase, was one of many who bristled at this pronouncement, on the basis of Holtmann's lack of expertise.[19]

This attitude refuses to acknowledge the genuine character of Holtmann's response to the painting. Derisive as it may be, it differs little in substance from Drainie's experience. The frequency with which Holtmann's comment was reiterated and the subsequent reaction to it suggest the degree to which it expresses, on the one hand, the latent hostility toward modern works of art and, on the other, the way in which non-expert aesthetic judgments are held in disdain. Bentley Mays, by insisting implicitly that judgment concerning the value of works of art be the sole preserve of expert culture, devalues the aesthetic experience of the majority of Canadians at the same time as he forecloses on the possibility of discourse. In effect, he delegitimizes the kind of response of which Holtmann is representative. Bentley Mays attempts instead to convince us that the NGC has merely mishandled the issue at the level of public relations: "instead of hitting back hard with solid arguments, the gallery is drawing up of [sic] the robes of high principle

about its chin, and affecting bewilderment. The official line being trotted out is, by and large, lame and very *ad hoc*."[20] Although he is right, he nevertheless assumes that the mere invocation of "solid arguments" (if they indeed exist) would suffice to end the controversy. It is not at all clear, however, whether the criteria upon which such solid arguments would be based are universally shared; for example, Brydon Smith, the assistant director of the NGC, published a pamphlet that was intended to explain *Voice of Fire* to gallery-goers, and which was met instead with reactions ranging from scepticism to outright derision.[21] It is clear that by ignoring or devaluing any genuine aesthetic experience outside the domain of expert culture, both Bentley Mays and Smith further exacerbated the antagonism directed toward the work and the social subsystem for which the painting stands in. As Rochelle Gurstein asserts, "This emphasis on professionals not only points to the devaluation of the ordinary person's good judgment, common sense and knowledge of human nature, it also suggests that art today is so esoteric that such capacities have little to do with an active engagement with or appreciation of art."[22] Here, the suggestion that any member of the public possesses the competency to make claims about art is derided.

Surprisingly, a little over a year later, in the midst of the subsequent controversy over Sterbak's *Vanitas*, Bentley Mays reverses himself on this issue. Instead of inviting the NGC to "tune out static" over Newman's painting, as his 1990 title suggests, he insists this time that "beefs about the 'flesh dress' must not fall on deaf ears."[23] Bentley Mays displays a reluctance to acknowledge the critical function of *Vanitas* as similar to that of its predecessors in the genre; he claims that the vanitas motif "cannot be used as a soapbox for advocating socialist revolution." In addition to noting that it is not clear how Bentley Mays has arrogated to himself the right to say what works of art can and cannot do, we should observe that he mistakenly attributes to the sculpture what is in fact a beef he has with a line from Sterbak's artist statement regarding the distribution of wealth.[24]

Then, after defending the use of a variety of materials in artwork, he goes on to say that "the fact remains that these steaks could feed hungry people, while paint is good for nothing other than painting," contradicting his own argument and ignoring the thrust of Sterbak's comment while mistakenly ascribing it to the work itself. He advises that the NGC, in opposition to his earlier counsel, "must not attempt in any way to trivialize or ignore the protests ... the art world should pay close attention to what's being said about it on the streets," thus neatly reversing his previous position with regard to the opposition to the purchase of *Voice of Fire*.

This may be a particular effect of works such as *Vanitas*, which are not immune to social criticism and create problems for aestheticians and critics accustomed to taking their own experience "as a transhistorical norm for every aesthetic perception."[25] The fact that Bentley Mays reverses himself on the question of the public's right to judge works of art is significant, and potentially symptomatic of the different ways that these two works engage the viewer, and the kinds of aesthetic experiences that arise from those engagements. *Voice of Fire*, since it renounces its communicative potential (and here I am assuming that it is representative of Adorno's formulation), leads at the most to consternation, a product of its opacity, and perhaps to outright dismissal as meaningless. Here, the opportunity to wheel in the metaphysical apparatus attached to the neo-Platonic work of art allows the aesthetician to speak with authority, and to offer meaning as a gift.[26] *Vanitas*, on the other hand, provokes *disagreement*, not over its status as a work of art so much, as over the social implications of what it represents. The question was never really raised as to whether *Vanitas* was a work of art, or at least not as directly and forcefully as in the case of *Voice of Fire*; rather, it was a question of whether or not meat was an appropriate material for a work of art. *Prima facie* this appears to be the same thing, but in fact it is different, since it never questions the status of *Vanitas* as a sculpture.

Defending *Vanitas* cannot proceed, therefore, as a defence of art *qua* art, since it is not a matter of establishing its pedigree as a genuine work of art. Instead, it becomes a matter of agreeing or disagreeing with its implications (although, of course, we may also disagree as to what those are), which are socially, and not necessarily aesthetically, controversial. A formal discussion of the qualities of a work will no longer suffice. The effect of this leads potentially to the kinds of contradictions evident in Bentley Mays's statements. At this point, Bentley Mays appears to be in full accord with Jack Anawak of the House of Commons Committee, who states, "It does not matter if 100,000 people say that it is art, it is still a piece of meat."[27]

As Bourdieu suggests, the difference between them is that the question of the work's value, to which both *Vanitas* and *Voice of Fire* are exposed, is for Bentley Mays a *special* experience, whereas for Anawak, it is quite straightforward:

> *if the extraordinary question of the source of the artwork's value, normally taken for granted, were to arise at all, a special experience would be required, one which would be quite exceptional for a cultured person, even though it would be, on the contrary, quite ordinary for all those who have not had the opportunity to acquire the dispositions which are objectively required by the work of art.*[28]

Bourdieu's insight as to the exceptional nature of such an instance is substantiated by Bentley Mays's remark that "while I would not usually recommend such a course, this is one time," the one-time-only clause marking the special case status against the normally taken for granted backdrop of self-evident value.[29]

Bentley Mays evidently struck a chord, since his comments are referred to in the Commons committee hearings. In an exchange with Dr. Shirley Thomson, director of the NGC, Rey Pagtakhan asks for Thomson's reaction to Bentley Mays's suggestion:

PAGTAKHAN: ... having read this constructive criticism from a professional visual arts critic, what from your point of view as the leader of the National Gallery do you hope to do?

THOMSON: We respect very much the critical insight of John Bentley Mays.... But we would be very reluctant to obey the instruction of a critic or any outside body in terms of what the National Gallery shows ... any call to remove Vanitas, for instance, is a call for us to censor the artist's work. Censorship is not part of our democratic tradition and in fact offends against our constitutionally guaranteed rights. I am sure we all believe in the freedom of expression and in the parallel concomitant duty of every citizen to make a judgment and form an opinion and express it.[30]

The question of censorship, especially if related to the question of the value of the work of art, cuts to the core of the relationship between autonomy and accountability. In this case, the invocation of democracy collides with Thomson's claim of the full autonomy of the gallery's decision-making policies — a right which is only secured by a fragile consensus and is not immutable. This is masked to a degree by having the right to freedom of expression stand in for the institutional power of nominating who should and who should not be shown, a wholly undemocratic process.

Thomson subtly contradicts herself with regard to the "duty" incumbent upon everyone to judge. Since there appears to be no instance in which such judgment would have any effect on the actions of the NGC, for which she claims full autonomy, there is no circumstance in which that judgment would be in any way meaningful. To put it bluntly, she gives with one hand and takes away with the other: she states that everyone has a duty to judge, but that such judgments, either those of professional critics, politicians, or the public, are irrelevant to the judgments made in the name of the NGC. Any question of public accountability is transformed into a case of individual rights, in which the institutional status of the gallery is elided.

Second, Dr. Thomson is wrong when she suggests that

there is no censorship: freedom of expression is in fact limited with regard to obscenity and what is called "hate literature," both of which place constitutional limits on freedom of expression in this country. These are the outside limits which circumscribe expression; there are thus moments when individual rights (and by extension, corporate/institutional rights) are weighed against the collectivity. As Gurstein has pointed out, "many cultural arbiters, like many political theorists, are strait-jacketed by a mode of discourse that narrowly conceives of disputes over what should appear in public in terms of individual rights — in this case the artist's right of expression — rather than in terms that address the public's interest in the quality and character of our common world."[31] Although the question of which "public" both she and Dr. Thomson refer to remains problematic, Gurstein nevertheless gets to the core of the current crises faced by the institution of art in the United States and Canada. If making art *qua* art is no longer sufficient as social critique, then contents engaging in social criticism are potentially subject in turn to social criticism. However, the tendency is, when faced with such criticism, to retreat to a defence of individual works in purely aesthetic terms, a move which reasserts the autonomy of aesthetic production and reception, and denies the social effects of the work.

Later, Pagtakhan returns to the question of freedom of expression, which leads to one of the most interesting exchanges in both hearings:

> *PAGTAKHAN: ... I am reminded, Mr. Chairman, using your term "experimentation by the artist" to someone with a background in medical research. We do research and experimentation, and we are guided by medical ethics. What is the code of ethics for artists?*
>
> *THOMSON: I believe that the responsible artist, such as the responsible institution, is to pursue the idea of excellence within that artist's or institution's capacity, and that is exactly the way we judge the art.*
>
> *PAGTAKHAN: Are there written guidelines?*

THOMSON: It is very difficult to write guidelines.... We have a group of highly skilled professionals who spend their time, just as a medical researcher spends time, in examining and in study and in writing critical reports. So all these forces come together to make the judgment.

PAGTAKHAN: When does freedom of expression end and license begin?

A question to which Dr. Thomson apparently had no reply.[32]

If the discourse of art is "strait-jacketed" to the degree Gurstein suggests within a conception of individual rights, when confronted with the idea of the public good or by someone claiming to speak in the name of the public, a breakdown will inevitably occur. It is at this juncture that a defence of the work of art rooted in the primacy of expression collapses, since the possibility of disagreement cannot be imagined. This renders the potential for communication problematic. At the same time, it devalues the ability of others to make valid claims about the work; and, as Gurstein notes, the emphasis on professionals assumes that common sense no longer has anything to do with an appreciation of art. Once the taken for granted background of shared assumptions is questioned, however, a communicative crisis emerges around the appropriateness of certain representational practices. When the function of the work of art is called into question, a rhetorical strategy is called for in order to make sense of those practices for those who do not share those background assumptions about their appropriateness.

The problem of criteria in relation to excellence is reminiscent of Immanuel Kant, and the difficulties of judging without criteria, as is the case with aesthetic judgments, subjective judgments which have no objective validity. There is, nevertheless, a space for communication, at least as I read Kant's formulation of the *sensus communis* as the capacity to communicate aesthetic experiences expressed in the form of judgments.[33]

The difficulty, of course, is how to go about winning consent for those judgments. In this case, it means in effect

mediating between, or developing communicative bridging structures between, two different worlds — the aesthetic realm and a public sphere represented (in this case) by the committee. Here, the Kantian notion of a *sensus communis* as the shared capacity both to have and to communicate aesthetic experiences comes up against a classical version of the *sensus communis* as a shared sensibility about the common good (not the beautiful), and this is why the ethical emerges as a contested site, "in terms that address the public's interest in the quality and character of our common world," as Gurstein writes, not in relation to individual expression. The problem, as Gurstein implies, is that when autonomy is traded in for social effect, art must be defended in ethical and political — not aesthetic — terms, as a consequence of becoming one social representation competing against other social representations. It is at this juncture that a potential audience emerges, one that can be constituted rhetorically. As Maurice Charland suggests,

> To the degree that social existence produces malaise, or that a gap is felt between attributed social knowledge and personal experience, or indeed that particular conjunctures render social knowledge itself evidently contradictory or problematic, a potential audience for rhetoric emerges. That audience, more than an assemblage of individuals, is rhetorically constituted as a collective ethical subject through an articulation of experience.[34]

It could be argued that this audience was effectively brought into being through the rhetorical strategies of someone like Holtmann, who entered the gap between knowledge and experience to articulate a shared sensibility.

We could also say that the artistic community (itself bound together discursively through the articulation of shared dispositions, as Bourdieu suggests) failed to recognize what Charland calls "political realism based in an understanding of the relationship between communicative acts and power."[35] In doing so, an opportunity to reinflect

a discourse spoken "in the name of the people" was lost. Instead, there was a consistent refusal to move beyond the reiteration of hoary shibboleths and to address actual circumstances, and therefore a failure to understand that theoretical niceties had to be traded in for a practical rhetorical strategy. Despite claims that these controversies constituted "healthy debate," a careful reading of the responses indicates the degree to which the ideology, if I may call it that, of the autonomy status of art was persistently reaffirmed through a discursive strategy designed to reinforce that status and which refused to yield to the exigencies of the rhetorical situation. As Charland notes, however, under conditions such as those pertaining to the two cases before us, "prescriptives and political programs derived from philosophy and abstract theorizations ... are doomed to ineffectiveness."[36]

This attention to the rhetorical situation underlines the situatedness of art in a fashion similar to that of Bourdieu's; it orients us toward the historical and contingent conditions of both judgments about art and the nature of reception of artworks. I think we can agree that this relationship is changing in regard to the production of works of art and, as the controversies upon which I have touched suggest, in their reception as well. Clearly, the aesthetic cannot be converted directly into the practical and made the organizing principle of praxis, as the failure of the avant-garde demonstrates. We can, however, as Wellmer states, "think of the *relationships* in which art and living praxis stand to each other as changeable."[37] This is not a question of art losing its specificity as art, as would be the case with the de-differentiation espoused by the avant-garde, but is rather a matter of rethinking the social status and function of art via the rediscovery of what Wellmer calls "the 'point of entry' for forces which, in their non-aesthetic usage, might restore a continuity between art and living praxis."[38]

This clearly cannot be accomplished through a retrenchment within an aesthetic subdivision of the social falsely construed as the realm of freedom. For once the question of

truth, in its "non-aesthetic usage," becomes intertwined with the question of aesthetic validity, the communicative dimension becomes paramount. At this point, as Wellmer insightfully recognizes,

> *Both the truth-potential and the truth-claim of art can thus only be explained with recourse to the complex relationship of interdependency between the various dimensions of truth in the living experience of individuals, or in the formation and transformation of attitudes, modes of perception, and interpretations.*[39]

It is at this precise point that discourse can begin, with the recognition that claims concerning not only aesthetic validity, but also sincerity and ethical rightness, are claims that are raised by those both within and without the institution of art in a non-aesthetic manner. If art is to have a social function in relation to the potential transformation of experience, then its institutional representatives must be prepared for social criticism. Once art is no longer practised *qua* art, it exposes itself to social criticism, both in terms of questions about its function and about its contents.

Sterbak is thus wrong to suggest, as she does in her artist's statement, "that the politicians redirect their efforts away from aesthetic discourse." If she wishes to have her work function as social critique, as I think it does, then the work in turn is subject to social criticism; that she may disagree with social policy is not grounds upon which to deny the validity of such criticism. Any claims made for the work on social grounds cannot be merely dismissed as irrelevant to an expert culture that lives the illusion of full autonomy. This ethical dimension of discourse emerges, as I noted earlier, with the acceptance of the sincerity of the claims made by, or in the name of, the public, even those of Holtmann, and must be addressed as sincere. This means accommodating individuals' living experiences and attitudes — which may be entirely hostile to the existence of art. Any rapprochement between aesthetics and the life-world cannot proceed without this fundamental recognition, or, I would

add, without recognizing the emancipatory potential hidden within a historical relationship that is not permanently fixed, but open to transformation.

It might indeed be the case that aesthetic experience has become radically other, to the degree that it is no longer even recognized and is now the foreign territory to which art was to be exiled in Plato's version of the state. Ironically, however, Plato's text is evidence of the centrality that aesthetic experience may potentially have in both disclosing reality and transforming it, as well as indicating that the relationship between art and the social is not immutable. Much as Plato imagined a world without art, so too can we imagine, in the light of his text, the opposite, where the realization of his imagination that has come to pass can be transformed by our own. Healing the torn halves of truth embodied in aesthetic experience and speech, the image and the sign, has to start here, in order that the arduous process of reconciliation might begin.

Notes

The author would like to thank Will Straw, Jody Berland, and especially Barri Cohen for their comments on portions of this paper.

1. Mark A. Cheetham, *The Rhetoric of Purity: Essentialist Theory and the Advent of Abstract Painting* (New York: Cambridge University, 1991), 38.

2. Plato *Republic* X, 607a.

3. Ibid., 607d.

4. The $1.8 million spent on the painting represented over one-half of the NGC's annual acquisition budget of $3 million (although this was only $1.5 million at the time the purchase was first approved). However, the gallery had substantially more funds available since it purchases on a three-year cycle.

5. "Cabinet to review purchase of painting," *The Globe and Mail* (Toronto), 16 March 1990, A7.

6. "Dress made from raw beef leaves opponents stewing," *Toronto Star*, 1 April 1991, A9.

7. The committee voted on 26 April 1990 to defeat the motion that "The Committee, as the decision makers of the National Gallery of Canada, consider the advisability of selling the painting *Voice of Fire* and commit the proceeds towards Canadian art, not necessarily pictures." *House of Commons, Minutes of Proceedings and Evidence of the Standing Committee on Communications and Culture*, 34th Parliament, 2nd Sess., Issue 10, 26 April 1990, 45–53. This followed a motion passed on 10 April which reaffirmed the "arm's length principle" in regard to the committee's oversight of NGC expenditures; see House of Commons, *Minutes*, Issue 8, 10 April 1990, 62.

8. Pierre Bourdieu, "The Historical Genesis of a Pure Aesthetic," *The Journal of Aesthetics and Art Criticism*, 46 (1987): 202.

9. "The aesthetic attitude, which establishes as works of art objects socially designated for its use and application (simultaneously extending its activity to aesthetic competence, with its categories, concepts, and taxonomies), is a product of the entire history of the field, a product which must be reproduced, by each potential consumer of the work of art, through a specific apprenticeship." Bourdieu, "Pure Aesthetic," 207.

10. As Rochelle Gurstein points out, "Repeatedly, conservative leaders such as Orrin Hatch and Jesse Helms claimed that the bill they sponsored ... had nothing to do with censorship; rather it was an issue of government sponsorship.... What was at stake, then, was not the public's interest in or engagement with contemporary art—which, as everyone knows, is minimal—but rather how its hard-earned tax dollars were going to be spent." Rochelle Gurstein, "Misjudging Mapplethorpe: The Art Scene and the Obscene," *Tikkun* 6 (November/December 1991): 70.

11. See Thomas Farrell, "Rhetorical Resemblance: Paradoxes of a Practical Art," *Quarterly Journal of Speech* 72, 1 (1986).

12. Peter Bürger, *Theory of the Avant-Garde*, trans. Michael Shaw (Minneapolis: University of Minnesota, 1984), 24–27.

13. Theodor W. Adorno, *Aesthetic Theory*, ed. Gretel Adorno and Rolf Tiedmann; trans. C. Lenhardt (London: Routledge and Kegan Paul, 1984), 17–18.

14. Albrecht Wellmer, *The Persistence of Modernity: Essays on*

Aesthetics, Ethics, and Postmodernism, trans. David Midgley (Cambridge: Polity Press, 1991), 10.

15. Bronwyn Drainie, "Voice of Fire's elitist message sure to make Canadians burn," *The Globe and Mail* (Toronto), 21 April 1990, C11.

16. Yet, rather bizarrely, Drainie concedes that these works "exude great energy and exuberance," but, for some unstated reason, only collectively; individually, they merely "glare back at you austerely."

17. Adorno's exclusive emphasis on this negative function comes, however, at the cost of explaining those works which are affirmative in character. As Jauss suggests, "The history of art cannot be reduced to the common denominator of negativity.... This is so in part because negativity and positivity are not defined quantities in the social dialectic of art and society, and can even turn into their opposite since they are subject to a curious change of horizon in the historical process of reception. There is the further fact that the path of progressive negativity is inappropriately one-sided in its emphasis on what is social in art, for it leaves out communicative functions." Hans Robert Jauss, *Aesthetic Experience and Literary Hermeneutics*, trans. Michael Shaw (Minneapolis: University of Minnesota, 1982), 16.

18. I refer you to Thierry de Duve's excellent article on this subject, "Vox Ignis Vox Populi," *Parachute* 60 (October/November/December, 1990): 30–34; English translation, 35–38.

19. John Bentley Mays, "National Gallery should tune out static over painting," *The Globe and Mail* (Toronto), 14 March 1990, C9.

20. Ibid.

21. "The flyer may evoke as much discussion as the painting itself..." Stephen Godfrey, "Can this voice put out the fire?" *The Globe and Mail* (Toronto), 30 March 1990, C6; "Gallery officials decided to distribute a flyer to try and inform viewers about the picture. Unfortunately, a draft version suggests that even this will be alarmingly bogged down in the language so favoured by contemporary art experts." Sarah Jennings, "Canada's National Gallery under 'Fire'," *The Wall Street Journal*, 19 April 1990, A12; "Brydon Smith...put out a flyer three weeks ago in which he tried to explain the painting in the sort of flat-footed documentary

terms he obviously thought Canadians would respond to." Bronwyn Drainie, "Voice of Fire's elitist message."

22. Rochelle Gurstein, "Misjudging Mapplethorpe," 71.

23. John Bentley Mays, "Beefs about 'flesh dress' must not fall on deaf ears," *The Globe and Mail* (Toronto), 6 April 1991, C13.

24. "The first concern seems to be that there is an actual shortage of food in Canada. This, of course, is not true. What is lacking is not food, but, a political and social desire to distribute the necessary economic means for everybody to purchase it. Since waste implies a real shortage, making art with meat is no more wasteful than painting: arguably the money expended for paint and canvas could have been better used to feed the hungry." Jana Sterbak, *Artist's Statement* (Ottawa: National Gallery of Canada, April 1991).

25. Bourdieu, "Pure Aesthetic," 202.

26. It is quite clear that Bentley Mays (as would be the case with many aestheticians) prefers the hygiene of the life of the mind over the disturbing presence of the body, as the contrasting reactions to these two works indicates.

27. House of Commons, *Minutes of Proceedings and Evidence of the Standing Committee on Communications and Culture*, 34th Parliament, 2nd Sess., Issue 21, 11 April 1991, 31.

28. Bourdieu, "Pure Aesthetic," 202–203.

29. John Bentley Mays, "Beefs about 'flesh dress'," C-3.

30. House of Commons, *Minutes*, 11 April 1991, 34.

31. Rochelle Gurstein, "Misjudging Mapplethorpe," 71.

32. Ibid., 40–41.

33. "Cognitions and judgments must, along with the conviction that accompanies them, admit of universal communicability; for otherwise there would be no harmony between them and the object, and they would be collectively a mere subjective play of the representative powers.... But if cognitions are to admit of communicability, so must also the state of mind ... admit of universal communicability." Immanuel Kant, *Critique of Judgment*, trans. J.H. Bernard (New York: Hafner Press, 1951), §20–21, 75.

34. Maurice Charland, "Rehabilitating Rhetoric: Confronting Blindspots in Discourse and Social Theory," *Communications*, 11, 4 (1990): 256.

35. Ibid., 260.

36. Ibid.

37. Wellmer, "Truth, Semblance, Reconciliation," 30 (emphasis original).

38. Ibid., 29.

39. Ibid., 27.

WHAT COUNTS AS CULTURE

Jamelie Hassan

THIS ARTICLE IS DEDICATED to Greg Curnoe[1] and like many of whom I will speak, he was a fighter. Not surprisingly, Greg Curnoe was an admirer of world champion boxer Muhammad Ali, who figured prominently in his murals of 1968, commissioned for the Dorval airport. After they had been in the public transit area of the airport for only one week, Transport Canada removed the panels because of the potential offence that Curnoe's anti-American content might pose to Americans visiting Canada. That offence came from a reference to Muhammad Ali and his refusal to fight in the Vietnam war, a refusal which resulted in the stripping of his title and his imprisonment. It was Muhammad Ali who, having left the ring, coined the phrase "writin' is fightin'." Greg's early political alignments with figures like Muhammad Ali, country singer Stompin' Tom Connors, and Milton Acorn, "the people's poet," are radical indicators of the non-hierarchical and independent thinking that characterized his work, creating an art which drew its energy more from the street than from the institution.

Within the contentious realm of issues surrounding cultural identity and sovereignty, Greg was one of Canada's most articulate and committed nationalists. Well known within the Canadian art community for many reasons, his pointed anti-Americanism and rooted regionalism looked ahead to what would emerge as the most compelling issues

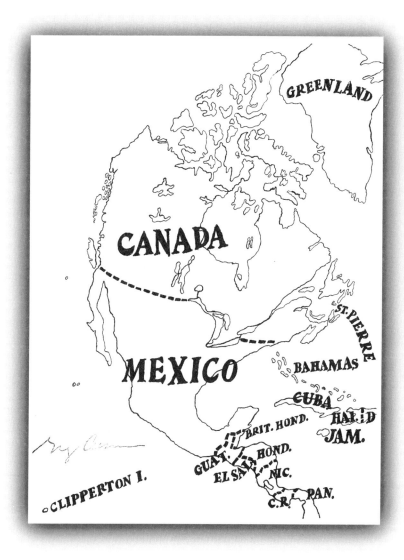

Greg Curnoe, *Map of North America*, 1972.
Ink on paper. Photo: Dalhousie Art Gallery.

confronting our country in the 1990s. In his catalogue essay for an exhibition at the Casa de Las Americas in Havana, Cuba,[2] Christopher Dewdney wrote of Greg's "uncompromising Canadian cultural vision." "His work," Dewdney continues:

> has always contained a strong anti-American stance, many of his paintings are laced with ironic barbs which poke fun at the satellite relationship which Canada has had with the United States in both the political and cultural arenas. His political commentary has always been overt, literal and outspoken, often printed on the margins of his paintings which themselves have depicted political figures. A lifelong advocate of Canadian independence he has maintained his position even in the face of direct government censorship of one of his public murals because of his anti-American bias. He has had a great influence on the "second generation" of London artists and on Canadian art in general.[3]

Greg was very aware of the different things that could count as culture. In Havana, on his first trip outside of Canada or Europe, Greg saw a culture and a politics that, despite the obvious differences from his own, seemed to him to embody qualities that he had fruitfully explored throughout his life. The poster for our group exhibition in Havana was the map of North America that Greg first created in 1972, and which he has repeated in various incarnations over two decades since he first managed to erase the overpowering land mass of our southern neighbour. This map found its way into the various works and forms that Greg continued to make, offering a geography which expressed Greg's humour, his politics, and his intellect. Through a simple realignment of the 49th parallel with the border of Mexico, he corrected our problematic geographical relationship to the United States by declaring our closer affinity to those nations south of the U.S./Mexican border.

Keeping alive Greg's preoccupation with geography and history, I note that I am asking the question which forms

my title amid the violence of this year, 1992. It is five hundred years since Columbus arrived at the shores of what José Martí has called "Our America" from a Spain that was simultaneously engaged in a war — expelling the Arabs from Al-Andulusa, reconquering Spain after almost seven centuries of Muslim rule, and immersing itself in a Europe that was itself shaped by centuries of religious excess through its inquisitions and Crusades to the East. The five hundred years since these events have brought little understanding or justice to the inhabitants of this post-colonial world.

Roberto Fernandez Retamar, writer and director of the Casa de Las Americas, began his powerful essay "Caliban: Notes Toward a Discussion of Culture in Our America" with a question posed to him by a European journalist in 1972 — the same year, coincidentally, in which Curnoe first drew his map. "Does a Latin American culture exist?" the journalist asked. Retamar says the question really being asked is: "Do you exist?" He goes on: "For to question our culture is thus to question our very existence, our human reality itself, and thus to be willing to take a stand in favour of our irremediable colonial condition, since it suggests that we would be but a distorted echo of what occurs elsewhere."[4]

These are familiar ideas, and similar to those on which Greg has written or used in his works so as to resist the colonializing spheres of influence found elsewhere. At a conference on the Americas entitled "Americanist Visions of Cultural Studies," held at Columbia University in March of 1992, Canada figured as prominently as Cuba in terms of the frequency of references within papers and questions from the floor. Greg's map was received with knowing laughter by cultural activists from across the United States, Canada, and Latin America.

The "Americanist Visions" conference attempted to create a forum for exploring the notion that "for those involved in studies based on the cultures of nationally and internationally disenfranchised communities persistently defined through race, much of the work has involved reconstructing a tradition, or documenting a people's culture."[5]

It is well known that Cuba has been a major political irritant to the United States—as the decades-long economic blockade instituted by the United States since Castro moved Cuba in a socialist direction demonstrates—but that Canada may share equal time with Cuba seems surprising, if not unlikely. While Cornel West, in a recent comprehensive anthology entitled *Out There: Marginalization and Contemporary Cultures*, questions the "monolithic and homogeneous," he fails to include a single Canadian contributor, despite the fact that our proximity, and the terms of analysis which mark much of the work in the volume, are especially relevant to the present Canadian condition.[6]

One set of efforts to engage in a genuine exchange of cultures and sharing of experiences was examined in a recent article by cultural critic Dot Tuer entitled "Decolonizing the Imagination."[7] Here, artist exchanges are looked at as one form of connection between Canada and Cuba. Tuer traces a number of significant histories, demonstrating that "Cuba was a reference point for the construction of a post-colonial culture," and points to a number of Cuban institutions, such as the Casa de Las Americas, which she sees as having provided "a context for artistic expression that was integral to popular struggles for national liberation and cultural self-determination."

While Dot Tuer accounts for this collective project in terms of Cuba's place within the Canadian imagination, the history of the project within Canada is revealing. This activity was initiated in London, Ontario, a regional rather than metropolitan site, by artists rather than institutions. It received little attention in Canada while it was taking place, and Tuer's article, one of the few to deal with the project, was published more than two years after the series of exchanges was completed. It is important to note, as well, that none of the Cuban artists, these "children of Utopia,"[8] who participated in the Canadian programming resides any longer in Cuba, which currently faces the most difficult stage of its post-revolutionary history.

The relevance to Canada of theories of post-colonial

society is problematic, as we — Canadian cultural workers — confront the unfortunate consequences of the fact that Canada is a colony, no longer of Britain (though most of our insecurities stem from that history), nor of France (which continues to determine that which is supposedly 'distinct'), but of the United States.

In a recent article entitled "Bordwell Considered: Cognitivism, Colonialism and Canadian Cinematic Culture," José Arroyo bleakly delineated the extensiveness of our colonization:

> *Our industry is branch plant and our abundant natural resources are exported for processing. The two pillars of our economy, two strengths, are simultaneously twin liabilities that make us economically dependent. Militarily our armed forces have been under the direction of the American Permanent Joint Board of Defense since the Ogdensberg Agreement in 1940. Politically, Pierre Trudeau estimated that the country has the freedom to make only 10 percent of the national decisions.*[9]

The case of cinema in Canada is one of almost complete colonization. As Manjunath Pendakur indicates in his aptly titled *Canadian Dreams and American Control*, 97 per cent of the screen time in our movie theatres is filled by imported films and 90 per cent of the nearly $1 billion in annual revenues from film and video is controlled by U.S. majors.[10] In my local video stores, it is not unusual to find Canadian cinema under the category of "foreign films." In his essay, José Arroyo goes on to cite Geoff Pevere, who noted that, in teaching an introductory course on cinema, "it was the Canadian section of the course that proved a major stumper to students. Canadian films were the most 'foreign'."[11]

Interrogating Identity was an exhibition of contemporary art from Canada, the United States, and Britain which, at the time of writing, was touring the United States. As one of the participating Canadian artists, along with Rebecca Belmore, Nadine Chan, and Lani Maestro, I have found it

revealing to follow the media reaction to the exhibit as it completed its two-year itinerary. "White Center Black Art" was one of the headlines when the show was reviewed in Minneapolis in conjunction with its exhibition at the Walker Art Center. Amy Cage flippantly wrote that

Diversity and multiculturalism have become the watch words (some would say the buzzwords) of the 90's. On college campuses, in corporations and now, it seems, in arts organizations, people are rallying to make society more attuned to the variety of ethnic group lifestyles that make up these United States. Walker Art Center is one of those institutions taking the mission of multiculturalism seriously.[12]

While the nationality of the Canadian artists was collapsed within an idea of "these United States" by the local media, the institution itself did not avoid the complicated questions of identity and race. Seitu Jones, community programs coordinator at the Walker Art Center, initiated a community task force to work toward permanently altering the image of the center, an image he described as "being elitist, being imposing, being racist, being sexist, just like any other institution in society."[13] Within the exhibition, it was in the work of Canadian artists that one saw challenges to uses of the term "black" as a totalizing definition of political affinities. This inability to encompass the diverse ways in which race signifies within Canada, in reference to First Nations Peoples, Asians, or Latin Americans, required of the curators that they rethink their exhibition.

In a paper entitled "Political Agendas, Cultural Production and Race," Monika Gagnon begins by reminding us of some recent Canadian events:

In Vancouver, 1989, In Visible Colours, *a festival symposium of film and video by Third World women and women of colour, brings together works by over 100 women. In six artist–run centres across the country during 1990 and 1991, Paul Wong curates works by 25 Asian-Canadian artists working with film,*

video and photography, under the banner of Yellow Peril: Recon-
sidered. *A controversy surrounds* The Spirit Sings *at the Glen-
bow Museum during the Calgary Olympics, and demonstrations
are brought against* Into the Heart of Africa *at the Royal
Ontario Museum in 1990.*

*All these events point to what might be perceived as a corre-
sponding momentum in cultural politics as it intersects or col-
lides with the art world: sanctioned, mainstream art discourses
are charged with exclusion, if an unconscious one, which is
guided by a form of racism.*[14]

Gagnon's pursuits in the field of cultural studies positions
her among a growing number of provocative voices being
heard in Canada today, voices which continually probe a ter-
rain in which polarities have been cultivated to devastating
effect. Gagnon states that her decision to follow

*the path of feminist cultural production and analyses, the moti-
vations underpinning the disparate but intimately connected
acts I've enumerated above, do not reveal a mere desire for inclu-
sion, but rather, also seek to expose and undo the ways in which
power (and its authoritative capacity for exclusion) is exercised
and reduplicated through various institutional structures.*[15]

What Monika Gagnon argues is that racism goes beyond
the social construct because of its "manifestations across
real bodies." In her contribution to this volume, Virginia
Dominguez rigorously examines the contemporary privileg-
ing of culture from the avowedly sceptical position of the
anthropologist: "As public discourse on 'culture' — in talk of
cultural politics, multiculturalism, cultural identity, cul-
tural pluralism, cultural policies, and cultural studies —
spreads well beyond anthropology and throughout much of
the world, my interest is piqued and my ambivalence grows."
She argues convincingly that campaigns for multicultural-
ism "focus on the 'multi' in multiculturalism and not on the
'culturalism' of it." Significantly, such campaigns are un-
able to transcend racism. This is the same racism of which

Monika Gagnon and Seitu Jones, writing and working within their respective *cultural* communities, are equally aware and critical.

Dominguez's argument against 'culture' rests on the term's polymorphous capacity to mean many things to many people at different times in different locations. That her argument is itself positioned so clearly within a Euro-centric interpretation of culture, rooted in the science of anthropology, is one reason why it seems to fall apart when she discusses "Fourth World Cultural Activism." Her suggestion that culture be separated out from the fight for "dignity, equality, voice, and resources" is a surprising one, an option that I doubt any First Nations leader, past or present, could consider viable. While Dominguez is eloquent in discussing multicultural theories and Third World cultural policies, she is not able to convincingly adapt these arguments about the 'it' of culture, what 'it' is, and why we should all have 'it,' when speaking of the activism of First Nations politics.

Some First Nations artists may find themselves in the trap that Evelyn Legaré, as cited by Dominguez, describes: "in order to legitimate their claims to Indianness, both in their own eyes and those of other people with whom they share national boundaries . . . , aboriginal peoples must 'maintain and retain' their aboriginal cultures. If they incorporate aspects of Euro-American/Euro-Canadian culture, they lose their Indianness."[16] Showing how arguments about authenticity, when taken to their extreme, may be used against indigenous peoples, Dominguez quotes "the case of a government lawyer who formally argued that the Gitksan had no legal basis for their land claims because they watched television and ate pizza."

In *Wadrihwa*, the quarterly newsletter of the Woodland Cultural Centre in Brantford, Ontario, the title of an article by the centre's director, Tom Hill, asks another vital question: "In time of constitutional uncertainty, do we need common cultural symbols?" "There is no correct definition of culture," his answer begins, as if responding to the

questions raised by Virginia Dominguez and, not so coinci-
dentally, to that which begins this paper. The unnamed
European journalist addressed by Retamar might also listen
as Hill continues:

> For me culture is all-encompassing, transforming constantly in
> a rapidly changing Canada. It is a manifestation in our com-
> munity of our inherited values, beliefs and knowledges. It is an
> Eskanye song from the traditional longhouse, and a pop-rock
> CD from Kashtin. It is a Hadoui mask from a faith keeper in our
> medicine societies and a contemporary performance work by
> Rebecca Belmore at the Power Plant. It is the poetry and rhythm
> of our traditional chanted "Ganyonhyk" and the metaphoric
> alliteration in a play by Tomson Highway. It is the total range of
> these activities and then some.[17]

Tom Hill then goes beyond this cultural inventory to attempt
to answer the question of what it is we have in common.
With the clarity of his Elders, he writes:

> I cannot help but feel that the solutions are here and perhaps,
> that our common ground is the physical landscape.... We must
> see ourselves as part of that landscape: we must return the Nat-
> ural World to our intellectual, mythological and spiritual
> domains: we must remove the predominately Judeo-Christian
> barricades which place the natural world into the camp that is
> to be controlled, exploited, and conquered.[18]

It seems appropriate at this juncture to take note of
the poster for the conference. *Tree-Planter*, by Lorraine
Gilbert, is enriched by Hill's invocation. The forests of
the Canadian landscape have been brutalized. It is the
tree-planter's labour which attempts to rescue the forest
from the results of the systematic clear-cutting of logged
forest areas. Away from the landscape, Gilbert's portrait
of the tree-planter does not lend itself to easy identifica-
tion. My mother, seeing the poster on my kitchen bulletin
board, thought she recognized within its image another

Lorraine Gilbert, *Louise with water*, 1987.
Black and white photograph.

geographical history. The peculiar, bandanna-wrapped headpiece, the almost refugee-like assortment of clothing, the tools of the migrant worker—all of these encouraged her misreading, to the effect that this was the image of a Middle Eastern *fellahin*, and not the contemporary portrait of a migrant tree-planter of North American origin.

One of the valuable lessons I have learned from feminism and critical theory is that, as Foucault has argued extensively, "the position of the subject can be assigned." Looking deeply into this phrase, Gayatri Chakravorty Spivak has, in her usual way, endowed it with interpretive significance, especially in relation to the "subject position" involved in "producing a feminism married to critical theory." In her essay "The Difference Within," Spivak writes: "Quite often when we say 'subject position' we reduce it to a kind of confessional attitudinizing. We say, 'I'm white, I'm black, I'm a mulatto/a, I'm male, I'm bourgeois.' A subject position is not, in fact, a confessional self-description either in praise or in dis-praise."[19]

In her essay, Spivak extends this analysis of "subject position," examining its various implications. She writes that "[t]he burden of critical theory is to look at the structure of the subject that produces the theory." Speaking of her position within "an institution with a history," she suggests that "whatever our colour, whatever our gender, whatever our national origin, this is an authoritative, Western-European structure within which, whether we *want* to or not, we are *willingly* placing our passion...." Here is a critical theory that asks us to take a position of responsibility beyond that of confessional description, to follow Spivak into the unease, to be "responsible to the trace of the other, the future, the reader...."

Notes

1. As I begin revision of this paper, on 15 November 1992, I am grieving for my very close friend and fellow London artist, Greg Curnoe. Greg was killed yesterday morning by a pick-up truck,

while on his regular Saturday morning bicycle ride with the Centennial Wheelers. If these words are awkwardly written, it is because I am feeling the impact of the loss of this exceptional individual to our community, our city, and the Canadian nation.

2. Four years before the day on which he died, on 14 November 1988, Greg, Sheila Curnoe, Zoe Curnoe, and her companion, Anne Rosner, had travelled to Cuba with Christopher Dewdney, Lisa Downe, and their son Tristan, Ron Benner, Murray Favro, Fern Helfand, and me. A reading and exhibition of contemporary art from London, Ontario, were presented at the Casa de Las Americas in Havana, Cuba.

3. Chris Dewdney, catalogue essay published in Spanish translation from the original English, translation by Marie Arismendi (Havana, Cuba: Casa de Las Americas, Galería Latinoamericana, 1988), 6.

4. Roberto Fernandez Retamar, "Caliban: Notes Toward a Discussion of Culture in Our America," *Caliban and Other Essays*, trans. Edward Baker (Minneapolis: University of Minnesota Press, 1989), 3.

5. From the description of the interdisciplinary conference, "Americanist Visions of Cultural Studies," Columbia University, New York, 6 and 7 March 1992.

6. Cornel West, "The New Cultural Politics of Difference," *Out There: Marginalization and Contemporary Cultures*, ed. Russell Ferguson, Martha Gever, Trinh T. Min-ha, and Cornel West (New York: New Museum of Contemporary Art, 1980), 19–38.

7. Dot Tuer, "Decolonizing the Imagination: Artists' Exchanges Cuba-Canada," *C*, no. 33 (Spring, 1992): 34–41.

8. This expression was the title of an article by Cuban writer Osvaldo Sanchez coined to describe the generation of Cuban artists who were educated during the revolution. It was published in *Third Text*, no. 7 (Summer, 1989). The 1988 project included Consuelo Castaneda, Humberto Castro and Gory, and was initiated by Ron Benner and Jamelie Hassan, as part of the exchange hosted by the Forest City Gallery, 1988. The 1990 project included José Bedia and Magdelena Campos Pons, and was curated by Ron Benner as part of the *Siting Resistance* series hosted by Embassy Cultural House, the Forest City Gallery, and the Cross-Cultural Learner Centre, London, Ontario.

9. José Arroyo, "Bordwell Considered: Cognitivism, Colonialism and Canadian Cinematic Culture," *CinéAction*, no. 28 (Spring, 1992): 77.

10. Ibid.

11. Ibid.

12. Amy Cage, "White Centre, Black Art," *Skyway News*, Minneapolis, 21, no. 173. Week of Nov. 19–25, 1991.

13. Seitu Jones, panel presentation, Walker Art Center, and quoted in Cage, "White Centre, Black Art."

14. Monika Gagnon, unpublished paper. This is from the text of the presentation Monika would have given at the "Art as Theory/Theory and Art" conference, had she been able to attend.

15. Monika Gagnon, personal communication.

16. Evelyn Legaré, "The Indian as Other in a Multicultural Context," cited in Virginia Dominguez, "Theorizing Culturalism: From Cultural Policies to Identity Politics and Back," in this volume.

17. Tom Hill, unpublished talk at the "Art as Theory/Theory and Art" conference.

18. Ibid.

19. Gayatri Spivak, "The Difference Within: Feminism & Critical Theory," *Critical Theory* series 8, ed. Elizabeth Meese and Alice Parker (Amsterdam/Philadelphia: John Benjamins Publishing, 1988), 208–209.

THE WRITING ON THE WALL

Barbara Harlow

> *Museums function, partly by design and partly in spite of themselves, as monuments to the fragility of cultures, to the fall of sustaining institutions and noble houses, the collapse of rituals, the evacuation of myths, the destructive effects of warfare, neglect and corrosive doubt.* (Stephen Greenblatt)

"Film hoardings," R. Srivatsan explains, are billboards, hand-painted billboards, or wall paintings in India advertising films. In the concluding paragraphs of his inquiry into the nature of the industry and its practitioners in India, their popular influence as well as the resistance that they exhibit to encroaching technologization, Srivatsan questions his essay's very interrogation of their significance: "How would one who is not a painter try to develop a strategy to counter the hegemony of the visible?"[1] "This question," the author goes on, "can be translated to read: How should one try to convert an active consumer into a counter-active critic?"[2] It is these two questions, then, in several specific variations, that I hope to address: the possibilities of such a translation, of speaking of art and theory from another disciplinary position than that of those people who deal in the "stuff" of art. For my own part, I am neither an artist nor an art critic in the conventional sense of those referents, but rather a dealer, as it were, in books, or texts — a professor of literature perhaps, in the sense of the

"novel" that was raised in an earlier discussion.[3] While I do not want to theorize, indeed cannot, or even, despite the imperatives of the conference's title, aestheticize any of these dealings, I do think there are some lines to be drawn. The drawing of these lines raises in turn issues of analogy — but not of the sublime, or of virtual reality, or even of a fear of technology, issues that have been raised by the preceding papers in the panel on "Vision and the Canonization of Knowledge."[4] What I propose to present is a set of four examples, exempla perhaps, from the political/textual configuration of "women, writing and political detention"[5] working more by way of anecdote than through argument in order to dislocate the placement of the formalized division drawn for polemical and political purposes between "art" and "theory" as deployed in relation to the academy and its disciplinary structures with their institutional affiliations to the museum. The museum and the academy serve together to house the social order's sanctioned practices of representation — both pictorial and political. I suggest that such a theoretical dislocation can be registered most clearly in terms of a number of practical examples of the "writing on the wall" — examples which, like Srivatsan's "wall paintings" or hoardings, suggest crucial points of translation between active consumerism and counteractive criticism.

Elaborating on the connections between prison, museum, and the academy, the first example is drawn from the prison memoir of Margaretta D'Arcy, an Irish dramatist who made a "tour of duty"[6] to Armagh women's prison in Northern Ireland during the "no wash" protest there. The second is taken from the prison writings of Ruth First, a white South African member of the African National Congress (ANC) and of the South African Communist Party (SACP) who was assassinated in 1982 by a parcel bomb sent from South Africa to her in Mozambique. The third example, one that establishes some of the intersections between prison, academy, and activism, comes again from the "no wash" protest and the hunger strikes in the late 1970s and early 1980s in

the British prisons of Northern Ireland. Finally, in reconsidering the institutional relations specifically of prison and academy, I would like briefly to raise a set of generic questions that are provoked in particular by prison letters and notebooks, but which might be adumbrated to distinguish historically and formally the politics of genre through prison writing, "the writing on the wall."

* * *

The writing of political prisoners, historically and contemporarily, is distinguished by its necessarily relentless recognition of the pressures enforced by the institutional spaces that occasion it — a recognition that, it seems to me, we in the academy are often peculiarly recalcitrant in acknowledging. Perhaps the books or texts that I propose to present can be considered as dissident, destabilizing labels to an exhibition — to cite that other institutional space, that of the museum — commentaries on the very walls, and hangings that frame the textual compositions of prison. These texts analyse not only the intersections of information and installation taken up in the presentation by Rosemary Donegan during the conference but also her comments on the absence of the conventional slide-show in her presentation as attributable to the difficult intercalation of information necessary to public reading of the slides' images. Although my own examples will be taken from the prison, implicit in my remarks will be the structural analogies — in particular the mural, the "walled" — between museum and prison. Eventually I would like to argue that the academy too must be critically integrated into this institutional configuration of coercion.

To the conventional encomium, both self-critical and self-congratulatory, that museums display all that is best about a culture, I would add another imperative: that prisons are designed for a related, if counter, reason — to conceal all that is considered worst in that same culture. The academy might well discover another critical injunction for itself, one

that would combine subversively the projects of museums and prisons: to disclose all that is worst in a society — its "fragility" in Stephen Greenblatt's terms — as best.[7]

By Way of an Introduction

The connection between the prison, the museum, and the academy is decisively established in the opening paragraphs of a short text by the Irish playwright Margaretta D'Arcy. *Tell Them Everything* is written from out of D'Arcy's experiences as a transient inmate in Armagh, the women's prison in Northern Ireland at the time. The text opens with an account of how D'Arcy, a much-respected and respectable, if controversial, representative of the literary establishment in the Republic of Ireland, or the "twenty-six counties," crossed the line and accomplished her conflicted entry into the prison on the other side of the border in the "six counties." In 1978, D'Arcy, as she tells it in a cogently narrated and instructive series of paragraphs, had been invited with her husband and sometime co-author John Arden to participate in an arts festival in Belfast. The festival coincided with the first major H Blocks march in the north of Ireland. The male prisoners in the H Blocks, the name popularly attached to Long Kesh prison, had been "on the blanket," wearing only their prison-issue blankets in protest at the withdrawal of political status that, among other things, had previously allowed them to wear their own clothes. They had also embarked on their "dirty protest" against the inadequate sanitary facilities in the prison. Because the march was banned, D'Arcy and the other festival participants attended a poetry reading held in the Ulster Museum instead.

> The reading began. Paul Muldoon. His first poem was dedicated to a seventeenth-century Spanish painter who had been banned. No ripple. Then he continued with nature poems about the Botanic Gardens. Next — Michael Longley: beefy, bearded and grizzled. He began a poem dedicated to the artist Gerard Dillon, who had lived in the Falls road, and whom I had met several

times when I was young and had admired. He was a courageous gentle person who hated cant. Here, I thought, were two dead artists being used by two living artists to present an impression of radical protest against censorship and the brutality of repression on the Falls Road; did the poets believe that by merely mentioning the names they could avoid all responsibility when the prisoners' families were not allowed to march in the street? It was hypocrisy; it was disgusting. I leant against the wall, took out a red marker and wrote H Block.

Except for the poet's words there was absolute silence at the time. The concentration, the dedication, the reverence to a poet. My marker squeaked; heads turned round; they registered—and they opened their mouths and yelled. I was determined to finish off my "picture" by putting a frame around it. I was dragged out by the museum attendants, taken downstairs, and made to wait for the RUC. The Black Maria arrived, and a young steely-eyed RUC man tipped me in, hoping to break my neck. When I righted myself, he grinned—"How did you like that?" The dream was over, the illusion—here I was staring at the reality of "Northern Ireland."[8]

The spatial and disciplinary displacements and containments of the women's prison are critical to D'Arcy's textual opening into them: arts festival—(banned) street march—poetry reading—literary criticism—museum—work of art—police car. Initiating these moves, the activist defacement of the museum wall both acknowledges and challenges the intent and purpose built into that same wall. Graffiti-making of a sort, "hoarding" even, D'Arcy's work of art also makes a political gesture, one that is implicitly banned by the protocols of law and order that govern museums no less than the streets. The etiquette of decorous reverence, silence, respect for the past, becomes explicit with her arrest. Although there will be other barriers for the playwright to cross, both ideological and institutional (including the reluctance of feminists to associate themselves with the republican prisoners' struggle for political status), D'Arcy will find herself incarcerated within the walls of Armagh women's prison during the "no wash" protest. *Tell Them*

Everything is D'Arcy's own self-styled narrative compliance, upon her release, with a request received from other prisoners whom she met there and who, when she was released, remained still within the walls.

Recalled: The Library
Like D'Arcy, Ruth First was an academic — a historian whose writing at the time of her arrest had been banned in South Africa. In 1961, First was working as a librarian, cataloguing the admissible texts of other authors for conservation within a sanctioned archive. First, a white South African woman activist in the ANC and the South African Communist Party, was arrested under the Ninety Day Detention Law, allowing for detention without trial for a period of ninety days, a prescribed term that was in any case renewable. Her prison memoir, *117 Days*, which takes its title from that renewed period of detention, is the account of her experience of internment. It opens, unlike D'Arcy's narrative, with First inside her cell, and relates an almost obsessive retrospective description of the transformative toll that incarceration took on her sense of self: "For the first fifty-six days of my detention in solitary I changed from a mainly vertical to a mainly horizontal creature."[9] The cell was small, with limited space for movement, and only a bed to lie on. Within an hour of her entry into the cell, First "found [her]self forced to do what storybook prisoners do: pace the length and breadth of the cell."[10] She read as well; she read the stories that were not yet books, which prisoners before her had written on the walls of the cell: the personal messages from young girls, common law "criminal" prisoners who admit to having slain their babies or having been in love; the political slogans, such as *Mayibuye i'Afrika* (Let Africa Come Back), traced by the women prisoners from the Sharpeville Emergency. Against the isolation imposed by penal solitary confinement, the prison walls are remade, reinscribed, to establish a different bibliographical or curatorial community whose oversight of the walls, their inscriptions, and their hangings, exhibits a

subversive alternative to the traditional practices of academic libraries and museums.

The intellectual function that informs First's initial responses to prison, as well as their recapitulation in memoir, instructs the entire account of her one hundred and seventeen days in a South African prison. Her first nights are spent in sleepless calculations and rehearsals of her forthcoming encounters with the inevitable prison interrogators: how will she contend with her interlocutors' aggressive attempts to elicit information from her? A historian well schooled in academic protocols is preparing for the prison version of the rigours of the "question and answer period." Such a comparison does not necessarily trivialize the physical extremities of the conventions of prison interrogation. Rather it poses once again the institutional and discursive continuities that maintain the dominant authority of both prison and academy hierarchy within a modern social order. Those continuities must be interrupted by First, the journalist and historian whose writing had addressed such issues as the bus boycotts and the exploitative conditions for peasants in the rural areas. She had been banned and exiled, and the newspapers and publications that she edited had been closed down by the South African government. First, for whom the question of writing was always at stake, is concerned and alarmed during her first night in the prison cell at her own unwitting collusion in her detention by way of her schooling in the etiquette of archive, academy, and authorship: the security forces had found an illegal copy of one of her own publications when they searched her home at the time of her arrest.

As historian and journalist, researcher and investigator, First was professionally committed to disclosing information, to exposing the abuses and repressions perpetrated by the apartheid regime of South Africa. Now, in prison, in order to maintain her political commitment, in order to sustain the agenda of African liberation that she has subscribed to, she must deny her professional training, forsake her institutional credentials. She cannot, must not, make

information available. When do you talk and when do you not talk? First's state interrogators demanded that she contribute to a punitive narrative that will be deployed by the police to incarcerate for life other ANC activists arrested in the Rivonia raids—if, that is, they are not given the death sentence.[11] First's intellectual contest with her interrogators must, paradoxically in strict academic terms, prevent that history from being written and carried out. Her self-imposed antithetical role as counter-historian is what then informs her prison experience and its subsequent narrativization as memoir. In other words, First, both like and unlike D'Arcy's scriptural challenge on the wall of the Ulster Museum, must develop a strategy against the "writing on the wall," must turn the public into the private and thus reverse the function of the writings that had greeted her on her arrival in her prison cell.

To this end, she devises multiple projects, such as reading the Bible. But what the South African communist elicits from that classic of prison reading and the memorizing of psalms and proverbs is not wisdom for the hereafter, but imperatives for transforming the present and coming to terms with interrogation: "A fool's mouth," she notes, "is his destruction/And his lips are the snare of his soul." Or again, more tellingly still, "Confidence in an unfaithful man in time of trouble/Is like a broken tooth, and a foot out of joint."[12] First retakes the Bible, reclaims it, as instructions in the means to withstand the circumstances of interrogation. She reads too the snatches of letters on the newspaper vendor's poster that is barely visible from her cell window. She imagines writing a novel as "storybook prisoners" might do. First's own academic training, it could be argued, is turned against the very institutions of state that had sanctioned it, and her example locates the cultural spaces of prison, library, and academy as congruent.

"Political Status"

The year before First was assassinated at Mondlane University (itself named for the assassinated Frelimo leader

Eduardo Mondlane), in Maputo, Mozambique, republican prisoners in Long Kesh in Northern Ireland went on a hunger strike. Nineteen ninety-one marked the tenth anniversary of the deaths of ten men demanding recognition of their status as political prisoners. Bobby Sands, the first of the strikers to die in May 1981, was followed over the next six months by nine others. These deaths — protracted, painful, and public — provoked powerful and passionate reactions: in Northern Ireland from the families of the men as much as from the church; in England, where Margaret Thatcher's refusal to respond to the strikers' demands exemplified current and historical British policy toward its oldest colonial possession; and internationally in the protest of human rights organizations and concerned individuals. The hunger strike also became the stuff of writing. *Ten Men Dead*, for example, by the *Guardian* journalist David Beresford and, interestingly, bylined from Johannesburg, addresses by its very composition the role and function of writing both in the waging of the strike and in its subsequent reprisals. *Ten Men Dead* — not unlike D'Arcy's "work of art" on the hallowed museum walls, or First's counterhistoriographical murals — critically combines three separate but intersecting textual and mutually commenting political narratives. In regular typeface is the account of the strike itself, including the standard journalistic reports on the family backgrounds of the participant-martyrs, the ideological processes that were involved in it, the negotiations to end it, and so on. In smaller type are transcriptions of what are called "comms," the written communications sent from inside the prison to the leadership whose responsibility it was to coordinate support work outside the prison for the prisoners' strike. Significant here is that only those "comms" from inside are extant in this archive of the strike, with those from outside presumably having had to be destroyed upon their reading within the walls. Finally there is an italicized fiction, continued serially at the end of chapters 2 through 9, of a prison visit during which a "comm" is passed from the republican prisoner to his

female visitor, herself a member of the movement posing as his sister.

That "fiction," generically constructed out of the "day in the life" paradigm (perhaps based too on Sands's own prison memoir of the "dirty protest," *One Day in My Life*, beginning with "wake up" and concluding with "a new day"), combines with a "boy meets girl" narrative. The prisoner's refrain, "Into jail at 22, out in his forties," articulates the necessary reframing determined by the prison sentence of these fictive conventions. Those eighteen years between twenty-two and forty, the period of manhood and romance, the stuff of novels, are gone and must be relocated, replaced with another narrative. The italicized fiction then builds up to a visit in which the prisoner will receive a communication from the IRA leadership outside. He must also deliver one himself. The "comm" from the commanding officer in the prison to the Belfast Brigade must get out, and the means of transmission of the meticulously rolled cigarette paper structure the first instalments of the fiction. In chapter 2, for example, there is just the tightly rolled package shoved between the prisoner's legs and the breakfast "marge" — good for "greasing your arse"[13] — to indicate the political significance of the impending visit. The prisoner fantasizes the forthcoming meeting:

> *He grinned to himself, wondering what she would be like. It would be odd, greeting a strange girl with an open-mouthed kiss. And him stinking, like he did. Like they all did. She was Sinn Fein and should know how to take his "comm" first. But it could always go wrong: two tongues simultaneously pressing two packages, locked in labial combat in the middle of the room. And if he dropped the "comm"! The screams from the women-folk in scramble for it. He'd butt the screw and they'd wrench his mouth open, trying to stop him swallowing. The beating and the silence of the Boards. The prisoner shook his head clear...*[14]

The meeting takes place, not quite as the prisoner had fantasized it, and the girl, as it turns out, is more experienced

than the prisoner in these exchanges. In addition, her Gaelic is better than his. But the messages are transmitted, the strike continues, and the fiction concludes: "Into jail at 22, out in his forties."

The republican prisoners' demand for political status, rescinded in 1975 as part of the British policy of "criminalizing" the republican movement, was a demand for recognition as equal participants in the political negotiations, discursive no less than military, on the history and future of Ireland. Denial of political status to the prisoners was also the denial of the political legitimacy of the struggle itself. The prisoners' protest then was writ large in the contemporary narrative of that struggle. It began in 1976 with the "blanket protest," that then developed in 1978 to include the "no wash" or "dirty" protest, in both the men's prison of Long Kesh and the women's prison in Armagh, in which, when prison authorities refused to slop out the cells, the prisoners took it upon themselves to empty their slops out of the windows. The windows were next boarded up, leaving no place but the walls of the cell for disposal of excrement and menstrual blood. For more than two years, then, the men and women prisoners lived with their bodies written on the walls of their cells. While many observers recoiled in horror at such protest, others vilified the prison as "bestial"; there is a political reading to be undertaken of this "writing on the walls." Whereas D'Arcy's scribbling "H Block" on the walls of the Ulster Museum led her to prison, the H Block prisoners' protest eventually provided them with representation and seats in Parliament. Pictorial representation, that is, must be seen as crossed here with political representation. Although the hunger strikers' demands for status were only cursorily acknowledged by the British government and their Northern Ireland representatives at the strike's conclusion, the dying Sands meanwhile had been elected MP to Westminster, acquiring by popular mandate the political status still denied by British officialdom to Sinn Fein and the republican movement.[15]

"All the Best"

The politics of writing, like the writing of politics, in these
instances of D'Arcy, First, and the 1981 hunger strike, are
made manifest by the very premises — the walls — that cir-
cumscribe and determine their composition against and
across those same walls. Prison letters, not unlike the clan-
destine "comms," exemplify in turn the traditionally and
officially denied (and thereby implicitly recognized) politi-
cality of the literary, the academy's refusal of political status
to literature. As Eoghan MacCormaic wrote in an H Block
poem,

> Open envelopes slipping through my door
> containing letters from my friends
> were welcome. Pity though that all
> their words and thoughts were second-hand
> or second-read before they reached me
> indirectly through the censor's scanning,
> prying, noting, blacking pen,
> the differential of the ignorant
> and the knowledge, the right to know
> or have the knowledge banned
> for reasons of Good Order, Discipline,
> Security and other such demands
> on his discretionary power.[16]

The missives that have been most consistently preserved,
edited, and archived, however, are usually those written
from inside to outside, and composed according to insti-
tutionalized conditions and criteria obtaining within the
prison system. Prison letters, that is, are no less formally
over-determined than a good sonnet or artwork. Overseen
and evaluated, graded, as it were, by a prison censor, the
format of the letters must often conform to regulations gov-
erning length and frequency; their content may be similarly
assigned and supervised (500 words, for example, rather
than fourteen lines, and with an extra permission for free
verse rather than a rigorous rhyme scheme). Similarly,

recipients might be limited to those who have obtained prior approval from the prison authorities. Prison letters, at once a model essay in elite academic instruction, and exemplary of strategies of subaltern resistance, represent the elaboration of a kind of rigorous, generic counter-writing against the walls and across the restrictions of censorship and the denial of political status. They alter too the received conventions governing authorship and readership, and establish alternative critical relationships to the "written." Such a reading of prison letters, to take but one example, could be crucially instructive to professors of the literary within the hallowed walls of our academies. But, as Antonio Gramsci wrote to his mother from Turi prison in 1931, "People don't write to a man in prison for one of two reasons. Either they are unfeeling, or else they are lacking in imagination."[17]

Not just in museums, but in prisons too, the best of our society could be displayed—if only we in the academy could see it written even now on our own institutional walls.

Notes

I want to thank David Tomas for his instructive suggestions on translating talks into texts.

1. R. Srivastan, "Looking at Film Hoardings: Labour, Gender, Subjectivity and Everyday Life in India," *Public Culture*, 4, no. 1 (1991): 22.

2. Ibid., 22.

3. See Francine Dagenais, "Synthetic Magic/Virtual Reality," in this volume.

4. See articles by David Tomas, Janine Marchessault, Olivier Asselin, and Francine Dagenais in this volume.

5. These examples are taken from my *Barred: Women, Writing and Political Detention* (Wesleyan University Press, 1992).

6. This formula is taken from a paper by Laura Lyons, "Margaretta D'Arcy's *Tell Them Everything*: A Feminist 'Tour' of Duty" (Paper presented at the "Gender and Colonialism" conference, University College, Galway, May 1992).

7. Stephen Greenblatt, "Resonance and Wonder," *Exhibiting*

Cultures: The Poetics and Politics of Museum Display, ed. Ivan Karp and Steven D. Lavine (Washington: Smithsonian Institution, 1991), 43.

8. Margaretta D'Arcy, *Tell Them Everything: A Sojourn in the Prison of Her Majesty Queen Elizabeth II at Ard Marcha* (Armagh) (London: Pluto Press, 1981), 15–16.

9. Ruth First, *117 Days* (New York: Monthly Review Press, 1989), 15.

10. Ibid., 16.

11. The Rivonia raids in 1963 resulted in the arrest and eventual imprisonment of major figures of the South African resistance, including Nelson Mandela.

12. First, *117 Days*, 71.

13. David Beresford, *Ten Men Dead: The Story of the 1981 Irish Hunger Strike* (London: Grafton Books, 1987), 81.

14. Ibid., 175–176.

15. Reviewing the transcript of this presentation in the first week of February 1992 in Galway, Ireland, I cannot refrain from citing the comments of Gerry Adams, Sinn Fein leader, following the massacre on 4 February 1992 in the Sinn Fein offices in the Falls Road of Belfast. According to *The Irish Times* (5 February 1992), "Mr. Adams said that it was hardly surprising given 'censorship and the demonising of Sinn Fein' that such attacks occurred....' 'Those who are involved in the demonising of Sinn Fein cannot easily distance themselves from this tragedy,' he said. People who tried to put Sinn Fein 'beyond the Pale' had to bear some responsibility. Mr. Adams pointed out that the shooting had taken place within sight of Divis Tower, on top of which the [British] army has an observation post. He felt that it was 'quite unique' that the attack could be carried out in clear view of the post."

16. Eoghan MacCormaic, "Point Number Three," *H Block: A Selection of Poetry by Republican Prisoners* (Sheffield: South Yorkshire Writers, 1991).

17. Antonio Gramsci, *Prison Letters*, ed. Hamish Henderson (London: Zwan Publishers, 1988), 157.

IDENTITIES

BODIES OF THEORY, BODIES OF PAIN:
Some Silences

Jody Berland

WE LIVE IN AN ERA of conferences, panels, and interviews whose proceedings—as this volume attests—are more and more active in the mapping of contemporary thought. Aside from offering rapid entry to the tidal wave of publishing in contemporary cultural theory, these events provide a series of records, often assiduously documented, of strategic encounters between our current thoughts and the evolution of "public"/published intellectual discourse. When something unexpected or exemplary happens in these events, we mark the occasion—the twist or deepening of our ideas brought on by what we encounter there—by referring to the panels or conferences themselves. "Last winter I participated in a discussion...." Perhaps we are creating new conventions for introductory narrative, situated somewhere among the history of ideas, autobiography, ongoing collective dialogue, institutional reportage, self-promotion in cooperation with the requirements of commodity production, explication of unresolved intellectual dilemmas, and gossip. How might we make good use of these emergent narratives? Which questions are being brought to the fore and which are disappearing? How has feminist theory worked to influence or alter these processes?

Last winter I was asked to participate in a panel concerned with women and the production of knowledge. During its evolution this panel had a number of titles, and its

nominal instability mirrored and exacerbated my own ambivalence on the subject.[1] Should I take the position that the institutions concerned with the production of knowledge — schools and universities, museums and galleries, publishers, journals, electronic media, and so on — had improved, would improve, with the increasing number of women working within them? Would that be speaking from experience or principle? Should I conclude that women should fight for more places, more advantageous places, in these institutions? Who or what would be silenced in such a course? To what degree is institutional legitimacy the primary goal for our work, and what does it mean to pose this question? In talking about knowledge production, how broadly should we define what we mean by institutions?

Obviously the concept of "institutions" was on my mind. The panel on women and knowledge raised a specific question in this regard. Did I want to talk about women's knowledge *in* the academy (the contributions of specific authors to theory, criticism, or pedagogy, for example) or women's knowledge *of* the academy, which raises a more veiled and problematic set of issues? The first option is predicated on taking the perspective of the academy, presumably in the interest of its reform. This perspective casts its shadow over an ever-wider and more various terrain. In response to the current prominence of theory, and to a host of other intellectual, economic, and social factors, women artists, critics, curators, and scholars increasingly conduct their work in connection with educational institutions. At the same time women are also working in more varied ways — as critics and students, artists and curators, students and editors — and in more marginal relationships to the complex of knowledge-producing institutions that enable this work. What are the consequences of this growing professionalization, this continuing tenuousness?

Taking the institutional perspective, we could all agree on the need to promote work on women and by women, on the need for better support and more opportunities in exhibition, writing and publishing, curriculum and hiring, or,

alternatively, in a more theoretical vein, on the importance of feminist challenges to science and epistemology, representation and art, and related research as predominantly androcentric practices within the academy.

The second option means taking the perspective of women: that is, (putting aside temporarily the question of whether such "a" perspective exists), acknowledging that women's knowledge and the institutions concerned with the production of knowledge, here referred to broadly (for practical and historical reasons) as "the academy," might not always be in harmony or even compatible with one another. It means recognizing that women's experiences, capacities, and investments may be fundamentally different, in the ways they fall between the cracks of these incompatibilities, from those that shape the work and everyday life of the academy, as well as from each other's. Taking the perspective of (actual) women, rather than that of the academy in which women are present, means examining more closely how we are affected by working within the already established institutional contexts that enable and contain our work. It means examining how we arrive there in the first place (this is not entirely an autobiographical question), and what happens to us once we are there: how we exchange stories and complaints, learn to arrange mutual support networks or not, own up to our own love-hate relationships with the institutions, the canons, the academy in the narrow and broad sense of the term. It means asking how many of us can make real choices in relation to the institutions, and how many of us survive them without real damage. And it means asking how the work we produce represents and shapes the conditions of possibility for women with whom we would share such spaces.

I want to stress the importance of keeping sight of the second meaning in order to assure that our work as producers of knowledge remains useful, self-reflexive, critical, true, and visionary. My intention is to discuss the implications of this distinction — between the academy's and women's perspectives — for critical practice, in light of the processes of

intellectual and social institutionalization we are presently witnessing. In particular, I will consider practices of autobiography and writing on the body as complex effects of institutional and social processes which engender both speech and silences. First, I want to emphasize that there is much to celebrate in women's accomplishments within the academy in recent years. Feminist writing has had profound effects on theory and criticism across most of the traditional disciplines and institutional boundaries: for instance, in the challenging restoration of women's place in many histories, in the creation of sophisticated textual/theoretical analysis across a range of cultural practices, and in the extensive debate about identity, biology, history, and discourse in relation to the female body. In addition, women have been among the most vocal and effective critics of specialization, seeking to form a new type of intellectual discipline (or undiscipline?) founded on interdisciplinarity. All of these figure in both positive and negative ways, as I will explain shortly; that is, they make what I want to say both possible and necessary.

Speaking of the Self

Arlyn Diamond describes the intellectual dilemma that she encountered, with others, in trying to conceive interdisciplinary work on women: if, as Lucien Goldmann suggests, "the progress of knowledge proceeds from the abstract to the concrete through a continual oscillation between the whole and its part," then "how does one grasp a continual oscillation, when one is part of the flux and cannot be sure which is a whole and which a part?"[2] "Again," wrote Virginia Woolf in *A Room of One's Own*, "if one is a woman one is often surprised by a sudden splitting of consciousness, say in walking down Whitehall, when from being the natural inheritor of that civilization, she becomes, on the contrary, outside of it, alien and critical."[3] This offers us, Gill Frith writes, "an understanding of feminine subjectivity as slipping continually between the apparently 'transcendent' and the specifically 'female'."[4] Most women who have had to work within institutional contexts know this sense of

oscillation — this occasional, very private, sometimes empowering, and sometimes extremely destabilizing movement between different senses of one's place there. Does our knowledge of these institutional spaces reveal any certain place for our own precarious subjectivities and too specific bodies? Does our knowledge of our own subjectivities and bodies offer any certain place for this legitimated, privileged, empowered and empowering self that we at least momentarily inhabit? How can we inhabit both of these spaces at once? Doesn't our awareness of these slippages in spatial terms measure the kinds of distances between them, distances which indeed define the awareness itself?

Arising as a response to this oscillation/slipping, this fluid movement between the aspiration to transcendent or abstract knowledge, and very different kinds of personal knowledge and feeling — one of the more visible contributions of feminist art, writing, criticism, and theory — is the increasingly valorized practice of autobiography. The requirement that authors locate themselves in terms that make explicit their own investments and conditions, and how these might bear on their subject matter and mode of inquiry, is now well ensconced in theory and to some limited extent in academic and critical practice. The emergence and legitimation of the first person singular for presentation or representation of self and idea, and more specifically, of autobiography as a valorizing narrative trope within critical writing, can be understood both as a positive influence of feminist politics within criticism and the academy, and as an expression of the crisis of authenticity within theory as a mode of intellectual production. Unlike visual production, the "authenticity" of criticism is not (so much) threatened by copies or reproductions, and, unlike contemporary music, is not (so much) "corrupted" by sampling, pirating, imitation, and audio holography; nonetheless, theory, and thus criticism, has shown its own evidence of immanent crisis.

In philosophical terms this crisis of authenticity has to do with the disintegration of truth and value as assumed normative attributes of humanist discourse. It is obvious

that this crisis has its origins in social contestation — challenges from women, from intellectuals or artists of different races and ethnicities, from gays and lesbians, even from Canadians reacting to the universalizing flourishes of American populist rhetoric — which is also articulated in/with theoretical discourses. But further examination of the context of contemporary social relations shows that the rise of autobiography as a privileged tactical response to this philosophical and narrative crisis can also be discussed, just as appropriately, in terms of the foregrounding of signature, whose importance is directly tied to the requirements of genealogy and market exchange (Who wrote Shakespeare? Is that artist or author white or black, straight or gay? Who is, needs to be, must be, cited? Did Gayatri Spivak or Stephen Heath first propose a "strategic use of essentialism?" Who has, and how, the "right" to speak?)[5] If we retain our knowledge of/outside the academy, as well as our demonstrable expertise within its constituent discourses, we can recognize the degree to which the contemporary academy can now accept, and perhaps in those areas where "signature" has been the subject of theoretical analysis — art criticism, literary theory, philosophy, feminist theory, cultural journalism, and "Theory" generally — may even privilege, the autobiographical gesture as a procedure for coping with contemporary methodological scepticism. For the autobiographical gesture can function as an expression of political or cultural pluralism and epistemological liberalism, as well as working as a vehicle for oppositional critique, and its current practice can be seen as consequently ambiguous in both intellectual and social/economic terms. Understanding its dual functioning in contemporary cultural production is key to explaining its proliferation, contradictoriness, and generative effects.

No doubt there are now as many styles of autobiography as there are of ambiguity, though I would not attempt to catalogue them here. However it is framed, the autobiographical moment productively addresses both terrains: it can ascertain more clearly the limits and implications of the

writer's own truth claims, and it can facilitate the entry of writing into a market with specific needs and conditions. In narrative terms, autobiography offers an accessible mediation between the storyteller/critic and that elusive whole, that demonstrable truth about the world which postmodernism has dismissed as master narrative. It marks at one and the same time the return of the story and the renovation of the subject: it was through the birth of fiction, after all, that the subject "I" was first introduced and legitimated in narrative writing. Secretly, none of us prefers to live without narrative (probably three out of four feminists has a mystery by her bed) and, at a time when theoretical imperatives are felt quite strongly, its pleasures are briefly restored (sometimes without otherwise alleviating or explicating theoretical opacity) by the autobiographical moment. The autobiographical strategy offers a way to place whatever experience we are willing and sanctioned to reveal in the context of larger historical and political systems, at least potentially — assuming that the storyteller is willing to take that crucial next step, which in some cases, like the proverbial other shoe, one may await forever. This placement of the personal within the frame of public debate is, at its most effective, a courageous gift that reveals and illuminates the important feminist adage that "the personal is political." At the same time, the autobiographical trope has come to offer a viable space for making recognizable/repeatable gestures of self-presentation which function as a post-expressionist, post-humanist, and (in some cases) post-visual mode of "signature," enabling critical and theoretical work (i.e. writing) to enter into and circulate within market processes that have defined the visual arts since the rise of modernism.

For "if each sign of the painting," as Jean Baudrillard writes in "Gesture and Signature,"

> retraces the subject in his [sic] act, only the signature designates him [sic] explicitly, giving us that particle of meaning, that reference and, hence, that security, which, in modern painting, is no longer given by the illegible truth of the world. The social

consensus, and beyond that, of course, all the subtle combinations of supply and demand play upon the signature.[6]

With the post-representational foregrounding of signature, it is not a rendition of the world, but a specific gesture within it, that is thereby valorized: "That which was representation — redoubling the world in space — becomes repetition — an indefinable redoubling of the act in time."[7] Warhol, among others, made this repetition explicit. In how many ways can this gestural act contain (in both senses) its own deconstruction? What are the possibilities for more critical, more visionary and far-reaching expression in the discourse constituted (and signed) by this gesture? In what conditions can this gesture challenge and point beyond the boundaries of the (art/theory) discourse that requires and contains it?

Artists themselves are often divided between the ideology of pure gestural values (values of authenticity) and this other ideology, the critical necessity of regrasping reality. The same dilemma is posed for art critics, moreover, who have great difficulty reconciling a tangled paraphrase of the creative action (gestuel) with an analysis of objective significations. In the light of what has just been said, this velleity of regrasping the world that is still new in contemporary art ... appears naive: it seems unaware of that systematic dimension according to which the modern gesture of painting is first organized — beside, or outside, or despite the conscious intentions of the artist. This velleity seems unaware that what is signified (and thus in a way domesticated) in contemporary art is no longer the world as substance and extension, but rather a certain temporality that is that of the subject in its self-indexing (and not the social individual of biographical data).... Any function that one may wish to assign to art (among others, that of critical realism and of any form of commitment) must be measured with respect to this basic structure, and thus to this limit of meaning.[8]

This "velleity," this "weakly willed impulse" of regrasping the world through the naive and/or polemical indexing

of the self, has been thoroughly problematized in art discourse. Signature and authorship are now widely interrogated, in other words, but no less constitutive as a discursive frame. The same process is increasingly visible in critical writing. This is, at least in part, because of the increasing collaboration and interdependence of art and theory in both symbolic and institutional terms. The notion of "authorship" attending the valorization of signature is a troubled one, and much recent feminist art practice has been dedicated to the critical destabilization and reappropriation of its vocabularies and consequences. Ironically the "death of the author," so productive and problematic for feminists and others concerned with finding voice and being heard, has coincided with the visible expansion of theory in processes of intellectual and economic legitimation (whose interaction we still know far too little about) of the work of art. The works of critics and theorists are no longer confined to the academy in the traditional sense, but have — with the social-discursive expansion and economic constriction (and monetarization) of the academy, become potentially available to art journals and magazines, catalogues, gallery publications, anthologies, books, public lectures, and so forth. It is through these venues that successful critics and theorists seek to establish their own recognizable/repeatable grounds of distinction whose value can be indexed at a glance. The writing of theory is thus empowered/constrained to produce and accommodate its own types of authorship, whether or not authors themselves affirm the possibilities for creativity and agency in practices of making art. Producers of theory and criticism thus seek to become sustained, celebrated, or marginalized through the same structured circuits of institutional/intellectual relevance, difference, authenticity, and marketability that work to organize hierarchically the reception and circulation of art objects informed and distinguished by their ideas.

The object and the analytic frame in which it is placed have, in other words, become increasingly interdependent in a social context characterized not only by feminist and

other challenges, but also by intensified commercial exchange and valuation wherein theory and criticism play a crucial but mainly unacknowledged role. This context encourages the dualistically functioning "systematic dimension" of self-indexing in writing that Baudrillard describes in the work of art.

These conditions and their consequences have, however, remained unexamined in the critical/theoretical writing and publishing whose proliferation inspired the organization of this conference. This discretion about money and the power of the marketplace is in strong contrast to the overt visibility of other incentives for practices of "self-indexing": theoretical, political, epistemological challenges to universalizing discourses, which draw some of their strength from the high visibility of politically motivated and currently (selectively) well rewarded markers of difference. These individualistically structured markers of difference work more syncretically with some cultures than with others, of course; in some cultures it is difficult to talk candidly about the self, and, for some non-Westerners, illustrating personal fragmentation and the non-identity of the subject seems an idle exercise. That aside, these "self-indexing" markers of difference, whatever their original motivations and effects, now also function as alibis for the promotion and circulation of texts shaped and sanctioned by the dynamics of a market in ideas constrained, like any other, by commerce and fashion, with all the consequent requirements for calculated risk, marketable signatures, and serial repetition. We can expect this dimension — the institutional promotion of symbolic difference articulated and domesticated through strategic self-indexing — to expand further with the increasing commercial organization of cultural production now evident in Canada because of conservative cultural policies.

The contemporary market in journals, catalogues, anthologies, and illustrative artworks requires, depends upon, and makes possible an expanded space for the dissemination of knowledge whose changing forms respond to multiple and complex contexts. This discursive space contributes to, and

relies upon, a thriving market in cultural theory dependent upon growing collaboration between the art world, the academy, and the publishing industry. The narrative practices produced by and within this conjuncture of intellectual, political, and economic determinants—among which I include not only theoretical canons, but also autobiographical gesture and signatures of difference—reveal specific assumptions, imperatives, and absences that have shaped autobiography as an emergent institutionally mediated narrative tactic. I turn now to consider several enlarged details of the picture I have presented. In looking at women, writing, and the body, we see that the institutional and conceptual mediation of this burgeoning field of inquiry has produced its own eloquent silences.

Writing over the Body

Women work, as I have already pointed out, in the context of a broad interwoven apparatus of educational, curatorial, and critical institutions, and tend to be situated in complicated ways between them, as teachers, graduate students, curators, researchers, artists, editors, and critics, drawing on a multiplicity of experiences, skills, resources, and sources of income. The rise of autobiography has occurred within these contexts and is marked by them: by the need for feminists to constantly challenge and debate universalizing discourses and practices; by the tendency for women to move (whether through greater professional fluidity or greater necessity or, more probably, both) among different contexts and discourses; by the need to create a viable intellectual and economic space for feminist work, often (but not always) at the edge of institutions and centres of power; by the conditions and constraints of contemporary theory; and by the contradictory politics and aspirations produced in these spaces. In what follows I will discuss the significant silences that have arisen in this context.

The first has to do with a more balanced understanding of power and privilege arising from being in the academy, that is to say, in the complex of cultural institutions as I

have broadly defined this term. Being located within this complex of institutions means being enfranchised to speak: to produce works, to theorize in and about works, and thereby (sometimes) to earn a living. This means being able to articulate or posit, in material terms, a unique subjectivity whose "signature" claims, and may even be rewarded with, the privilege of display and/or circulation in commodity form. Aside from feminist humour, current writing all too rarely affirms (or challenges) this privilege. As Kari Delhi observes in a recent anthology of essays on feminist struggles in the university:

> There seems also to be another process at work here, even as academic feminists embrace autobiography and personal narratives. While it is important for all kinds of women to tell stories of relations with men and experiences in male-dominated institutions, it still seems difficult for us to talk about our locations inside several sets of social relations and practices where we are dominant rather than dominated.[9]

As women we are subject to an endless parade of petty and other horrors — those we are personally subject to, those we observe (and can we clearly delineate the difference?) — but we are also mainly middle-class, white, variously privileged in terms of cultural and symbolic capital, and variously able to exercise our privilege in relation to the professional world. We pursue careers in institutional communities whose structures, shapes, and divisions of labour are so far little altered by our presence. And we are able to transform our experience into pleasurable text-making activities, publications, grants, exhibitions, personal myths, reputations, and even tenure, regardless of whether our critical output succeeds in affecting the lives of students or secretaries, or those whose lives we document or discuss in our work.

The second area has to do with the physical and psychic suffering that we experience and tolerate by working in male-dominated institutions, especially academia, where

women who wish to pursue artistic and critical careers are increasingly located (though why, in that case, is the proportion of women teaching in colleges and universities rising so very slowly?). As Kate McKenna writes in the publication to which I have already referred:

> What seems to have changed with women's entry into academia is not the actual work or organization of that work but that more women—mainly white women, usually from privileged backgrounds—have gained entry into the abstracted mode. For the most part, the mental/manual division of academic labour, the erasures of bodies, the denial of location and the institutional hierarchies of authority and subordination have still not been problematized.[10]

The silences measured here concern the dark side of our work within those institutional contexts, of which we so rarely speak in our work: erasure, denial, dislocatedness, subordination, infantalization, and their effects: illness, anger, and despair.[11]

Now these appear, on the surface, to be contradictory assertions: first, that what remains largely silenced is our own privilege, creativity, powers of myth-making, and practices of empowerment; second, that what remains largely silenced is our own subordination and suffering within the institutions. They are, of course, connected. It is valid but too easy to say that such vulgarly material issues tend to disappear in what McKenna calls the "abstracted mode," wherein discourses usually associated with women—everyday life, gender, community, the body—have now been introduced, but often appear as analytic abstractions subject to epistemological and theoretical debates wherein autobiography functions as illustrative gesture. In her discussion of feminism and interdisciplinarity, Arlyn Diamond describes a dualistic silence, much like this one, which she attributes to a disciplinary distinction; in her experience, humanists have felt apologetic about their lack of power, while social scientists have felt defensive about the abuse of

power.[12] For those of us working across the disciplinary divide, this is an interesting, but not an adequate, explanation. McKenna seeks a more intimate connection between these two silences: "I am beginning to suspect that these silences and erasures of 'the private,' of 'the personal' are practices that enable middle class women to deny our positionality — constructing it as obvious, neutral and universal."[13] Like McKenna, I envisage the articulation of these absent "personal" truths not merely as confessional, revelatory, or illustrative "self-indexing" gestures, but rather in some reflexive, critical, and pragmatic relation to the processes of institutionalization that empower and contain these selves, these truths, these silences. For it is not only positionality that is denied by these strategic silences, but also alternative and more complex feminist definitions of our needs. This means, as Nancy Fraser argues in *Unruly Practices*, that women must seek to permit previously "private" questions of legitimate needs to enter into our institutional and discursive spaces, while being prepared simultaneously to challenge the institutional and administrative interpretation of women's needs in patriarchal discourses. As Fraser argues, the articulation of needs may follow a therapeutic or resistant path, but contestation cannot occur in silence.[14]

These silences have consequences and costs. Among the consequences is the fact that women, like men, are compelled (internally and externally) to ascribe to the hyper-theorization, competitiveness, and hyperbolic production quotas of contemporary professional self-marketing and institutional survival/advancement, without acknowledging either the social arrangements that make this level of production possible (if only for some) or the costs that make achieving it painful and problematic. These costs are important because they contribute to continuing hidden inequities between women on the basis of different conditions such as health, wealth, partnership, child support, age, and singularity of commitment. We cannot, in other words, separate the consequences from the costs of these silences. Three

categories help to identify these costs: the political, the physical, and the pedagogical.

Much of the current theorizing about identity, representation, gender, and the body — aside from AIDS research — has occurred in an analytic sphere that pays little regard to public and institutional contexts and needs. This abstraction can be advantageous within the contemporary critical/academic apparatus, which privileges performative theory. And it no doubt seems safer to excel in institutionally sanctioned intellectual performance than to criticize the institutions or expose their lived consequences. But such abstraction has an obvious political cost. As Kari Delhi observes:

> Learning particular forms of argument — debating within new or established academic discourses — is an important part of academic training.... The pressures to write, research or teach within specific forms, for example, by showing 'mastery' of 'the literature', are embedded in the ways university education is put together and practiced. Learning how to use difficult concepts, reciting the arguments of 'great' theorists, or publishing in scholarly journals is a hard and time-consuming business. It is this kind of work rather than political activism and personal history which counts as properly academic. The more feminists adjust their work to these parameters, the more we risk being split from transformative politics within and beyond the universities.[15]

Second, there are physical costs, with which I have long been on intimate terms. But I am not alone; if female illness was once interpreted as metaphor for hidden passion, it is now emerging as a sign of hidden overwork and personal implosion. Chronic or acute illness, divorce and familial disintegration, hyper-stress, drugs, physical collapse — many women have become variously disabled vis-à-vis their work and/or personal life as a consequence of the intense demands of their work. The frequency of women's illness among intellectuals and teachers is appalling and remains largely unacknowledged outside of conservative medical contexts

and discourses (whose linking of women and disease we know all too well). Most women continue to try to meet all their obligations, their opportunities, afraid to refuse even one despite their accumulating costs. Given the recession, the rising cost of living, the reduction of public spending, the precariousness of grants, the remarkable speed-up of work in academic and cultural institutions, the continuing institutional marginality of women, the continuing inequities of housework and child care, and the competitiveness of the communities in which we work, being professionally active means working schedules of which our mothers (not to mention fathers) would have never dreamed. We find ourselves in the midst of a subtle undeclared war against the physical and spiritual capabilities of our bodies, our relationships, our families and communities. The work patterns and social practices required by these institutions were not designed for women, even before such demands were exacerbated by contemporaneous speed-up, cut-backs, and hyper-productivity. They were designed for men whose wives managed the practicalities of their everyday lives. It is now a commonplace to observe how much harder women work, often without the structures of caring and comfort or the benefits of public approval taken for granted by male colleagues. What I see in many women and have experienced in my own life is a resistance to institutional exploitation and alienation that is expressed through the body because it is not able to be expressed elsewhere. Thus the growing frequency of collapsed immune systems, intolerable allergies, migraines, neurological diseases (particularly MS), alcoholism, drug abuse, ectopic pregnancies, miscarriages, infertility, mental breakdowns, suicide, and above all cancer, as well as a plethora of unidentified ailments. Illness has come to function as a silent private narrative by women about the failures of public life whose only translations into public discourse take place in expert languages of medicine and related gender-biased victimhood. There are many poignant reasons for this silence. There are also consequences; the number of women who live on the border of

physical or emotional collapse still outnumbers those who succumb to it, but by how much, and for how long? When our women colleagues and friends collapse, what changes? What is permitted, and what is spoken?

Despite the present hegemony of bodily thematics in feminist theory, the body continues to be "written" as a subject of textual analysis focusing on gender identity and the theory and critique of representation, rather than as a site of knowledge whose articulation can variously empower/disempower women and would certainly seek to challenge present institutional arrangements. Aside from work on AIDS and reproductive technologies, contemporary discourse on the body, now a dominant currency in artwork and critical theory, threatens to become indistinguishable from a new type of formalist semiotics in postmodern guise: the body with its disposition(s) offers itself up as a sign system for complex and convincing but overly transcendent textual analysis. This texted body has a gender (or not) and a deliciously worked vocabulary, but it does not have an everyday life: it does not have to decide whether to get up and go to work, does not speak about the suffering or danger of sitting for hours in front of the computer, and does not register the traumas of overwork and indifferent administrators. It is never injured by its own being-thought, and it does not register the effects of its own labours. It is a body that produces meanings, in other words, but not commodities. Its silences are therefore akin to those I have discussed in current autobiographical narratives. This textual body eliminates not only the production of commodities, however, but also that of/in space: the space of the computer, the office, the rushing about, the aching body taking up thought where words should be, without finding its way to words. The space of this body is reduced to that of two measurable but problematic tropes, sexuality and observability, conflated through the critique of representation. These bodies remain in an abstracted space, a philosophical space, rendered as a space of surfaces, which is to say, no space at all.

This semiotic inflation provides us with a set of critical readings or textual analyses "informed by an ideological-critical perspective, and hence necessarily sensitive to social and political factors. But they are rarely readings which attempt to discuss representation as the complex product of processes and institutions," as Janet Wolff writes in another context.[16] These readings speak of the body, but not about the disembodying conditions of producing such readings, nor about the effects of contemporary modes of intellectual or artistic production on the body, especially — as I look about me — the woman's body. These bodies are subject to (and index of) a historic foregrounding of the body as carrier of meaning marked resolutely by irresolute fragility — that is to say, by an inadequately fuelled "velleity of regrasping the world." These unspoken "processes and institutions" meanwhile retain their (internal/external) power by converting our experience into textuality, working to ensure continuing productivity and the unacknowledged perpetuation of systemic and inequitable suffering and pain.

The third consequence of this silence is pedagogical. It concerns the models we are able to set for viewers, readers, and students, which oscillate between the subjectivity of victimhood and the shadow of intimidation — being a successful woman within the professional cultural/theoretical terrain means having to write two books and eighteen articles a year, attend many conferences, sit on ten juries or committees, and often (though this is not pursued in public) abandon family life, especially motherhood. So many women now seem to be writing or making art as daughters, as though our mothers are the last generation of women who can identify us. (The explosion of mother/daughter films is closely linked to current debates in feminist psychoanalytic theory, but in what context is this an adequate explanation?) Joining the new academy comes to resemble a new type of voluntary commitment, as in a religious order; at Concordia, a colleague warned incoming graduate students that they should be prepared to sacrifice jobs, relationships, and family life during the duration of their studies.

There are now an unprecedented number of feminist graduate students working in the domain of culture and theory. Is this the product of the post-1970s seduction of theory as it disseminates itself across institutions, disciplines, and practices? Or rather, does it derive from the increasingly brutal fiscal crisis of the state, which greedily and vindictively rationalizes the spaces for intellectual and artistic work? There is much to be said about the relationship between these developments. While students now have marginally more women faculty members with whom to work than I did, I have never heard so much ambivalence and anxiety about life in the academy. It is not surprising: they observe a seemingly merciless standard of intellectual productivity — the dark side of institutional survival which relies on health, privilege, a growing inability or disinclination to respond to the demands of teaching and/or local community (neither of which are rewarded with publishing contracts or tenure), and a new level of structurally enforced competitiveness that undermines everything that women can and must bring to critical knowledge.

These issues have tended to be set aside in feminist theoretical and critical discourse, whose sophistication in debates around psychoanalytic theory, representation, textual analysis, and subjectivity has emerged with ambiguous success in the context I have described. Such sophistication makes it possible to demonstrate one's familiarity with the masters, and to position one's work in relation to theory in its most recent formulation. But it is also possible, given the intellectual, symbolic, and social resources that feminists have struggled to create, to pursue strategies for feminist intervention which would counteract the silences I have described. We can learn something from homeopathy, which reinvents the "reading" of the body's messages by searching for meaning in terms of systemic interactions between social experience and personal well-being. Rather than shunning the well-entrenched metaphorization of illness or further perusing the well-examined labelling of women as hysterics, we need to confront, appropriate, and transform

these "metaphoric" discourses for our own needs.[17] Such work will resituate the critical thematics and practices of feminist theory, drawing on the resources of autobiography, the structural analysis of institutions and markets active in the production of knowledge, ideas, and images, critical analysis of patriarchal institutional discourses, the medical politics of AIDS activism, and the suppressed knowledges and narratives of the body. With such work we can continue to challenge and rebuild the contexts in which art, knowledge, and women's lives are produced.

With this in mind, I append my statement to the "Art as Theory: Theory and Art" conference on International AIDS Day (1 December 1991). Its purpose was to affirm what we have learned in the past decade from the work of gay and feminist activists, artists, and intellectuals engaged in the struggle with AIDS. This is in addition to their embattled engagement with medical professionals and medical knowledge, whose relationship with the concerns in this paper would require another one to explore.

(1) The critique of representation—of images, signs, symbols, social narratives—is connected in profound and distinctive ways with the domains of politics, identity, power, solidarity, life, and death, both separately and together.

(2) We know that rigorous and subtle work can be produced in the context of collective work, a collective spirit, and a collective (if often contentious) agenda.

(3) We are continuously reminded of the urgency and intensity of challenges facing artists and critics today: to know the fragility of the human body, the neediness of the social body, the desperate state of the body politic (yesterday diagnosed with rigor mortis), and the health of the earth itself, outside and beyond any of our bodies. We turn our backs on these at our peril.

Notes

Many friends have offered critical feedback and moral support in the writing of this paper. I wish to thank especially Marilyn

Burgess, Lani Maestro, Mary Anne Moser, Cheryl Simon, Carol
Wainio, and Cheryl Sourkes.

1. In their original sequence: "Perspectives on Theory: Women
in Scholarship"; "Perspectives, Positions and Singularities in the
Academy — The Case of Women"; "Political Correctness — Women
in the Academy"; "Women and the Production of Knowledge";
"Gendered Knowledge"; "Women and the Production of Knowl-
edge: Savoir a-t-il Une Sexe?" One might interpret these titles as
follows:

— On theory: a space to refer to influential or excluded authors
from the vantage point of the contemporary canon.

— Women in the academy: a chance to talk about academic knowl-
edge from the perspective of these authors.

— Political correctness: debates about women, politics and ideology,
from outside the academy, outside feminism, with a polemical
response.

— The production of knowledge: this could be inside or outside the
academy, and so implicitly introduces different kinds of relation-
ship between "knowledge production" and the academy, recogniz-
ing the possibility of non-identity between the two.

2. Arlyn Diamond, "Interdisciplinary Studies and a Feminist
Community," *For Alma Mater: Theory and Practice in Feminist
Scholarship*, ed. Paula Treichler, Cheris Kramarae, and Beth
Stafford (Urbana: University of Illinois Press, 1985), 205.

3. Gill Frith, "Transforming Features: Double Vision and the
Female Reader," *New Formations* 15 (Winter 1981): 74.

4. Ibid.

5. Spivak raises this question — and returns to it — in the inter-
view "Practical Politics of the Open End," *The Post-Colonial
Critic: Interviews, Strategies, Dialogues*, ed. Sarah Harasym (Lon-
don: Routledge, 1990), 109. Her interviewer, Sarah Harasym,
introduces a discussion of "the critique of the ideological subject
constitution within state formation and systems of the 'political
economy'" by referring to the dual concept of representation
employed by Spivak. Spivak raises the question of essentialism in
connection with the process of representing. What is so interesting
about this discussion, and the challenge Spivak herself mentions
("Well, you know people talked about you and it was stressed that

IDENTITIES: JODY BERLAND 153

Stephen Heath had actually said this before you...") is that she returns to authorship/genealogy several times but never addresses or explicates it as such. It seems odd to see this anxiety present but unexamined in the context of discussing "the ideological subject constitution within state formation and systems of the 'political economy'!" But it's one of many instances.

6. Jean Baudrillard, "Gesture and Signature: The Semiurgy of Contemporary Art," *For a Critique of the Political Economy of the Sign*, trans. Charles Levin (St. Louis, Mo.: Telos Press, 1981), 105.

7. Ibid., 106.

8. Ibid., 107. *The Concise Oxford Dictionary* defines velleity as a "low degree of volition not prompting to action: slight wish or inclination."

9. Kari Delhi, "Leaving the Comfort of Home: Working through Feminisms," *Unsettling Relations: The University as Site of Feminist Struggles*, ed. Himani Bannerji, Linda Carty, Kari Delhi, Susan Heald, and Kate McKenna (Toronto: Women's Press, 1991), 50.

10. Kate McKenna, "Subjects of Discourse: Learning the Language That Counts," *Unsettling Relations: The University as Site of Feminist Struggles*, ed. Himani Bannerji, Linda Carty, Kari Delhi, Susan Heald, and Kate McKenna (Toronto: Women's Press, 1991), 125.

11. Perhaps this is why the increasingly popular genre of mystery fiction by women now proliferates with murderous horrors on university campuses mainly enacted upon and detected by valorous women otherwise committed to more traditional scholarly pursuits.

12. Diamond, "Interdisciplinary Studies and a Feminist Community," 200.

13. McKenna, "Subjects of Discourse," 126–127.

14. Nancy Fraser, *Unruly Practices: Power, Discourse and Gender in Contemporary Social Theory* (Minneapolis: University of Minnesota Press, 1989), 171–183.

15. Delhi, "Leaving the Comfort of Home," 49–50.

16. Janet Wolff, *Feminine Sentences: Essays on Women and Culture* (Cambridge: Polity Press, 1990), 109.

17. Cf., J. Berland, "Condemned to Meaning: Sex, Gender, Knowledge, Pain," *Rx: Let's Play Doctor*, ed. Monika Gagnon (Vancouver/Toronto: Artspeak, 1993).

IMITATING AUTHORITIES:
Theory, Gender, and Photographic Discourse

Elizabeth Seaton

IN A HIGHLY MALEVOLENT act of remembrance, much of
the photo-based work produced in art schools during the
eighties may be recalled as being very serious, as though
there was this death-watch going on in which any theoreti-
cal faux-pas was closely monitored. It can be recollected as
a period of countless Mary Kelly spin-offs, floating Charcot
bodies, and snippets of disembodied text accompanying
fuzzy photographs. At best, these repetitive photographic
practices — as if to confirm a Bourdieuian notion of the
avant-garde — seemed to speak to no one but other like-
minded cultural producers. At worst, their engagement with
theory — invoked for its ability to raise a contestatory and
critical consciousness — produced only the monotone voice of
a formal language which, in the end, seemed to speak to no
one at all.

This mean-spirited memory recalls a time not only when
the market for art photography boomed, but also when a
booming party was held for the Death of the Author, an
extended wake in which extreme unction was offered by
famous French men and numerous obituaries were written
across the texts of photographic theory and criticism. It was
a time, then, when both the complicities and conflicts
involved in the practices of photographic criticism and the
production of a marketable photographic canon were sharply
brought into view.

Interestingly Roland Barthes, as one who offered extreme unction, began his last rites for the Author with Honoré de Balzac's story "Sarrazine." He recounted that part of the tale in which La Zambinella, the castrato disguised as a woman, is described as "woman herself, with her sudden fears, her irrational whims, her instinctive worries, her impetuous boldness, her fussings and her delicate sensibility." And Barthes asked, "Who is speaking thus?"

> *Is it the hero of the story bent on remaining ignorant of the castrato hidden beneath the woman? Is it Balzac the individual furnished by his personal experience with a philosophy of Woman? Is it Balzac the author professing literary ideas on femininity? Is it universal wisdom?... We shall never know, for the good reason that writing is the destruction of every voice, of every point of origin. Writing is that neutral, composite, oblique space where our subject slips away, the negative where all identity is lost, starting with the very identity of the body writing.[1]*

There is much room for expectation here, for Barthes posited the Death of the Author as coterminous with the Birth of the Reader. Hence, the significance of a text—once anchored to a certain place of origin—was freed to drift towards more uncertain, and always contingent, destinations. And yet, just as immediately, this optimism dissolves into darker areas of discontent where suspicious questions arise. For is it no accident that Barthes begins his account of authorial demise with the story of an unwhole subject hiding behind the body of a woman? Is this not a story of feminine masquerade and the hopeless pursuit to discover what is beneath the mask of femininity: the impossible quest to reveal the identity of the woman, of the "woman herself" behind the mask? Is it not again a report, filed by a man, of a feminine subject as missing person?

In one of the key theoretical texts of the eighties—a text that was to find its image in the works of female photographic artists such as Cindy Sherman and Sherry Levine—Stephen Heath writes of how "the masquerade comes out as

a basic fact of female identity." Acting on Joan Riviere's 1929 essay "Womanliness as a Masquerade," Heath notes that "the masquerade says that woman exists at the same time that, as masquerade, it says she does not."[2] And indeed, we see this in the works of Sherman, where the truth and the lie turn upon one another, each image marking no specificity, no "point of origin," other than the representation of woman herself.

This poststructuralist movement has held decisive importance for feminist photographic critics and practitioners, just as it is they who have importantly advanced its direction. Attention to the material and semiotic productivities of images have enabled feminist photographic critics and practitioners not only to spell out the assignment of sexed subjectivities through representation, but also to divert or interrupt these assignations (as evidenced again, in a work of masquerade). When acted out upon a female body, the masquerade of femininity does not simply strike an empty pose to an appreciative audience; it strikes back at those who would fill this figure with an essential meaning. It has the political capacity to ridicule the categorical differences which picture and produce a gendered identity. But there are drawbacks as well as gains to be had from such anti-essentialist theorizations. Taken to the extremes of their logics, they may threaten to pull any effectual grounds for identity out from under the feet of women. And it is in this respect that poststructuralist explanations may collude and continue with an ongoing negation of female photographic artists as authors – that is, as the creative and inventive producers of culture.

I don't mean to imply that incomplete, plural, and provisional identities mean a loss of political capacity. Nor do I wish to propose some sort of singular, coherent, or immutable identity of authorships for women (which of course, in its universalist tendencies, would no doubt end up being the beige kind). My purpose in bringing up these gendered tensions (between authorship and the Death of the Author) which lie at a particular historical moment is to raise the

uncertainty by which theory can be said to offer political direction to critical photographic discourse. The identity of authorship, as we have learned from social-constructionist theories, is not based upon some innate, prior moment of being or meaning. Authorship is itself a construction of representation. And yet, while the Death of the Author continues to contribute to the interventions of recent photographic discourse, authorship is still very much alive and extant within the discursive and institutional apparatuses of photography. It remains a necessary component not only for the commodification of a photographic object, but also for the critical interpretation, explanation, and situation of photographic practices. Authorship, in sum, plays a key role within the overdetermined conditions of possibility which permit or prohibit different things about photography to be seen, said, and known at a given moment in time. It does make a difference who makes a photograph.

Historically, women have been refused proprietary claims to this status, owing to both the social constitution of gendered identities and, correspondingly, the gendered construction of authorship. Quite simply, women have not been socially endowed with the fictional identity of a determinate and sovereign subjectivity deemed to be the requisite criteria for authorship. Denied the full weight of such a singular presence, female identity is thought of in other respects — as that which is drawn up and held at one oppositional end of a gendered dualism. Behind this identity configured through sexual difference, there is no essential or evident subject to be found. Hence it was that, during a heightened presence of poststructuralist thought within photographic discourse, women were posed as the very ciphers, the representative stand-ins, for the celebrated death of a determinate and sovereign artistic subject. And it is perhaps for this reason that so many women, as honorary guests, were invited to dance on the Author's grave. But at what cost does this invitation come? In considering this decades-long wake for the Author, I want to think through certain conditions of possibility and impossibility which contemporary

cultural theories have offered to the critical interpretation of female photographic authorships.

Contemporary cultural theories have provided many analytic tools needed for the reformulations of recent photographic discourse. Nuanced theoretical approaches which emphasize the social relations of visual representation and the unconscious — which posit both representation and self-representation as the product of symbolic codes and systems — have been enlisted to disturb the entrenched wisdoms of a modernist photography, particularly its ontological and epistemological supports of realism and authorial expression. Much of the pedagogical and political status of these theoretical interventions rests precisely upon their presumed marginality to mainstream photographic discourse. And yet while these innovative theoretical practices may still remain marginal to a much larger commercial and aesthetic photographic apparatus, they do enjoy a degree of persuasiveness within certain institutions: namely, art schools, the fine arts departments of universities, parallel or non-commercial galleries, critical art journals and magazines, and, increasingly, museums and commercial galleries. I raise this point only because I want to question whether such theories, which are undoubtedly adversarial and contentious at one time and place, necessarily remain so in another. Differently put, theory cannot be accorded an *a priori* place, or condition of origin, for the meanings and political inflections of recent photographic criticisms and practices. Theoretical choices involve political choices, which, like photographic practice, are always historically constituted.

In this respect, the alliances between theory, criticism, and photographic practice can be found to be neither straightforward, nor always hospitable. The application of theory to photographic discourse is highly dependent upon a contingent moment of social and political relations — a contingency which produces slippages, inconsistencies, and contradictions, rather than an unmediated or wholesale exchange. The engagement with theory has led to a series of challenges to the insularity and insidious dogmatism of

previous photographic canons. But, as my mean-spirited memory insists, it is not immune to dogmatism itself.

It is from this contradictory situation that I want to rethink the logics of causality or determinacy by which contemporary photographic discourse (theory, criticism, practice) is recognized as "political" (wherein the "political" is always recognized as "progressive," rather than conservative). Given that theory itself has no common or stable problematic — no common agenda always already inscribed onto itself — we can only look to its use within specific historical and institutional limits. What needs to be questioned then are the links between different theoretical approaches and different levels of social powers, political powers, and economic powers involved in a photographic apparatus. Who benefits from these linkages? And how may the engagement with theory not only act to interrupt claims to a stable set of referents, but also act to further certain continuities and conservations, particularly in terms of the sexual specificity awarded to concepts of authorship?

In keeping with Barthes's account of authorial demise, I want to pursue a historical trajectory in which female photographic artists have been commonly represented in mysterious terms of ambiguity or disguise. In this respect, I shall begin with the story of a female photographer who was said to be never quite there, and whose presence as an author paradoxically became more pronounced as she herself was to become literally absent. I shall continue then to trace the historical recurrence of this ambiguous figure within more recent critical discourses of photography, and mark the ways in which her representation has continued to enable, as it masks, the gendered values of a photographic discourse which has been written over her form. Finally, I want to conclude by considering the possibilities which a relational or "performative" theory of authorship may offer to the present, and how it may be used to negate and disrupt that loss of authorial identity for female photographers which Barthes claims begins with "the very identity of the body writing."

Certain Bequests

My account, then, begins somewhat cruelly with another death: the disappearance of a woman by her own hand. In a black-bordered obituary entitled "Diane Arbus: The Mirror Is Broken," the photographic critic A.D. Coleman wrote in the 5 August 1971 *Village Voice*:

> *Diane Arbus slashed her wrists and bled to death in her West-beth apartment—sometime late Monday or early Tuesday, since her diary contained an entry dated Monday, July 26....*
>
> *Of her death, Richard Avedon, who knew her well, said, "Nothing about her life, her photographs, or her death was accidental or ordinary. They were mysterious and decisive and unimaginable, except to her. Which is the way it is with genius."*

Diane Arbus is well known for her photographic portraits of the 1960s, in which she portrayed, with an unsettling eccentricity, what has been called "the normalcy of the grotesque and the grotesqueness of normalcy."[3] In a decade in which photographic culture was obsessed with the perversity of American society, Arbus's work did not stand apart, in any general way, from that of her contemporaries (Larry Davidson, Danny Lyon, Gary Winogrand). Within a rampant climate of liberal pluralism, the subject matter of the late sixties was the quotidian, and those who got the closest to it were the heroes of the day. Like Tom Wolfe's stories of Park Avenue hosts wooing Black Panthers at fancy cocktail parties,[4] the idea was to get intimate with the controversial or the exotic without overstepping a fine line of difference. The challenge was to associate with the ruined and the ruinous, but without coming to ruin yourself.

The problem for, and the popular myth of, Arbus was that she got too close. This dangerous proximity was only confirmed and advanced by her suicide. With her death, her representations of tortured souls became all the more self-representative; her incursions into the private disasters of others could be read as her own journey into night. The cruel instrumentality of these portraits could now slide all

the more easily onto the terrain of the honorific because, after all (it was said), these were really self-portraits.

As the director of New York's Museum of Modern Art's photography department for twenty-eight years, John Szarkowski has wielded much influence within the discursive apparatus of art photography. In particular, it was his formalist approach — borrowed liberally from Clement Greenberg — which was to provide the authoritative model for interpreting and evaluating sixties modernist photography. Szarkowski writes of Arbus soon after her death:

> *She valued psychological above formal precision, private above social realities.... She was interested in people for what they were most specifically: not representatives of philosophical positions, or lifestyles, or physiological types, but unique mysteries. Her subjects surely perceived this, and revealed themselves without reserve, confident that they were not being used as conscripts to serve an exterior issue. They were doubtless also interested in her. At times it may have been unclear who was the mariner and who was the wedding guest.*[5]

In addition to the attempt to exonerate Arbus from the politics of her photographs, what is evident here is Szarkowski's gendered construction of Arbus as a woman acting in the service of others, rather than guided by her own, individual volition. In this respect, whether or not Arbus's subjects are "used as conscripts for an exterior issue," Arbus most certainly is. Arbus's subjectivity is seen as guided by something above and beyond herself — in this case, her subject matter. In her photographs, authoring subject and pictured subject are believed to collide to the point that it becomes unclear "who is the mariner and who is the wedding guest." Arbus's artistic subjectivity is precisely constructed as an authoring of self, as a self-representation. But this is a self-representation derived from elsewhere — from the image rather than from the woman.

The details of this representation become distinct in light of its history. It occurs at a time when the constitution of an

absolute and sovereign subjectivity for modernist photographers reigned supreme. It is the signature of this artistic subject which lends value to the photograph. It is the mark of an authoring subject who was posed as original, singular, and always in control. It was very much the representation of a masculine subjectivity — one removed from and held above the banal specificities of commerce, politics, and history (as was the majority of modernist photography which leaned upon a distanced and depoliticized formalism).

So strong was this concept of the sovereign subject that the artists themselves refused to talk of any motivating interests. Thus Lee Freidlander is quoted as saying: "I was taught that one picture is worth a thousand words, weren't you?"[6] Duane Michals, in the tone of the day's hippie individualism, simply stated, "You are the trip."[7] And Gary Winogrand, much to the exasperation of his interviewer, claimed, "I don't have anything to say in any picture."[8] While these statements of refusal may be seen to deny the authority of self-expression, in the end they only act to protect both photograph and photographer from any unwanted factors which may have disrupted their status and value. They maintained a distanced, self-contained, and disembodied subjectivity for the art photographer — a subjectivity whose appearance was grounded in a coherent, albeit transcendent self, rather than drawn between opposite ends.

All the Difference in the World
To my mind, the two visible canons for photography in the past half-century have been the modernist and the postmodernist. But I locate their distinction not in the usual reasons of historical contrast. My interest in modernist photography centres upon Arbus, on how she was made to occupy gender-specific constructions of authorship in order to be included within the roster of a sixties boys' club. My interest in postmodern photography does indeed lie in the ways in which its political emphasis was directed against the past sins of a photographic modernism: against its formalistic and ahistorical tendencies; against its constructions

of a sovereign subjectivity. But more so, my interest is held by the fact that this postmodern photographic canon was largely made up of women whose work was particularly anchored to feminist concerns with gendered subjectivity, sexual difference, and representation. In contrast to the anomaly which Arbus posed to a mostly male modernism, we now find a large number of female artists (Barbara Kruger, Cindy Sherman, Sherry Levine, Jenny Holzer) who have all been present on the cover of *ArtNews*, "whose *People* magazine approach," as the critic Richard Bolton puts it, "is the best vehicle to certify the arrival and collectibility of a new star."[9] Perhaps there is optimism to be grasped under this cynical statement. Perhaps the arrival of a canon largely comprised of women offers a representation of female authorship previously unseen. But given that the explanation of a text, or canon of texts, cannot be dismissed from that historical moment which inspires and informs it, it is not a quantitative difference which needs to be measured here.[10] Owing to the historical dependency of canon to authorship, it may be more useful to examine the particular "author functions" demanded by a supposedly authorless age.

In her 1984 essay, "Winning the Game When the Rules Have Been Changed: Art Photography and Postmodernism," Abigail Solomon-Godeau locates a feminist critique within a postmodern photographic practice that had previously been defined only in terms of the aesthetic limits of deconstruction. In writing of Sherrie Levine's now infamous rephotograph of Edward Weston's *Study of Neil*, she notes how Levine's appropriation of this photograph did not simply disclose the constructed authorities of "an original master of photography," but also revealed the way this privileged vision had so often (particularly in photography) stood in for sexual privilege. Levine's wholesale theft of this image undermined not only the aesthetic and legal but also the paternal authorship of Weston. Solomon-Godeau writes:

Levine's refusal of traditional notions of authorship has social and political implications as well ... the notion of the author is integrally linked with that of patriarchy; to contest the dominance of the one, is implicitly to contest the power of the other.[11]

Informed by the theoretical practices of poststructuralism, postmodern photographic critics asserted that there was no vantage point outside – no stable referent of "the real" or "truth" – from which to challenge the politics of representation. Similarly, in refuting an authorial and artistic subject, they would also assert the constitution of subjectivity through representation. Renouncing the possibility of an *a priori* presence, either in the human mind or in the human world, these critics worked to explicate the absence of any original difference. As Douglas Crimp wrote in an early article, "The Photographic Activity of Postmodernism," "even the self which might have generated an original is shown to be itself a copy."[12] In this respect, the authorial status of postmodern photographers was considered to be securely exhausted and exempt from the stain of traditional concepts of artistic subjectivity. Rather, they were seen to be "linked," as Solomon-Godeau put it in her 1982 "Playing in the Fields of the Image," "by a common absence of authorial presence, vision and subjectivity." For Solomon-Godeau, "the exemplary practice of the player-off of codes require[d] only an operator, a producer, a scriptor, or a pasticheur." She felt that "The notion of subjectivity and self-expression is less disputed than considered to be entirely beside the point."[13]

Clearly, the political agenda of these critics was to make visible the dependence of the artist (for both status and practice) upon existing structures and institutions of representation. Yet while much of these critical articulations bespoke a defensive manoeuvring against the authorial supports of a modernist art photography, they also acted to recuperate a distanced subjectivity for postmodern photographers. More to the point, while pushing a sovereign and authorial subject out the front door, they let him in again

through the back, only this time disguised. This "anonymous player-off of codes" was in fact sexually specific, or rather his refusal of accountability and presence hid the specific privileges of his sex. Consider, for instance, the symptomatic evidences given by Solomon-Godeau for the subjectivity of Richard Prince, an "almost him" which "functions as an analogue to a fully conventionalized reality composed of images and simulacra."[14] And yet, in contradistinction to a "simulated" subjectivity, the effectivity of Sherie Levine's rephotograph of Weston's image stems in a large part from the presence of her own name, typed neatly below.

During postmodernism's hey-day, the "crisis of representation" loomed large over the rhetorical horizon. Any enabling vantage point, any stable place from which to stake a claim, was seen to collapse, and, with it, the conventional authorities of representation. And insofar as the critic was constantly reconsigned to a shifting point of view, the certainty of his or her evaluative claims was also brought under question. Without a fixed or essential signification, from what defining horizon was a critic now to make assertions in a detached and final manner?

Logically, this ought to mean that the recognition which a materialist analysis demands—that the explanations of a text are dependent upon its historical specificity—cannot be ignored. To see a critic's explanations as equally bound to epistemological and institutional situations would be to erode those privileged biases which allow for authoritative statements (of the real, of truth, of evidence). And yet, contradictorily, this historical crisis gave way to an ahistorical epistemology. In the rush to disown claims to authority, all knowledges and all structures of power became suspect: all were found to be equally, and necessarily, the same. It seemed that on the other side of that postmodern coin which read, "all the difference in the world," were the words "no difference." The pluralistic dismissal of these hierarchical distinctions (of origin, of place) served to conceal the specificity of a practice which is precisely predicated

upon sexual, racial, and class hierarchies of enunciation and representation. It allowed critics to speak from the universalities of an unmarked place — a bleached-out place (it almost goes without saying) of whiteness.[15] Moreover, it enabled critics to continue camouflaging the artist against the specific effects of history — leaving an "almost him" free from having to stake a visible claim in politics, while reinscribing the impossibility of an achieved authorial identity for certain others. In effect, something was left to continue in the claim that it no longer existed.

Leaving Illusions for the Real Thing

Nowadays, the influential ground which postmodernism held has fallen away; indeed, the word itself at times seems almost embarrassingly dated, which is what happens to most styles worn after their fashionable moment. Less flippantly, the effectivity of theoretical and representational strategies is always bound to specific historical limits. It was in just this postmodern conversation which contradictorily preserved silence that the voices of others were shouting to be heard. As one of the many women to critique this "postmodern turn," Nancy K. Miller wrote:

> *the postmodernist decision that the Author is dead, and subjective agency along with him, does not necessarily work for women and prematurely forecloses the question of identity for them. Because women have not had the same historical relation of identity to origin, institution, production, that men have had, women have not, I think (collectively) felt burdened by too much Self, Ego, Cogito, etc.*[16]

During the mid to late 1980s, an emerging "identity politics" began to reveal a growing resistance to the universalizing discourses of postmodernism. Particularism and difference (and not an infinite semiosis) were forefronted in activist practices which were to speak clearly from a social identity and thus seem to establish parameters of commonality and consensus based upon that coherency. And yet, as

is now well known, there were, and continue to be, problems with "identity politics." Foremost is the way in which "experience" is used as the guarantor, or the authenticating ground, for the propriety of an identity. Admittedly there is an attractiveness in the claim to experience, particularly in the way it insists upon, and echoes, that feminist dictum regarding the interconnectedness of the personal and the political. And yet, such privileging of experience as the ground of an authentic or coherent identity also tends to block off connections between different structures, individuals, and identities, and too often ends up as a bad version of one-upmanship — as in, "my experience (as a woman, a lesbian, a black woman, a working-class woman) is more oppressive (more valid, more real, more authentic) than yours." In the end, such games of identity politics, while authorizing the words of some, tend to annul the speech of others.

More particularly, and in line with my questions regarding the theoretical articulation of female photographic authorship, it must be stated that while the recognition of ethnic, racial, and sexual specificity was to become increasingly "institutionalized" within photographic discourse at this time, such awareness did not necessarily elide the convenience of dualistic categories of difference. In a repeated reliance upon binaristic models for the explanations of identity, it was identity as "otherness," rather than a complex and contradictory historical formation, which was to act as the predominant explanatory factor for the interpretation of female photographic practices.

This dualistic framework represents a continuing conceptual dilemma for the question of female identities and authorships. For if "experience" is to be used as the authenticating ground of a female authorship, then one risks recuperating some very essentialist claims. Conversely, to emphasize the social construction of female identity may act to deny any agential capacity on the part of the author — asserting rather that she is, as Richard Dyer has put it, "not really there [but] merely a product of social forces."[17]

This dilemma becomes especially conspicuous within those critical writings which lean heavily upon the trope of feminine masquerade for their explanations of female photographic authorship (something which, again, we saw in interpretations of Sherman's work). As an untruthful, and yet only truthful, image of femininity, the tactics of masquerade have been claimed by critical discourse in order to negate the possibility of an intrinsic referent for a feminine identity. The emphasis is on the dressing-up that women must do in order to flaunt, and thus hold the representation of femininity at a distance. And yet, in not seeing women, but only the masquerade of a woman, critics can effectively guarantee the absence of the effectual identity for female artists (an absence which is neatly explained in terms of the absences disguised by masquerade). It is a particularly effective sleight of hand, especially potent in the way it ostensibly mimics its object of inquiry. While asserting no unitary basis for the existence of "woman herself," such tactics may contradictorily place women within a unifying representation of non-existence. The blank space left by masquerade's refusal of "the real" may thus serve as a screen for further masculine projections. My intention in raising some of the consequences of this rendering of masquerade is not to claim a prior ontological feminine which has somehow gone missing under the mask of theoretical make-up. But not believing in a universal or innate female authorship does not mean that one must fall for a universalist theory of the representation of femininity. And, thankfully, there are better things to believe in than that system of belief (in correspondences or equivalences) which underscores theories of ideology and representation.

In large part, the dilemma of female authorship that I have attempted to address speaks to a quite troublesome problematic residing in what Stuart Hall names "arbitrary closure," enunciated in his statement that "to say anything at all, you do have to stop talking."[18] The contradiction of this statement, the paradoxical necessity of staying put, if

only momentarily, in order to put something forward, underlines the difficulty of articulating the authorship of a female photographer. In order to be entitled as a female author, the author's identity must in some respects be definitively placed, and yet, as a "woman," her identity is always deferred. Identity, as Hall has pointed out, must rest to some extent upon a shared, imagined ground of "being." And yet, identity is also simultaneously given over to a constant and endless process of "becoming"; it is that which is always being made anew within shifting constellations of bodies, movements, and affects. In that process, identity always escapes and exceeds those binary structures of representation which would definitively fix it as a product of otherness. In thinking the identities of female authorship, we may move beyond the conceptual limits of representation and ideology to consider the ways in which female identities are mutually and momentarily articulated within the interdependent effectivities of gender, sexuality, race, nation, ethnicity, or class. We may think through the ways in which female authorships are contingently enunciated in the momentary coherences, the "arbitrary closures," of a woman's active engagement within and against the social ways of the world.

This act of stopping, if only momentarily, in order to stand and make a claim for oneself, may also involve a backward look at the ground which one has passed—and been passed over—before (for surely, female photographic artists have not necessarily been prohibited, but more simply passed over, by a masculine economy of canon and authorship). As the abject, or the unnamable, within a discursive structure in which masculine subjectivity is named as the only original, female photographic artists have been posed, at best, as only playing at, or imitating, another's cultural property. But if in fact, as Judith Butler tells us, gender (all gender) is but a drag, a performance, "a kind of imitation for which there is no original,"[19] then so too is the masculine standard of authorship only a theatricalized copy of an invented "original." It is in this respect that all gender (not

just femininity) and all authorship is increasingly recognized as performance—sometimes brilliantly posed, sometimes awkwardly embodied, but always played out within specific historical relations.

Thus it is that contemporary cultural theories are now being skilfully drawn upon and redrawn by female photographers in ways which elaborate a wider reach of identity. And like the shock posed by the castrato discovered beneath the clothes of Sarrazine's idealized love, the efficacies of photographic discourse's set categories of analysis may also be increasingly scrutinized. For it is from this point of exposure that the density of a dualistic sight may begin to break up, and the detachment and distance of representation may begin to break down, in order to accommodate the complex energies, movements, and moments of authoring and embodied subjects.

Notes

1. Roland Barthes, "The Death of the Author," *Image, Music, Text*, trans. Stephen Heath (New York: Hill and Wang, 1977), 142.

2. Stephen Heath, "Joan Riviere and the Masquerade," *Formations of Fantasy*, ed. Victor Burgin, James Donald, and Cora Kaplan (London: Methuen, 1986), 54.

3. Jonathon Green, *American Photography: A Critical History* (New York: Harry Abrams, 1973), 206.

4. Tom Wolfe, *Radical Chic and Mau-Mauing the Flak Catchers* (New York: Farrar, Straus and Giroux, 1970).

5. John Szarkowski, *Looking at Photographs: 100 Pictures from the Collection of the Museum of Modern Art* (New York: Museum of Modern Art, 1973), 206.

6. "Untitled 2 and 3," *Friends of Photography* (Carmel, California, 1972), 10.

7. *Afterimage*, "Report on the Society for Photographic Education Conference, October 23–25, 1975" (November 1975): 3.

8. Mary Orovan, "Gary Winogrand," *U.S. Camera* (February 1966): 21.

9. Richard Bolton, "Enlightened Self-Interest: The Avant-Garde in the 80s," *Afterimage*, vol. 16, no. 7 (February 1989): 17.

10. This inclusion of female artists and feminist critiques into the folds of canon cannot be considered in isolation from a historical moment (the 1980s) in which the art market boomed and bloated to notorious proportions and collectors eagerly paid for the privilege of owning an artwork which confirmed their own liberal sensibilities.

11. Abigail Solomon-Godeau, "Winning the Game When the Rules Have Been Changed: Art Photography and Postmodernism," *Screen*, vol. 25, no. 6 (November/December 1984): 98.

12. Douglas Crimp, "The Photographic Activity of Postmodernism," *October* 15 (Winter 1980): 98.

13. Solomon-Godeau, "Playing in the Fields of the Image," *Afterimage*, no. 10 (1982): 13.

14. Abigail Solomon-Godeau, "Winning the Game When the Rules Have Been Changed: Art Photography and Postmodernism," 99.

15. Indeed, the representational powers of "whiteness" precisely depend upon the "common-sense" or inevitability implied in the statement, "It goes without saying." As Richard Dyer remarks on the ability of whiteness to "colonize the definition of the normal,"

> In the realm of categories, black is always marked as a color (as the term 'colored' egregiously acknowledges), and is always particularizing; whereas white is not anything really, not an identity, not a particularizing quality, because it is everything— white is not color because it is all colors. from "White," *Screen*, vol. 28, no. 4 (Autumn 1988): 45.

16. Nancy K. Miller, "Changing the Subject: Authorship, Writing and The Reader," *Feminist Studies/Critical Studies*, ed. Teresa de Lauretis (Bloomington: Indiana University Press, 1986), 106.

17. Richard Dyer, *Now You See It: Studies on Lesbian and Gay Film* (New York and London: Routledge, 1990).

18. Stuart Hall, "Minimal Selves," *Identity*, ICA Documents no. 6 (London: Institute of Contemporary Arts, 1987), 45; see also Hall's "Cultural Identity and Cinematic Representation," *Framework*, no. 36 (1989): 68–81.

19. Judith Butler, "Imitation and Gender Insubordination," *Inside/Out: Lesbian Theories, Gay Theories*, ed. Diana Fuss (New York and London: Routledge, 1991), 21.

THE EXCLUSIONS OF THEORY:
Feminist Ambivalence in Art Practice
and Criticism

Janet Wolff

THE PREMISE OF THE conference "Art as Theory: Theory
and Art" was the centrality of theory to contemporary art
practice. But this centrality, as became clear at certain
moments during the conference, is both problematic and
contested. Here I want to consider resistances to theory,
especially with regard to feminist art practice. In the con-
text of a commitment *to* theory, I will explore the very real,
and often justified, reservations in play in three related
areas: first, art practice and criticism; second, feminism in
general; and third, feminist art practice and criticism.

Art/Theory
In November 1990, a seminar was convened at the Forest
City Gallery in London, Ontario, entitled "Criticism or
Jargon." The meeting was initiated by a group of artists
concerned about the exclusionary effects of art criticism in
the art community. Speakers were asked to relate their
comments to one of the following six terms: reference, liais-
ing, practice, commodification, jargon, problematic. Those
attending the discussion could pick up bookmarks which
listed these terms, together with the title, date, and place of
the seminar. (It was unclear whether these terms, or some
of them, were chosen as examples of "jargon," though it
seems unlikely that the word "jargon" was intended to be
an example of itself.) On the whole, and predictably, the

divide on the question of theory was between artists (against) and academics and some critics (for). There were exceptions to this, since here as elsewhere there were cultural producers much involved with theory (and employing it in their work), as well as writers hostile to theory (or at least "high theory"). In general, though, the issue was that of accessibility and usefulness, and a view expressed more than once was that any artist ought to be able to understand critical writings about his or her own work. I don't happen to agree with this argument, since in this the artist may be regarded as *any* member of the public who would not normally expect, or be expected, to keep up with critical language and analysis. But this is not to say that all "jargon" is justified, or that there isn't an issue of accessibility to be considered, particularly with regard to journalistic as opposed to academic criticism.

On this occasion, though the debate was somewhat confused, the central issue seemed to be the pragmatic one of comprehensibility. Sides were taken on whether or not "difficult" theory was necessary in the service of complex analysis. The fact that debate on this issue does tend to get confused (is it a matter of opposition to *mystifying* theory or *all* theory?) obscures this question. A similar confrontation, based, I think, on the same blurring of issues, was recently staged in the pages of three journals. Steven Durland, in his editorial notes in *High Performance*, took issue with a talk given by Henry Giroux at a conference of the National Association of Artists' Organizations in Spring 1991, on the grounds that it was impenetrable. He refers to critical comments he had made on these lines at the conference itself:

> *After the panel discussion people said to me that it was my job to learn this new language. I say bullshit. I say it's the job of those who create it to teach it, to translate it, to make the ideas it encompasses accessible.... Most people are trying to develop theories on how to pay the rent. They don't have time to figure out what someone is talking about when it requires more than a ten-year old paperback dictionary.*[1]

Giroux replied to Durland in the journal *Afterimage*.[2] As Grant Kester has pointed out in an article in *The New Art Examiner*, both authors are wrong (and right): Durland is wrong to assume that "what [he] knows about and doesn't know about constitutes a standard of clarity,"[3] and Giroux was wrong not to give more consideration to the kind of audience he was addressing at the conference. Again, the issue turns out to be not so much one of whether theory in itself should be resisted, but whether the critical perspective produced with the benefits of theoretical work can be "translated" — the issue, that is, of the strategic and situational problems of communication.

In a very different manner, the problem of theory has also emerged within the academy. Here, it's a matter of an *excess* of theory. And here, theory is really Theory — that is, poststructuralism(s) which have steadily and radically displaced the "real" in cultural analysis. The potential opposition between Theory, on the one hand, and the social history of art, on the other, was already identified in the introduction to a 1986 collection of essays on the new art history, in which it was becoming clear that social histories of art may be epistemologically naive. If work in this area between 1975 and 1985 had been inspired by Marxism, formulated by T. J. Clark and others, and based on the recognition that art is a social product implicated in the relations and ideologies of a class-based society, the effect of poststructuralism (in the work of Michel Foucault, Jean Baudrillard, Jacques Derrida, Roland Barthes, and others) was to move from *class* to "*class*." As A.L. Rees and F. Borzello note, this shift evacuates the ground of any social history:

> *Too much stress on the social aspect of art ignores the qualities which make it art rather than something else. A different kind of dissolving is found in the new theory, which defines art as one of the major fictions in the grand fiction of western metaphysics. Since the concept of reality is another of these fictions, an extreme deconstructionist view can lead to a form of nihilism which not only dissolves art but threatens to cut the ground from*

under the feet of the social historians who base their studies on historical reality.[4]

The project of a social history of art has always been to ground the study of visual texts in social structures and processes; poststructuralist theories, ostensibly a development of that project, appear to undermine it by putting in question the categories of the social themselves, which are now perceived as effects of discourse. This paradox, here related specifically to social histories of class, comes up in a similar way in feminist debate, and I will come back to this later. The issue now is not whether to permit theory (jargon), but whether one can have "too much" theory. (Of course, the question of accessibility is also relevant within academic-critical work, since proponents of Theory are often called upon to defend difficult and complex language and ideas. This too is a concern within feminism, as I shall argue.)

As a provisional and rather summary response to the issues raised in this section, I would propose the following:

(1) Theorizing is essential to critical debate and analysis. Resistance to theory often simply means unwillingness to investigate the implicit theories with which one operates (a fundamental Frankfurt School argument against positivism).

(2) Communication is strategically necessary and politically important. Obscurantism and exclusionary mystifications should be resisted, and specific audiences and readers recognized and respected. In addition, the escalation of complexity in academic discourse is often unnecessary, and operates as an exclusionary practice itself.

(3) Understanding the discursive construction of the social world does not imply that there is no "real" or that there are not persistent structures of inequality which affect and interact with (and are affected by) culture. *Class* does not need to be between quotation marks.

Feminism/Theory

Feminism has an ambivalent relationship with theory. On the one hand, feminism *is* a theory (or perhaps a variety of theories), since it depends on the view that there are systematically structured inequalities of gender in society. On the other hand, feminists in a number of areas have exposed the androcentric nature of theory and theories. In the past ten years, feminist interventions in philosophy, science, and the humanities have taken issue with assumptions about the knowledge and theory which we inherit from the Enlightenment. These are some of the most prominent and important examples of this destabilizing of theoretical knowledge.

Philosophy of Science

The very bases of scientific method and knowledge are shown to be gendered in certain ways. Susan Bordo has argued that scientific thought and Western notions of rationality are products of a cultural construct of masculinity.[5] Evelyn Fox Keller and others demonstrate the congruence between the scientific model of "objectivity" and certain key aspects of masculine identity in our culture.[6] In some cases, this resultant (androcentric) model is perceived to operate in pernicious and distorting ways with respect to women's lives and interests.[7] Much of this work is indebted to the psychoanalytically based exploration of the construction of gender identities by Nancy Chodorow and others, which concludes that commitment to "objectivity" is the product of the tendency to separateness and to resistance to relational modes which form a central part of the male psyche in our culture. The implications of this analysis for rethinking science and scientific theory are evident. In addition, the directions and motivations involved in scientific work, particularly in areas like medical research, are clearly based predominantly on the concerns, needs, and fears of men.

Scientific Methodology

Related to epistemological critiques are arguments about the "masculine" nature of research methods, here particularly

in the social sciences. Liz Stanley and Sue Wise, for example, stress the importance of new methodologies which avoid the gender biases of the mainstream, and others have examined those biases in the collection of statistics, in interview techniques, and in styles of social scientific enterprise.[8]

Institutional Factors

As in most of the professions, women have historically been excluded or disadvantaged in the social and (especially) the natural sciences, both in their academic and their other institutional locations (private enterprises, independent laboratories, and so on). This is both a product of, and part of the reason for, the androcentric nature of scientific inquiry. This, together with the other factors I have listed, means that theory, including "scientific" theory (its most respectable, unquestioned version), has to be challenged and deconstructed.

Cultural Theory

Any analysis rests on a theoretical basis, whether this is articulated or not. Feminist literary critics and film critics have by now provided plenty of examples of ways in which such theories obscure factors related to gender differentiation. Accounts which seem neutral in fact operate on the basis of masculinist bias. For example, feminists have taken issue with Jürgen Habermas's critique of late capitalism and his account of the decline (and potential revival) of the "public sphere," a notion which, though potentially progressive, is premised on the historical exclusion of women (and working-class subjects) from that sphere, and which ignores the crucial interconnection between the public and the private spheres, a matter of real importance for women, who have been historically (and ideologically) associated with the latter.

In a recent paper, I have suggested that the current prevalence of metaphors of *travel* in cultural theory should be challenged for their gender bias.[9] Such vocabularies, themselves a valuable response to critical work in post-

modern and postcolonial studies, in the interests of destabi-
lizing theory rely on a metaphor which is already gendered,
and which imports into theory and cultural analysis the
connotations of its other usages. Notions of travel are gen-
dered, not because women do not travel (they clearly do), or
because they have not travelled in the past (though there is
no doubt that women who travelled faced far more obstacles
than men), but because the *ideology* of travel identifies the
male as the traveller, and therefore marginalizes or pathol-
ogizes women travellers. At the very least, I suggest, we
have to be aware of the possible implications of employing
certain tropes and of aligning ourselves with particular the-
oretical positions. (I have in mind here, for example, the
adoption by some cultural critics of the notion of "nomadic
theory" from the work of Gilles Deleuze; also in currency
are other "mobile" theoretical models, based on vocabu-
laries of maps, hotels, motels, travelling theory, tourist-as-
critic, and so on.)

All of this is meant to suggest that, across a range of
academic disciplines and theoretical practices, we cannot
assume gender-innocence. Rather, it often turns out that
there is a clear, and sometimes damaging, masculinist bias
in the theories and methodologies we employ. For this rea-
son, it has been suggested by a number of writers that there
may be an important alliance between feminism and post-
modern philosophy, both of which have an investment in
the demolition of (patriarchal) metanarratives. Among
philosophers of science, Sandra Harding has promoted this
view, arguing for a primarily destabilizing strategy which
does not attempt to reinstate a new orthodoxy of metanar-
rative.[10] In the arena of cultural practice, Craig Owens was
one of the first to propose this alliance.[11] But here we come
back to the paradoxical relationship between feminism and
the critique of theory. In short, too much deconstruction
undermines feminism itself. For one thing, the poststruc-
turalist critique of the subject has been resisted on the
grounds that women, who are only now gaining status and
self-identification *as* subjects, cannot afford to be decentred.

In addition, as Nancy Fraser and Linda Nicholson have pointed out, radical postmodernism eliminates the theoretical and social basis for critique, a basis which remains crucial for feminism.[12] Their compromise is in favour of a pragmatic retention of theory (if not of *meta*-theory).

By this point, it begins to emerge that theory means different things and hence the challenge to theory is not a uniform attack. In these debates about theory, there are at least four meanings — sometimes distinct and sometimes confusingly elided:

— theory as knowledge (science, etc.)
— theory as critique (for example, social-historical analysis)
— theory as metanarrative (for example, grand theories of historical development)
— theory as poststructuralism (Theory, deconstruction, postmodernism).

Presumably feminism need not reject the first two of these (while remaining alert to androcentric tendencies in each); about the second two, it retains an ambivalence born of the commitment to destabilization and intervention which it shares with the critique of metanarratives and the promise of poststructuralism (including postmodernism). All of these meanings, with their accompanying confusions, are in play in the debates about feminist art practice, to which I now turn.

Feminism/Art Practice

Judith Barry and Sandy Flitterman, in an early and influential article, argue for a feminist art practice grounded in theory, and one which, with the benefit *of* theory, engages in the constructions in representation of the very categories of gender.

> We are suggesting that a feminist art evolves from a theoretical reflection on representation: how the representation of women is produced, the way it is understood, and the social conditions in which it is situated.... Both the social constructions of femininity and the psychoanalytic construction of sexual difference can

> *be foregrounded if the artwork attempts to rupture traditionally*
> *held and naturalised ideas about women.*[13]

This statement is representative of what in the 1980s became a dominant view of the essential task of feminist artists.[14] The work of artists like Mary Kelly, Sherrie Levine, Cindy Sherman, and Martha Rosler is cited as paradigmatic of the project of a feminist art practice whose objective is to interrogate ideology, and specifically ideological constructions of gender. This is also the project described by Craig Owens, and he names the same artists in his discussion of a postmodern art practice. Here, one could say not only that art is informed by theory, but that art *is* theory, in that the critique is undertaken and presented in the visual text.

But this position, which has appeared to some to constitute a certain orthodoxy in feminist art criticism, has been opposed by other feminists on a number of grounds.[15] First, the difficulty of the work itself is cited, requiring as it often does a grasp of complex theoretical positions (Lacanian psychoanalysis, French feminism, semiotics, and so on). In response to an exhibition of Mary Kelly's major installation *Post-Partum Document*, two British feminists wrote the following in a letter to the feminist magazine *Spare Rib*:

> *The exhibition, free to anyone who wants to walk in, appears to*
> *be open and accessible: in fact it is opaque, and not so much par-*
> *ticipatory as excluding and exclusive. This mystification of the*
> *theory and the art, rebounds on the impact of the framed objects:*
> *they cannot carry the weight of the significance attributed to*
> *them and become weak visual metaphors for an esoteric intellec-*
> *tualisation.*[16]

This argument in defence of accessibility unfortunately coincides with another kind of populism, not so much on behalf of women but as part of a view that all art should be accessible—a version of the argument employed at Forest City Gallery. The art critic of the *Guardian* in London, reviewing a feminist art show and its accompanying texts,

writes: "Feminist art has tied itself into useless theoretical knots.... Gone are the days when feminist artists listened to their spleens. Nowadays they listen to Dr. Griselda Pollock from Leeds University who pulls them around in ever decreasing theoretical circles."[17] But we do not need to subscribe to an uncritical populism to take seriously the feminist argument about elitism and exclusion. Angela Partington raises the problem in a somewhat different way, considering the strategic issues involved and suggesting that any political cultural practice has to take account of its potential audiences. In other words, specific works would be assessed as feminist interventions on the basis of an audience-centred critique.[18]

A different criticism of postmodern, deconstructive art practices speaks in favour of *celebratory* tactics in which feminists are not inhibited by the critique of the subject or essentialism, from constructing alternative, positive images of women without taking on the task of demonstrating the constructed nature of "woman" in the work itself. The more simplistic of such arguments do align themselves with essentialist positions (the view that there are certain intrinsically female characteristics), but more often they are (again) strategic moves, operating with a provisional subject identification. Related to this is the theoretical objection to decentred subjects by artists and critics who believe it is important for women artists to be visible as subjects from the point of view of identity politics and institutional intervention. Linda Klinger has recently made this point:

> The critique of authority, widely introduced into America at a moment of political significance for feminism and art, may not completely erode a feminist position; it nonetheless carries enormous potential for stymieing the full participation of women artists in contemporary culture at the point where critical practice and artistic production meet.... Perhaps it is overly cynical to say that when women artists obligingly evaporate their "authorship" their work becomes more palatable.[19]

In addition, this particular resistance to Theory has been associated with a critique of the ethnocentrism of Western feminism, on the grounds that women artists of colour have a double investment in the politics of the subject and hence, perhaps, in celebratory rather than deconstructive art practices. It has been suggested that in general the "race for theory" makes less sense for black feminists than for Euro-American women.[20] The critique of Theory in feminist art practice is here based on the same concern to avoid a new feminist imperialism.

Conclusion: Feminism/Theory/Art Practice

As in the case of the artists/critics debate, with which I began this paper, I think it is possible to devise a middle position on these issues. On the question of accessibility, one can speak in defence of a feminist art practice which makes sense to the widest possible audience, without condemning the more narrowly "elite" practices which exclude many but nevertheless participate in an important way in a particular political and intellectual community. On the question of deconstruction/identity politics, too, we can acknowledge the crucial importance in some circumstances and for some groups of women of engaging in strategic (non-essentialist) cultural politics of the subject (both the artist-as-subject and the subject-as-represented), without losing sight of the fundamental cultural construction *of* gendered subjects in our culture. Here, too, there is a place for the more esoteric but absolutely crucial representational strategies of postmodern artists, whose work, while not always accessible to a majority, makes an enormous difference within a limited but important arena. Again, then, resistance to theory is both valuable and misplaced; it depends on the respective claims to universality of the competing practices.

In the end, I think the best way to think through the problematic relationship of feminism, theory, and art practice is to return to the formula of the conference itself: art as theory/theory and art.

Art as Theory

This is one possible model for political (including feminist) art. This means both that the work is informed by theory, and that it operates as theory—it performs the critique in representation which engages with ideologies (of gender) and exposes their operation. But this is only one possible objective for feminist art practice, and it will depend on the specific community of its production and reception.

Theory and Art

Here I want to insist more strongly on the necessity for theory, in the sense that we need theory to make sense of art (its histories, its institutions and practices, its insertion in the social and political arenas). With regard to feminist art practice, we (critics and artists) need theory, for otherwise there is no real prospect of interventions in the cultural sphere. By theory here, of course, I simply mean informed analysis, based on an understanding of the processes of the social, the cultural, and the aesthetic. In this sense, I disagree with those whose critique of Theory seems to include a wholesale rejection of *theory*. Spontaneity and ad hoc strategies cannot be a substitute for systematic analysis.

The arguments I have made about feminist art practice apply equally to feminist art criticism. Writers and academics, too, have to judge their audiences. That is why the artists at Forest City Gallery were partly right in condemning obscurantism in journalism (but wrong in extending this critique to a rejection of *any* highly theoretical writing *any*where).

I conclude by stating my own commitment to theory—in *all of the four senses* I identified earlier. We need theory as knowledge/analysis, theory as social-historical critique, theory in the sense of metanarratives (despite their ultimate provisionality), and theory in the sense of critiques of discourse and representation. But this does not mean I endorse what has been referred to by some as the "scripto-visual" orthodoxy in feminist art criticism and practice (that is, the

commitment only to visual work informed by theory, in which text, often integrated into the image, plays a crucial part). As I have argued, commitment to theory in analysis does not imply commitment to theory in every instance in art practice. In addition, I have suggested that we need to remain aware of the androcentric tendencies of the theories which we employ and in which we live. And we have to judge the appropriateness of theory in art practice, as well as in art writing, on the basis of our assumed and intended reception communities.

Notes

1. Steven Durland, "Notes from the Editor," *High Performance*, 14 (Summer 1991): 4–5.

2. Stanley Aronowitz and Henry Giroux, "The Politics of Clarity," *Afterimage*, 19, no. 3 (October 1991): 5+.

3. Grant Kester, "Slouching Towards Clarity," *New Art Examiner* (February/March 1992): 18–20, 56. Thanks to Grant Kester for bringing this debate to my attention.

4. A.L. Rees and F. Borzello, eds., *The New Art History* (London: Camden Press, 1986), 8. On poststructuralist revisions of Marxism, see Gareth Stedman Jones, *Languages of Class: Studies in English Working Class History, 1832–1982* (London: Cambridge University Press, 1983).

5. Susan Bordo, "The Cartesian Masculinization of Thought," *Signs*, 11, no. 3 (1986): 439–456.

6. Evelyn Fox Keller, *Reflections on Gender and Science* (New Haven: Yale University Press, 1985). See also Sandra Harding, "Feminism, Science and the Anti-Enlightenment Critiques," *Feminism/Postmodernism*, ed. Linda J. Nicholson (London: Routledge, 1990), 83–106.

7. See, for example, Hilary Rose, "Hand, Brain, and Heart: A Feminist Epistemology for the Natural Sciences," *Signs*, 9 (1983): 73–90. I discuss many of these texts in my essay, "Women's Knowledge and Women's Art," *Feminine Sentences: Essays on Women and Culture* (Berkeley and Los Angeles: University of California Press, 1990).

8. Liz Stanley and Sue Wise, "Method, Methodology and Epistemology in the Feminist Research Process," *Feminist Praxis*, ed. Liz Stanley (London: Routledge, 1990); Ann Oakley and Robin Oakley, "Sexism in Official Statistics," *Demystifying Social Statistics*, ed. John Irvine et al. (London: Pluto Press, 1979); Ann Oakley, "Interviewing Women: A Contradiction in Terms," *Doing Feminist Research*, ed. Helen Roberts (London: Routledge & Kegan Paul, 1981); David Morgan, "Men, Masculinity and the Process of Sociological Enquiry," *Doing Feminist Research*.

9. Janet Wolff, "On the Road Again: Metaphors of Travel in Cultural Criticism," *Cultural Studies*, 7, no. 2 (May 1993): 224–239.

10. Sandra Harding, *The Science Question in Feminism* (Ithaca, N.Y.: Cornell University Press, 1986), 194.

11. Craig Owens, "The Discourse of Others: Feminists and Postmodernism," *The Anti-Aesthetic: Essays on Postmodern Culture*, ed. Hal Foster (Seattle: Bay Press, 1983).

12. Nancy Fraser and Linda J. Nicholson, "Social Criticism without Philosophy: An Encounter between Feminism and Postmodernism," *Feminism/Postmodernism*, ed. Linda J. Nicholson (London: Routledge, 1990), 19–38.

13. Judith Barry and Sandy Flitterman, "Textual Strategies: The Politics of Art-Making," *Screen*, vol. 21, no. 4 (1980): 117.

14. See, for example, Griselda Pollock, "Theory and Pleasure," *Sense and Sensibility in Feminist Art Practice* (Nottingham: Midland Group, 1982). Reprinted in Rozsika Parker and Griselda Pollock, eds., *Framing Feminism: Art and the Women's Movement, 1970–1985* (London: Routledge & Kegan Paul, 1987).

15. I discuss some of these issues in "Postmodern Theory and Feminist Art Practice," in *Feminine Sentences*.

16. Margot Waddell and Michelene Wandor, "Mystifying Theory," *Spare Rib*, no. 44 (1976). Reprinted in Parker and Pollock, eds., *Framing Feminism*, 204.

17. Waldemar Januszczak, "How Feminists Paint Themselves into a Corner," *The Guardian* (December 1982).

18. Angela Partington, "Feminist Art and Avant-Gardism," *Visibly Female: Feminism and Art Today*, ed. Hilary Robinson (London: Camden Press, 1987).

19. Linda S. Klinger, "Where's the Artist? Feminist Practice and Poststructuralist Theories of Authorship," *Art Journal* 50, no. 2 (Summer 1991): 39–47.

20. Barbara Christian, "The Race for Theory," *Cultural Critique*, 6 (1987): 51–63; Teresa de Lauretis, "Upping the Anti(sic) in Feminist Theory," *Conflicts in Feminism*, ed. Marianne Hirsch and Evelyn Fox Keller (London: Routledge, 1990), 255–70.

PART 3

AN IDENTITY IN CRISIS:
The Artist and New Technologies

David Tomas

> *Goethe has said,* Wo Begriffe fehlen da stellt ein Wort rechten
> Zeit sich ein. *(Where there is no understanding, there a word*
> *appears at the right time.) In the beginning was the Word and a*
> *new word may also be a beginning.* (Manfred Clynes)[1]

One of Raymond Williams's motivations for compiling and
publishing his seminal vocabulary, *Keywords*, was "to show
that some important social and historical processes occur
within language, in ways which indicate how integral the
problems of meanings and of relationships really are."
These relationships, traced through clusters of "interrelated
words and references," were not only "new kinds of rela-
tionship, but also new ways of seeing existing relationships"
which "appear in language in a variety of ways."[2] Williams
went on to note that "the kind of semantics to which these
notes and essays belong is one of the tendencies within
historical semantics: a tendency that can be more precisely
defined when it is added that the emphasis is not only on
historical origins and developments but also on the pre-
sent — present meanings, implications and relationships —
as history."[3] While this implies a sense of community with
the past, Williams is quick to emphasize the importance of
conflict, discontinuity, and radical change which could also
be signalled in the meanings and uses of words in everyday
contexts.

In the vocabulary of *Keywords* one finds the word "art." In keeping with his stated objective, Williams registers the semantic shifts suffered by this word from the thirteenth to the twentieth century, as well as the shifting relationships in domains of human skill, divisions of labour, and social purposes that were signalled in these shifts of meaning. As he points out, the opposition between artist and scientist or technologist is a recent development linked to the emergence of capitalist commodity production in the nineteenth century. Before that time, "the arts" and "artist" were terms used to denote a common domain of human skill that encompassed what we now understand as artistic, scientific, and technological practices, while "science" and "art" were sometimes used interchangeably or sometimes categorically to distinguish between theoretical and practical knowledge.[4]

An advanced imaging system generically known as "virtual reality," currently being perfected in the United States, Europe, and Japan, is beginning to attract the attention of artists, among others,[5] because of its capacity to immerse individuals and groups in a total three-dimensional interactive environment. Moreover, its potential for complete sensory reproduction suggests an eventual challenge to conventional Western ways of conceiving of the human body, in the sense that it holds the promise (or threat) of the body's eventual absorption or reduction into a pure digital medium. There can be no doubt that a challenge such as this will extend to the traditional divisions of labour that have conditioned this body in terms of customary domains of skill. In particular, it threatens to disrupt inherited nineteenth-century divisions of labour between the scientist, technologist, and artist that have determined to this day their professional identities. In fact, a recent seminar and residency at the Banff Centre for the Arts in Banff, Alberta, has looked at the early symptoms of this disruption.

Between 7 October and 13 December 1991, a group of artists, musicians, writers, and computer specialists were

brought together at the Banff Centre for the Arts, "principally for the purpose of advancing their own art production."[6] The occasion was a residency on the bioapparatus. A "virtual seminar on the bioapparatus" was convened during the course of the residency, on 28 and 29 October, with a "parallel objective" of expanding "the discourse around technology and culture" by encouraging "debate" in order to "involve a large number of people" in mapping "significant shifts in philosophical and representational issues that are coextensive with technological change."[7] Documents and proceedings related to the two-day seminar were published in December 1991.

The word "bioapparatus" was coined as an umbrella term for the residency as a whole by its organizers, Catherine Richards and Nell Tenhaff, because it combined "an understanding of particular philosophies of technology with theories about the technological apparatus, the technologized body, and the new biology."[8] The word was considered, moreover, to cover "a wide range of issues concerning the technologized body as well as the current cultural and political manifestations of one specific new technology, virtual reality."[9] However, once this neologism was coined, it was immediately noted that "to describe the origins of such an open-ended word, one that seems to resonate even without explanation, is to offer only a précis of a large and complex territory."[10]

Nonetheless, the organizers did produce a précis in the form of a genealogy which presented a general philosophical/theoretical context within which to address the question of technology and culture. This was achieved through a secondary reading (by Arthur Kroker) of the work of Canadian historian Harold Innis and philosophers of technology Marshall McLuhan and George Grant, which was augmented by references to contemporary theorists of the apparatus, notably Jean-Louis Baudry, Gilles Deleuze, Laura Mulvey, Christian Metz, and Paul Virilio. References to feminist/psychoanalytic counter-theorists Joan Copjec, Constance Penley, and the boundary theorist of the body Donna Haraway completed the genealogy.

In addition to situating the word in an intellectual geography, the genealogy provided a preliminary topography of its two principal semantic fields. The one, grounded in the "bio" of "bioapparatus," was connected to the issue of subjectivity, "how it is constituted and how it is located in relation to the body."[11] The other, whose centre of gravity was provided by "apparatus," was variously traced to post-Freudian notions of the gendered "influencing machine," poststructuralist examinations of advanced technologies of representation, and the resulting crisis of representation as articulated through the concept of simulation.

As previously noted, the residency was also convened with a particular technology in mind — virtual reality technology — chosen because it was the most recent and radical of Western representational technologies that raised "questions about the construction of self (or subjectivity)" and because it challenged "traditional thinking that relies on a distinction between subject and object as it functions directly with the body's multi-sensory physiological thresholds."[12] However, if a theoretical and practical examination of this new technology was to be the *modus operandi* of the residency, it soon became evident that conflicting agendas were seriously compromising its parallel theoretical agenda. By the end of the residency, artists, computer specialists, and others had retreated into their various domains of practice to pursue personal investigations.

While it is becoming a commonplace gesture to point to ongoing political and social transformations in contemporary Western and non-Western cultures resulting from the increased use of new computer-based information systems, such gestures are less common in regard to virtual reality's potential impact. If the Banff residency was designed to provide an opportunity to address these transformations and link them to this technology, its ultimate failure to achieve its objectives calls for detailed commentary. Not only is it important to understand where this failure lies so as to avoid such pitfalls in the future, but one should not ignore the opportunity that a multidisciplinary gathering of this

type presents for reflection and comment on the current status of artistic production as it relates to advanced imaging systems and the body/technology question.

In retrospect, a number of questions come to mind. Did a descriptive failure—a failure, in other words, in metaphoric resonance, to be ascribed to a bad choice of neologism—lead to the collapse of the residency's specific theoretical objectives? Or were they undermined through an inappropriate choice of participants? Perhaps there is reason to attribute failure to the seminar's existence at a particular historical juncture, when social identities and disciplinary paradigms are in flux, and confusion reigns as to the pertinence of inherited modes of thought and practice when confronted with new technologies? Or, finally, was it a conjunction of two or more of these possibilities that conspired to limit discussions to well-worn issues and conventional perspectives on the human body, its genders, and virtual reality technology. Answers to these questions can only be attempted in the wake of a detailed examination of the residency's social and intellectual dynamics, an examination that leads directly to more general questions concerning artistic identity and practices in the late twentieth century.

The Virtual Seminar on the Bioapparatus
At first sight, the Banff residency was predicated on three broad divisions of labour. There were the artists from a variety of subdisciplines (performance, installation, painting, electroacoustics, etc.) and from a wide range of social and cultural backgrounds: Canada's First Nations, China, England, Holland, and the United States. Then there were the researchers whose interests were limited to technical, university, or corporate agendas. Finally, there were representatives of the administration, whose interests were divided according to their particular allegiances to specific projects and/or theoretical positions.

A series of preliminary meetings and discussions of previously prepared position papers during the opening weeks of the residency soon exposed conflicting views on the

cultural implications, and social and artistic uses, of virtual reality technology. Various interest groups coalesced around similar points of view and, as a consequence, common positions were soon established, most notably in connection with the role of "theory" in general, and feminism in particular, in providing a fruitful means of executing agendas connected with the development of the technology and the furthering of practical artistic projects.

These early positions and their overarching system of categorization according to conventional domains of theory and practice were crystallized in the context of the seminar. Hence, papers, sessions, and individuals were classified according to issues connected with history, the body, or subjectivity (Day One), versus issues grounded in particular domains of practice, such as sound and fiction (Day Two).

Thus it was not long (especially since the seminar was convened at the end of the third week of the residency) before the participants and observers experienced a powerful object lesson on the contradictory social life of virtual reality technology plotted according to the interactions of the various individuals and groups who were present at Banff. At its best, seminar activity illustrated the tenuous, almost ephemeral, interface between the often divergent social practices of art and computer engineering. At its worst, participants were trapped in a social and artistic netherworld where questions of social practice, virtual reality technology, and the body—its genders, socio-political status, and cross-cultural transformations—were subverted, marginalized, or simply ignored in a situation fragmented by conflicting agendas that bore imprints of archaic systems of belief and personal/professional ambitions. The confusion —indeed, the often subtle gender-based violence with which some positions were defended during the course of the seminar—influenced the social interaction between participants during the remaining weeks of the residency. As opposed to exploring and mapping out the domain of the bioapparatus, the seminar and residency thus ended up by exposing some important contradictions in the relationships that could be

negotiated, under current historical divisions of labour, between artists, computer engineers, and technologists in the context of an advanced and potentially radical late-twentieth-century imaging system.

In retrospect, it is possible to conclude that polarization occurred, in the most immediate instance, from a lack of common language. However, in the case of the seminar, the subversion of critical reflection was also the product of alliances between groups that crossed the frontiers of art and technology. Thus artists who looked to the seminar as a forum for "theoretical" discussion found themselves opposed to artists who were interested in using the seminar as an arena for the presentation of their work, as if the two were by their very nature incompatible. The result was a more than ironic divorce of theory and practice since it implied that work could be presented under the rubric of "Art," which would then ensure that it was totally divorced from theoretical considerations, while theory could be treated as if it were an autonomous product whose only grounds of legitimation were to be found in its academic ori-gins—whose elitism then served as an excuse for summary dismissal. Meanwhile, self-professed technophiles occupied a high middle ground in this affair because of their com-mand of technical knowledge and more or less direct access to pertinent hardware and software systems. Finally, the seminar exposed contradictory attitudes to theory and prac-tice as well as reproducing, by way of these contradictions, a disjunction between mind and body which resulted in those persons who were most interested in the body and its vicissitudes (the majority of whom were women) being mis-represented as proponents of the "mind"—this constituting the principal irony of the seminar's many ironies.

The two days of presentations, discussions, and behind-the-scenes ruminations and arguments which constituted the seminar, including the articulation of frustration and despair on the part of a large portion of women artists and theorists, can be summed up in the following observa-tion: while the majority of artists appear to have been

theoretically and practically ill-equipped to deal with this new technology at the level of its technical organization, those involved in developing its hardware and software systems were equally ill-equipped to deal with its social and cultural dimensions as well as its political implications. As a result, important issues — the gender of technologies as functional artefacts and social practices, the body as site of multiple political experiences — were lost to critical reflection and analysis. In fact, it was almost as if at times the language of critical reflection was deliberately stifled or repressed because it dared to speak of these difficult topics.

The Intellectual and the Artist: Archaic Identities in the Service of New Technology

Warren Robinett, a prominent figure in the development of virtual reality technology, summed up his experience of the seminar under the title "To those artists who want to influence the development of virtual reality." His commentary, exemplary of the defensive response of computer-based specialists, began with the following observations:

> *I have heard much criticism of technology and of virtual reality but, though I strain to understand and ask the critics for clarification, I am left with abstract and incomprehensible phrases echoing in my mind. I am utterly unable to relate these criticisms to the choices I must make as I work to develop virtual reality. If you want to influence what I do, you will have to offer concrete suggestions of what to do or what to do differently.*
>
> *You will also have to talk in a language that we ... can understand. If I hoped to argue convincingly in art theory or feminism, I would have to speak in terms that art theoreticians or feminists understand. If you wish to change what I do, you have to convince me, and you cannot do that using language I do not understand.*[13]

While Robinett's cautions are clearly reasonable and illustrate the types of communication problems that emerge in the context of conflicting theoretical, artistic,

and technical languages, his commentary also reveals the kinds of cultural biases that conditioned exchanges during the course of the seminar and residency. If the distinction between domains and languages of theory and practice are noted and registered, translation between domains is considered effective, from a technical point of view, only when pursued in one direction: from art and/or feminist theory to virtual reality research and not vice versa. Hence Robinett concludes: "Talking or writing might influence what I do, or it might not. After all, I have my own interests and goals. It would be most effective to *show* me what virtual reality could be, according to your own vision."[14] The challenge, presented in terms of criteria of visibility, is clearly predicated on specific notions of what constitutes intellectual and technical labour. While abstract thought, talking, and writing are seen as integral components of the theoretician's/feminist's *modus operandi*, concrete (ocularcentric) action is a distinguishing feature of the technologist's practice.

> *When I work at developing the medium itself—the hardware, software and conventions of virtual reality—I fail to see how a sensitivity to gender issues should influence my choices. Should I improve the resolution of the head-mounted display? Improve the accuracy of head-tracking? Build improved manual input devices? Develop methods for travelling through virtual spaces? Yes, I should. Would a feminist choose differently?*[15]

It is precisely these kinds of technical questions that determine the choice of arena—technique—as the principal site in terms of which judgments are to be extended in connection with the value and pertinence of critical cultural practices such as feminism.

"Would a feminist choose differently?" As this phrase suggests, the burden of proof is projected onto a theoretical domain whose access to the technological means of experimentation—of counter-practice—is, as Robinett is well aware, limited by restricted access to software expertise, hardware, funding, and so on. It is limited, moreover, by the

specialized languages of research and development, which, in addition, are almost exclusively focused on rational tasks such as the improved efficiency of modes of visualization, the accuracy of tracking, and the geometry of navigation. Indeed, the quest for increased speed and efficiency, resolution and accuracy, vehiculates a rationalist mode of technological practice at the expense of all other forms of practice and, as a consequence, contributes to the technologist's transparent sense of social perplexity when confronted with these other forms which include feminist practices centred on the body and its genders.

Similar dichotomies governed the commentary of another participant, Garry Beirne. In his summation of the seminar's exchanges, Beirne recorded a number of intellectual characteristics which, in his opinion, severely limited its value. These included "arguments about future contexts of the politically and historically correct," "contemporary intellectual games," and "esoteric references from the postmodern bookshelf."[16] As in the case of Robinett, phrases such as these betray evident unease with and fear of new approaches to probing technology in the name of critical understanding and historical change. That these opinions should be presented from a technological perspective as a legitimate basis for developing a critique of intellectual activity while simultaneously serving as the foundation for rationalizing existing research agendas is not surprising. However, the proliferation of such opinions is, given the recent climate of conservative thought on the relationship between culture and the economy, cause for concern, especially since similar anti-intellectual views were voiced by artists.

If one were to seek for a reason for the widespread voicing of various anti-intellectual opinions during the course of the seminar, one would have to go no further than to isolate the archaic concepts that articulated the spectres of "the intellectual" and its traditional antithesis "the artist," which provided a common frame of reference for this polyglot group of individuals. Participants' perceptions of one another seem to have been governed by a commonly

accepted, if unspoken, definition of "theorist" as a practitioner of purely mental activity (and more specifically feminist high theory, whether or not this body of knowledge was actually brought to bear on specific problems of the body and technology). This definition implies a form of labour which is pursued, in a specific academic sense, in isolation from the social. Moreover, the perception was enhanced through juxtaposition with a conception of art as an isolated domain of personal or emotional expression, vision, and so on, as if art and its institutions were not fully integrated into a culture and its social organization. Such correspondences were made notwithstanding the obvious fact that in a number of cases the persons who were most closely identified with a theoretical position were in fact *practising* artists.

However, as Williams reminds us, both definitions have very particular historical trajectories. He points out for example, that "intellectual," "as a noun to indicate a particular kind of person or a person doing a particular kind of work," dates effectively from the early nineteenth century.[17] In noting its negative connotations, Williams concludes that "the social tensions around the word are significant and complicated, ranging from an old kind of opposition to a group of people who use theory or even organized knowledge to make judgments on general matters, to a different but sometimes related opposition to *elites*, who claim not only specialized but directing kinds of knowledge."[18]

Conversely, Williams reminds us that art, as currently understood, is also a product of the nineteenth century. In particular, he relates the modern distinction between science and art "to the changes inherent in capitalist commodity production, with its specialization and reduction of use values to exchange values" and traces a "consequent defensive specialization of certain skills and purposes to **the arts** or *the humanities* where forms of general use and intention which were not determined by immediate exchange could be at least conceptually abstracted." For Williams, these constituted the "formal basis of the distinction

between **art** and *industry*, and between **fine arts** and **useful arts** (the latter eventually acquiring a new specialized term, in TECHNOLOGY*)*."[19] Within this division of skills, the modern artist takes on a very different social identity, which is distinct "not only from *scientist* and *technologist* — each of whom in earlier periods would have been called **artist** — but from *artisan* and *craftsman* and *skilled worker*, who are now *operatives* in terms of a specific definition and organization of WORK."[20]

If we were witness, during the course of the seminar, to the marginalization of the intellect as site of critical reflection, it is important to note that it was a process that was not peculiar or isolated to this specific group of individuals or this seminar and its structure, for this type of marginalization is a product of certain historically determined conceptual classifications that structure social and cultural practices in Western Anglo-European cultures. While it is possible to account for the seminar's intellectual and social turbulence as the product of contact and friction between persons who implicitly aligned themselves, in their attempts to come to grips with a new and potentially useful technology, with either one of two principal historical domains of Western human labour (the utilitarian and non-utilitarian, or socio-economic and socio-cultural), it is worth noting the profound contradiction in this alignment: old divisions of labour whose points of social articulation were precisely the human (i.e., labouring) body were used to structure a research agenda devoted to a concept (bioapparatus) and technology (virtual reality) that were concerned in one way or another with the physical dissolution of that body.

Beyond the Interface of Theory and Practice

While Williams's vocabulary of keywords has been indispensable in uncovering the nineteenth-century underpinnings of the Banff seminar's deployment of discourses around the body and virtual reality, the seminar's keyword, "bioapparatus," should now alert us to the possibilities and limitations of conceptualizing significant changes in the

grounds for constituting and reconstituting the discourses of social identity solely on the basis of theoretical agendas plotted in terms of archaic divisions of labour. It is therefore in terms of its own contradictions that the seminar suggests that a profound shift in our collective identities is in order, while clearly constraining our ability to conceptualize its parameters. The kind of emergent, multi-dimensional, post-industrial landscape—computer chip-design, programming languages, and computer networks—which is configuring new imaging systems such as virtual reality, as well as the conceptual thrust of new keywords like "bioapparatus," signals the demise of the nineteenth century as a legitimate site in terms of which to situate late-twentieth-century social practices and identities.

While some might object that new technologies like virtual reality do not have as yet the social or cultural power to generate new social identities and domains of knowledge, there is considerable evidence to suggest that it is certainly within the purview of these kinds of technology to radically change our conceptions of ourselves and the social structures and cultural contexts that determine our identities as individuals and groups.

If the residency on the bioapparatus can be considered to have been germinal, it was in the way that it posed the question *in absentia* of the demise of the intellectual as a viable subject-identity for thought and social action at the interface of new technologies; for it highlighted this question in terms of a politics of representation that went well beyond specific domains of critical theory, artistic practice, and computer engineering as currently understood.

One of the principal object lessons to be extracted from this seminar on the bioapparatus is the necessity of surmounting archaic categories of thought in the interests of identifying and investigating potentially fundamental processes of socio-technological transformation early enough to be able to intervene in their development. As such, critical practice can no longer be limited to traditional domains such as that of the humanities (in its broadest sense), but

must now also encompass other forms of technical labour including computer architecture, programming, and network design, in order to engage in a dialogue with new patterns of thought, experimental modes of labour, and social relations in an age of information. On the other hand, technologists can no longer afford to ignore the social and political consequences of their engagement with advanced technology, for they too must understand that, insofar as technology is the product of the human mind, it bears the imprints of its dreams, desires, and prejudices. We must therefore confront the legacy of archaic practices, their systems of classification and myths, in order to understand that our bodies, our subjectivities, as persons in the late twentieth century, can no longer be sustained by professional identities whose origins are firmly rooted in nineteenth-century social practices. Instead of locating our sense of self in the distant past, we must look to the present for clues as to the shifting patterns of social identity we inhabit inasmuch as it enables us to situate ourselves in terms of our futures.

Cyborg Practice: Social Contradictions and Political Agendas at the Interface of the Body and Technology
Participants were presented with the following guidelines for the bioapparatus residency.

The bioapparatus *residency will explore questions of the integrity of the body and of subjectivity. The apparatus, as we construe it, is itself a perceptual model, a reflection of social and cultural value systems, of desires. It can be seen as a metaphor that not only describes but generates subjectivity, a subjectivity problematized by the objectifying effect of any technological instrument. The apparatus splits the body, the person, into subject and object, and its history thus merges with the philosophical history of dualism: body/mind, nature/culture, female/male. One question posed by feminist critiques of technology in the context of media, science and medicine is whether the historically constructed subject/object relation can be*

reconstituted so that its power dynamic is one of commonality and attunement rather than objectification and conquest.[21]

The guidelines are interesting for two reasons. First, they suggest that "apparatus" was considered as the primary site for theorizing the split between subject/object, body/mind, nature/culture, and female/male. Second, they illustrate the insidious slippages that can often occur between name and object or process named, such that a word can appear to take the place of the thing named. Thus, not only does the apparatus describe subjectivity, but it also "generates" it; not only is it a "perceptual model" but it "splits the body, the person, into subject and object." While these dualisms are clearly the product of a word's semantic field, and the object or process to which it refers, slippages between the two can often lead to suggestive and fruitful ways to conceptualize social practice as a practice *in* and *out* of language. In the present case, the slippage is rendered all the more significant in that "bio*apparatus*'s" principal domain of reference was not high technology but rather critical theory situated at the juncture of philosophy and "theories about the technological apparatus, the technologized body, and the new biology."[22]

The domain surveyed and mapped by Richards and Tenhaff was that of contemporary theories of the apparatus — a purely intellectual geography inasmuch as no attempt was made to ground these theories in the social and cultural practices of the majority of the protagonists cited as important theoretical sources or, for that matter, the scientists, technologists, and computer engineers who were, and are, engaged in developing pertinent software and hardware systems. If such practices had indeed been registered, the fact that they were limited for the most part to the academy (and in the case of critical theory to humanities and social sciences departments within the university), or the corporate sector of the economy, would have shed additional light on the contradictory forces that influenced the course of the residency. For instance, it is not surprising that university-

based technologists and computer specialists, whose principal habitat was science departments within the same academy, should have reacted with perplexity when confronted with what appeared at first sight to be alien systems of thought. The same observation can, of course, be made in the case of corporate scientists and computer specialists. On the other hand, it would also have come as no surprise that most of the artists should have had difficulty in penetrating the heavy technical atmosphere surrounding virtual reality technology, since they had, for the most part, little insight into the languages and cultures of scientific research laboratories or the more obscure patterns of corporate and military sponsorship that more often than not sustained much of their advanced research agendas.

While the neologism "bioapparatus" was proposed as a common ground between these two often antagonistic constituents of the academy, it was virtual reality technology that provided the stage for a clash of opposing world views. If the result can be summarized as a series of theoretical skirmishes along the boundaries of this new technology, one would also have to conclude that a core agenda of research and development remained, under the economic auspices of corporate/military sponsorship, immune to critical intervention. The geographical and economic distance between Banff and corporate and university sites of virtual reality research—North Carolina, California, Toronto, and Edmonton—only served to emphasize this immunity. The conceptual distance between the bioapparatus's semantic domain and this other world can be measured in terms of another closely related word, "cyborg," which was coined in a scientific laboratory context and which has since been appropriated by critical theorists in the name of late-twentieth-century oppositional practices. The comparison is especially illuminating since "cyborg" was proposed as a way to describe new relationships extrapolated from laboratory experimentation. Later uses of the word illustrate the way an existing term can be employed to suggest new ways of thinking through old patterns of social relationships.

"Cyborg" bears a close kinship to "bioapparatus" since it was specifically coined to describe a similar union between human organism and machine. The word was proposed by Manfred E. Clynes and Nathan S. Kline in 1960 to describe "self-regulating man-machine systems" and in particular an "exogenously extended organizational complex functioning as an integrated homeostatic system unconsciously."[23] The technical density of the definition was a function of its proposed sphere of operations: the application of cybernetic controls theory to the problems of space travel as they impinge on the neurophysiology of the human body. In fact, the cyborg was posited as a solution to the question of "the altering of bodily functions to suit different environments."[24] For these researchers, alteration to the body's ecology was to be effected primarily by way of sophisticated instrumental control systems and pharmaceuticals. Thus, "the purpose of the Cyborg, as well as his own homeostatic systems" was, according to these early pioneers, "to provide an organizational system in which such robot-like problems [as the body's 'autonomous homeostatic controls'] are taken care of automatically and unconsciously, leaving man free to explore, to create, to think, and to feel."[25] And as the references to 'his' and 'man' indicate, this problematic was gender specific.

"Cyborg" was appropriated however, in an influential article first published in 1985 by a socialist-feminist historian of biology, Donna Haraway. It was used in this case for a different social purpose, "rhetorical strategy and...political method."[26] For Haraway, the cyborg was not only a "hybrid of machine and organism," it was also a "creature of social reality as well as a creature of fiction."[27] Within a new semantic context provided by socialist-feminist discourses on the gendered body, she argued that this word could function as "a fiction mapping...social and bodily reality and as an imaginative resource suggesting some very fruitful couplings."[28]

In contrast to the Clynes/Kline cyborg which was conceived to be a sort of superman capable of surviving hostile

non-earth environments, Haraway's cyborg was a product of late capitalist earth. If it transgressed the social/symbolic boundaries between human and animal, animal-human (organism) and machine, and the physical and non-physical,[29] it was a transgression negotiated in terms of science fiction worlds and the everyday worlds of postcolonial multinational capitalism. Indeed, insofar as it was a product of *feminist* science fiction, Haraway's cyborg was "a creature in a post-gender world" and, inasmuch as it was conceived as a social and political mentor, it was pictured as "oppositional, utopian, and completely without innocence" in the sense that it was "resolutely committed to partiality, irony, intimacy, and perversity."[30] It was in these multiple senses that Haraway suggested that cyborg "is our ontology; it gives us our politics."[31] Moreover, it was a politics which, in its process of semantic rearticulation, clearly acknowledged the cyborg's military/industrial origins.[32]

Thus, while "cyborg" was the hybrid product of the U.S. space program and a medical research laboratory (both Clynes and Kline were at the time researchers at Rockland State Hospital, Orangeburg, New York), Haraway's socialist-feminist cyborg was the joint creation of political activism and academic radicalism. In fact, while the body's physiological ecology ("the body-environment problem")[33] determined its early semantic field, Haraway's socialist-feminist background was the determining factor in the articulation of a postgendered oppositional cyborg.

Conversely, "bioapparatus" was coined within an artistic milieu (both Richards and Tenhaff are artists, although the former was a research consultant for a computer laboratory). Given many Anglo-American artists' preoccupations with questions of gender, representation, and vision, it is not surprising that perception should have been the determining factor in the organization of the bioapparatus's semantic field. In fact, it was precisely the perceptual aspect of virtual reality's articulation of the body/technology problem which was cited as the principal reason for its central

role in informing the research agenda for the bioapparatus residency:

> *Virtual reality or virtual environment technology is of particular interest in the context of the bioapparatus. It is a symptom as well as an instrument of a re-ordering of perception and, one can anticipate, of power relations. The current mythology surrounding the technology reconstitutes the mind/body opposition, and raises issues of "bodily materiality" (a term proposed by Rosi Braidotti). As such, virtuality can be looked at as an expression of social discourses that are already in place. One of the intentions of the residency is to address the broader context of sociocultural shifts that are both the cause and symptom of technological changes.*[34]

Thus, while acknowledging the existence of determining social discourses, Richards and Tenhaff were clearly interested in mapping virtual reality's perceptual impact on the social distribution of power and, in particular, on the distribution of social power in connection with the gendered human body (as opposed to the postgendered body).

There are, however, a number of other significant differences between the way "cyborg" was used to map new social relationships and the way "bioapparatus" was conceptualized in the context of the Banff residency. Whereas "cyborg" had, and continues to have, a precise reference in the interface between the human/organic and the material/technologic, the optic embodied in "bioapparatus" is most closely associated with Paul Virilio's notion of the "ubiquitous orbital vision" produced by a *logistics of military perception*.[35] The reference of "bioapparatus" is therefore more global in scope and more ephemeral in substance than that of "cyborg." Hence, "cyborg" was only one possible point of articulation in the semantic field of "bioapparatus." Others included:

— *the idea of machines as essentially social assemblages*
— *the tool as a political site for shifts in the mediascape and its*

definition: the military, the American "world culture" and its
media, the drug cowboys, medicine
— the fictions of science and the science of fiction
— "man"/machine interaction, cyborgs, boundary degeneration
— artists' definitions of machines: futurism, bachelor machines.[36]

Again, the same can be said of virtual reality, since it was only conceived as a moment in the apparatus's ongoing trajectory:

The apparatus has probed, extended and blurred the boundaries
between viewer and viewed, knower and known. Virtual reality
can be seen as one moment on this trajectory. The apparatus has
now become so sophisticated that it presents itself as merging
with the body — becoming the bioapparatus *— obscuring the bor-*
ders drawn by instrumentality and redefining body functions of
perception, sensations, understanding.[37]

In addition, and notwithstanding the concise articulations of "the" apparatus as fields of vision, or the claim to have addressed the fusion of body and apparatus in terms of the fusion of pertinent semantic components, the residency and seminar were conceived in terms of a given theoretical domain whose genealogy was in fact split in terms of *biology* (the [female] body) and technology (the [male] apparatus). It was in this sense therefore that the organizers replicated at the level of their conceptualization of the word the very categories of thought (body/mind, nature/culture, female/male) that they were most interested in questioning. As its genealogy suggests, "bioapparatus" was not proposed as a direct medium for conceptualizing specific interfaces between the animal-human organic and the cybernetic-technological, or, on the other hand, the relations between these interfaces and given domains of practice and their practitioners. However, as the Clynes/Klines cyborg concept reveals[38] and as Virilio and Haraway argue each in their own way,[39] what is at stake in the late twentieth century *is* the precise social and political nature of the interface between the organic and post-organic.

The institutional stories and related divisions of bodily labour accessed by words such as "cyborg" and "bioapparatus" bring us back to Williams's initial quest for the new relationships that were signalled in the use of new words or the new uses to which old words were adapted. Words like "cyborg" and "bioapparatus" can serve to highlight the shifting semantic economies that link such disparate domains of social and technological labour as research into space travel, socialist-feminist political activism, and the contested terrain of contemporary art practices. It is these economies in particular that raise complex questions concerning processes of naming and the "new kinds of relationship" and "new ways of seeing existing relationships," which, Williams argues, "appear in language in a variety of ways."[40] For Williams, it is important to plot the existence of clusters of interrelated words and references in order to understand the historical present in terms of patterns of social and political change. The importance of adopting such an approach is made clear from the different uses that a word like "cyborg" can acquire as it circulates across institutional boundaries and domains of social practice. Additional insight into the interconnections between these economies can be obtained when one begins to situate the Richards/Tenhaff attempt to introduce "bioapparatus" as a constitutive semantic dominant in a pre-existing cluster of words which include "feminism" and "cyborg."

According to Michel de Certeau, the stories which are woven around words compose particular spatial or social practices.[41] Not only is every story "a travel story," but it is also "a spatial practice," and, in the sense that these practices constitute "spatial trajectories," they "concern everyday tactics."[42]

> These narrated adventures, simultaneously producing geographies of actions and drifting into the commonplaces of an order, do not merely constitute a "supplement" to pedestrian enunciations and rhetorics. They are not satisfied with displacing the latter and transposing them into the field of language. In

reality, they organize walks. They make the journey, before or
during the time the feet perform it.[43]

Thus, for Clynes, following Goethe, the word "cyborg" can mark a new beginning and inaugurate a new relationship between "man" and outer space. For Haraway, the same word can straddle science (fiction) and reality in a different way that suggests that the boundary between (science) fiction and social reality is an "optical illusion."[44] Having established a bridge over these boundaries, she can then cross them in search of new possibilities and new couplings. Conversely, "the notion of an apparatus becomes specific," for Richards and Tenhaff, "both as metaphor and diagnosis of a general condition,"[45] which results in the visualization of a particular theoretical domain of critical practice.

However, in contrast to the relatively well-defined types of professional identities produced by institutionalized medical/scientific, artistic, and socialist-feminist labour (whatever the fictions associated with their practices might be), words like "cyborg" suggest a completely different mapping of the social, indeed a radically different conception of the social itself. Of paramount importance in developing an understanding of how a new social will function in relation to the peculiar hybrid human/machine identities which are its products is, as previously noted, the key concept of interface.

As Haraway argues, the question of interface or boundary highlights the problem of *translation* and coding.[46] Moreover, it is in terms of this problem that her arguments concerning a socialist-feminist politics can be equally applied to artistic and laboratory politics. Indeed, there can be no difference between them in *practice* — in the sense in which she defines the interface of new technologies and the animal-human organic as a cryptographic site. In the end the body is reduced to a pure fusion of myth and tool[47] in which the translating device attains the stature of a social entity. At this point, theory and practice are imploded

together in terms of a new kind of post-organic politics of representation. It is by way of this politics that we move beyond the initial set of questions which introduced this essay — questions concerning shortcomings in a particular residency on the bioapparatus at Banff — and indeed beyond the contradictions produced when nineteenth-century conceptions of artistic and intellectual labour influence and even threaten to determine practices associated with advanced twentieth-century imaging systems.

In a cyborg world, questions of political practice are themselves in question, in terms of bodies (*polites*) and communities (*polis*). Haraway provides us with another far more accurate and fruitful, although potentially more sinister, visualization of the new social in her observation concerning "control strategies to concentrate on boundary conditions and interfaces, on rates of flow across boundaries — and not on the integrity of natural objects"[48] — and, one might add, personal and collective selves. As she points out, "the cyborg simulates politics" and this constitutes "a much more potent field of operations."[49] Hence to speak of a socialist-feminist cyborg politics — a "theory and practice addressed to the social relations of science and technology, including crucially the systems of myth and meanings structuring our imaginations" or the cyborg as a "kind of disassembled and reassembled, postmodern collective and personal self," a "self feminists must code"[50] — is to speak in the language of pastiche, the ultimate cyborg language since it is a pure language of simulation.

Marshall McLuhan has proposed a utopian vision which, although dated in terms of its uncritical global celebration of the unifying powers of technology, embodies an acute observation on the future of language itself. He has suggested that the extension of "our senses and nerves in a global embrace" by way of electric technology can be achieved outside of conventional languages.[51] Indeed, "electric technology does not need words any more than the digital computer needs numbers."[52] The implications of this view are, of course, profound and warrant an essay of their

own, especially when treated in conjunction with Haraway's comments on a cyborg simulation of politics. For the moment it is sufficient to note that conventional language as we know it — the grounds for Williams's observations concerning the kind of politics of language that motivated the collection of his vocabulary of keywords — can no longer provide a legitimate site for conceptualizing possible futures since these futures are already being written elsewhere in other codes.

Perhaps this is the reason for a subtle and potentially fatal political discontinuity or disjunction in Haraway's concept of a post-gendered, feminist-socialist cyborg. If the word "cyborg" can serve, as it has done in Haraway's case, to reconceptualize the interface of the human and nonhuman, it can only achieve this new vision at the expense of a grounded — etched, encoded, and hard-wired — oppositional politics of technology. Although the possibilities for this politics still exist at a metaphoric (fictional/theoretical) level, they are rapidly vanishing at the level of hardware. While the former level allows, as we have seen, for the articulation of a politics of the visible, the latter has ensured that the grounds for a practice of politics are themselves being rapidly transformed according to the dictates of an "aesthetics of disappearance."[53] If this new practice is providing the conditions of existence for a new social entity (a technician of invisibility — the artist of the twenty-first century) it is this practice which must then be subverted through the application of a new concept of politics to be inaugurated at the level of technology or hardware itself.

Notes

1. Manfred Clynes, Foreword to *Cyborg — Evolution of the Superman*, by D.S. Halacy (New York & Evanston: Harper & Row Publishers, 1965), 7.

2. Raymond Williams, *Keywords: A Vocabulary of Culture and Society* (London: Flamingo, 1983), 22.

3. Ibid., 23.

4. Ibid., 40–42, 277.

5. See, for example, Michael Benedikt, ed., *Cyberspace: First Steps* (Cambridge, Mass.: MIT Press, 1991).

6. Catherine Richards and Nell Tenhaff, "Introduction to the *Bioapparatus*," *Virtual Seminar on the Bioapparatus*, ed. Mary Anne Moser (Banff: The Banff Centre for the Arts, 1991), 5.

7. Ibid.

8. Ibid.

9. Catherine Richards and Nell Tenhaff, "Call for Submissions," *Virtual Seminar on the Bioapparatus*, ed. Mary Anne Moser (Banff: The Banff Centre for the Arts, 1991), 9.

10. Richards and Tenhaff, "Introduction to the *Bioapparatus*," 5–6.

11. Ibid., 6.

12. Ibid., 8.

13. Warren Robinett, "To Those Artists Who Want to Influence the Development of Virtual Reality," *Virtual Seminar on the Bioapparatus*, ed. Mary Anne Moser (Banff: The Banff Centre for the Arts, 1991), 115.

14. Ibid. (emphasis in the original).

15. Ibid.

16. Garry Beirne, "Immersion, Re-embodiment and the New World Order," *Virtual Seminar on the Bioapparatus*, ed. Mary Anne Moser (Banff: The Banff Centre for the Arts, 1991), 113.

17. Williams, *Keywords*, 169.

18. Ibid., 170–171 (emphasis in the original).

19. Ibid., 42 (emphases in the original).

20. Ibid. (emphases in the original).

21. Richards and Tenhaff, "Call for submissions," 10.

22. Richards and Tenhaff, "Introduction to the *Bioapparatus*," 5.

23. Manfred E. Clynes and Nathan S. Kline, "Cyborgs and Space," *Astronautics* (September 1960): 27.

24. Ibid., 26.

25. Ibid., 27.

26. Donna J. Haraway, "A Cyborg Manifesto: Science, Technology, and Socialist-Feminism in the Late Twentieth Century," *Simians, Cyborgs, and Women: The Reinvention of Nature* (New York: Routledge, 1991), 149.

27. Ibid.

28. Ibid., 150.

29. Ibid., 151–153.

30. Ibid., 150, 151.

31. Ibid., 150.

32. Ibid., 151:

The main trouble with cyborgs, of course, is that they are the illegitimate offspring of militarism and patriarchal capitalism, not to mention state socialism. But illegitimate offspring are often exceedingly unfaithful to their origins. Their fathers, after all, are inessential.

33. Clynes and Kline, "Cyborgs and Space," 26.

34. Richards and Tenhaff, "Call for Submissions," 10–11.

35. Paul Virilio, *War and Cinema: The Logistics of Perception*, trans. Patrick Camiller (London and New York: Verso, 1989), 2.

36. Richards and Tenhaff, "Call for Submissions," 11.

37. Ibid.

38. Cf., Clynes, "Foreword," 8. According to Clynes:

The cyborg concept helps man overcome the limitations of his earthly birth and adapt himself to space by using the accumulated experience of mankind plus his own courage and inner drive. By such participant evolution he is also about to bring us a step nearer to understanding the relationship between inner and outer space (or mind and universe) as a necessary corollary to the evolution of physiologic means for the creation of cyborgs.

Insofar as this statement by Clynes envisages a (white) male cyborg as the outcome of the accumulated experience of mankind, it is open to contestation on the grounds of gender and race politics. Thus, it is in this sense that it can be said to reveal the social and political nature of the relationship between "inner" and "outer" space.

39. Virilio, *War and Cinema*, 35. If Haraway has managed to successfully address the problem of gender in the context of her post-gendered cyborg, her success is less evident in the case of its race or ethnicity. Insofar as she has chosen to ground her image of the cyborg in a utopian space of "cyborg semiologies" ("A Cyborg Manifesto," 163), she fails to take account of the reconstruction of race or ethnic difference in terms of *technicity* (the definition and

differentiation of individual/group identity primarily in terms of technology as opposed to other systems of mapping similarity/difference). In fact, the "problem of coding" (164) and the question of "boundary conditions and interfaces" or "rates of flow across boundaries" (163) which she sees as the basis for cyborg semiologies implies an arrow of technological acculturation which, as the 1991 Persian Gulf War has made abundantly clear, is almost exclusively defined and controlled by a civilization that valorizes science and technology as its primary social, economic, military, and political motor.

While Haraway's account of the post-gendered cyborg is clearly designed to open up the field of science to fictional possibilities, it must also take account of the Western economic and military strategies which continue to divide the world into different geopolitical zones of influence, notwithstanding the continuing breakdown of social identities and coherent ethnicities in the cosmopolitan centres of First World nations. To continue to acknowledge and situate the principal locations of current social and political practices (traditional and oppositional) — which range from research laboratories to the academy — in terms of First World social, cultural, and political agendas is to remain cognizant of ever-present legacies of colonial and imperial activity. Should we choose to ignore these legacies, we are liable to reinscribe other peoples and more distant locations in our own spheres of interest, thus replicating the old Eurocentric patterns of ignorance and violence which motivated and accompanied colonial practices for the last 450 years. To challenge and take over a given domain of social practice in the name of a politics of metaphor is one thing; to actually challenge it at the level of entrenched and highly situated research practices is another. For a discussion of technicity in William Gibson's cyborg culture, see my article "The Technophilic Body: On Technicity in William Gibson's Cyborg Culture," *New Formations*, 8 (1989): 113–129.

40. Williams, *Keywords*, 22.

41. Michel de Certeau, "Spatial Stories," *The Practice of Everyday Life*, trans. Steven Rendall (Berkeley: University of California Press, 1988).

42. Ibid., 115.

43. Ibid., 116.

44. Haraway, "The Cyborg Manifesto," 149.

45. Richards and Tenhaff, "Introduction to the *Bioapparatus*," 7.

46. Haraway, "The Cyborg Manifesto," 164.

47. Ibid.

48. Ibid., 163.

49. Ibid.

50. Ibid., 163.

51. Marshall McLuhan, *Understanding Media: The Extensions of Man* (New York: McGraw-Hill, 1964), 83.

52. Ibid.

53. Paul Virilio, *The Aesthetics of Disappearance* (New York: Semiotexte, 1991), 101.

With speed, the world keeps on coming at us, to the detriment of the object, which is itself now assimilated to the sending of information. It is this intervention that destroys the world as we know it, technique finally reproducing permanently the violence of the accident....

The techniques of rationality have ceaselessly distanced us from what we've taken as the advent of an objective world; the rapid tour, the accelerated transport of people, signs or things, reproduce — by aggravating them — the effects of picnolepsy, since they provoke a perpetually repeated hijacking of the subject from any spatial-temporal context.

SPECTATORSHIP IN CYBERSPACE:
The Global Embrace

Janine Marchessault

IN THE EARLY SEVENTIES, Jean-François Lyotard set out to draft a new form of cinematic eroticism which he called "acinema." He imagined this to be a cinema not of memory, nor of identification or emotion, but one of abstract lyricism in motion. In the acinema, the representation of the fantasmatic body is replaced by the cinema's material supports which take on the task of libidinal agitation: "the film strip is no longer abolished (made transparent) for the benefit of this or that flesh, for it offers itself as the flesh posing itself."[1]

The victim is no longer the body represented on the screen, but the spectator, that Cartesian subject forever in search of unity. Abstract cinema, like Rothko's canvases, demands the paralysis not of the "object/model" but of the "subject/client," the "decomposition of his own organism." Acinema reverses the oppressive arrangement of classical cinematic representation as it turns the gaze in on itself by bringing the spectator into the frame of vision. Lyotard's strategy is largely directed toward doing away with "the phantom of the organic body or subject which is its proper noun" by suspending "that anchorage in nothing which founds capital." Yet he admits to some uncertainty when he concludes: "is it necessary for the victim to be in the scene for the pleasure to be intense? If the victim is the client, if in the scene is only film screen, canvas, the support,

do we lose to this arrangement all the intensity of the sterile discharge?"[2]

Though perhaps opposed to the modernist impulse toward sublimity underlying Lyotard's proposed acinema, the counter-cinema of Laura Mulvey's "Visual Pleasure and Narrative Cinema," formulated two years later, also seeks to turn vision in on itself by freeing "the look of the camera into its materiality in time and space and the look of the audience into dialectics, passionate detachment." For Mulvey, "there is no doubt that this destroys the satisfaction, pleasure, and privilege of the 'invisible guest'," whose gendered pleasure — unlike that of Lyotard's seemingly neuter subject/client — she has no interest in recuperating.[3] The formulation of a passionate detachment is inspired, on the one hand, by the consciousness-raising politics of the feminist movement and, on the other, by the epistemological mission of the historical avant-garde. Like Lyotard, her aim is in part to deconstruct the spectatorial body, opening spectatorship to difference via a certain historical materialism. In both the high modernism of the acinema and the revolutionary avant-gardism of the counter-cinema, the spectator rather than the author is pivotal. It is the spectator who is targeted for attack, who must suffer a painful disengagement by entering into the process of production. Identification is hindered expressly through the subject's being made both the consumer and the producer of meaning. As Brecht formulated it, the strategy of incorporating the spectator into the spectacle is paradoxical, for it is by breaking down distance that distance is generated. The metaphor of the open window, used to describe the intentionality and freedom of an earlier modernism, relates instead to an engagement which, while liberatory and democratic, is both confining — in its opposition to escapist fantasy — and alienating. These forms of reflexivity are by now familiar territory to the cultural theorist.

The reason I return to this earlier moment in film history is that I am struck by the ways in which the aims of spectatorial reflexivity — the desire for the spectator to be an

active participant, the paradox of distance, the shattering of disembodied vision—which define various cinematic modernisms have, to some degree, been realized by the processes of spectatorship under global capital.

Though Brecht sought to make pleasure and cognition—the receptive and the critical attitude—coincide, Adorno maintained that his project was doomed to fail. In a capitalist system which opposes pleasure to work, he argued, the pleasurable experience is derived from that which requires little concentrated effort.[4] I want to argue, nevertheless, that the culture industry's corporate avant-garde can rightly claim to have accomplished the fusion of pleasure and cognition. It is precisely those strategies of resistance which were employed to empower the viewer and democratize vision through a radical critique of realism, through alienation and distantiation, that now lend credence to the discourses of technological pluralism espoused by the corporate elite. Noël Burch has raised this very point:

> For years certain Marxist critics and film-makers ... have assumed that the alienation effect was inevitably illuminating and liberating, that anything that undercut the 'empathetic' power of the diegetic process was progressive. To be reminded that the scenes unfolding on stage and screen were artifice, to experience any mode of 'distantiation' was for an audience to be made able to think the textuality, to read the dialectics of the production of meaning, etc.... But it is beginning to appear to me today that the United States television [and Japan and Latin America]... mobilizes a number of strategies whose cumulative effect is to induce a certain disengagement, a certain feeling that what we see—no matter what it is—does not really count. Distancing, in short, has been co-opted; it has found a place among the panoply of weapons available to the ruling class of the USA to depoliticize, demobilize the working masses (ethnic and racial divisions, geographic distance, overconsumption, etc.).[5]

This very movement of capital—the tendency toward incorporation, atomization, and abstraction, the sophisticated

reflexivity which purports to "show things as they really are" — is what cinematic modernisms failed to anticipate. Burch makes a crucial point: television renders the critique of cinematic illusionism meaningless, precisely because reality is now experienced as illusion (i.e., through television). The general teleology of the illusion of reality has been displaced by the staging of reality as illusion; thus, whatever one sees "does not really count."

Given the co-optation Burch describes, I want to suggest that technical developments in moving image technologies (film, television, and digital images) might be understood not in terms of a progressive verisimilitude (the modernist assumption) but, on the contrary, in terms of a distancing and an abstraction, a narrowing of views, imposed on the order of the seen and, therefore, on the order of history. It is not that at this historical juncture there is more to see, but rather that there is nothing left to see... nothing left but the material conditions of visibility itself, a visibility defined and delineated through technology.

The televised war in the Persian Gulf gave us the answer to Lyotard's question: the victim need not be on stage for pleasure to be intense; in fact the intensity of the discharge depends on the total disintegration of the victim. Foregrounding the technological means of production functions not to give visibility to bodies but to render them completely invisible so that, as in the acinema, the technology is "no longer abolished for this or that flesh but rather, offers itself as the flesh," integrating and managing both the flesh of the victim and that of the subject/client as it achieves its sterile discharge. *The War as Never Before Seen* is the subtitle of the home video *Desert Storm*, the story of a war fought with images. In this war, explosions are never actually seen from the bomb's point of view because the image *is* the explosion that renders the world transparent.

I would like to offer a few speculations concerning this senseless integration or disintegration of the material world, by contemplating some of the forms of spectatorship that new image technologies instate.

Spatial Integration

Consider the intersection of three spectatorial regimes in the year 1926: *Napoleon Vu Par Gance*, *Don Juan* and the first public demonstration of television. One of the most monumental and extraordinary attempts to deconstruct the colonizing effects of monocular vision in the silent cinema era is Abel Gance's *Napoleon Vu Par Gance*. Gance's polyvision across spectacular triptychs sought to delinearize the cinema's sensational spatial and temporal capabilities and, at the same time, to problematize historical narration. *Napoleon Vu Par Gance* reproduces on a cinematic scale the great feats of one man — Napoleon — retrospectively, as seen by Gance. Its embodied field of vision gathers together vast heterogenous spaces under the rubric *Vu Par*. In this respect, *Napoleon* is really about Gance. The images are separate from the history they recount, typifying the "art of film," the visionary "auteur" at the height of cinematic Expressionism.

Gance's astounding cinematographic feat, however, was overshadowed by the coming of sound. The year 1926 sees the inauguration, with the release of Warner's *Don Juan*, of the Vitaphone system — a system of synchronous sound that promised to provide every viewer in every viewing situation with the best orchestral accompaniments previously available only to those in large city centres. What impressed audiences the most was not the democratic assurance of access, nor John Barrymore's seductive Don Juan, but the short prelude that carried Will Hays's synchronous speech to the audience. This filmed speech would lead one spectator to write: "No closer approach to resurrection has ever been made by science."[6]

As is well known, Hays was assigned the task of cleaning up Hollywood's image to enable it to better compete with the extensive appeal of the radio and the automobile. So it is indeed appropriate that he marks the coming of sound to Hollywood, harkening in the perfect synchronization of production and consumption, a system of controls and censorship, through that all-encompassing system of vertical

integration. This was an integration whose global circuits would, for a time, far exceed the spatial limitations of the radio and automobile which inspired it in the first place.

Synchronized sound in classical narrative cinema signalled a greater dependence on off-screen space to effectively suture the spectator into the scene. To this end, it changed the entire viewing experience, demanding silence and complete attention — producing the impression of a presence unmatched by the silent film. Paradoxically, the standardization that came with the sound film worked to remove the live presence both of early musical accompaniment and of the silent film's spectator, bringing to a close, by closing down the senses, the radical possibilities for collective participation described so hopefully by Walter Benjamin. The sound cinema's scopic regime would come to rely heavily on the role played by sound in enveloping and containing the viewer in a visuality which exceeds the world, circumscribing and disciplining the plurality of spectatorial looks. In this way, the spectatorial body becomes an integral part of the machine, mirroring the processes of commodity production.

The year 1926 marked not only the coming of sound to the cinema, but, as well, the first official television transmission by John Baird in England. Just as sound was being employed to bring the cinematic image to life, a new technology — one of direct transmission — was being devised to bring life to the viewer. The Renaissance dream of omniscient seeing, of seeing life as it unfolds at a distance, was to become reality. Taken up in the modernist telos, breaking down epistemological barriers, exceeding the expanded present of Gance's polyvision, the television transmission transforms the viewing situation into a reverse shot. It transfers the 'genius' of the visionary artist and the ontology of the sound film directly to the spectator. Television as global embrace is sustained by the fantasy, so succinctly summarized by Stephen Heath and Gillian Skirrow, "that the image is live, and direct for me."[7] The fantasy of "live" transmission is further reinforced by what Raymond

Williams has described as television's "flow," a constant flux of programs which reduplicates the flux of the life it claims to deliver.[8] And it is this disintegration of barriers, a marketed intimacy, that can be seen to both unify and disperse the spectatorial body, to rationalize and control the consumption of images.

The three specular instances I have just described coincide with Gilles Deleuze's periodization of the moving image. Deleuze describes a fascination that has migrated from "what is beneath the image" to "what it contains" to "how to insert oneself into images." The source for Deleuze's periodization is Alois Riegl who characterizes art's relation to nature in terms of three stages: embellishing nature, spiritualizing it, and, in the end, becoming its greatest rival. For Deleuze, Riegl's delineation is logical and historical precisely because it follows the movement of capital.[9]

Within two decades of its first transmission, television was steered away from the large-screen theatre television which John Baird and others foresaw to be consolidated into the expansive new model of integrated circuits and controls offered by network radio.[10] In their essay "Broadcasting Politics: Communications and Consumption," Kevin Robins and Frank Webster delineate some of the ways television has colonized leisure life and the privacy of the domestic sphere to suit the organization of a market economy. For them, Taylorism marks the first genuine information revolution as a rationalization of work that would come to include consumption in the development of that modern process we call marketing.[11] It is this earlier rationalization of work and political economy that enables capital to break down the division between production and consumption, to subsume both the public and the private sphere within a common wealth that, as Arendt has emphasized, has nothing common about it except that it is "strictly private."[12]

The term common wealth has a history born of democratic revolution; assimilated and disjoined of its more radical connotations, it now carries only an innocuous association with the general welfare under capital. In effect, this most

public of phrases has, in the postindustrial world, become privatized. The structure of the television apparatus, the history of its development under capital must be taken into consideration if we are to more fully understand the role that this apparatus plays in fusing pleasure and cognition. In other words, we must consider the role that the televisual apparatus plays in marketing consumerism under the guise of participatory democracy, transforming the flow of ideas into the circulation of commodities. For, as Stuart and Elizabeth Ewen point out, the impressive achievement of the mass media and of television in particular, "is to have reconciled widespread vernacular demands for a better life with the general priorities of corporate capitalism."[13]

Short-Circuit Enlightenment
This reconciliation is meticulously capsulized in an early advertisement for Dumont television. "The Little Princess and Her Enchanted Mirror" made its first appearance in the *National Geographic Magazine* in 1949, on the eve of 1950's consumer culture (figure 1). It is worth noting that the magazine itself emerged sixty years earlier in that age of expanding territorial empires and American imperial adventures—those things that, like broadcasting, would make the world smaller. Dumont sells its television by appealing to imperial myths of conquest and crusade, the chivalric tradition so fundamental to the Western's rugged individualism and receding frontiers. The fantasmatic environment of the enchanted mirror overwhelms and "belittles" the princess who will be enveloped by the speech of "learned men and skilled musicians." She will be rescued by television, the knight in shining armour, in a system of exchange that depends on her total integration.

The television viewer, unlike the film spectator, does not see; rather, she experiences a "deep understanding" in this peculiar inversion of the gaze, in this "enchanted mirror." For the mirror (a familiar metaphor for television, connoting access and mastery), as "enchanted" as it may be, has nothing to do with little girls. Here, both the spectator and

The Little Princess and Her Enchanted Mirror
Advertisement, *The National Geographic Magazine*, March, 1949.

the spectator's place are completely traversed, opened up as liberation becomes synonymous with penetration: she doesn't watch TV; rather, TV watches her, enlightening and informing her.

The power of television, divorced from the historical circumstances of its production, is seen to stem from diffuse magical — maternal — origins which encompass and engender the spectatorial space. Mary Ann Doane has argued that the representation of the female spectator in mainstream discourses is always problematic because, within this economy, women presumably do not have access to the processes of individuation necessary for the mastery of the image.[14] Doane points out that Freud identified the problematic of this feminine position with masochism (classic perversion). Masochism in Freud's scenario is feminine expressly because it means identifying with experiences "characteristic of womanhood, i.e., they mean that he is being castrated, is playing the passive part in coitus, or is giving birth."[15] Yet the paradox of pleasure in pain is primary for the subject; for both men and women, it is a central and relentless manifestation of the death drive.

The fluid somatic boundaries of the prepubescent princess and her fairy godmother pledge access to the regressive flow of history — a return to the crusades of earlier times, a nostalgia seemingly uncharacteristic of the modern medium of "live" broadcasting in 1949. Yet it is precisely this kind of nostalgia, a yearning for the connectedness of things, that television carefully formulates and markets as perfect integration. Corporate ideologies assure infinite regress through development, making the world accessible only through progressive consumption in a neurotic cellular publicity that deadens the senses. Thus, this early marketing strategy (a staple for today's advertising industry) claims to incorporate precisely what it excludes.

The threat posed by real-time live television, the potential it held for the construction of a public sphere separate from the corporate conglomerates that gave it life, was by the mid-1950s to be almost completely evacuated from

American television. Joyce Nelson suggests that the two television genres to have emerged out of this cold war, the sitcom and the crime series, work to simulate and enhance the division between public and private, between personal and political universes.[16] The sense of immediacy conveyed by studio production and often, as in the case of the sitcom, by videotape is limited to the quotidian, which serves to mirror the enclosure of the spectatorial space, its distance from the outside world. In contrast, cinematic dexterity and mastery are relegated to the wielding of power and the law in the outside and depersonalized world of crime. This division underlines the conviction that the individual spectator has access to power and the public sphere only through television, the knight in shining armour.

Television breaks down the division between outside and inside only by first introducing the idea that the outside world is inaccessible to the viewer, who, without television, would otherwise be powerless. In this sense "The Little Princess" plays a convincing role, standing for the blind spectator who is able to see only through television. This is the tautology of objective power that Foucault distinguishes: we can exercise power only through the production of a truth which is itself produced through power (i.e., by watching TV).[17]

The external threats that unchanging TV characters must endlessly combat to maintain their status quo,[18] as well as the never-ending and ever-growing flow of television's competing channels, which exceed the capacity of any one viewer, foster two important assumptions. The first is that the external world is something to be controlled; the second, that this world is beyond the viewer's control. Television, unlike the cinema, offers no closure—it only threatens us with it. While the cinema promises to reveal everything in the end, television does not come to an end, and hence insists that viewers keep watching, "stay tuned" or "glued" to the set. Reversing the plenitude of the cinematic image (resurrection as the absence, which is also a presence), television institutes loss through a presence that

can never be apprehended in its totality. Every televisual reality exists as present and immediate; each moment is exhausted, discarded, and hence, as Doane has put it, is completely "forgettable."[19] Even if, as Sean Cubitt[20] has argued, VCRs bring television into the age of mechanical reproduction, empowering the viewer with the technological means of impeding the televisual flow (making it subject to reproduction and viewer control), there will always be some immediate present that exceeds this control. Television's imaginary immediacy makes recording inconsequential, the power of the moment always already outdated.

Kiss of Death

The threat of castration, of being cut off from the controlling power, is incorporated into the television apparatus, into its excess. It is this fear, the fear of being disconnected that the latest interactive cyber-technologies count on.

After forty years, "The Little Princess and Her Enchanted Mirror" has grown into something quite different in a publicity photo for holographic television (figure 2). The viewer is no longer engendered but empowered by the freedom of expression — the freedom to see beyond the frame. It is no accident that this nostalgia references an infamous cinematic image whose receding boundaries and dark geographies automated the fetishist's secret industry, his circus of desire confusing production with consumption. Recalling an earlier scopic regime in the cinema that conveyed something hidden behind the image, the art of montage and of the veil, this image promises its disintegration. There is nothing to see beneath the holographic image of Marilyn Monroe, no cuts to provoke hidden depths, only the invisible splice that severs the filmed body from its historical relations of production and meaning, from its association with other images.

As with "The Little Girl and Her Enchanted Mirror," this new television apparatus offers the viewer a reality previously denied: the magical origins of the fairy godmother, that innocent gust of wind, the movement that passed too

Marilyn Monroe and holographic television.
Computer generated image, *Maclean's*, September 11, 1989.
Credit: Westenberger / Gamma Liaison.

quickly. All that had remained hidden can be made to appear, can be made to order on a single plane—by the viewer.

Herein new developments in artificial reality will promise an even greater disavowal: you no longer play at controlling power's penetrating force; rather, you are the penetrating force. Cyberspace hardware is intended to provide the illusion of direct experience with the use of computer-generated images in near real time. Composed of a head-mounted display (goggles) containing two colour LCD monitors which project a stereoscopic image to each eye, as well as stereo sound through earphones, this technology enfolds the user in a graphic illusion of real space. A head-tracking device correlates head movement with the displayed scene creating the compelling feeling of being inside a virtual environment. A data glove allows the user to grasp and manipulate computer-generated objects inside the illusory space. The effect promised is that you no longer play at Super Mario; you are Super Mario.[21] Thus, through the most spectacular of vanishing acts, the spectator is made to appear in the machine.

The driving potency of the television apparatus, its masterful access, is now—finally—available to the viewer, but at a price. The cost of admittance to the sphere of power will be the body. Each new development in virtual reality will restrain, restrict, and impose a corporate regimentation and disciplinary directive on the indefinite limits of the imagination. Now freed from the historical circumstances of its body, the public imagination—so the magazine *Audio/Video Interiors* tells us—has been captured by cyberspace technology:

> *It is quite possible that before the turn of the century, people will be able to don body stockings and opaque contact lenses ... and enter elaborate fantasy worlds: fly a Spitfire high over the English Channel in 1943; fend off Martians in the War of the Worlds in 2010; perform before a packed audience on Broadway; or single-handedly create an art museum, conjuring up abstract sculptures at will.[22]*

Breaking down the circuits between user and keyboard, this extroversion manufactures chance by remote forecast, puts in order the possible outcome, and equalizes bodies by producing fantasies which propagate nothing less than that historical hallucination: the bourgeois individual.

Though the fantasy of cyberspace is all about phallic violence (i.e., dominating maternal bodies — Captain Power, Power Glove, Hyperjoy Stick, and Super Cockpit, to name some of its earlier configurations), it is not predicated on a repressive power. Rather, it doubles, and therefore covers over and ensures, the actual exercise of power. The profound reflexivity of the interactive regime, which in order to be interactive must simulate an acting-upon an acting subject, obscures the real workings of power by mirroring them. Reassured by the illusion of mastery, the viewer as user experiences a technical sovereignty that collapses production and consumption more completely than ever before, transforming "the extensions of Man" to suit the workings of the machine.

Donna Haraway has observed that high-tech culture challenges the old dualisms of mind and body, subject and object, real and illusory. With machines becoming "smaller and cleaner" (i.e., some technologies are nothing more than electromagnetic waves), it becomes difficult to locate the source of power, difficult to decipher who is making and who is being made.[23] The opposition between pleasure and work is mediated in interactive culture through choice. Choice marks the merging of the utopian ideals of democracy and freedom with consumption. To be sure, the choices offered and pleasures derived from current cybernetic technologies are gender specific. They unabashedly confirm a phallic mastery that has lost sight of its origin but reinvents a new fiction: not the Cartesian "Man as God" but the postmodern-romantic-machine-made-Man.

If the cinema had to keep the spectator in the dark and in silence to conceal the mystery of its creation, and if television for its part amplifies the viewer's separation from these processes by placing her at an even greater distance

from them, then the new eye- and earphones of cyberspace technology complete the cycle of atomization by binding and enveloping her in a continuous unfolding of surfaces which censor even the most immediate depth of the present. This censorship—the fact that there is nothing left behind the image, the fact that the only cut experienced is the one that cuts you off—makes truth indecipherable and, hence, completely objective.

From spectator to viewer to user, the art of making everything appear, of showing and knowing all, takes its shape by unveiling the indefinite limits of consumption. In this way, there is no end to the use-value of knowledge because there is no position available from which to question use-value. This is indeed the work of modern science coiling up at its own tail as Arendt has described it, moving

> into the boundlessness of progress with its inherent admission that the good and the true are attainable. If they were ever attained, the thirst for knowledge would be quenched and the search for cognition would come to an end.... Yet the point is that the modern idea of progress implicitly denies such limitations.[24]

The information implosion is a veritable revolution, a return of the same as difference, a never-ending sequence of desire consuming itself. The digitized environments of cyberspace technology promise to circumscribe the sensual consumption of the material world in all its forms, in all its histories, as absolute totality. And in this dematerialized totality, *everything* is possible, every infinite possibility a priorized, all histories coded as information, all difference anticipated and relativized. According to Timothy Leary, cyberspace is the ultimate democratic experience: freed from our bodies and, hence, our identities, racism and sexism can be defeated once and for all. Whereas with earlier technologies, such as film and photography, the borders of the seen are limited by the apparatus as frame or window, in cyberspace the limits of the seen are said to be dictated only by the senses; limits

are imposed only by the individual user. In this case, there is nothing, no historical frame, to direct our gaze.

Thus, cyberspace signals the annihilation of authorship. It is not that we can all be authors but, rather, that the category no longer makes sense. Reduced to information, history is severed from the material circumstances of its production; it is no longer made but consumed in infinite form as probability colonizes chance. And when history dies, so perishes authorship as accountability for the world. This is why, for Deleuze, television has spelled the end of cinema and the end of art as noetic supplement.[25]

It is not a question of resurrecting humanist discourses of authenticity and origin, of separating the real from representation (the two were never separate anyway), but, perhaps, of redirecting new forms of image-making, interrogating, and transforming through images — as Marx put it, "a situation that requires illusions."[26] Within the context of a highly rationalized corporate culture, oppositional practices have the greatest stake in entering into the contradictions of identity and difference, in claiming bodies and histories, and in forging new public spaces — instead of the imagined worlds (the kiss of death) promised by the global embrace.

Notes

1. Jean François Lyotard, "L'Acinema," *Cinéma: Théorie, Lectures* (Paris: Ed. Klincksieck, 1973). Translated by Paisley Livingston in *Wide Angle*, 2, no. 3 (1978): 53–59.

2. Ibid., 59.

3. Laura Mulvey, "Visual Pleasure and Narrative Cinema," *Screen*, 16, no. 3 (Autumn 1975): 6–18.

4. T.W. Adorno, *Aesthetic Theory*, trans. C. Lenhardt (London: Routledge and Keagan Paul, 1984), 344.

5. Noël Burch, *Life to Those Shadows*, trans. Ben Brewster (Berkeley: University of California Press, 1990), 262.

6. Cited in Harry Geduld, *The Birth of the Talkies* (Bloomington: Indiana University Press, 1971), 142.

7. Stephen Heath and Gillian Skirrow, "Television: A World in Action," *Screen*, 18, no. 2 (Summer 1977): 57.

8. Raymond Williams, *Television: Technology and Cultural Form* (New York: Schocken Books, 1974), 86–96.

9. Gilles Deleuze, "Optimisme, Pessimisme et Voyage," *Pourparlers* (Paris: Les Editions de Minuit, 1990), 107.

10. Cf., William Boddy, "The Shining Centre of the Home: Ontologies of Television in the Golden Age," *Television in Transition* (London: BFI, 1986), 133. William Boddy has shown that American television would consolidate "radio's programming and merchandising goals with the persuasive aesthetic tools of Hollywood film-making." The effect was to extend the limits of the look, as the cinema had done, by conferring on it the extensive and boundless properties of radio sound — creating a seeing through hearing. Against the marketed mythos that broadcast technologies represent a return to earlier oral traditions, and against the seemingly utopian characteristics of sound as exceeding the rationalization of visual discourses, mainstream cinema and television employ sound to cover over and ensure subject/object divisions. They rely on sound to provide the illusion of expanded vision.

11. Kevin Robins and Frank Webster, "Broadcasting Politics: Communications and Consumption," *The Media Reader*, ed. Manuel Alvarado and John Thompson (London: BFI, 1990), 135–150.

12. Hannah Arendt, *The Human Condition* (Chicago: University of Chicago Press, 1958), 69.

13. Stuart Ewen and Elizabeth Ewen, *Channels of Desire: Mass Images and the Shaping of American Consciousness* (New York: McGraw-Hill, 1982), 128.

14. Mary Ann Doane, *The Desire to Desire: The Woman's Film of the 1940s* (Bloomington: Indiana University Press, 1987), 15.

15. Ibid., 17.

16. Joyce Nelson, *The Perfect Machine: TV In The Nuclear Age* (Toronto: Between the Lines, 1987), 55–57.

17. Foucault, "Two Lectures," 93.

18. Nelson, *The Perfect Machine*, 49.

19. Mary Ann Doane, "Information, Crisis, Catastrophe," *Logics of Television*, ed. Patricia Mellencamp (Bloomington: Indiana University Press, 1987), 229.

20. Sean Cubitt, *Time Shift* (London, New York: Routledge, 1991).

21. Cf., Philip Elmer-Dewitt, "(Mis)Adventures in Cyberspace," *Time* (3 September 1990): 57.

22. Frank Lovece, "Howard Rheingold," *Audio/Video Interiors* (December 1990): 38.

23. Donna Haraway, *Simians, Cyborgs, and Women: The Reinvention of Nature* (New York: Routledge, 1991), 153.

24. Hannah Arendt, *The Life of the Mind*, 1 (New York, London: Harcourt Brace Jovanovich, 1978), 55.

25. Deleuze, "Optimisme, Pessimisme et Voyage," 102.

26. Karl Marx and F. Engels, *Historisch-Kritische Gesamtausgabe. Erste Abteilung*, vol. 1, p. 608. Translated in Robert Tucker, *Philosophy and Myth in Karl Marx* (London: Cambridge University Press, 1961), 101.

THE SUBLIME:
The Limits of Vision and the Inflation of Commentary

Olivier Asselin
Translated by Francine Dagenais

THE ISSUE OF THE RELATIONSHIPS between contemporary art and theory is really that of a particular instance within a more general problem, and a less recent one—that of the relationships between the so-called visual arts and language. Contrary to the "idée reçue"* of their immediacy, a corollary to the no less traditional view of innocence of perception, the arts of vision are permeated with language. From the point of view of its production, the work is often already motivated by language. Its principles and techniques of production are consigned and communicated by the medium of language (by oral teaching in studio, the academy, or school, by books, whether they be treatises or poetics). Its sources are often language-based and more precisely bookish (stories borrowed from the literature of antiquity, of Christianity, of modernity; ideas borrowed from the sciences — physics, humanities, social sciences, etc.). And then, the work itself can take on a linguistic form: it is often structured *like* a language (*ut pictura poesis*: it is discontinuous, it refers, and often it refers arbitrarily). It is also often structured *by* language (it includes text, such as *impresa* or conceptual art). Finally, from the point of view of reception, the work is always accompanied by language. It is framed by it (preceded by readings — books, magazines, catalogues, signs, labels, and signatures). It requires a competence, a knowledge, generally mediated by language (a

knowledge of history, of principles and techniques, of sources, etc.). Moreover, the work invites discourse (articles, books, colloquia) of all kinds (critiques, history, theory), mixing all sorts of phrases—descriptions for the most part (simple or scholarly ones, refined or general: iconological, formal, semiological, narratological, pragmatic, aesthetic, genetic, sociological, historical, etc.) but also prescriptions and judgments, although this is rare. But contemporary art is, more than any other art, permeated with language and by the particular language of theory; it is inspired by it and incites it incessantly.

Historically speaking, the old proximity between art and language has variable causes and aims. But the stakes are often social, that is to say symbolic and/or economic. Language legitimates the artistic practice—whether it be a craft seeking the status of a liberal art or a marginal practice seeking a raison d'être—and thus language contributes to giving it a meaning and/or value. There is no doubt that language and its institutions (universities, magazines, etc.) have an important role to play in the production of symbolic goods, in their circulation from studio to gallery to museum, and in their funding by patrons and the state. The art-public still being small in numbers (producers still constitute the greater part of the viewers) and consequently of secondary importance, theory always occupies a decisive place in the evaluation of the works.

That art practice is now taught in universities and that the history and theory of art, the human and social sciences, and philosophy seem to be a mandatory detour in the education of an artist today (like classical studies, perspective, or anatomy used to be) is no doubt a symptom of this new dependency. With that, we witness a return to the old figure of the artist as intellectual—scientist, sociologist, anthropologist, and so on—an enlightened and enlightening citizen.

We can well deplore this state of affairs, this proximity of art and language, of contemporary art and theory. We can invoke, as some have done, the weaknesses or excesses of the theories which have been retained—from the Marxism

of the Frankfurt School to poststructuralism — or the ill usage that is made of them here, the simplifications that they undergo in this translation or this adaptation, or simply the mediocrity of some of the works that they engender, which seem to be worse than simple illustrations and vulgarizations, to be veritable *mise-en-scène*s of knowledge — a theatricalization. From such punctual, very often legitimate, remarks to a general condemnation of art and the theory of contemporary art, there is but one step (that some cross with enthusiasm) to considering, like Plato, art as merely imitation, and the artist as a protean imitator, a sophist and rhetor, who seems knowledgeable but is not, simulating science without having a command of it, especially (as is often the case these days) when she or he pretends to settle the affairs of the City. "Tell us this," one might ask the artist, as Socrates asked Homer, "What city was ever governed better because of you?"[1]

Yet, whatever some might say, this link between contemporary art and theory is perhaps not as contingent as it may appear to be. What becomes obvious is perhaps a requirement of modernity in general, at least as it is defined by Jean-François Lyotard. For the past fifteen years, the philosopher has been examining, among other things, a hypothesis first formulated in 1982 in "Réponse à la question: qu'est-ce que le postmoderne?,"[2] and a second time in 1983, in "Le sublime et l'avant-garde."[3] "It is in the aesthetic of the sublime," he writes in the first text, "that modern art (including literature) finds its motivating force, and in the logic of the avant-gardes, its axioms."[4†] "The sublime," he goes on in the second text, "is perhaps the mode of artistic sensibility which characterizes modernity."[5] In his book, *Leçons sur l'Analytique du sublime* (1991), Lyotard is more ambitious:

> *the sublime expresses and consecrates a major mutation in what is at stake in the arts and literatures.... It is, historically, a slow, uncertain, movement, always under threat of being repressed.... We can follow its various incarnations in the West, at least since*

the High Middle Ages, from the dispute between the Victorines and the Bernardines, through the baroque motif which overtakes and impedes the revival of Classicism, to the Querelle des Anciens et des Modernes, *the appropriation of Longinus's Treatise and the discussion of the sublime figure in the eighteenth century, of which the Kantian analytic is a major element. This possible mutation in the finality of arts and literatures continues through Romanticism and the avant-gardes until today.*[6]

In the disquieting scope that Lyotard now confers upon it, the concept no doubt loses some of its sharpness and force. The fact remains that the sublime becomes, at least in the eighteenth century, at the origin of modernity, the stakes of artistic practice, and will remain so no doubt under different names and modes, and according to varying degrees. But the century that invents or reinvents this problematic also sees the birth of art criticism and aesthetics and we could venture that this is not coincidental; the expansion of the question of the sublime in artistic practice is perhaps linked to the inflation of commentary which this practice incites in modernity.

Indeed, in the eighteenth century, the sublime is already subject to an abundant theorization. Edmund Burke and Immanuel Kant in particular will try to define the sublime, its occasion (the sublime spectacle), and its effect (the sublime feeling). For Burke, in *A Philosophical Inquiry into the Origin of Our Ideas of the Sublime and Beautiful* (1756),[7] the feeling of the sublime is, at least partially, a terror felt in reaction to certain events or representations of events that bring the imagination into play by excess and/or by default (of magnitude, power, light, sound, society, etc.), and evokes a menace to the existence of the spectator, such as pain or death: darkness, lightning, a starry sky, the troubled ocean, wild animals, certain unpleasant tastes or smells, dark colours, violent sounds (such as thunder) or lugubrious ones (such as an intermittent bell or the cries of animals), silence, forests, deserts, ruins, solitude, the void also, and everything that suggests an immensity or an eternity.

But the sublime feeling is not all made of terror. According to Burke, when the observer is at *a certain distance* (spatial or temporal) from what seems menacing, when she or he is *safe*, that is "*hors-scène*,"‡ terror is then mixed with a kind of pleasure, a negative indirect pleasure which comes from the suspension of danger or its "*mise en représentation*." This is what Burke calls "delight" in opposition to "pleasure."[8]

In the *Critique of Judgment* (1790),[9] Kant pursues Burke's reflection and gives it a transcendental twist. The spectacle of an exceptional magnitude or might, immense or irresistible, like the starry sky or a storm, is the occasion for a conflict between the faculties—specifically between, on the one hand, imagination (which generally synthesizes through apprehension and comprehension, and often schematizes the intuitions provided by sensibility in order to present them to the understanding) and, on the other hand, Reason, the source of Ideas, that is to say, of concepts without sensible objects or corresponding intuitions. Indeed, in front of such a spectacle, reason, which always strives toward totalization, conceives of the sublime idea of the infinite, the idea of the absolutely great or mighty, and demands that the imagination present it, that it provide a sensible intuition for it. The imagination can successively and progressively apprehend portions of an infinity (a fragment, then another, etc.) and thus provide, through the mediation of a concept of the understanding, a standard for a logical or mathematical evaluation of the infinite through "composition." Kant says:

> *a tree that we estimate by a man's height will do as a standard for [estimating the height of] a mountain. If the mountain were to be about a mile high, it can serve as the unity for the number that expresses the earth's diameter, and so make that diameter intuitable. The earth's diameter can serve similarly for estimating the planetary system familiar to us, and that [in turn] for estimating the Milky Way system. And the immense multitude of such Milky Way systems, called nebulous stars, which presumably form another such system among themselves, do not lead us to expect any boundaries here.*[10]

But its very progression makes it "lose on the one hand [backwards] what it gains on the other [forwards]." The imagination is incapable of comprehending the entire series simultaneously, of grasping its totality instantaneously in an aesthetic evaluation or synthesis. According to Lyotard, that is the meaning of this passage of the third *Critique*. Luc Ferry, in *Homo Aestheticus*,[11] offers a different interpretation of the same passage: that which occasions the sublime manifest not only the "psychological" limits of the imagination (of aesthetic comprehension), but also the transcendental limits of sensibility, which prevent us from going beyond space and time.[12] Whatever the case, the occasion for the sublime produces a conflict of the faculties and a contradictory feeling, which bears witness to what Lyotard terms very generally the "undetermined" – the imperceptible and the unknowable which exceed the imagination and understanding. Upon reflection, according to Kant, such a conflict between sensible nature and the Idea, between imagination and reason, reveals the finitude of the subject, the limits of knowledge and power, the weakness of the imagination and of the body, and produces a feeling of displeasure. But at the same time, it reveals the infinite power and ambition of reason, capable of conceiving beyond all intuition, beyond all possible experience, the "supersensible," and thus provoking a feeling of pleasure, "the feeling of our supersensible vocation,"[13]

> *For although we found our own limitation when we considered the immensity of nature and the inadequacy of our ability [imagination] to adopt a standard proportionate to estimating aesthetically the magnitude of nature's* domain, *yet we also found, in our power of reason, ... a superiority over nature itself in its immensity. In the same way, though the irresistibility of nature's might still makes us, considered as natural beings, recognize our physical impotence, it reveals in us at the same time an ability [reason], to judge ourselves independent of nature, and reveals in us a superiority over nature.*[14]

Curiously, Burke and Kant are mostly sensitive to the natural sublime. Yet, at the same time, in the second half of the eighteenth century, some works of art already seem to tend toward a rupture with classical poetics and rhetoric (which took the beautiful as an ideal, imitation as a means, and pleasure as an end) to shape or revive an aesthetic of the sublime, arousing more disturbing feelings, such as pathos, pleasure and displeasure, pity and fear, terror and delight. Burke and Kant do use a few artistic examples; often they are taken from poetry, though sometimes they are architectural or musical. But painting, and no doubt sculpture as well, are in one case ignored and in the other excluded from the arts susceptible of bringing about a feeling of the sublime. At this point, Burke begins to make a distinction between painting and poetry, which will not leave Lessing indifferent, in that it constitutes a critique of the doctrine *ut pictura poesis*. But Burke's distinction is less concerned with the question of temporality, as Lessing's is, than with the question of figuration, or imitation. Painting, writes Burke, offers an image, clear and distinct of its object, the limits and contours of which are always defined. Painting does not even come close to infinity. Conversely, poetry for the most part offers only indistinct and obscure images. Certain words—those that Burke calls "compound abstract words," like "virtue," "honour," "justice," "liberty" —do not trigger in the imagination of the listener or reader any precise image or idea, but do produce nonetheless (or perhaps even more so because of it) a strong affection by their very sound. Burke gives the example of the poet Mr. Blacklock, blind from birth, who has not any image or any idea of what he is describing, but whose words affect us nonetheless, and with intensity. Hence, sublime subjects, like the temptation of Saint Anthony, Vulcan's cavern, or angels, are better dealt with in poetry—which does not convey an image of them but renders them affective—than in painting—which conveys a precise image of them which is very often ridiculous. Burke concludes that poetry's goal is not exact description and imitation, as it is for painting, but

sympathy. Words express the passions of others (that in turn arouse our own) better than any other art. They can represent affective events which rarely happen in reality, can present ideas that have never been presented to the senses, and can allow combinations of rare and sublime words and ideas.

The distinction between painting and poetry that Lessing will make a few years later in his *Laocoon* is essentially concerned with the modes of imitation and, consequently, the temporality of the two arts, the temporality of their referent, and of their perception. Poetry, comprised of successive signs, and of articulated sounds succeeding each other in time, can only translate successive objects or their successive elements, that is, actions. Painting, made up of juxtaposing signs, forms, and colours spread out on a surface, can only express objects in juxtaposition or comprised of elements in juxtaposition — that is, bodies. Like Burke, Lessing will raise the question of figuration. Like painting, poetry can "create an illusion" and represent "visible objects," but, unlike poetry, painting cannot represent objects "that do not fall under the gaze," he writes (unfortunately without giving any examples).[15] From this perspective, painting is limited and doubly so: it can and should represent only visible and static objects. However, Lessing's reflections on the representation of feelings (of pain in particular) and of death may contradict this limitation. Even if the moderation required in painting seems to come for Lessing from an aesthetic of the beautiful, it partakes in an aesthetic of the sublime, at least in that it privileges the ellipsis, or the allegory.

But contrary to the opinions of these theoreticians of the sublime, painting has the means to evoke the infinite and, in that way, the limits of imagination and the weakness of the body. As Kant already notes, that which occasions the sublime is not necessarily an *absolute* magnitude or power, an absolutely unsynthesizable or unmasterable infinity (such as space or time in their totality). *Relative* magnitude or power, relatively unsynthesizable or unmasterable, can, in some contexts, evoke infinity. According to

the interpretation that Lyotard gives to this passage, the aesthetic comprehension of magnitude by the imagination is analogous to the perception of a magnitude by the senses and in particular to visual perception. In the case of the sublime, the two attempt to present a whole—one an absolute whole, an idea, the other a relative whole, a sensible object —but the two are limited—one to its fundamental standard, the other to the visual field. Luc Ferry gives an interpretation of this passage which is similar but differently formulated since he does not seem to wish to make a distinction between visual perception (which is the product of a sense) and aesthetic comprehension (which is the product of a faculty, the imagination). For Ferry, it is much more the "psychological" finitude of aesthetic comprehension which is analogous to the "transcendental" finitude of sensibility. Whatever the interpretation, that which occasions the sublime is not necessarily a spectacle of infinite magnitude or power, stretching beyond the limits of our imagination. Kant's examples are explicit: if the starry sky can be the occasion for a sublime reflection, then so can the pyramids of Egypt, or St. Peter's Basilica in Rome, and:

> *bold, overhanging and, as it were threatening rocks, thunderclouds piling up in the sky and moving about accompanied by lightning and thunderclaps, volcanoes with all their destructive power, hurricanes with all the devastation they leave behind, the boundless ocean heaved up, the high waterfall of a mighty river, and so on.*[16]

In a general way, the sublime merely requires an excess, absolute or relative, of the object over the subject (in the philosophical sense).

Painting can already evoke such an excess by way of its subject matter, when it represents excessive spectacles of relative or absolute magnitude or smallness, of relative or absolute might and power (the orrery, the volcanoes of Wright of Derby, the storms of Vernet, and the ruins of Robert are all sublime, as are the real starry sky, ruins,

storms, and volcanoes), and better still when it specifies the scale by means of a representation within the same image of the human scale, thus allowing a comparison and pointing to an excess of one part of the subject over the other (a minuscule figure represented at the foot of a pyramid or a giant increases their relative size). But the sublime effect can also be achieved in painting by way of the composition, or merely by means of the spatial and temporal "découpe" (framing) that it imposes on the subject, which sometimes seems in excess of its frame (a tight frame allowing only the representation of a fragment of the subject increases its relative size, as Hubert Robert demonstrates with his truncated pyramid). Yet—and we enter here into a logic of abstraction and of the monochrome—painting can produce the sublime effect in the manner in which the painting material is applied, which can seem in excess of the form (imprecise contours or a continuous surface deprive the gaze, that is the imagination, of forms and the understanding of concepts). Just as the imagination is sometimes incapable of presenting a totality through an additive process, it is also sometimes incapable of presenting a minimal unity in the infinite division of matter, a point which Burke addresses.[17]

Finally—and we enter here into a logic of installation—painting can bring about a sublime reflection by means of its format relative to the scale and position of the observer. A very large painting seen up close, for example, exceeds the boundaries of the visual field, and thus prohibits instantaneous perception and forces a lengthier duration of contemplation, requiring the intervention of memory, such as Savary's Pyramid to which Kant refers.[18] Such are the many pictorial means of presenting, at least negatively, the absolute.

But in painting's shift from an aesthetic of the beautiful to an aesthetic of the sublime, the commentary that it generates is also unsettled. Diderot's criticism is, in this perspective, exemplary, since it seems to be sensitive to this shift and even to desire it wholeheartedly. As René Demoris notes,[19] Chardin's beautiful still-lifes, although greatly

appreciated by Diderot, are the occasion of only a few mea-gre remarks: "What of this partridge,"§ he writes in the *Salon of 1769* on one of the works of the artist, "Can't you see it? It is truly a partridge. And this one? Yet another one."[20] The perfection of imitation, the tame conformity to the visible realm, provokes admiration but hardly a com-mentary. On beholding the beautiful landscapes of Vernet or the pathetic works of Greuze, Diderot becomes more loqua-cious, for imagination freely enters into play — the critic invents a stroll into the time frame of the painting or the novel of the before and the after. But the critique here remains mostly descriptive (of the visible, actual, or poten-tial), a mere double of the work. The sublime ruins of Robert, or the storms and shipwrecks of Vernet and Louthe-bourg, however, are the occasion for quite a different dis-course. In front of this scene painted with ruins, Diderot, as a viewer, is referred back to himself. Imagination also comes into play, but in a different way, not to clarify or complete the image but to imagine the future, his future. "We are turned inward," writes Diderot, in the *Salon of 1767*, about a work by Robert, "we anticipate the ravages of time, and our imagination scatters upon the earth the very buildings which we inhabit. At this moment, solitude and silence reign around us. We remain alone, the sole survivors of an entire nation that no longer exists."[21]*

The painting of ruins, though without ceasing to repre-sent only a moment, presents negatively (by representing its effects) a duration and an infinite duration — time in its totality which, in all its magnitude (it is infinite), and its power (it is inescapable and irreversible), remains unmaster-able, imperceptible, and unknowable. The sentient, know-ing, and acting being is always subjected to its duration. Hence the imagination in this instance attempts to imagine not only our future, but time in its entirety, to infinity. The written text being more sensitive to duration than painting (which is for once in art criticism an advantage), the com-mentary accompanies the imagination in this interminable essay. "Into what gloomy depths does my eye penetrate and

lose itself? How far away is that portion of sky which appears in the opening distance!"

Ruins suggest noble thoughts in me; that everything decays and dies and passes away, only the world remains and time endures. What an old world it is! My path lies between two eternities. Wherever I cast my eyes I am reminded by the surrounding objects that everything comes to an end, and I become resigned to the shortness of my own life. What is my ephemeral existence compared to that of this rock which crumbles away, or to this valley which is being hollowed out, to this forest whose trees are falling, to those shattered buildings above my head? I see even the marble of tombstones falls with dust, and shall I refuse to die, or expect a feeble tissue of flesh and muscle to escape the doom which falls on bronze? A torrent is carrying on the nations one after another to a common abyss; and shall I, I alone, expect to reach the shore and stem the flood which is rushing past me? One never tires of looking. Time stands still for he who marvels.[22]

From Lyotard's perspective, all modern and postmodern works are not sublime; some would still be related to an aesthetic of the beautiful or of the baroque, in which imagination encourages the proliferation of forms or aesthetic ideas to the point of precluding any re-cognition by the concepts of the understanding. But many modern works, particularly in the so-called visual arts, reflect upon what exceeds the gaze, upon the invisible, or more generally upon the imperceptible, or the unimaginable, the unpresentable, and partake at least in this way of an aesthetic of the sublime. Lyotard furnishes multiple examples of this from the eighteenth century to contemporary art, through the avantgardes and these schools of simplicity that are abstraction and minimalism. In this context it is not surprising that commentary is proliferating, and in that form in particular, neither purely descriptive nor truly prescriptive: a reflective, critical essay prompted by what exceeds it but sensitive to its limitations — in the image of its object.

Translator's Notes

* An inherited idea, a preconceived notion as regards an issue.

† All the translations of texts by Lyotard are mine.

‡ *Hors-scène* refers to what is outside of the scene or the event taking place.

§ Because of certain problems with the official translation of this portion of the text, notably taking short lines out of context, I have chosen to translate the following passages.

Notes

1. Plato, *The Republic*, Book X, 599c.

2. *Critique*, no. 419, 1982. Reprinted in Jean-François Lyotard, *Le postmoderne expliqué aux enfants* (Paris: Galilée, 1986), 11–34.

3. *Poésie*, no. 34, 1985. Reprinted in Jean-François Lyotard, *L'inhumain: Causeries sur le Temps* (Paris: Galilée, 1988), 101–118. Translated in *Artforum*, 22, no. 8 (April 1984): 36–43.

4. Lyotard, *Le postmoderne expliqué aux enfants*, 25.

5. Lyotard *L'inhumain*, 105.

6. Jean-François Lyotard, *Leçons sur l'Analytique du sublime* (Paris: Galilée, 1991), 187–188. Cf. *Le différend* (Paris: Minuit, 1983), 189–196, 232–246; "Judicieux dans le différend," *La faculté de juger*, ed. Jacques Derrida, Vincent Descombes, Garbis Kortian, Philippe Lacoue-Labarthe, Jean-François Lyotard and Jean-Luc Nancy (Paris: Minuit, 1985), 195–236; *L'enthousiasme: La critique Kantienne de L'histoire* (Paris: Galilée, 1986); "L'intérêt du sublime," *Du sublime*, ed. Jean-François Courtine, Michel Deguy, Eliane Escoubas, Philippe Lacoue-Labarthe, Jean-François Lyotard, Louis Marin, Jean-Luc Nancy and Jacob Rogozinski (Paris: Belin: 1988), 148–177.

7. Edmund Burke, *A Philosophical Enquiry into the Origin of Our Ideas of the Sublime and Beautiful*, ed. James T. Boulton (Notre Dame: University of Notre Dame Press, 1958).

8. Ibid., 35–36.

9. Immanuel Kant, *Critique of Judgment*, trans. Werner S. Pluhar (Indianapolis: Hackett, 1987).

10. Ibid., 113.

11. Luc Ferry, *Homo Aestheticus. L'invention du Goût à L'âge Démocratique* (Paris: Grasset, 1990).

12. Ibid., 135–145.

13. Kant, *Critique of Judgment*, 115.

14. Ibid., 120–121.

15. Gotthold Ephraim Lessing, *Laocoon* (Edition présentée par Jolanta Bialostocka, Paris: Hermann, 1964), 106–109.

16. Kant, *Critique of Judgment*, 108, 120.

17. Burke, *A Philosophical Enquiry*, 64.

18. Kant, *Critique of Judgment*, 108.

19. René Démoris, "Diderot et Chardin: La Voie du Silence," *Diderot, les Beaux-arts et la Musique*, C.A.E.R. XVIII (Aix-en-Provence: Université de Provence, 1986), 43–54.

20. Denis Diderot, "Salon de 1769," *Salons*, Texte établi et présenté par Jean Seznec, vol. IV (Oxford: Oxford University Press, 1967), 420.

21. Denis Diderot, "Salon de 1767," *Salons*, Texte établi et présenté par Jean Seznec, vol. III (Oxford: Oxford University Press, 1983): 227.

22. Ibid., 228.

23. Ibid.

INTRODUCTION, DISSEMINATION, AND EDUCATION:
Michel Foucault, "Integrated Intellectuals," and Writing on the Visual Arts in English Canada

Tim Clark

> *Education is the progressive development of the individual in all his faculties, physical and intellectual, aesthetic and moral. As a result of the disciplined growth of the entire personality, the educated man shows a balanced development of all his powers; he has fully realized his human possibilities.* (The Report of the Massey-Lévesque Commission on National Development in the Arts, Letters and Sciences, *1951*)

Introduction

My paper examines some of the reasons for, and consequences of, the introduction and dissemination of Michel Foucault's work in the context of writing on the visual arts in English Canada. I based my research on the premise that writing on the visual arts in Canada denotes a discursive/socio-institutional practice. In conducting this study, I wished to know whether there are economic, political, and discursive factors that affect the productive activity of universities, museums, and serial publications. With respect to those who incorporate the thought of Foucault in their work, I query whether their positions reflect, at the level of the narrative and argumentative structure, reading and writing patterns promoted by these institutions? Finally, I am interested in whether links can be made between economic and political factors mediated by these institutional contexts.

Given these goals, my initial efforts were directed at determining the total number of writers who have used some aspect of Foucault's work in their own writing. Any use, however slight or marginal, was of interest. I arrived at an initial list of thirty authors. In letters to these authors, I asked for interviews. Fourteen replied positively to my request, while one author, whom I could not talk to, responded to my questions by letter. From among these fourteen, I have selected certain cases for a more detailed examination.

Regarding my methodology, I might add that this paper is not concerned exclusively with art criticism in its traditional and limited sense of positive and negative evaluations of works of art. Writing on the visual arts must, I decided, include all forms of writing within the field.

In determining the actual scope of the primary source material, I had to choose from an extensive range of serials, catalogues, and monographs published in Canada from the late 1960s through to the 1990s. However, in order to limit this large body of publications, I excluded writing related to the disciplines of archaeology, art education, art therapy, museology, and those publications that dealt exclusively with the visual arts of film, video, and architecture. If articles that covered these particular visual arts did appear within the scope of publications which I examined, I did deal with them. The same also applies to all serials that only occasionally published work on the visual arts, or, in which this material would only form a very small percentage of the various types of articles published.

For a variety of reasons I concentrate on the work of anglophone writers. In my preliminary research I looked at French and English source materials which predictably confirmed an obvious fact about the Canadian cultural scene: only a very small proportion of English writers have published work in both French and English, while a much higher proportion of French writers have been published in both languages.

The concentration on anglophone writers was the result,

in part, of significant differences in the reception of Foucault by the francophone and anglophone communities. One difference resulted from the time-lag between the initial reception of Foucault's work by anglophone writers, like myself, who had to rely on translations of his work. From this research, it becomes clear that the dissemination of these translations was consequential to a number of the writers I contacted.[1] As Philip Monk remarked during his interview:

> I was both the beneficiary and victim during the late 1970s when a lot of other work started to come forward in translation — so it was this material being delivered all at once outside of its historical context. It was also a very fertile period when a lot of source material became available — it was not just the French work but also the German material of Adorno and that whole series of writers.[2]

James Patton stated:

> Madness and Civilization — I don't know when it came out in paperback but, that had something to do with it. When these things come out in paperback … I mean they were immediately available. Also the same people were reading October magazine and looking at those authors … we were enjoying Foucault's text in an anti-establishment way … we saw it as perverse in a fine way.[3]

If Foucault's work does play a major role in the evolution of Canadian writing, where and when did the writings of the authors examined here appear? Where did these writers first hear or read of Foucault's work, and, when and under what circumstances did this occur? Moreover, why is there a gap of several years between the period when thirteen of the English-Canadian writers first began to read Foucault in English, and the time when his most important *early* work first appeared in translation? Finally, what were the consequences of this introduction? Once these questions

have been addressed, it will be possible to respond to the question — why use Foucault's work?

In order to answer these questions, I have divided the work of the authors studied into two subgroups. The first of these is composed of articles by Walter Klepac, Philip Monk, and Heather Dawkins. Klepac's article points to some of the changes within Canadian writing resulting from the dissemination of work like Foucault's in the late 1970s and early 1980s. Dawkins's and Monk's texts represent the ways that the second subgroup uses Foucault's work. Rather than analyse the writing of the second subgroup, I will draw upon material from their interviews.

Transformation, Critique, and a "World Turned Around"

Twentieth-century modernist art has always been a self-conscious enterprise in one way or another. Within the decade of the 1960s alone, however, the focus of this self-consciousness shifted significantly: what was once a matter of questioning a given work's status as an art object turned into a question about its status as an object in the world. That is, the art of the "anxious" or problematic art object gave way to an art in which the object was conceived of as a vehicle for investigating and revealing the fundamental episteme of the artist/viewer — the assumptions, cognitive habits and network of associations upon which the artist's and viewer's conception of the world is based.[4]

Here, Walter Klepac proposes a critique of some postmodernist readings of contemporary art. These premises are, he argued, "rooted in ... the writings of a group of predominantly French intellectuals referred to as the Structuralists."[5] In particular, he attempts to provide alternative theoretical and historical readings of certain events revolving around late modernism and the complex developments of the 1960s and 1970s — objectives that are reflected in the title of the article, itself an ironic restatement of the title of Michel Foucault's 1966 masterpiece, "Les mots et les choses."

Klepac wrote this article thirteen years after he had been the art reviewer for the Toronto underground newspaper *Guerrilla* in 1971. While completing his BA, which included a double major in English literature and philosophy at Wayne State University in Detroit, Michigan, in 1969, he had studied and written some literary criticism at university. He did not write professionally until his work for *Guerrilla*. Writing, to Klepac, was a way of pursuing those interests he had developed in university inasmuch as "some of the philosophical issues dealt within analytical philosophy seemed to be more fully engaged in the work of art, particularly the work I saw at the Carmen Lamanna Gallery which had just started up at that time." In particular, the work of Ron Martin, the Rabinowitch brothers, and Michael Snow (who, at the time, was with the Isaacs Gallery), "dealt with those problems of epistemology and perception that seemed to parallel issues being raised in analytical philosophy."

While Klepac expressed a liking for Foucault's and Derrida's work because of the case it "presented against the fundamental assumptions of the Western episteme," his article actually demonstrates a much deeper philosophical apprehension over the nature of their arguments. Moreover, it is clear that his greatest concern was the uncritical and highly rhetorical use of their work by Canadians writing on the visual arts. Consequently, though the article takes to task the critical project of the French structuralists and their American counterparts, one of the main critical goals was the targeting of those Canadian writers who were presumably working from the same set of structuralist premises as the Americans:

What got me reading representative works of the postmodern and poststructural enterprise [for example, Klepac did not read Foucault's The Order of Things *until he was researching for his article] was that it was so antithetical to the fundamental principles of the most exciting and original work being produced in Canada at the time. In the hands of Canadian writers it became so widespread that it was quite devastating to a number of*

artists, like Roland Poulin and Ron Martin, whom I talked to . . .
they felt like the world had turned around.[6]

The 1984 publication of Klepac's article falls between
1977 and 1989, when twenty-eight of the thirty authors who
had used Foucault, as well as the works of other structural-
ists, first began to write and publish. More important, this
article appeared in *C* magazine, a later but nonetheless sig-
nificant partner to *Parachute* and *Vanguard* — important
both for their writing on the visual arts and for the propa-
gation of postwar international and regional modernism in
Canada. The connection between these publications and
writers goes beyond the simple fact of providing a venue for
publication, since Bruce Grenville, Robert Graham, Lesley
Johnstone, Russell Keziere, and Philip Monk have all had
some form of professional relationship with at least one of
the three periodicals.[7]

There are, moreover, other important factors that must
be taken into account when considering the time frame
within which these serials were founded, and into which all
of the thirty writers I interviewed emerged. For instance,
their appearance, starting in the late 1970s and running
into the late 1980s, reflects a much larger transformation
of the economic and socio-institutional framework of the
Canadian art world. Between 1965 and 1990, there is a 1110
per cent increase in the number of serials that provide pub-
lication venues for texts on the fine arts. Most important,
from 1965 to 1975, a period I consider most significant to
the transformation of this art world, there is a 350 per cent
increase in the number of publications dealing with the
arts. Other important venues for the public dissemination
of texts are institutions such as museums, galleries, and
artist-run spaces. Here again, there was a significant
increase in the number of exhibition spaces that could sup-
port the publication of catalogues. For example, Diana
Nemiroff, in her study on the emergence of artist-run
spaces in Canada, notes that the number of these spaces
rose from one in 1967 to over ninety in 1985.[8] Max Brice

notes in his 1979 study of the postwar growth of museums in Canada, that of the 575 museums Statistics Canada listed as existing as of 1976, 56 per cent appeared between 1967 and 1976. In other words, 322 museums began to operate at this time.[9] It is significant that the budget of the Canada Council — the single most important funding agency for the arts to emerge during this period — rose between 1965 and 1975, from $3.5 million to $24 million — an increase of 686 per cent! At the provincial government level, the budgets for the Ministère des Affaires Culturelles in Québec and the Ontario Arts Council (the largest funding agencies outside of the Canada Council) increased by 391 per cent in Quebec — from $4.5 million to $17.6 million — and in Ontario by 190 per cent — from $5 million to $9.5 million.[10]

Finally, as Joan Horseman has noted, there is also a rapid expansion of secondary and postsecondary education in the arts, which, from the mid-1960s onwards, can in part be seen as a consequence of the recommendations put forward in the Report of the Massey-Lévesque Commission.[11] In the booklet *The Arts and Education*, Horseman describes the commission's attempt to resolve a potential jurisdictional conflict between the federal and provincial governments over who controls the formation and implementation of education policies:

> *At the time the Commission was conducting its investigation on ways in which the federal government could promote opportunities in the arts, many argued that the arts were a matter of educational concern. Since education was the exclusive domain of the provinces, the federal government was impinging on provincial powers.* The Commission agreed that the arts were prime instruments to achieve humanistic aims of education. *However, it was adamant that the federal government had the right to make such contributions to the cause of education as lay within its means.*
>
> *The Commission believed that the conflict arose from a misunderstanding of the kinds and methods of education. Two approaches were possible. One approach was to provide opportunities for formal education in schools and universities;* a second

method was to provide opportunities for general non-academic education through books, periodicals, radio, films, museums, art galleries and so on. *As argued by the Commission, the arts were a part of formal education when they were included within schools and universities,* but they were more generally the means by which people gained educational opportunities *after completing formal education [emphasis added].*[12]

Introduction and Dissemination: Writers, Foucault, and the Canadian Educational Art World Context

While it is important to examine the nature of the relationship between the educational background of each Canadian author and the commission's "two approach" proposal, it is, I will argue, equally important to understand that there is also an historical relation that structurally links this "approach" to the dissemination and function of European critical theory. In particular, Foucault's work can be linked to the commission's proposal and the educational framework of the authors. Consequently, the final sections of this paper will attempt to trace the effects of Canadian writing on the interrelation of these three historical developments.

Scott Watson taught part-time at the University of British Columbia while pursuing an MA in art history, which he completed in 1977. After graduating, he worked as a registrar at the Vancouver Art Gallery from 1978 to 1980. In 1978, the director of the gallery, Luc Rombout, encouraged him to write catalogue essays for a forthcoming exhibition of minor French Impressionist paintings. Rombout showed it to Russell Keziere, who encouraged Watson to submit it for publication in a 1979 issue of *Vanguard* (whose offices were then housed at the Vancouver Art Gallery).

Watson first read Foucault's *The Order of Things* in the early 1970s, as a consequence of his friendship with the Vancouver poet Robin Blazer, whose familiarity with Foucault was the result of his "concern with the state of subjectivity in twentieth-century poetics." The historical background to Foucault's transmission in this case was provided

by the Black Mountain School of poetics, which "was very big in Vancouver given that all the members of the school, including, most prominently, Charles Olson, had come out here in the 1960s." Blazer had been a friend of Olson's, and "his reading of Foucault was tempered by his relation to this poet."[13] During the early 1950s, Olson had formulated a strikingly similar usage of the concept of archaeology, at least in its anti-humanistic aspects, as found in Foucault's work. However, Watson, like Klepac, did not start to deploy Foucault's work in his own critical writings until 1983, when he began to search for a more theoretically informed, alternative mode of historical analysis. He stated that he subsequently found his first 1978 catalogue essay "embarrassing" because of its reliance upon connoisseurship practices.

We find a different trajectory in the case of Robert Graham. He finished his BA at McGill in 1973, where he had also studied some art history. Although he entered the MA program in communications, he left the program, returning to complete his MA by 1989. As in Watson's case, Graham's first published text appeared after he completed his undergraduate degree, in a 1980 issue of *Parachute* magazine. Graham read Foucault's *The Order of Things* after completing his BA but before starting his MA. During his MA in communication studies, his exposure to Foucault's work increased. He had also heard Foucault, who had been invited to Montreal by the Université de Montréal, lecture at McGill on Manet's painting. In addition, he had taken a communications seminar directed by the American Foucault scholar Donald Bouchard. As for Graham's undergraduate study of art history, we can see, through his elaboration of his experiences, a common pattern of institutional resistance to, or lack of interest in, other theoretical and methodological frameworks not normally available within the departments in which a number of the writers were working.

While at McGill when I did take art history classes, I attempted to introduce material from outside the discipline ... they looked at me as if I had just pissed on the floor.

I did not spend a lot of time there, it was not my formative area...the Communications department was most important... a department that was itself not as strongly developed...it could accept Foucault fairly easily and what Foucault was trying to do was considered acceptable and welcome. Meanwhile, I still had this art interest...I was learning from communications, including Foucault, and I continued to think and talk about art with those tools, and I brought them to the art world.

Now my experience was that this was welcome in the art world...I had a good reception with this material, I didn't have to do battle with anyone.[14]

Marnie Fleming completed her MA in art history at the University of British Columbia in 1980, and, in 1981, while working at the Vancouver Art Gallery, she was encouraged by Russell Keziere to write her first article for *Vanguard*. Contact with Foucault's work occurred when she was studying with Professor David Solkin, who was teaching in the art history department. Fleming's situation is similar to Graham's and Watson's in that her first published work appeared around the time that she had completed her MA. With the exception of Solkin's support (as had been Graham's experience at McGill), the art history department showed little interest in the type of research methodologies of someone like Foucault. Like a number of the other writers, as Fleming pointed out, she was interested in theoretical and methodological frameworks that were opposed to positions such as formalism and connoisseurship.

My interest in Foucault was generated by Professor David Solkin, then at the University of British Columbia. I was introduced to Foucault in 1978 when I was preparing my MA thesis on Canadian artist William G.R. Hind. My other professors there were connoisseurs who viewed art and politics as separate spheres with intentions that were diametrically opposed; art to them transcended the matters of political debate...the writings of Noam Chomsky, Michel Foucault, James Clifford, Edward Said, Gayatri Spivak, and Griselda Pollock interested me.[15]

Trevor Gould's academic and publishing history reveals some parallels with the previous writers. There is, however, one major difference insofar as he never mentioned during his interview any instances of institutional resistance to his theoretical interests. Gould finished his MA in Canadian studies at Carleton University in 1987. His first published work appeared in *Parachute* in 1981, two years after he finished his undergraduate degree. In the early 1980s there was a shortage of people writing on the visual arts in Ottawa, and Chantal Pontbriand, editor of *Parachute*, had asked him to write because Philip Fry, a regular contributor to the magazine and a teacher at the University of Ottawa, had recommended him to her. Philip Fry introduced him to Foucault's work for the first time, though Gould had heard Foucault's name mentioned while he was studying sociology in South Africa. As a consequence, Gould read Foucault against the background of his previous research in sociology – a sociology that was itself grounded in a phenomenological and hermeneutic approach. He favoured this approach because he realized that "traditional art history and aesthetics were very limiting ... [because] they never really supplied answers to crucial questions I had. I found their answers too reliant on a formalism that was typified by Michael Fried ... I sought answers through social theory and literary criticism."[16]

Bruce Grenville completed his MA in art history at Queen's University in 1984. His first article appeared in 1982 in *Vanguard* magazine. Grenville started writing because there was no one writing about contemporary art in Kingston. He first came across Foucault's *The Order of Things* while in graduate school when he was doing research for a 1983 catalogue essay on John Clark's work. It was also around this time that he came into contact with French theory when he read *Parachute* magazine's 1981 anthology, *Performance Text(e)s & Documents*. It was one text from this anthology, Craig Owen's "The Allegorical Impulse: Towards a Theory of Postmodernism," which proved to be "an eye opener, and [which led me to] read

everything that was cited in the bibliography." As in the case of other writers of his generation, Grenville looked outside his department at Queen's because it did not provide the type of theoretical and methodological grounding he wanted nor did it offer courses dedicated to the contemporary work that he wished to write about. According to Grenville:

> *Queen's was very conservative... I was reading material in art magazines that was an entirely different way of writing about, say, Monet than the professors.*
>
> *Art history there was founded on a type of connoisseurship that came out of the professors who were trained at the Courtauld Institute.*
>
> *There was little interest in contemporary art. As for Foucault, I started with the chapter on "Las Meninas" in* The Order of Things—*it stunned me as a means for analysing work.*[17]

James Patton obtained his MA in art history from McGill University in 1990. His first article was published three years earlier in *Études des Arts*. Patton first read Foucault outside of his undergraduate art history studies at the University of Toronto. As in the case of a number of the other Canadian writers working in the late 1970s and 1980s, this shift to the outside was due in large part to the conservative nature of the art history being taught in the department at the time.

> *The University of Toronto was very conservative with a traditional art historical formulation... a self-reflexive methodology was used to refer to an internal system within the evolution of art practices. Paintings only refer back to other paintings, therefore, they do not refer to broader social or political issues.*
>
> *At the same time, I was influenced by some friends outside the university context who were reading other things—like Foucault. These friends were outside of the university context in that they had finished their BA's and were working in the subcultural milieu of Queen Street West. Books were being passed around—Foucault was really big—everyone was reading*

Madness and Civilization. *While I was being exposed to this kind of material, I was also reading* Parachute...*I noticed in the footnotes that people were referring to various authors whose names were coming up...I mean I was not aware of them, but I noticed that similar names were coming up all the time. Reading Foucault and related authors has allowed me to go into other areas of research...my main area of interest being Feminism.*[18]

Carol Williams's educational background, though similar in certain respects to those of the other writers, followed a somewhat different path of development, which led her to complete an MA in the social history of art at the University of Leeds in 1988. She published her first article in *Issue* approximately two years after completing her undergraduate degree. The completion of her MA was the culmination of a long period of self-initiated research by Williams. It began as a consequence of her hearing Martha Rosler speak at the Banff Centre, where Williams was enrolled in the winter studio program. Hearing Rosler, as well as reading works like Griselda Pollock's 1981 *Block* article, "Vision, Voice and Power," sparked her desire to pursue research into critical feminist writings (a project that was combined with her earlier grass-roots involvement in the women's movement). After Banff, she continued this research while enrolled in the fine arts program at Simon Fraser University. Here, once again, her reading of Marxist-feminist materials was self-initiated, since these materials were not available in the studio arts program of the school at the time. This situation also led her to attend a film studies seminar with the American film theorist and feminist Kaja Silverman. She also took the occasional women's studies course available in other departments because, as she stated, the "politically engaged material that I was interested in — issues concerning power, the body, and knowledge — was suppressed in the school."[19] Her first contact with Foucault's work, *The Order of Things* was by way of her partner Don Gill, who, while studying communications at Simon Fraser University in 1982–83, was reading Foucault.

Russell Keziere has, like Carol Williams and others, followed an eccentric path of development that has also included frustration with aspects of his university education. He started an honours BA in English literature at the University of Victoria, completing it in 1975 at the University of Massachusetts. This was followed in 1976 by a one-year period of independent studies in metaphysics at the Seminary of Christ the King in British Columbia. While at university, Keziere pursued minors in art history (medieval art and architecture) and philosophy. However, it was not long before he too became disenchanted with how these disciplines were being practised and taught. Keziere's first published article appeared in a spring 1978 issue of *Criteria* magazine.

> *I was in a Benedictine monastery for about a year after graduating from university where I was studying philosophy. I was dissatisfied with the philosophical rigor that I received at university and with the inability of people to take ideas and make them become real in some way. At that time I had been interested in contemporary art which seemed to be a place where one could discuss ideas concerning spirituality and politics — it was a place where ideas could become real and that was probably the reason I became interested in art. It was, in fact, reading an article in* Parachute *no. 2 on Joseph Beuys. The text made me firstly interested in the artist and, secondly in his mixture of politics, spirituality, and political interventionism. This experience, combined with my personal relations with artists, encouraged me to start writing about art.*
>
> *I was looking for a community where people believed what they said seriously enough for it to change their lives. There was something about their model of life — the way an artist does, or the way a poet does — of integrity. I just didn't see it in the people that were teaching philosophy and art history at school. Foucault's work is to engage — he follows in that existentialist model of John Paul Sartre — the political French intellectual. This was something that I did not have at university. This being the role model of the integrated intellectual.*[20]

His first contact with Foucault's work occurred while he was editor of *Vanguard* magazine: "I first met Foucault through my writers.... There was a number of people using Foucault around 1979–80–81."[21]

Philip Monk completed a BA at the University of Manitoba in 1972, after which he obtained an MA in art history at the University of Toronto in 1978. His first published article, on David Rabinowitch, appeared in a 1977 issue of *Parachute* magazine. As in the case of some of the other writers, he became dissatisfied with the traditional discipline of art history, especially with regard to contemporary art and the conservative way that art history was approached in general. Monk said:

> *Before I finished the MA, I became dissatisfied with the conservative nature of the way art history was approached at the university. My interest in contemporary art was always there—it was then that I decided that I did not want to continue on in art history and I started to write on art.*
>
> *I was interested in contemporary art for a long time before grad school which had submerged that interest—there were no contemporary courses there.*
>
> *At that time I decided that I was most interested in writing. I saw writing—not necessarily criticism—as just another outcome of thinking about art. It was more a way to continue to think about art.*[22]

Monk is not certain about the exact time when he first read Foucault's work, although it may have developed in the context of an emerging "general interest in all the new critical material [French writing]," which he became aware of after he left the University of Manitoba in 1974. While he may or may not have read his work at this time, there is more certainty about the context in which his interest in Foucault would have begun to develop since, as he pointed out, "it emerged in the context of a lot of other things."

*For instance, when all the other critical theories were being pub-
lished or translated. So if it started about the time when I was
becoming dissatisfied with the program at university, then that
would have been around the time of the mid 1970s — certainly by
1977 I would have been interested in him.*[23]

Heather Dawkins completed a BFA at Nova Scotia College
of Art and Design (NSCAD) in 1980, followed by an MA in the
social history of art from the University of Leeds in 1984,
and a PhD at Leeds in art history in 1990. Her first pub-
lished works appeared in a 1983 issue of *Parachute* maga-
zine, in student art magazines, and in a local feminist
newspaper in Halifax, *Women's Words*. Her first contact
with Foucault's writings came at NSCAD, where "most
everyone was reading him." However, her interest in his
work was a result of her involvement in producing a perfor-
mance with another person on sexuality in 1981–82: "I was
interested in Foucault because of gay and lesbian politics."[24]

Philip Fry, is the only major exception to the above pat-
tern, since his first contact with Foucault's work did not
occur within the Canadian context. He completed his doc-
torate at the Université de Paris (Sorbonne) in the philoso-
phy of art in 1968, under the direction of Jean Grenier. For
Fry, "the central issue has always been, and still remains,
the question of the limits of rational thought and the func-
tion of poetic expression." This was a question that was the
conclusion of a difficult process of personal evolution that
started when, as a Catholic priest, Fry came into direct con-
flict with ecclesiastical authority. According to Fry:

*The overriding thing was that I ran into the problem of author-
ity directly head on and had to try and deal with ecclesiastical
authority as being an official interpreter of a certain kind of
word. The work that I had been doing with biblical hermeneu-
tics inside the church led me to understand that there was a
kind of fluidity to this type of language. It led me to believe that
biblical texts are poetic texts.*[25]

Outside of the primary importance of this early work in biblical hermeneutics and his interest in Roman Jakobson and John Cohen, Fry stressed the importance of Foucault for his work, and the assistance that it provided to early structuralism in its attempt to rethink semiological/structural analysis.

> *We were stuck in first generation structuralism. It was a plodding, mechanical type. We had to find a way of carrying on with a rational investigation of sign-systems, but be able to do it in such a way that we would seat it somewhere other than for example in the problematics of the double articulation. Then Foucault comes out with a way of reading different disciplines and their manner of functioning and the text.*
>
> The Archaeology of Knowledge, *it was something that fit because it helped me to assess one of my main problematics — the problem of space — why spaces have values. I was more and more convinced that objects and space relate to each other — they generate their own shapes in regard to each other.*[26]

If we separate the questions of when, and under what conditions, these writers first read Foucault's work from when each writer first started to write outside the university, then, I would argue, the institutional context of the university provides two possible answers as to why there is a time differential between the first appearance of a number of Foucault's most important early writings in translation, and that period in which most of these writers began to publish work on the visual arts. First, there is, for a number of the writers, the lack of any early exposure to Foucault's work within their respective art history departments. Second, the year 1977 marks the beginning of the time period during which (with the exception of Fry and Klepac) Philip Monk, Russell Keziere, and Scott Watson began to publish. The other writers within my sample began to publish during the 1980s. Therefore, 1977 to 1987 is a significant period — it is when these writers were finishing their university studies. At the most obvious level of analysis, in passing through a

particular system of university education, all the writers had to have spent time digesting and reacting to the intellectual material to which they had been exposed, and the institutional settings in which they worked. Furthermore, with the exception of those individuals who had to leave and return at a later date to complete their degrees, this time period would also have been a direct function of the minimum and maximum time required to complete undergraduate and graduate degrees. Virtually all of the writers that I examined published their first article somewhere near the date of completion of their undergraduate or graduate degrees.

There is, however, another significant reason for this time-lag, and this is, of course, the perceived lack of publishing venues for the sort of material that these writers were interested in. *Only Paper Today* (originally *Proof Only*, which was published by A Space, Toronto's first parallel gallery) and *Artist's Review* were founded in 1973–74 and 1977 respectively, while *Criteria* emerged initially as an insert in the Vancouver Art Gallery newsletter *Vanguard* in 1974. *Vanguard* became a separate national art magazine as of February 1979, while *Parachute* began in 1975. I use the term "perceived" here because, as Klepac has noted, before the appearance of serials like *Parachute*, or *Artist's Review*, there were few existing venues for the types of material that some writers wished to publish. Of those that did exist, one of the most important was *Arts Canada*, and it posed problems for some writers who were interested in specific kinds of contemporary art:

> *In the early 1970s a number of us [writers] were interested in art, and this interest eventually led to the emergence of* Only Paper Today. *We were looking for a place to publish. This short lived publication, along with* Artist's Review, *was important to a number of new writers. One of the most profound publishing events in this context was the emergence of* Parachute, *in particular the difference between issue one, and issue two.*
>
> *As for* Arts Canada, *it was still a place where you could be taken seriously ... the catch was you couldn't do what you*

wanted to do. You were given assignments — when I asked to write about certain people, I was not allowed to do them. (For instance, in the case of a lot, though not all of the people associated with Carmen Lamanna's gallery and Isaacs.) The editorial attitude at Arts Canada *was very limiting. It was a situation that everyone was aware of. Consequently, when* Parachute *appeared, it was like a thaw. I had my reservations about* Parachute *but it opened things up a lot.*[27]

Foucault and "Work": "Esoteric Knowledge" and Some Patterns of Argumentative Activity

In 1978, Philip Monk wrote a critical assessment of the sculpture exhibition "Structures for Behaviour," which was held at the Art Gallery of Ontario under the curatorial directorship of Roald Nasgaard. In his article, Monk singled out the works of Richard Serra and David Rabinowitch for critical praise. Conversely, he focused on the works of George Trakas and Robert Morris because they exemplified precisely those negative characteristics that he critiqued in Nasgaard's curatorial assumptions. For example, both Serra and Rabinowitch produced efforts that, without any reliance upon verbal elements, provided specific situations for a given viewer to experience experimentally — a critical awareness of their own productive interaction with each work. In each case, the production of the artist did not promote a mode of subjectivity that was a function of phenomenological premises; nor did the works, as Nasgaard would argue, release the viewer from "the continuous narrative of history" into an unmediated contact with the "natural world." It was precisely this endorsement of an anti-phenomenological stance that tied Serra's and Rabinowitch's work to what Monk considered to be a proper critical understanding of the viewer's experience of the external world. It is during his discussion of Rabinowitch's work that we also find Monk citing a single passage from Foucault's *The Order of Things* in support of his own critique of phenomenological arguments. Monk writes:

Why engage in an anti-phenomenological enterprise, especially when phenomenological processes must be used to deconstruct themselves? Because of the limitations and questionability of phenomenology some of the problems of which Michel Foucault has outlined: "If there is one approach that I do reject, however, it is that (one might call it, broadly speaking, the phenomenological approach) which gives absolute priority to the observing subject, which attributes a constituent role to an act, which places its own point of view at the origin of all historicity — which, in short, leads to a transcendental consciousness."[28]

In Heather Dawkins's 1986 article "Paul Kane and the Eye of Power: Racism in Canadian Art History," there is a broader use of Foucault's work. This is closer to a genealogically grounded historical analysis, which, in examining selected aspects of Paul Kane's work, is actually directed at the then current institutional and educational context of Canadian art history. This article was a product of her participation in two conferences held in 1985, the "Feminism and Art Symposium" held in Toronto and the conference of the University Art Association of Canada. In it she argues that issues of racism, sexism, and cultural imperialism cannot be dealt with adequately, if at all, until the current institutional framework for the training of art historians and the methodological norms that underwrite that training are changed, since such norms reflect "its universalizing, ahistorical, conflict-free, and object-privileging assumptions."[29]

Foucault's work is deployed extensively in the course of her argument when, for example, Dawkins remarks that the archive that is represented by Kane's visual and written production forms neither a realist document nor a subjective perception of Indian culture, inasmuch as it is "implicated in, and constitutive of power." According to Dawkins, Kane's work can be better understood against the historical background of the shift in power relations that commenced during the early eighteenth century, when monarchic power gave way to a highly decentralized, rationalized form of power relations instantiated within the discursive and

institutional practices of "surveillance, discipline and the production of knowledge." The critical heart of her examination of Kane's work is clearly outlined in the last paragraph of the article, where, in a classically Foucauldian manner, she argues that

> To write this history does not retrieve a nineteenth-century other, but it refuses the benevolence customarily accorded to Kane's work in Canadian art history.... That work, of changing social relations and changing knowledges, is crucial to the disruption and transformation of the concepts and the languages of racism in this culture. As the symposium recognised, such questions should not be seen as a healthy alternative that merely revitalizes art history. Rather, they are of central importance in art history as a political practice, as part of the transformation of knowledge and behaviours that is cultural politics.[30]

However, beyond these more obvious theoretical and argumentative functions, there is another perspective from which we can examine Monk's and Dawkins's use of Foucault's work. Both writers were educated within an Anglo-American university system. As we all know, the use of selected quotations to bolster arguments is a practice typical of academic writing, where the citation of sources and the use of supporting material like direct quotes are an accepted methodological and argumentative component of the writing of research papers. Furthermore, this merely reflects the deeper discursive-institutional practice of reasoned argumentation, where one draws upon, critiques, and rereads sections from other discourses as one attempts to construct background sets of theoretical premises that ground each writer's arguments. Consequently, their citations may have as much to do with the academic practice of critical-analytical writing as with their interest in the research activity that is represented by Foucault's own critical writing. This point may also be extended to the other writers, given that in this group eleven completed their MAs, two their PhDs, one her MFA, and two their BAs.

This relationship between Monk's and Dawkins's educational background, academic writing practices, and work is important. The concept of "work"[31] refers, on the one hand, to a much broader socio-institutional context that is connected to the availability of options, inasmuch as each writer may have had to, at some time, perform teaching, curatorial, editorial, art critical, or art historical roles for a wide range of institutions on either a part-time, freelance, or full-time basis. As a consequence, each writer's ability to practise is a function of her or his respective teleological interests and the work he or she could obtain. On the other hand, there is the disciplinary-academic component. Traditionally the typical sociological model of "professions" ("occupational groups") has had four formal characteristics: "1) a body of esoteric knowledge... 2) monopoly — that is, recognition of the exclusive competence... in the domain to which the body of knowledge refers; 3) autonomy or control by the profession over its work, including who can legitimately do that work and how that work should be done; 4) a service ideal."[32] When examining the social actions of Canadian writers, the interrelation between education, work, and the issues of knowledge, monopoly, and autonomy or control by the profession must be taken into account because these relations provide one of the major structural contexts that frame their decisions and actions. The career development of each writer was circumscribed by various socio-institutional contexts where, depending on the nature of these contexts, the disciplinary-academic component could have been important insofar as "a body of esoteric knowledge" is of primary significance with regard to this component. I would suggest that each writer would have had to control a development process with respect to their careers that required them to negotiate paths of accommodation and "resistance"[33] as they attempted to locate themselves within the Canadian art world. The work of Michel Foucault, or (in the case of Carol Williams) Martha Rosler and Griselda Pollock, provided *other* critical positions and bodies "of esoteric knowledge" that would have set in

motion the constitutive transformation of localized settings in that art world when the teleological interests of someone like Williams intersect with the work of a Foucault or a Pollock.

Conclusion: "Resistances," "Integrated Intellectuals," and Burgeoning Venues

While twelve of the fourteen writers examined in this study started publishing from the late 1970s onward, the remaining two began in the early 1970s. It is clear that all, with the exception of Klepac and Fry, emerged from a burgeoning Canadian educational context. It is within this context that a number of these writers encountered difficulties as a result of their interests and research. Heather Dawkins spoke in her interview of "resistances," while in her article on Paul Kane, she pointed to an art-historical practice that was both methodologically exclusive and politically exclusionary. Foucault's production forms a significant methodological and explanatory component in Dawkins's program of critical feminism — a program that also plays different roles in the work of a number of the fifteen writers. Clearly, though, from my discussion of the educational and art world context, the negotiations of paths of resistance and accommodation developed somewhat differently for each writer and involved, in addition to feminist concerns, other important issues. For a large number of the writers, this process of resistance operated along ethical-political/professional-academic lines, with respect to the discursive/socio-institutional framework within which each of the writers worked. The key discursive and sociological factors that have emerged here have to do with how issues of esoteric knowledge, resistance, and accommodation functioned in relation to socio-institutional contexts.

While this paper has concentrated on the work of Foucault and the type of "esoteric knowledge" represented by that work, it is also obvious that Foucault's role is often matched, or surpassed, by the role of authors such as Benjamin, Rosler, Adorno, Derrida, and Owen. This situation is

demonstrated, in part, by the presence of an extremely large number of citations of non-Canadian authors in the works of all fifteen Canadian writers.[34] More significantly, when Canadian writers are cited, they typically function as secondary sources citing the work of the non-Canadian writers. When viewed against the background of the overlapping socio-institutional contexts of resistances and careers, this pattern points to an interesting historical situation. I would suggest that these non-Canadian authors helped to provide a number of Canadian writers with differing argumentive frameworks whereby these Canadians could intellectually and socially integrate into the Canadian art world.

The help provided by the translations of the work of these authors only accounts, however, for one major aspect of this process of integration. At *exactly* the same time as this material appeared on the market, there also occurred a massive and very rapid expansion of the institutional structures of the art world. Consequently, when each writer left school, or was nearing completion of his or her studies, there was either already in place, or being developed, a number of new alternative, or revised, institutional work venues. It is one of the central arguments of this paper that this development was, along with other factors, a function of the Massey-Lévesque commission's "two approaches" counter-proposal concerning education. This led, on the one hand, to the huge increase in exhibition and writing venues, and, on the other hand, to the concurrent increase in secondary and post-secondary education venues. Furthermore, as a consequence of these increases, the commission's report also helped to bring about the transformation of writing in Canada on the visual arts, insofar as its ideological support of the humanistic-academic concept of education contained in its proposal helped to foster both the professionalization and "academic" restructuring of that writing.

Notes

1. The importance of translations cannot be underestimated insofar as all the anglophone writers, with the exception of one, relied exclusively on translations of Foucault's work. Moreover, during my research I found that translations of the work of Foucault, Derrida, Lyotard, Barthes, Baudrillard, Benjamin, Lacan, and Kristeva, the writers most commonly cited by those Canadian writers using Foucault's work, all began to appear in print from the middle 1960s on. This, as we shall see, precisely parallels what I consider to be the most important time period for English-Canadian writers reading Foucault's work — 1965–75.

2. Interview with Philip Monk by Tim Clark, 1991.

3. Interview with James Patton by Tim Clark, 1991.

4. Walter Klepac, "The Order of Words The Order of Things: Deconstruction in Contemporary Art," *C* Magazine (Fall 1984): 42.

5. Ibid., 43.

6. Interview with Walter Klepac by Tim Clark, 1990.

7. The importance of these serials is further supported by the fact that of the 390 texts published in periodicals by the thirty authors using Foucault's work, I found that 36 per cent of them appeared in *Vanguard*, 26 per cent in *Parachute*, and 10 per cent in *C* Magazine.

8. Diana P.C. Nemiroff, *A History of Artist-Run Spaces in Canada, with Particular Reference to Vehicle, A Space and the Western Front* (masters thesis, Concordia University, 1985), 6.

9. Max O. Brice, *A Profile of the Museum Sector in Canada* (Ottawa: Research and Statistics Directorate, Arts and Culture Branch, Secretary of State, 1979), 9.

10. Paul D. Schafer, *Aspects of Canadian Cultural Policy* (Paris: UNESCO, 1976), 49.

11. Joan Horseman, *The Arts and Education* (Toronto: Canadian Conference of the Arts, 1975), 6.

12. Ibid., 2, 3.

13. Interview with Scott Watson by Tim Clark, 1990.

14. Interview with Robert Graham by Tim Clark, 1990.

15. Interview with Marnie Fleming by Tim Clark, 1990.

16. Interview with Trevor Gould by Tim Clark, 1990.

17. Interview with Bruce Grenville by Tim Clark, 1990.

18. Interview with James Patton by Tim Clark, 1990.

19. Interview with Carol Williams by Tim Clark, 1990.

20. Interview with Russell Keziere by Tim Clark, 1991.

21. Ibid.

22. Interview with Philip Monk by Tim Clark, 1991.

23. Ibid.

24. Interview with Heather Dawkins by Tim Clark, 1991.

25. Interview with Philip Fry by Tim Clark, 1990.

26. Ibid.

27. Interview with Walter Klepac by Tim Clark, 1991.

28. Philip Monk, "Structures for Behavior," *Parachute*, 12 (Autumn 1978): 21, 25.

29. Heather Dawkins, "Paul Kane and the Eye of Power: Racism in Canadian Art History," *Vanguard*, 15, no. 4 (September 1986): 24.

30. Ibid., 27.

31. Jan Goldstein, "Foucault among the Sociologists: The 'Disciplines' and the History of the Professions," *History and Theory*, 23 (1981): 175.

32. Ibid.

33. Interview with Heather Dawkins by Tim Clark, 1991.

34. In a citation analysis of work by Canadian writers who reference Foucault, I calculated the percentage of non-Canadian to Canadian authors cited ten or more times out of a total of 1208 citations. Of that total the following non-Canadians were cited (37%) 442 times: Foucault, Barthes, Benjamin, Derrida, Lacan, Baudrillard, Krauss, Lyotard, Crimp, Buchloh, Deleuze, Kristeva, Adorno, Guattari, Jakobson, Marx and Bataille. The following Canadian writers were cited (3%) 42 times: Monk, Wallace and Payant.

SYNTHETIC MAGIC/VIRTUAL REALITY

Francine Dagenais

THE EXPRESSION VR or "virtual reality" contains its own ambiguous structure and illogical connotations. The perception of reality is necessarily rooted in subjective experience; accordingly, the perception of a virtual reality is equally rooted in subjectivity – in the interstice between empirical knowledge and being. But how do we define the virtuality of this version of reality? The term "virtual" is a neologism of "virtualiter," coined (quite fittingly) by a logician, Duns Scotus (d. 1308) in the Middle Ages. According to classical philosopher Michael Heim, Scotus proposed

> *that the concept of a thing contains empirical attributes not in a formal way ... but ... virtually ... the real thing contains its manifold empirical qualities in a single unity, but it contains them virtually.... Virtual space – as opposed to natural bodily space – contains the informational equivalent of things. Virtual space makes us feel as if we were dealing directly with physical or natural realities. As if...*[1]

So, in this passage, Heim defines virtual reality as an "As if" reality, as opposed to Plato's "real reality." Heim points out that a virtual world can only remain virtual if it can be compared with the real. Thus far, virtual reality systems have yet to rival reality in that respect. The user can still tell a virtual world from a real world. Virtual reality remains

virtual for now. The effects of "jacking into cyberspace" are nevertheless far-reaching and at present uncontrolled and unknown.

Having introduced the topic which I am about to discuss, I feel that it is necessary from the outset to attempt to investigate its origins both technically and conceptually and to circumscribe the present acception of virtual reality. Although the framework for virtual reality's conceptual model was developed during the nineteenth century with the advent of the stereoscope and cinematography, it was not until the 1960s that a primitive device was implemented. Ivan Sutherland created a

> *head-mounted display that allowed a person to look around in a graphic room by simply turning their head. Two small CRTs driven by vector graphics generators provided the appropriate stereo view for each eye. In the early 1970s, Fred Brooks (University of North Carolina) created a system that allowed a person to handle graphic objects by using a mechanical manipulator. When the user moved the physical manipulator, a graphic manipulator moved accordingly. If a graphic block was picked up, the user felt its weight and resistance to their fingers closing around it.*[2]

Since then, developments in this field have occurred at an alarming rate, so rapidly that we are just now realizing that this technology will have a very "real," not virtual, impact on our world, though we have yet to define that impact. While technopractice has evolved unencumbered, fuelled by research grants and defence contracts, theorists have had barely enough time to grapple with the changes in virtual reality. Yet it is through theory and the media that most artists and writers have had their first glimpse of virtual reality. Its media existence, however, is relatively short; only since an article on flight simulators (cockpit environments and head-mounted display units were then an innovation) appeared in 1986 in *Scientific American* has virtual reality begun to have mass appeal. In nine years, virtual

reality has made the cover of such non-specialized publica-
tions as *The Village Voice* and has received wide television
coverage as the new medium. Since then, the technology
has proliferated into a variety of systems, from flight simu-
lator head-mounted display helmets with sophisticated pan-
cake lenses and fibre optic bundles (the best systems
currently available) to eyephone gear, data gloves, and suits
destined for a variety of military or commercial uses, such
as in-flight combat training, selling kitchen cabinets, or
advanced versions of video games.[3] These constitute the
current applications of virtual reality, as opposed to those
projected for virtual reality in the future.

Scott S. Fisher, who was founder and director of the Vir-
tual Environment Workstation project at NASA's AMES
Research Center, says that present research at NASA focuses
mainly on Telepresence and Dataspace. Telepresence has
been explained as a "remote task environment that repre-
sent(s) viewpoints from free-flying or telerobot-mounted
camera platforms," and Dataspace as a "display environment
in which data manipulation and system monitoring tasks
are organized in virtual display space around an operator."[4]

As well, multi-person cyberspace decks[5] are currently
being developed for a wide range of uses: cyberspace play-
houses, cybergalleries for virtual exhibits, and, perhaps
most frightening of all, the cyberclass—a virtual environ-
ment for learning. These proposed systems are, however, all
collective environments; at present, cyberspace is not "the
consensual hallucination" that William Gibson spoke of in
his science-fiction novel *Neuromancer*. Rather, it is a very
solitary first-person experience of a duplicated reality.

This reality is presented in a non-physical space. The
environment is created within the body by transferring
computer-generated information through sensory interface.
The goal of technopractitioners is to one day cover the
entire human sensorium, thus eliminating any sense of
being in one's natural body space. The virtual reality thus
described is not simply an illusion/duplication of reality, but
its replacement. This replacement would effectively negate

any possibility of comparison between the virtual and the real. Jacked into cyberspace (a term coined by Gibson), the body is nearly forgotten, its limbs become an encumbrance. The body no longer has an image, being substituted by a hand/index to direct it through an illusionary space and a head as receptacle and processor of sense data. The effaced body contains the environment.[6] Like Gilles Deleuze's and Félix Guattari's "corps sans organe" (body without organs)[7] the body is disembodied, decapitated, but at the same time it also becomes a "corps organique," the body as traditionally conceived by science—controlled by a central nervous system and brain. In this conception, the body is equated with the brain. It is both within and without, permeating and permeable. The body becomes a receptacle for a fundamentally schizoid experience of outwardness. The body is lost and isolated in a cyberplace and a cybertime, lost inside itself. The body becomes a receptacle for motion;[8] in Paul Virilio's words, it finds more and more normalcy in "dromoscopia," the static body experiencing movement by means of an apparatus: a car, a plane, a train, a film or video screen, or a virtual reality system.[9] It is a receptacle for vertigo, a sensation both thrilling and nauseating.[10] The patron as sense-data receptacle, interfacing with a virtual reality system, becomes an integral part of that system, "a machine that contains its own principle of motion,"[11] an automaton.[12]

In this cyberplace there is no crowd. Modernity's quintessential spectator, Charles Baudelaire's flâneur (or flâneuse), is definitely "out of place." He does not dawdle,[13] receiving an infinite number of what could only be termed "tableaux morts." As Susan Buck-Morss suggests, after modernity, the flâneur becomes "a mobile consumer of a ceaseless succession of illusory commodity-like images,"[14] a Pacman ingesting images. A flâneur automaton. In "On Some Motifs in Baudelaire,"[15] Walter Benjamin distinguishes between various versions of the flâneur—Edgar Allan Poe's, Baudelaire's, and, E.T.A. Hoffmann's. In a short piece entitled "The Cousin's Corner Window," Hoffmann describes

how his immobilized paralytic cousin is unable to physically follow the crowd, looking out instead from his corner window: "His opera glasses enable him to pick out individual genre scenes. The employment of this instrument is thoroughly in keeping with the inner disposition of its user...." Accordingly, the cyberstroller can pick out individual programs and specific aspects within these programs, remaining immobile while continuing on his dromoscopic path.[16]

In the context of the fiction surrounding virtual reality,[17] the body has become "wetware" with which to interface. The experience of virtual reality is an experience of alienation from one's own body. The puppet assumes the vicarious motions of the patron. The patron observes himself or herself at a distance through the actions of the puppet.

I chose to compare this experience of distance to that of the flâneur for several reasons. Chief among them is the fact that the technology underlying virtual reality systems is a combination of refinements of inventions and science-fictional conceptions dating back to the nineteenth century. As I mentioned earlier, virtual reality was made conceivable by the advent of both the stereoscope and cinematography. (We could add to this a wide range of optical devices and visual diversions serving as popular amusements, such as the diorama environment.)

Hoffmann's cousin uses opera-glasses which are somewhat akin to the stereoscope. They are composed of two similar (Galilean) telescopes, one for each eye. Although the various stereoscopic cameras, viewing devices, and images are much more complex, they are all based on the concept of binocularity. The stereoscope's deployment of the binocularity of vision is not new. It can be traced as far back as Egnatio Danti's *Optics* in the sixteenth century, and the seventeenth-century work *Opticorum Libri Sex*, a book on optical science by the rector of the *Jesuit Maison Professe* at Antwerp, François d'Aguilon (Aguilonius), with illustrations by Peter Paul Rubens (engraved by Theodore Gale). This consisted of five books, the fourth, *On Misleading Appearances*, dealing with the parallax phenomenon. This

discovery, made during the heyday of linear perspective, was viewed primarily as a problem to be overcome.[18]

It was not until the nineteenth century, when theories of vision, perspective, and optics had changed radically, that the stereoscope was invented. Interestingly, this occurred in 1832, before the advent of reproducible photography in England, with the talbotype. The invention of photography per se is normally traced to 1816, when Nicéphore Niépce produced the first photograph in negative image, and to 1822 and the production of the first direct-positive image. By 1837, Louis-Jacques-Mandé Daguerre had perfected his deceased partner Niépce's invention and had produced the daguerreotype, which was officially proclaimed a "gift to the state" by the French government in 1839. In 1835, William Henry Fox Talbot had developed a functioning negative on paper and, by the time the dagguerreotype had been confirmed, Fox Talbot had also perfected his process. The latter had the advantage, over Daguerre's system, of being able to produce multiple-image printings.[19] During its heyday, the stereoscope was associated almost exclusively with photographic images. It is important to note, however, that "the earliest sustained attempt to simulate the phenomenon in flat designs was made in, or shortly before, 1832 by Sir Charles Wheatstone," who was a pioneer of electrical science.[20] According to Martin Kemp, the reflecting stereoscope showed the earliest parallax representations of simple geometrical forms. When Wheatstone heard of the invention of photography shortly after 1839 (which would coincide with the dissemination of the daguerreotype), he immediately set out to exploit the principles of the stereoscope in combination with photography and so asked Fox Talbot to prepare stereoscopic talbotypes of "full-sized statues, buildings, and even portraits of living persons."[21] Although the daguerreotype was also used in the making of stereoscopic images, Fox Talbot's reproducible image was much more useful for this precise application.

In 1849, Sir David Brewster conceived a more manageable system: a lenticular stereoscope which was compact

and highly effective: "He failed to introduce the device in Britain and so introduced it to two Parisian opticians (Soleil et Dubosq)."[22] It was shown with success at the Great Exhibition of 1851. Kemp tells us that, by 1856, half a million had been sold and ten thousand different sets of images were available. The simplest and best known of these devices was invented by Oliver Wendell Holmes (the Harvard medical professor, jurist, and essayist) and Joseph Bates. In "The Work of Art in the Age of Mechanical Reproduction," Benjamin describes the more public and theatrical setting for stereographic images which came with the "Kaiserpanorama": "Before the movie had begun to create its public, pictures that were no longer immobile captivated an assembled audience in the so-called 'Kaiserpanorama'."

Here the public assembled before a screen into which stereoscopes were mounted, one to each beholder. By a mechanical process individual pictures appeared briefly before the stereoscopes, then made way for others. Edison still had to use similar devices in presenting the first movie strip before the film screen and projection were known.[23]

Edison's kinetoscope was invented in 1893. The stereoscope would disappear with the invention of cinema. Echoing Baudelaire's claim concerning photography itself, Jonathan Crary suggests that the stereoscope was "inherently obscene, in the most literal sense" of the word.[24] "It shattered the scenic relationship between viewer and object that was intrinsic to the fundamentally theatrical setup of the camera obscura." He argues, as did Benjamin, that there is a close relationship with the "visual culture of modernity" and the desire for appropriation. According to Rosalind Krauss, the stereographic image opens onto a virtual tunnel-like space consisting of a *feuilleté* of planes which can be read by repeatedly focusing on various parts of the image.[25] Generally, the object in the foreground juts out and comes into close contact with the eye. For Florence de Mèredieu, this contact appears to be without mediation; it is this point

of contact that would produce a discomfort in the viewer and be felt as the ultimate transgression. Jonathan Crary posits that "although the reasons for the collapse of the stereoscope lie elsewhere ... the simulation of tangible three-dimensionality hovers uneasily at the limits of acceptable verisimilitude."[26] He suggests that photography's single viewpoint triumphed over binocularity, and that the stereoscope's vividness and likeness were reinforced by this point of contact with the eye in what he refers to as "tangibility." It was this tangibility which associated the stereoscope with pornography. Benjamin argues that:

> *Art forms in certain phases of their development strenuously work toward effects which later are effortlessly achieved by the new ones ... [T]he institution of the Kaiserpanorama shows very clearly a dialectic of the development. Shortly before the movie turned the reception of pictures into a collective one, the individual viewing of pictures in these swiftly outmoded establishments came into play once more with an intensity comparable to that of the ancient priest beholding the statue of a divinity in the cella.*[27]

The Kaiserpanorama was a prophetic glimpse at a sensory diversion and type of sensory interfacing that would, a century later, become virtual reality. Indeed, it is within the imaginary scope of the nineteenth century that many technological innovations of the twentieth century are rooted:

> *Science-fiction, utopia and extraordinary voyages are all literary genres borrowing from reality to create plausible worlds outside of our own spatio-temporal boundaries. It is this flight outside of these boundaries which characterizes them as part of a model known as cognitive estrangement. This distancing is necessary in order to produce the framework for rational conjecture.*[28]

Fredric Jameson speaks of the inception of science fiction in these terms:

Whatever its illustrious precursors, it is a commonplace of the history of science fiction that it emerged, virtually full-blown, with Jules Verne and H.G. Wells, during the second half of the nineteenth century, a period also characterized by the production of a host of utopias of a more classical type. It would seem appropriate to register this generic emergence as the symptom of a mutation in our relationship to historical time itself.[29]

Science fiction would then be superimposed on the place once occupied by the past, on the historical novel:

The moment of Flaubert, which Lukacs saw as the beginning of this process, and the moment in which the historical novel as a genre ceases to be functional, is also the moment of the emergence of science fiction, with the first novels of Jules Verne. We are therefore entitled to complete Lukacs' account of the historical novel with the counter-panel of its opposite number, the emergence of the new genre of science fiction as a form which now registers some nascent sense of the future, and does so in the space on which a sense of the past had once been inscribed.[30]

Even though the various technological systems were already in existence, the concept of virtual reality was born out of such science fiction literature. Gibson's term "cyberspace," taken from his novel *Neuromancer*, will attest to that. Systems of virtual reality are applied models of estrangement.

In *Strange Weather*, Andrew Ross devotes a chapter to getting out of the "Gernsback continuum" — the title of Gibson's first published story, in which a freelance photographer is asked to document the futuristic architecture of the thirties in North America. The story is a critical commentary on "a future perfect that never was, a tomorrow's world planned and designed by technophiles faithful to the prewar ethic of progressive futurism." It is fitting that Hugo Gernsback should find himself the subject of a science fiction story. An entrepreneur and driving force behind the dissemination of pulp science fiction, he is said to have

invented the genre with the publication of *Amazing Stories* in 1926. In his publications, Gernsback promoted the vulgarization of science and the popularization of amateur science, as well as a code of scientific and technical plausibility.

> *Like the streamline designers, who thought that basic units like the tear-drop were Platonic forms, essentially perfect solutions to all design problems in the future, the Gernsbackian version of futurism was untroubled by its ideological assumptions about the future's unilinear shape. Both aesthetics would fall victim to the new logics of obsolescence — social and stylistic — with which* art moderne *was industrially associated. The "future" look would soon be out of fashion, proving, perhaps, that the future really was a continuum, and illustrating one of those time paradoxes of which SF is so fond. The Gernsback Continuum would ultimately leave Gernsbackianism behind.*[31]

In Italy, in the late sixteenth century, the camera obscura was seen as a device for entertainment, a means for viewing nature. Battista della Porta describes its theatrical presentation — "scenes of battles, strange animals or diabolical apparitions" — in a book titled *Magiae naturalis* ("natural magic") (1558 and 1589). According to Martin Kemp, "Optical magic was termed 'artificial', that is to say based on the inventor's ability to contrive painted, drawn or printed illusions that achieve astonishing effects when viewed under specific circumstances."[32] Virtual reality, as distinct from "real reality," would certainly fall into the category of artificial magic. "Artificial" implies that it is human made, which virtual reality ultimately is; however "synthetic" implies a combination of things of unnatural origin — it is, in a sense, the product of the artificial. A generation removed from artificial magic, the synthetic magic of virtual reality must be addressed. What is left to create is the theoretical framework for deconstructing the relationship between science-fictional fantasy and its technological realization.

We can no more afford to see ourselves as unavoidably victims of technological development than as happy beneficiaries of a future that has already been planned and exploited. Such an attitude does not lead to empowerment. While it may offer a way out of what Gibson called the "Gernsback Continuum," it is a one-way ticket to a future that we must try to make obsolescent as quickly as possible.[33]

Notes

1. Taken from Michael Heim, "The Metaphysics of Virtual Reality," *Virtual Reality: Theory, Practice and Promise*, ed. Sandra K. Helsel and Judith P. Roth (London: Meckler, 1991), 29–30.

2. Myron W. Krueger, "Artificial Reality: Past and Future," *Virtual Reality: Theory, Practice and Promise*, 19.

3. And most recently to train robots, data-insects, and computers. For more information on "insectoid" research, see Paul Wallich, "Silicon Babies: Trends in Artificial Intelligence," *Scientific American*, 265, no. 6 (December 1991): 125–134.

4. Scott Fisher, "Virtual Environments: Personal Simulations and Telepresence," *Virtual Reality: Theory, Practice and Promise*, 107–108.

5. Though the word "deck" has yet to be standardized, it is the most widespread in current usage. It is a cyberspace system whose structure is based on the feedback loop: the user or "patron" makes use of the system by means of an input device or keyboard, the "puppet" is the human or artificial intellect's incarnation in virtual space, the patron "affects virtual space through a puppet's sensors and learns of events in virtual space through a puppet's effectors. That is, a puppet's sensors are a patron's effectors, and a puppet's effectors are a patron's sensors." Randall Walser, "II. Practice: Application and Development, The Emerging Technology of Cyberspace," *Virtual Reality: Theory, Practice, and Promise*, 36–37.

6. The following is based on my reflections over the past few years, a small part of which was originally published in 1991; see Francine Dagenais, "Perfect Bodies," *Virtual Seminar on the Biopparatus*, ed. Mary Anne Moser (Banff: Banff Centre for the Arts, 1991), 43, 114.

7. Gilles Deleuze and Félix Guattari, *Mille Plateaux* (Paris: Les Editions de Minuit, 1980), 194.

8. Dagenais, "Perfect Bodies," 43, 114.

9. For more on "dromoscopia" see Paul Virilio, *L'horizon néga-tif: essai de dromoscopie* (Paris: Galilée, 1984).

10. The fact that these systems need to be perfected, and that the image resolution is low for most virtual environments, does not hinder the hypnotic quality of the medium. The popularity of video arcades bears witness to the fact that interacting with a moving screen, however unsophisticated the program or graphics may be, is an all-encompassing pastime (as opposed to activity). The recent advent of interactive cinema and televised soap operas is also an indication of this.

11. A concept originally found in Rabelais's *Gargantua* in the sixteenth century; see Jean-Claude Beaune's essay, "The Classical Age of the Automaton," *Fragments for a History of the Human Body,* Part I, ed. Michel Feher (New York: Zone, 1989), 431.

12. "Automate," "contrived a thousand little automatory engines, that is to say, moving of themselves." See Dagenais, "Perfect Bodies," 43, 114.

13. See Walter Benjamin, "On Some Motifs in Baudelaire," *Illuminations*, ed. Hannah Arendt (New York: Schocken Books, 1969), 172–200.

14. Susan Buck-Morss, "The Flâneur, the Sandwichman, and the Whore: the Politics of Loitering," *New German Critique*, 39 (Fall 1986): 99–140.

15. Benjamin, *Illuminations*, 173.

16. Virilio, *L'horizon négatif.*

17. With few exceptions, these issues are just now starting to be discussed by theorists, as opposed to the technopractitioners and science fiction writers who inspire them.

18. For more on this subject, see Martin Kemp, *The Science of Art: Optical Themes in Western Art from Brunelleschi to Seurat* (New Haven and London: Yale University Press, 1990), 102–103.

19. H. and A. Gernsheim, *L.J.M. Daguerre: The History of the Diorama and of the Daguerreotype* (New York: Secker and Warburg, 1968), 89; and, G. Buckland, *Fox Talbot and the Invention of Photography* (London: Scolar Press, 1980).

20. B. Bowers, *Sir Charles Wheatstone* (London, 1975), 194.

21. Kemp, *The Science of Art*, 215.

22. Ibid., 215.

23. Benjamin, *Illuminations*, 250.

24. A concept that Crary borrows from Florence de Mèredieu. "De l'obscénité photographique," *Traverses*, no. 29 (October 1983): 86–94.

25. Rosalind Krauss, "Photography's Discursive Spaces," *The Contest of Meaning*, ed. Richard Bolton (Cambridge: MIT Press, 1989), 286–301.

26. Jonathan Crary, *Techniques of the Observer: On Vision and Modernity in the Nineteenth Century* (Cambridge and London: MIT Press, 1990), 127.

27. Benjamin, *Illuminations*, 250.

28. Dagenais, "Perfect Bodies," 114.

29. See Fredric Jameson, "Progress vs Utopia," *Art after Modernism: Rethinking Representation*, ed. Brian Wallis (New York: New Museum of Contemporary Art, 1984), 241–242.

30. Ibid., 241–242.

31. Andrew Ross, *Strange Weather: Culture, Science and Technology in the Age of Limits* (London, New York: Verso, 1991), 135.

32. Kemp, *The Science of Art*, 202–203.

33. Ross, *Strange Weather*, 135.

ART AND THEORY:
The Politics of the Invisible

Tony Bennett

IN HIS ESSAY "The Historical Genesis of a Pure Aesthetic," Pierre Bourdieu offers a useful thumbnail sketch of the historical processes involved in the formation of an aesthetic structure of vision — what Bourdieu calls the "pure gaze" — in which the work of art is attended to in and for itself. The organization of the categories governing how works of art are named or labelled, Bourdieu argues, plays an important role within these processes and he suggests that the term "theory" might aptly be used to describe these categories, the manner of their functioning, and their effects. "Theory," he writes, "is a particularly apt word because we are dealing with seeing — *theorein* — and of making others see."[1]

To analyse the historical processes through which the "pure gaze" is constituted is thus, in part, to trace the formation of those spaces and institutions in which works of art are so assembled, arranged, named, and classified as to be rendered visible as, precisely, "art," just as it is also to examine those forces which produce spectators capable of recognizing and appreciating those works as such. In truth, these are two sides of the same coin, the production of "art" and the production of aesthetes forming two aspects of the dialectic through which, as Marx argued in the *Grundrisse*, the processes of producing an object for consumption and a consuming subject always organize and beget one another

in the forms required for the circuit of exchange between them to be completed.[2] As Bourdieu puts it:

> *The experience of the work of art as being immediately endowed with meaning and value is a result of the accord between the two mutually founded aspects of the same historical institution: the cultured habitus and the artistic field. Given that the work of art exists as such, (namely as a symbolic object endowed with meaning and value) only if it is apprehended by spectators possessing the disposition and the aesthetic competence which are tacitly required, one could then say that it is the aesthete's eye which constitutes the work of art as a work of art. But, one must also remember immediately that this is possible only to the extent that the aesthete himself is the product of a long exposure to artworks.[3]*

It is, however, theory—in this case, a distinctive language of art—which mediates the relations between the aesthete and the work of art, offering, through its categories (of art's autonomy, of creativity, of the irreducible individuality of the artist, etc.), a means whereby the works on display can be construed and experienced as the manifestations of a higher-order reality ("art") of which they are but the tangible expressions. In this way, theory—present just as much in the principles governing the display of artworks as in the aesthete's head—organizes a particular set of relations between the visible (the works of art on show) and the invisible ("art") such that the former is perceived and utilized as a route to communion with the latter. Yet this theoretical ordering of the relations between the visible and an invisible also plays a role in organizing a distinction between those who can and those who cannot see; or, more accurately, between those who can only see what is visibly on display and those who are additionally able to see the invisible realities ("art") which the theory posits as being accessible via the objects exhibited.

This helps to account for the different attitudes of different types of visitors to the use of labels, guidebooks, or other kinds of contextualizing and explanatory materials in

art museums. In their now classic study *The Love of Art*, Bourdieu and Darbel note that working-class visitors typically responded most positively to the provision of guidebooks or directions as to the best route to take through an art museum. It may well be, Bourdieu and Darbel argue, that such clarifications are not always able to "give 'the eye' to those who do not 'see'."[4] Nonetheless, their presence in a gallery is symbolically important just as is the demand for them by working-class visitors in that both testify to the possibility that the gap between the visible and the invisible may be bridged by means of appropriate trainings. If, by contrast, and as their evidence suggested, the cultivated classes are the most hostile to such attempts to make art more accessible, Bourdieu and Darbel argue that this is because such pedagogic props detract from that charismatic ideology which, in making "an encounter with a work of art the occasion of a descent of grace (*charisma*), provides the privileged with the most 'indisputable' justification for their cultural privilege, while making them forget that the perception of the work of art is necessarily informed and therefore learnt."[5]

It would, of course, be wrong to eternalize the findings of this study, especially in view of the economistic leanings which characterize Bourdieu's view of the relations between class and culture. As John Frow has shown, there is a tendency in Bourdieu's work to polarize aesthetic dispositions around two options—the popular and the bourgeois—whose coherence derives from the pre-given class logics on which they depend.[6] Be this as it may, it is a tendency which runs against the grain of Bourdieu's more general argument that the characteristics of the artistic field, and thus of the specific competences that individuals need to acquire in order to perceive its invisible significances, are a mutable product of the relations between the practices of art galleries, the discursive categories that are made available by art theory, the means by which these are circulated, and the forms of art training and familiarization available in educational institutions. A more recent finding—made some twenty

years later and in Australia—that support for the view that art galleries should provide explanatory and contextualizing material was strongest among those with the highest levels of education, may thus be evidence of an artistic field which is differently structured in these regards.[7]

Even so, the more general point I am concerned to make here remains valid: that, in art galleries, theory, understood as a particular set of explanatory and evaluative categories and principles of classification, mediates the relations between the visitor and the art on display in such a way that, for some but not for others, seeing the art exhibited serves as a means of *seeing through* those artefacts to see an invisible order of significance that they have been arranged to represent.

The same is true of all collecting institutions. In *Collectors and Curiosities*, Krzysztof Pomian defines a collection as "a set of natural or artificial objects, kept temporarily or permanently out of the economic circuit, afforded special protection in enclosed spaces adapted specifically for that purpose and put on display."[8] Pomian defines such objects as semiophores—that is, objects prized for their capacity to produce meaning rather than for their usefulness—and, in asking what it is that the objects contained in different kinds of collections have in common which accounts for their being selected as semiophores, concludes that their homogeneity consists in their ability to be involved in an exchange process between visible and invisible worlds.

Whatever the differences between them in other respects, then, the objects housed and displayed in collecting institutions—whether museums, temples, or cabinets of curiosities—function in an analogous manner. In comprising a domain of the visible, they derive their significance from the different "invisibles" they construct and from the ways in which they mediate these to the spectators. Or, to put this another way, what can be seen in such institutions is significant only because it offers a glimpse of what cannot be seen. When, in the classical world, offerings intended for the gods were put on public display, the result, Pomian thus argues, was that:

These offerings could continue to function as intermediaries for this world and the next, the sacred and the secular, while at the same time constituting, at the very heart of the secular world, symbols of the distant, the hidden, the absent. In other words, they acted as go-betweens between those who gazed upon them and the invisible from whence they came.[9]

In the modern history museum, by contrast, objects are typically displayed with a view to rendering present and visible that which is absent and invisible: the past history of a particular people, nation, region or social group. This organization of a new invisible was the combined result of the choice of a new set of semiophores (period costumes, for example) and of the display of old semiophores in new arrangements (the tombs of notables arranged in chronological succession) through which a national past, say, could be rendered materially present through an assemblage of its artefactual remnants.

However much truth there might be in these generalizations, though, the orders of the visible and the invisible are not connected in an invariant manner. Rather, the ways in which the former mediate the relations between the latter and the spectator depend on the role of specific ideologies of the visible. At times, different ideologies of the visible may even inform the arrangement of the same collection, giving it a multi-levelled structure. Alexandre Lenoir thus arranged his collection at the Musée des Monuments Français from two points of view. From a political point of view which echoed revolutionary conceptions of the need for transparency in public life, he thus argued that a museum should be established with sufficient splendour and magnificence to "speak to all eyes" (parler à tous les yeux).[10] From this point of view, the invisible which the Musée des Monuments Français allowed everyone to see was the history of the French state, its glory made manifest in the chronological succession of tombs and relics that had been rescued from revolutionary vandalism in order, precisely, to organize a national past and render it publicly

visible and present. As Michelet subsequently described the museum:

> *The eternal continuity of the nation was reproduced there. France at last could see herself, her own development; from century to century, from man to man and from tomb to tomb, she could in some way examine her own conscience.*[11]

From the point of view of the museum's role as a vehicle for public instruction, however, its artefacts were so arranged, and its architecture so contrived, as to give access to a second-order invisible: the progress of civilization toward the Enlightenment. Conferring a visibility on this developmental conception of time, Anthony Vidler has argued, was the result of an architectural arrangement which, as the visitor's route led chronologically from one period display to another, allowed for a progressive increase in the amount of natural light available to illuminate the exhibits, thus symbolizing man's journey from darkness toward the light.[12] In passing from room to room, as Lenoir put it, the more the visitor "remonte vers les siècles qui se rapprochent du nôtre, plus la lumière s'aggrandit dans les monuments publics, comme si la vue du soleil ne pouvait convenir qu'à l'homme instruit."[13]

In the early years of their establishment, public museums were centrally concerned with this latter kind of invisible: that is, with an order of significance which, rather than being thought of as spontaneously available to the inspection of all, was seen as requiring a calculated arrangement to make it visible. In this respect, those critiques which attribute a fetishism of the object to nineteenth-century museum exhibition practices quite often miss their mark. For, by the end of the century, at least in natural history and anthropology museums, the objects on display were far from being regarded as being meaningful and significant in and of themselves. Rather, they were often viewed as merely convenient props for illustrating — making visible — the ordering of forms of life or people proposed by scientific

principles of classification. In endorsing George Brown Goode's famous maxim that a museum is "a collection of instructive labels illustrated by well-selected specimens," Henry Flower, Richard Owen's successor as director of the British Museum of Natural History, thus went on to advise on the correct way of organizing a museum display:

> First...you must have your curator. He must carefully consider the object of the museum, the class and capacities of the persons for whose instruction it is founded, and the space available to carry out this object. He will then divide the subject to be illustrated into groups, and consider their relative proportions, according to which he will plan out the space. Large labels will next be prepared for the principal headings, as the chapters of a book, and smaller ones for the various subdivisions. Certain propositions to be illustrated, either in the structure, classification, geographical distribution, geological position, habits, or evolution of the subjects dealt with, will be laid down and reduced to definite and concise language. Lastly will come the illustrative specimens, each of which as procured and prepared will fall into its appropriate place.[14]

Similar reasoning had been applied to art galleries when their potential to function as instruments for public instruction had been the paramount consideration governing their conception and design. In 1842, a year after a House of Commons Select Committee had recommended that all its pictures should be clearly labelled and that a cheap information booklet be produced for its visitors, Mrs. Jameson thus summarized the historicist principles of the chronological hang which had proved so influential in the design of London's National Gallery:

> A gallery like this — a national gallery — is not merely for the pleasure and civilisation of our people, but also for their instruction in the significance of art. How far the history of the progress of painting is connected with the history of manners, morals, and government, and above all, with the history of our religion

might be exemplified visibly by a collection of specimens in painting, from the earliest times of its revival, tracing pictorial representations of sacred subjects from the ancient Byzantine types...through the gradual development of taste in design and sensibility in colour.... Let us not despair of possessing at some future period a series of pictures so arranged...as to lead the enquiring mind to a study of comparative style in art; to a knowledge of the gradual steps in which it advanced and declined; and hence to a consideration of the causes, lying deep in the history of nations and of our species, which led to both.[15]

Of course, the chronological hang was typically not just historicist but also nationalist in conception. If, as Carol Duncan and Alan Wallach have aptly christened them, "universal survey museums" display art historically with a view to making the progress of civilization visible through its artistic achievements, the role of the particular "host" nation in question is always accorded a privileged position such that the state acquires a visibility of its own in and amidst progress's relentless advance. Duncan and Wallach thus argue, taking the post-revolutionary transformation of the Louvre as their example, that art, in being transferred from royal collections into the new space of the public museum, could then be used to make visible "the transcendent values the state claims to embody" and so lend "credibility to the belief that the state exists at the summit of mankind's highest attainments."[16]

In the case of France, similar principles applied to the development, in the Napoleonic period, of a public museum system in the provinces in view of its dependency on strongly centralized forms of support and direction. Thus, in his study of the *envoi* system whereby works of art were made available on loan from national collections to provincial art museums, Daniel Sherman has shown how the primary purpose of this scheme was to make the state as such visible throughout France. "It would be only a mild exaggeration," Sherman thus writes, "to say that the state attached less importance to the pictures themselves than to

the labels on them that said '*Don de l'Empereur*' (gift of the Emperor) or later, more modestly but no less clearly, '*Dépôt de l'Etat*' (deposit of the State)."[17] It was similarly important that, in the system of inspection set up to supervise the standards of those museums which took part in the *envoi* system, considerable emphasis was placed on the desirability of well-ordered, clearly-labelled exhibitions from the point of view of their capacity to instruct. "If a museum does not, through its methodical arrangement, facilitate general instruction," the inspector Charvet wrote of the art museum in Roanne, "if it is nothing but a place where objects of artistic or historical interest or curiosities are assembled, it cannot attain precisely that elevated goal that the curator has so well detailed in the preface to his inventory."[18]

However, Sherman also throws useful light on the processes whereby, in its later development, the ethos of public instruction that had initially fuelled the public art museum declined as such institutions — to a greater degree than any other museum type — came to play an increasingly crucial role in the process through which relations of social distinction were organized and reproduced. Three aspects of these developments might usefully be commented on here.

First, in association with the "Haussmannization" of, initially, Paris, and, subsequently, France's major provincial cities, debates regarding suitable locations for art museums took on a new aspect. By the 1860s and 1870s, a premium was no longer placed on the degree to which the general accessibility of an art museum's location could enhance its utility as an instrument of public instruction. To the contrary, as part of what would nowadays be called "city animation" strategies, new art museums — in Bordeaux, Marseilles, and Rouen — were typically situated in parts of the city where they might serve as marker institutions targeting hitherto derelict parts of cities for programmes of bourgeoisification. In making such areas fashionable, art museums attracted bourgeois residents to their neighbouring suburbs, resulting in a rise in property values which forced working-class residents to seek accommodation

elsewhere. In this way art museums furnished a crucial component of the material and symbolic infrastructure around which new forms of class-based residential segregation were developed.

It is, then, small wonder that the bourgeois should wish his or her status to be recognized when visiting art museums. Recognition of such distinction, however, became increasingly difficult to secure—and partly because of the very success of art museums and kindred institutions in reforming the manners, the standards of dress and behaviour of the museum-visiting public. Although the point cannot be made incontrovertibly, it is likely that the opening of museums such as the Louvre and the British Museum did not spontaneously result in their being regularly used and visited by the urban middle classes. To the degree that such museums could be and were visited by artisans and workers who, if not unwashed, were often rude and boisterous, then so, as Michael Shapiro has argued, the norms of behaviour that were later to facilitate middle-class participation in museums had yet to emerge.[19] Those norms were only gradually fashioned into being through a history of rules and regulations, of prescriptions and proscriptions, by means of which new publics were tutored into codes of civilized and decorous behaviour through which they were to be rendered appropriately receptive to the uplifting influence of culture. As Michael Shapiro puts the point:

> Middle-class audiences learned that the restraint of emotion was the outward expression of the respect for quality, the deference to the best demanded of those who viewed objects in public places. Exhibitions thus became textbooks in public civility, places where the visitors learned to accord their counterparts recognition while avoiding modes of speech and conduct that intruded upon another's experience.[20]

But what could be learned by the middle classes could also be learned by the working classes. Indeed, in the conception of those who viewed museums as instruments of social

reform, it was intended that they should function as spaces of emulation within which visitors from the lower classes might improve their public manners and appearance by imitating the forms of dress and behaviour of the middle classes. The consequence, viewed in light of related developments over the same period, was that different classes became less visibly distinct from one another.

The development of mass-manufactured clothing, Richard Sennett has argued, resulted, in the second half of the nineteenth century, in a tendency toward increased homogeneity and neutrality of clothing as being fashionable came to mean "to learn how to tone down one's appearance, to become unremarkable."[21] The more standardized clothing became, however, the greater was the attention paid to those trivial details, the minutiae of costume through which, to the discerning eye, social status might be symbolized. It is in this light, Daniel Sherman suggests, that we might understand the passion with which, in the 1880s and 1890s, middle-class visitors resisted attempts by French provincial museums to introduce regulations requiring that umbrellas be checked in rather than carried through the galleries. For, Sherman argues, although umbrella-carrying was a habit that had spread to all classes, "the shape and condition of an umbrella could provide clues about the social status of the person carrying it."[22] The umbrella was, in short, a visible sign of distinction, and the struggle (largely successful) that was waged to retain the right to carry umbrellas reflected the degree to which the space of the art museum had become increasingly mortgaged to practices of class differentiation.

If, in this way, the bourgeois public rendered itself visibly distinct in a way that was manifest to the gaze of others, it was also able to render itself distinctive in its own eyes by organizing an invisible which it alone could see. By the late nineteenth century, to come to Sherman's third point, the earlier enthusiasm for rationally ordered, clearly labelled displays no longer applied to the new provincial art museums constructed in this period. Instead, under the influence of a

revival of Baroque aesthetics, pictures from different schools, types or periods were juxtaposed with one another in densely packed displays which virtually covered entire exhibition areas. Reflecting their concern to please rather than instruct the public, labelling was a low priority for the new museums of this period with the result that they either lacked descriptive labels for several years after their opening or provided such labels in such a minimalist fashion that they tended to institutionalize rather than overcome the cultural divide between their cultivated visitors and (for such is how it was conceived) the residue of the general public.

In recommending that there should be labels indicating the artist and subject for every painting, the director of the Rouen museum thus contended that the result would be

> *a kind of abridged catalogue — not enough for real art lovers, it's true, but enough to disseminate some 'glimmerings of truth' among the mass of the public, who are only interested in a work when they know the subject or when a famous name halts them en route and forces their admiration.*[23]

As Sherman argues, this recognized a division in the museum's public which "emphasised rather than dispelled its less educated members' inferior status."[24]

When endorsing the view that a museum should be regarded as "a collection of instructive labels illustrated by well-selected specimens," Flower had not exempted art museums from the requirements this entailed. It is true that he regarded art museums as having further to go to meet these standards than other museum types, complaining of their tendency to display too many works of art, incongruously juxtaposed to one another in unsuitable and poorly contextualized settings. However, Flower could see no reason why art museums should be exempt from the general requirements he believed needed to be met if public collecting institutions were to function effectively as vehicles for instructing the general public. "Correct classification, good labelling, isolation of each object from its

neighbours, the provision of a suitable background, and above all of a position in which it can be readily and distinctly seen," he argued, "are absolute requisites in art museums as well as in those of natural history."[25]

It is, perhaps, a long way from the decontextualizing Baroque principles of display Sherman describes — and to which Flower was reacting — to the subsequent history of the modernist hang in which the idea of art's autonomy was given a spatial and architectural embodiment. For it is only with the advent of modernism that the art gallery space assumes a value in and of itself as that which, in endowing the work of art with an illusion of separateness and autonomy, also then requires spectators capable of responding to it in its own right. "The ideal gallery," as Brian O'Doherty puts it, "subtracts from the artwork all clues that interfere with the fact that it is 'art'. The work is isolated from everything that would detract from its own evaluation of itself."[26] Be this as it may, one can see the respects in which the late-nineteenth-century display practices Sherman describes begin to prepare the ground for modernism in their commitment to the organization of a new invisible — "art" — which only the *cognoscenti* could catch a glimpse of. In the initial phases of their development, public art museums, it was suggested earlier, served, through the arrangement of their exhibits, to make the history of the state or nation, or the progress of civilization, visible. By the late nineteenth century, in a manner which differentiated them sharply from other types of museums, and continues to do so, the relations between the visible and the invisible in art museums became increasingly self-enclosing as the works on display formed part of a coded form of inter-textuality through which an autonomous world of "art" was made visible to those who were culturally equipped to see it.

If a genealogy for the role of theory in the modern art museum is called for, it is, perhaps, along the lines sketched above that one might be found. If it is true of all collecting institutions that they so arrange the field of the visible as to allow an apprehension of some further order of significance

that cannot, strictly speaking, be seen, the art museum is unique in simultaneously organizing a division between those who can and those who cannot see the invisible significance of the "art" to which it constantly beckons but which it never makes manifest. Far less freely and publicly available than the artefacts on display in the art museum, the aesthetic theories of modernism and postmodernism selectively mediate the relations between the visitor and the museum in providing—for some—a means of reading the invisible grid of inter-textual relations through which the works on display can be experienced as "art." Moreover, this affects the production as well as the consumption of artistic objects to the degree that much artistic production is now commissioned by, or is made with a view to its eventual installation in, art museums. This institutional complicity of art with the art museum has, Ian Burn argues, "created a need for affirmative (and self-affirming) theory, with art increasingly 'spoken for' by the new writing which has evolved its own academic forms of 'disinformation' about works of art."[27]

Of course, this is not to suggest that there is a simple or single "politics of the invisible" associated with the modern art museum. To the contrary, it is clear that those critiques of the art museum which have been developed from positions outside it have sought to politicize the museum space precisely by pointing to the respects in which, in making "art" visible to some but not to others, it simultaneously occludes a view of the diverse social histories in which the assembled artefacts have been implicated. The feminist critiques of Roszika Parker and Griselda Pollock and the critical ethnographic perspectives of James Clifford are cases in point.[28] In both cases, moreover, their implications for the exhibition practices of art museums are the same: that the artefacts assembled in them should be so arranged as to produce, and offer access to, a different invisible—women's exclusion from art, for example, or the role of museum practices in the aestheticization of the primitive.

It is, however, crucial to such interventions that they should take into account the more general "politics of the invisible" associated with the form of the art museum if they are not to be limited, in their accessibility and therefore in their influence, to those elite social strata that have acquired a competence in the language and theory of "art." This is not to suggest that existing forms of aesthetic training should be made more generally available without, in the process, themselves being modified. Rather, my point is that those interventions into the space of the art museum which seek to take issue with the exclusions and marginalizations which that space constructs, will need, in constructing another invisible in the place of "art," to give careful consideration to the discursive forms and pedagogic props and devices that might be used to mediate those invisibles in such a way, to recall Bourdieu and Darbel, as to be able, indeed, to "give 'the eye' to those who cannot 'see'."

The theories which inform such interventions may well be complex. However, the scope and reach of their effectivity will depend on the degree to which such theories are able to be translated into a didactics that is more generally communicable. The question of the role of theory in art museums is thus not one that can be posed abstractly; it is inevitably tied to questions of museum didactics and hence to the different publics which different didactics imply and produce. This means that the place of theory in the art museum has always to be considered in relation to the role of schooling in the production and distribution of artistic trainings and competences. When the schooling system fails to work methodically and systematically to bring all individuals into contact with art and different ways of interpreting it, Bourdieu and Darbel argue, it abdicates the responsibility, which is its alone, "of *mass-producing* competent individuals endowed with the schemes of perception, thought and expression which are the condition for the appropriation of cultural goods."[29] To the degree that no schooling system at present accomplishes this, any attempt to renovate the art museum's space theoretically

and politically must simultaneously be committed to developing the means of instruction which will help bridge the gap between the invisible orders of significance it constructs and the social distribution of the capacity to see those invisible significances.

Notes

1. Pierre Bourdieu, "The Historical Genesis of a Pure Aesthetic," *Journal of Aesthetics and Art Criticism*, 46 (1987): 203.

2. Karl Marx, *Grundrisse: Foundations of the Critique of Political Economy* (Harmondsworth: Penguin Press, 1973), 90–92.

3. Bourdieu, "The Historical Genesis of a Pure Aesthetic," 202.

4. Pierre Bourdieu and Alain Darbel, *The Love of Art: European Art Museums and Their Public*, trans. C. Beattie and N. Merriman (Cambridge: Polity Press, 1991), 53. First published in French in 1969.

5. Ibid., 56.

6. John Frow, "Accounting for Tastes, Some Problems in Bourdieu's Sociology of Culture," *Cultural Studies*, 1, no. 1 (1987): 59–73.

7. See Tony Bennett and John Frow, *Art Galleries: Who Goes? A Study of Visitors to Three Australian Art Galleries with International Comparisons* (Sydney: Australia Council, 1991).

8. Krzysztof Pomian, *Collectors and Curiosities: Paris and Venice, 1500–1800* (Cambridge: Polity Press, 1990), 9.

9. Ibid., 22.

10. Cited in Anthony Vidler, "Gregoir, Lenoir et Les 'Monuments Parlants'," *La Carmagnole des Muses*, ed. Jean-Claude Bornet (Paris: Armand Colin, 1986), 141.

11. Cited in Francis Haskell, "The Manufacture of the Past in Nineteenth-Century Painting," *Past and Present*, 53 (1971): 115.

12. See Anthony Vidler, *The Writing of the Walls: Architectural Theory in the Late Enlightenment* (New Jersey: Princeton Architectural Press, 1987).

13. Vidler, "Gregoir, Lenoir et Les 'Monuments Parlants'," 145.

14. Sir William Henry Flower, *Essays on Museums and Other Subjects Connected with Natural History* (London: Macmillan, 1898), 18.

15. Cited in Gregory Martin, "The Founding of the National Gallery in London," *The Connoisseur*, no. 187 (1974): 279–280.

16. Carol Duncan and Alan Wallach, "The Universal Survey Museum," *Art History* 3, no. 2 (1980): 457.

17. Daniel J. Sherman, *Worthy Monuments: Art Museums and the Politics of Culture in Nineteenth-Century France* (Cambridge, Mass.: Harvard University Press, 1989), 14.

18. Cited in Sherman, 76.

19. Michael S. Shapiro, "The Public and the Museum," in Shapiro (ed.) *The Museum: A Reference Guide* (New York: Greenwood Press, 1990).

20. Ibid., 236.

21. Richard Sennett, *The Fall of Public Man: On the Social Psychology of Capitalism* (New York: Vintage Books, 1978), 164.

22. Sherman, "Worthy Monuments," 228. See also Daniel Sherman, "The Bourgeoisie, Cultural Appropriation, and the Art Museum in Nineteenth-Century France," *Radical History Review*, 38 (1987): 38–58.

23. Sherman, "Worthy Monuments," 217–218.

24. Ibid., 218.

25. Flower, *Essays on Museums and Other Subjects Connected with Natural History*, 33.

26. Brian O'Doherty, *Inside the White Cube: The Ideology of the Gallery Space* (San Francisco: Lapis Press, 1976), 14.

27. Ian Burn, "The Art Museum More or Less," *Art Monthly* (November 1989): 5.

28. Roszika Parker and Griselda Pollock, *Old Mistresses: Women, Art and Ideology* (New York: Pantheon, 1982); James Clifford, "On Collecting Art and Culture," *The Predicament of Culture: Twentieth-Century Ethnography, Literature, and Art* (Cambridge, Mass.: Harvard University Press, 1988).

29. Bourdieu and Darbel, *The Love of Art*, 67.

APPENDIX:
Statement of Concerns Sent to Presenters

Art as Theory: Theory and Art
Theory has emerged as the privileged site of mediation between processes of market valorization and discourses of intellectual and political legitimation in the production and circulation of art. This conference is being organized to discuss the conditions and contexts for such changes and their impact in contemporary culture. We present the following list of contextual conditions for discussion, and invite participants to address them in their presentations.

(1) The increasing predominance of academic institutions in the training, funding, and employment of artists.

(2) The changing function of museums in contemporary culture: curatorial agendas and vocational formations.

(3) The growth and rationalization of the publishing industry and the critical/promotional infrastructure: the proliferation of theory in art journals and, increasingly, in books.

(4) The evolving canonization of theoretical models in academia. The increasingly interconnected consumption and citation of legitimated/fashionable authors and ideas through publication and circulation of texts; their timely consumption as a precondition of entry into a privileged domain of knowledge.

(5) The shifting centrality of artistic works or movements as privileged objects for theoretical legitimation in the field

of academic cultural politics. Also, the inversion of this: the invocation of theoretical knowledge in the legitimation of art works.

(6) The monetary inflation and global rationalization of the art market; the interconnected international circulation of art works and critical texts.

(7) The collapse of immanent critical teleological artistic discourse, i.e., the post-war collapse of the avant-garde; the displacement onto theory as the context in which historical significance and change are marked.

(8) The rapid consumption of marginal and oppositional discourses and practices by high theory and its systems of legitimation, including the markets for books, journals, art works, and conferences. Inversely, theory's role in identifying and informing critical and oppositional practices.

Jody Berland, Will Straw, David Tomas
April 1991

NOTES ON CONTRIBUTORS

WILL STRAW is Associate Professor in the Graduate Program in Communications at McGill University in Montreal. From 1984 to 1993, he was Assistant Professor of Film Studies at Carleton University, Ottawa. He has published widely on popular music, film and cultural studies, and is on the editorial committees of *Screen*, *Cultural Studies*, and *Perfect Beat*.

THIERRY DE DUVE has written extensively on modern and contemporary art, with an emphasis on the work of Marcel Duchamp and its theoretical implications. His English publications include *Pictorial Nominalism* and *The Definitively Unfinished Marcel Duchamp* (of which he was the editor). An updated synthesis of his theoretical work is forthcoming from MIT Press under the title *Kant after Duchamp*. He has been professor at the University of Ottawa (1982–91) and director of studies of the future Ecole des Beaux-Arts de la Ville de Paris (1991–93), a project abruptly cancelled by the City of Paris. Since then, he has taught at MIT and at Reid Hall, Paris.

VIRGINIA R. DOMINGUEZ, currently Professor of Anthropology and Director of the Center for International and Comparative Studies at the University of Iowa, is the author of *White By Definition: Social Classification in*

Creole Louisiana (Rutgers University Press, 1986), and *People as Subject, People as Object: Selfhood and Peoplehood in Contemporary Israel* (The University of Wisconsin Press, 1989).

KEVIN DOWLER is a writer and artist living and working in Toronto. He has a PhD in Communications from Concordia University, and is currently working on the history of video art in Canada while holding a Social Sciences and Humanities Research Council Post-Doctoral Fellowship. He has written on the history of aesthetic debates surrounding television.

JAMELIE HASSAN was born in London, Ontario, where she currently lives. She is an artist whose diverse activities involve investigations of the power and politics of representation and of the position of the subject — especially in relation to the supposed neutrality of representation. She has exhibited widely in Canada and internationally since the 1970s.

BARBARA HARLOW teaches English and Comparative Literature at the University of Texas at Austin. She is the author of *Barred: Women, Writing and Political Detention* (Wesleyan University Press, 1992) and *Resistance Literature* (Methuen, 1987), and has written on cultural politics and third world literature.

JODY BERLAND teaches Cultural Studies in the Department of Humanities, Atkinson College, York University, Toronto. She has published extensively on music, media, and social space, and on Canadian communication and cultural theory. She has also written on landscape and tourism, video and television, and Canadian cultural politics and policies. She is currently writing a series of articles on the cultural and technological mediations of weather, which will be collected in a book entitled *Weathering the North*. She is co-editor of a forthcoming anthology on culture in Canada.

BETH SEATON is Assistant Professor in the Programme in Mass Communications at York University. She has taught within the areas of media and gender, cultural studies, and communication at Concordia and Carleton Universities. Her published articles and book chapters are predominantly concerned with the cultural politics of gender, identity, and representation. She is currently co-editing a book on recent approaches to communications and cultural studies.

JANET WOLFF is Professor of Art History and Visual and Cultural Studies at the University of Rochester. Her publications include *The Social Production of Art, Aesthetics and the Sociology of Art*, and *Feminine Sentences: Essays on Women and Culture*. She is completing a book of essays on memoir, travel, and cultural theory, entitled *Resident Alien*.

DAVID TOMAS is an artist and anthropologist living in Montreal. He teaches in the Department of Visual Arts at the University of Ottawa. His articles have appeared in *Public*, *New Formations*, *Parachute*, *Sub-Stance*, *Visual Anthropology Review*, and various anthologies.

JANINE MARCHESSAULT teaches Cultural Studies at McGill University, Montreal. She is a founding member of the Public Access collective, and is on the editorial boards of *CinéAction* and *Public*. She is the editor of *Mirror Machine: Video and Identity* (YYZ Books, 1995), and is currently completing a book on science and imaging. She has also produced several videos including *The Act of Seeing with Another Eye* (1990) and *The Numerology of Fear* (1995).

OLIVIER ASSELIN received his doctorate from the Université de Paris VIII and is Assistant Professor of Theory and History of Art in the Visual Arts Department at the University of Ottawa. He has published articles in *Parachute*, *Trois*, *Protée*, and numerous other magazines and journals. In collaboration with Johanne Lamoureux, he is currently

preparing a special issue of *Trois* entitled "Fictions suprêmes: Diderot et la question du site."

TIM CLARK received an MFA in Photography in 1980 and an MA in Art History in 1991 from Concordia University. He teaches part-time and works full-time as a technician in the Department of Printmaking and Photography at Concordia. As an artist his interest has been in producing installations that he describes as performance works *for* the audience. Both his research in art history and his installation productions deal with the problematics of modernity.

FRANCINE DAGENAIS is an art historian, theorist and translator who has written for a number of specialized arts publications. She has just been awarded a Canada Council grant to study the impact of computer technology on art-making in Canada. She is currently living in Montreal.

TONY BENNETT is Professor of Cultural Studies in the Faculty of Humanities at Griffith University in Brisbane, Australia. He is the author of several books, including *Bond and Beyond* (with Janet Woollacott), *Formalism and Marxism*, *Outside Liberalism* and *The Birth of the Museum*.

THEORY RULES
ART AS THEORY / THEORY AND ART

EDITED BY
JODY BERLAND, WILL STRAW, AND DAVID TOMAS
MANAGING EDITOR: JANE KIDD
DESIGNED BY HAHN SMITH DESIGN
TYPESET BY RICHARD HUNT AT ARCHETYPE
IN AVENIR, CENTURY SCHOOLBOOK AND COMPACTA
PRINTED ON ACID FREE PAPER

PRINTED AND BOUND IN CANADA

YYZ PUBLISHING COMMITTEE PAST AND PRESENT MEMBERS:
PETRA CHEVRIER, CHRISTINE DAVIS,
MARC DE GUERRE, TERESA HEFFERNAN, SUSAN KEALEY, HEIDI MACKENZIE,
JANINE MARCHESSAULT, BERNIE MILLER, STEVE REINKE.